EUROPEAN DRAWINGS

1375 – 1825

EUROPEAN DRAWINGS 1375–1825

Catalogue compiled by

CARA D. DENISON & HELEN B. MULES

with the assistance of

JANE V. SHOAF

1981

The Pierpont Morgan Library
Dover Publications, Inc.

NEW YORK

LIBRARY OF CONGRESS CATALOGING IN PUBLICATION DATA

Pierpont Morgan Library, New York.
 European drawings, 1375–1825.

 Includes bibliographical references and index.
 1. Drawing, European—Catalogs. 2. Drawing—New York (City)—Cata-
logs. 3. Pierpont Morgan Library, New York—Catalogs. I. Denison, Cara
D. II. Mules, Helen B., 1948-. III. Shoaf, Jane V. IV. Title.
NC225.P5 1981 741.94'074'01471 80–27913
ISBN 0-486-24159-9 (Dover)

This catalogue has been made possible in part by a grant from the National
Endowment for the Arts, an agency of the United States Government.

Printed in the United States of America

Cover Illustration: Cat. No. 32. Albrecht Dürer, *Adam and Eve*.

For Felice Stampfle

TABLE OF CONTENTS

PREFACE

IN this volume we have attempted to present a survey of European draughtsmanship over four hundred fifty years, from the end of the fourteenth century to the time in the nineteenth century when drawing and painting became so varied in style that to carry the survey to the end of the century, or into the present one, might well have required another book of drawings. The selection given here is limited to the collection of master drawings in The Pierpont Morgan Library and has been chosen in relation to its strengths. Although there are notable American works in the Library, most are European, and although there are a number of later drawings, most were made before 1825. There are undoubted masterpieces in this volume, and of course more in the collection of the Library, but the drawings were selected not only for their outstanding quality but also to illustrate the range of European draughtsmanship, the various schools and techniques, the different periods, and the achievements of the major artists.

In 1910 through the purchase of the Charles Fairfax Murray Collection, Pierpont Morgan was able to bring the first classic collection of European old master drawings of all schools and periods to America. It remains the core of the Department of Drawings at the Morgan Library. Today the Morgan collection consists of approximately five thousand drawings and within its limits remains unexcelled in this country. In its student room, in its involvement with the journal *Master Drawings*, in its publication of catalogues and books on drawings, as well as in its active acquisitions policy, this Department remains very much at the center of interest in master drawings in the United States. This catalogue reveals how keenly alive the collection is: nearly one fourth of the drawings illustrated in this book were acquired in the last ten years; in fact, eight of the one hundred twenty-five drawings came to the Library during the past two years. Although we have all lamented the difficulty of obtaining distinguished examples of drawings, particularly of the sixteenth century and earlier, you will find that seven of the twenty-nine drawings shown here and acquired in the last decade are from that period.

The excellence of the acquisitions in recent years and the appreciation of drawings and research on them at the Morgan Library are in great part due to the connoisseurship and

scholarship of Miss Felice Stampfle and her colleagues. Miss Stampfle has been Curator of Drawings and Prints in the Library for thirty-five years. Her devotion to the Library and its collections and to the whole world of master drawings is widely recognized; it is only fitting that we dedicate this book to her. It is a small tribute to her knowledge and taste, and to her contributions to the study of drawings.

Cara D. Denison, Associate Curator, and Helen B. Mules, formerly Assistant Curator of Drawings and Prints, have prepared this text and the exhibition at the Morgan Library (19 February – 3 May 1981) of the drawings illustrated here. We are all indebted to them for their discernment and their thorough scholarship. Mrs. Denison provided entries Nos. 1–8, 11–19, 24–26, 28–29, 38–39, 41–55, 86–88, 91–92, 97–106, 120–121, as well as the Introduction; Mrs. Mules wrote Nos. 10, 20–23, 27, 30–35, 37, 40, 68, 78, 89–90, 93–96, 107, 109–110, 116–118, 123–124; Miss Jane V. Shoaf contributed Nos. 111–115. In view of the recency of Miss Stampfle's catalogue *Rubens and Rembrandt in Their Century*, the entries for drawings included here from the Dutch and Flemish schools, Nos. 56–67, 69–77, and 79–85, have been used with little change; one of these (No. 63) was written by R.-A. d'Hulst, the rest by Miss Stampfle. Similarly, eight of the entries in the catalogue have been only slightly revised by the compilers from the volume *Drawings from the Collection of Mr. and Mrs. Eugene V. Thaw*, 1975 (Nos. 9, 36, 60, 76, 108, 119, 122, and 125). Mrs. Ronnie Boriskin and Francis S. Mason, Jr., have been most helpful with the arrangements for publication of this book. Once again our friends at The Stinehour Press and The Meriden Gravure Company have designed and printed a volume of distinction and elegance; we are particularly grateful to Roderick Stinehour, Glenn Hogan, and Stephen Stinehour.

As will be plain from information concerning the acquisition of each drawing, the collections of the Morgan Library have been wonderfully enriched through the generosity of the Association of Fellows and through the special gifts of individual Fellows and Trustees. Nearly half of the drawings in this volume have come or will come to the Library in this way. Six of them are promised gifts: the drawing by Raphael (No. 13), from an anonymous private collection, and drawings by Rubens, Rembrandt, Goya, Friedrich, and Constable (Nos. 60, 77, 119, 122, and 124), which are in the collection of Mr. and Mrs. Eugene V. Thaw. To all of these benefactors of the Library, past and present, we give heartfelt thanks.

This publication was made possible, in part, by a grant from the National Endowment for the Arts, a federal agency. We are also grateful to The Charles W. Engelhard Foundation for generous support of this and other publications of the Morgan Library.

Charles Ryskamp
DIRECTOR

INTRODUCTION

THE Morgan Library's drawing collection—its origins, its development, and its contents—has been treated in detail by Felice Stampfle. Throughout her term as Curator of Drawings and Prints, which began in 1945 and extends to the present time, her exemplary scholarship has covered these topics so thoroughly that much of what is written here must necessarily only reflect what she herself has already said so well elsewhere.

The single greatest acquisition and the event which may be regarded as the beginning of the Library's collection was Pierpont Morgan's well-known purchase in 1910 of virtually all the holdings of Charles Fairfax Murray. Morgan thereby enriched the Library by approximately fifteen hundred old master drawings from the collection of the English artist and *marchand-amateur*. Prior to that, no group of such scope or artistic significance had ever come to America, although several smaller groups of drawings of lesser importance had arrived in this country during the nineteenth century.

Fairfax Murray (1849–1919) began to buy drawings in Italy but it was not really until he returned to England in the late 1870's that he started to collect in earnest and compete seriously in the sales room as he did over the course of the next thirty-five years. He succeeded in putting together a well-rounded collection of high quality with special strengths in Italian, Dutch, Flemish, and English drawings. The French School is represented in his collection less comprehensively although the group includes an especially fine concentration of drawings by Claude, and, to a lesser extent, by Poussin and Fragonard. Sixteenth-century drawings make up approximately half of his Italian holdings—a fortunate preference, given the high esteem in which Renaissance drawings have been held since Vasari's day and their increasing scarcity on today's art market. While less comprehensive, Fairfax Murray's holdings of seventeenth-century Italian drawings include representation of such major figures as Guercino and Bernini. The eighteenth century begins with works by Giovanni Battista Piazzetta, who revitalized the art of Venice after nearly a hundred years of relative stagnation; the Tiepolos, who dominate the century, are represented by more than one hundred drawings, chiefly by Giovanni Battista but with characteristic examples by his son Domenico. Fairfax Murray's holdings of English drawings surveyed the major draughtsmen of the eighteenth century,

notably an excellent range of the drawings of Thomas Gainsborough and an important series of drawings by the satirist William Hogarth. In addition to these strengths, Fairfax Murray had a special affinity for the great seventeenth-century Dutch and Flemish masters, and his classic collection of their drawings has been examined in great detail very recently by Felice Stampfle in her catalogue of a selection of the Library's holdings of this school. It is a measure of the quality of this group that the late Frits Lugt, founder of the superb and in many ways analogous collection of the Institut Néerlandais in Paris, always regretted that he had failed to acquire the collection of his old rival in the sales rooms, Fairfax Murray. Given the quality and range of Fairfax Murray's collection, it is not surprising that nearly half the drawings selected for this survey have been chosen from this group alone.

Another eight drawings illustrated in the present volume were also acquired early as part of the original group assembled by the Library's founder, J. Pierpont Morgan. *The Morning Stars* (No. 116) stands in token of the twenty-one watercolor illustrations of the Book of Job by William Blake purchased by Mr. Morgan in 1903. The Boucher sheet (No. 102) was an early purchase of Pierpont in 1905, but it did not enter the collection until 1943 after the death of Pierpont's son, J. P. Morgan; the same is true of the Gainsborough *Study of a Lady* (No. 112). Another of Pierpont's early acquisitions was the French boxwood sketchbook (No. 3), purchased in Paris in 1906. Four years later through his nephew Junius, Pierpont acquired four great Dürer drawings in the Von Lanna sale, including the *Adam and Eve* (No. 32) and the *Kneeling Donor* (No. 33). At Agnew's in 1911 he bought two exceptional drawings by Watteau (Nos. 99–100).

In terms of the drawings collection, the Library was relatively inactive in the auction rooms and dealers' houses between 1911 and 1950, although J. P. Morgan continued to enrich the already formidable collection of Rembrandt etchings begun by his father who had acquired the Irwin and Vanderbilt collections in 1900 and 1905 respectively. The records show, however, that the drawings grew by some three hundred items during this time, a figure which includes some sketchbooks and a group of fifty-four rather slight sketches made by Eugène Delacroix during his trip to Morocco in 1832. An album of French eighteenth-century illustrations to Ovid was presented by Mrs. George Blumenthal.

After World War II there was a new focus on acquisitions. Of the remaining drawings included in this survey, thirty-seven were acquired by selective purchase and another twenty-four were direct gifts of the Fellows and Trustees from their own collections. With the advent of Felice Stampfle as Curator of Drawings and Prints, the Department made its first major acquisition in 1947, Guardi's sparklingly impressionistic view *The Bucintoro off S. Niccolò*

di Lido (No. 94). In 1949 when ill health forced the retirement of Belle da Costa Greene, the Library's first Director, she was succeeded by Frederick B. Adams, Jr. Under his leadership, in concert with the Trustees, the Association of Fellows was formed, a group whose keen interest and support has made it possible for the Library to implement a dynamic program of acquisition as well as expanded activities. The first purchase was Blake's twelve watercolor illustrations of Milton's *L'Allegro* and *Il Penseroso* (No. 117). Within the first four years of the fifties alone, over sixteen hundred drawings were added to the collection, a figure accounted for in large measure by the gifts of the late Junius S. Morgan and Mr. Henry S. Morgan from the collection of architectural and flower drawings formed by their mother, Mrs. J. P. Morgan (d. 1925). Another large group of two hundred and one drawings for book illustration by Giovanni Battista Piazzetta and his workshop was presented by the Samuel H. Kress Foundation. Other major donors during the twenty years of Mr. Adams' directorship were Belle da Costa Greene, Janos Scholz, Hall Park McCullough, H. P. Kraus, and John Fleming. A number of drawings acquired during that time were purchased as the gifts of the late Walter C. Baker and Mrs. Anne Bigelow Stern, whose interest and support made it possible to add a drawing a year in each of their names. Miss Stampfle, working with the Director and the Fellows, recommended a number of drawings that expanded the collection in areas not previously represented.

Under Charles Ryskamp, Director since 1969, the holdings of the Department have continued to grow rapidly. In the last decade more than one thousand drawings have been added to the collection. This figure reflects the numerous gifts to the Library which have substantially augmented purchases. Among the donors of outstanding gifts are Miss Louise Crane, John Crawford, H. P. Kraus, Paul Mellon, and the late Benjamin Sonnenberg as well as the Mary Flagler Cary Charitable Trust and the E. J. Rousuck Fund. In addition there have been the bequests of Lois Duffie Baker, Therese Kuhn Straus, Mrs. Landon K. Thorne, and Helen Gill Viljoen. In 1970 Mrs. Robert H. Charles made possible the acquisition of the important group of two-hundred and sixty-seven drawings by Benjamin and Raphael West. Miss Alice Tully's generosity has enabled the Library to purchase a number of especially fine Italian drawings; Mr. and Mrs. Claus von Bulow, new benefactors of the Library, helped us to acquire a number of important French drawings, including two by Watteau (No. 98) and a portrait by Ingres (No. 121). Mrs. Charles W. Engelhard and Mrs. Christian H. Aall have also been responsible for gifts of distinction. In 1980, thanks to the munificent general bequest of Lois Duffie Baker to the Library, it has been possible to establish a special departmental fund for the acquisition of drawings. It is to be known as the Lois and Walter C. Baker Fund

in acknowledgment not only of Mrs. Baker's generosity but of the earlier donations and support of her husband. Turner's *View of Dunster Castle* (No. 123) has been purchased in recognition of the singular generosity of Mrs. Baker.

Under Dr. Ryskamp's directorship two exceptional collections have been promised to the Library which will eventually add well over sixteen hundred drawings. In 1973 Janos Scholz announced that his collection of more than fifteen hundred Italian drawings would come to the Morgan Library. Over the course of forty years Mr. Scholz has amassed a comprehensive collection which encompasses the major and many minor schools of Italian draughtsmanship from the fifteenth to the eighteenth centuries. To date close to a hundred and fifty of his drawings have been added to the Library's collection by donation and purchase, and in time the Scholz collection will strengthen the Library's position as an outstanding center for the study of Italian draughtsmanship in this country. The other major collection which will someday come to the Library is that formed and refined over a twenty-five-year period by Mr. and Mrs. Eugene V. Thaw. It is a strong collection of around one hundred drawings which will enrich and extend the Morgan collection comprising as it does, not only an impressive group of old master drawings but a fine range of nineteenth-century draughtsmanship as well, with examples by Goya, Delacroix, Géricault, Ingres, Daumier, Degas, and Cézanne. The Thaws have already given twenty-two drawings to the Library, recently the Jörg Breu (No. 36) and the Samuel Palmer (No. 125). Among the promised Thaw gifts included in this volume are the Rubens (No. 60) and Rembrandt (No. 76) sketches, both preparatory for compositions of the Descent from the Cross.

In May 1973, it was announced that a substantial part of a third collection of drawings, that owned by Dr. and Mrs. Rudolf Heinemann, would come to the Library. The late Dr. Heinemann was an ardent supporter of the Morgan Library, especially the Department of Drawings, and Mrs. Heinemann continues to be extremely interested in the development of the Morgan collection. Despite his preference for anonymity, mention should also be made of a most generous and discerning collector, a Trustee of the Library, who over the course of the last decade has again and again given drawings of the highest quality. He is represented in the present catalogue by the Montagna (No. 7), the Florentine *Christ* (No. 15), the Rubens portrait study (No. 58), and by his most recent and perhaps most precious gift, the superb Rembrandt *Nude* (No. 78) given in honor of Charles Ryskamp's tenth anniversary as Director. This was the first Rembrandt drawing to enter the collection since 1910.

The survey presented in this volume has kept within the basic limits of the collection, comprising European master drawings from the fourteenth century through the early years

of the nineteenth. The largest representation of a national school is the group of forty-three Italian drawings. The French School accounts for twenty-five more drawings. Nineteen Dutch and fourteen Flemish drawings follow, and the English School is exemplified by eleven drawings. The German drawings number eight, four of them by Albrecht Dürer. Five sheets, including two by Goya, reflect the Library's scant holdings of Spanish draughtsmanship. The catalogue has been arranged chronologically in centuries, first by school and then by artist.

While few drawings survive to illuminate the shadowy period of mediaeval draughtsmanship, the Library is fortunate in being able to begin this survey with the diverting Lombard pattern or model book (No. 1) and the exquisite French boxwood sketchbook (No. 3). Equally rare is the fourteenth-century *modello* or finished drawing made to give the patron an impression of the final painting or other work of art (No. 2). Italian Renaissance draughtsmanship is beautifully represented by Signorelli's superb drawing *Four Demons* acquired at the Harewood sale in 1965 (No. 4); the unusual fragment of a cartoon by Botticelli (No. 5); a lovely double-sided sheet by Filippino Lippi drawn in metalpoint on prepared paper, acquired in 1951 (No. 8); a delicately worked leaf, also double-sided, from an album of landscape studies by Fra Bartolomeo, purchased in 1957 (No. 11); Bartolomeo Montagna's austerely beautiful study of a nude (No. 7); and Francia's highly finished rendering of *Judith and Holofernes* (No. 6). The two drawings of completely different character by the Northern artists Bernhard Strigel (No. 10) and an anonymous Franco-Flemish master (No. 9) fall naturally into the survey's chronology here. Michelangelo is represented by the four small but progressively evolving studies for *David Slaying Goliath* (No. 12); Raphael, by the rare early *modello* for one of the murals of the Piccolomini Library in Siena (No. 13), which is the promised gift of a private collector. The eclectic North Italian master Pordenone is shown at his best in the finished drawing the *Conversion of St. Paul* (No. 14) as is Correggio in the atypical but immensely powerful *Head of a Woman Crying Out* (No. 17). The essential structure of the human figure, which was a primary concern of the sixteenth-century Florentine draughtsmen, is nowhere better exemplified than in Andrea del Sarto's study from the live model (No. 16) or in the double-sided drawing of Andrea's most brilliant student, Pontormo, a work of eccentric *bravura* (No. 18). The refined handling of the chalk in the study for *Christ on the Cross* (No. 15) by an as yet not clearly identified artist presupposes an awareness of the Florentine School's achievement in figure draughtsmanship. Vasari's complex allegorical *Ceiling Design* (No. 24) and Salviati's imposing Mannerist *Head of a Man* (No. 23) com-

plete the survey's representation of sixteenth-century Florentine draughtsmanship. Three sheets each executed in a different medium (Nos. 20–22) stand in token of the Library's substantial holdings of Parmigianino drawings. Tintoretto (No. 25) and Veronese (No. 26) represent sixteenth-century Venetian draughtsmanship. Perino del Vaga's refined and decorative style is displayed in one of his *modelli* for a crystal plaque (No. 19), and Federico Zuccaro is shown in a bold pen-and-wash drawing made while he was in exile in Venice (No. 27). The School of Fontainebleau, a hybrid of Northern and Italian artistic and cultural ideals, essentially formed by Italian artists imported to France by Francis I, is represented by Antoine Caron's drawing of a royal festival which is as fascinating as a document as it is decorative (No. 28) and by the recently purchased rendering of *Procris and Cephalus* (No. 29) by the anonymous master known as the Maître de Flore. An interesting drawing attributed to Hieronymous Bosch (No. 30) and the magisterial *Mountain Landscape* by Pieter Bruegel the Elder (No. 31), one of the outstanding acquisitions of any time, precede the impressive group of sixteenth-century German drawings including the four Dürers: the superb pen-and-wash study for the 1504 engraving *Adam and Eve* (No. 32); the masterful brush drawing on blue paper, the *Kneeling Donor* (No. 33); the fine calligraphic *Design for the Pommel Plate of a Saddle* (No. 34); and the delicately tinted *Design for a Mural Decoration* (No. 35). Drawings on prepared paper by two gifted draughtsmen, both strongly influenced by Dürer, Jörg Breu the Younger (No. 36) and Tobias Stimmer (No. 37), conclude the showing of sixteenth-century draughtsmanship.

Bologna dominated seventeenth-century draughtsmanship in Italy for a time and the survey of this century begins with Annibale Carracci's vigorous pen study of an *Eroded River Bank* acquired in the Ellesmere sale in 1972 (No. 38). It continues with a work by Carracci's most important student, Guido Reni, the sensitive chalk study of a male torso for a painting of the Crucifixion (No. 39). Domenichino's impressive large-scale chalk cartoon *Head of an Angel* (No. 40) was acquired in 1973 through the generosity of Miss Alice Tully. It precedes two quite different examples by Guercino (Nos. 42–43) and the *Head of Christ* (No. 41) by the Genoese artist Bernardo Strozzi, whose work in Venice helped to distinguish a relatively stagnant period of Venetian art. The period of the High Baroque in Rome is represented by Pietro da Cortona's singularly beautiful drawing *Woman Holding the Papal Tiara* (No. 44), preparatory for the ceiling of the Palazzo Barberini, Rome. The two splendid portraits by Gian Lorenzo Bernini, the one a vivid life study of Cardinal Scipione Borghese for the famous sculptor's marble bust (No. 45), and the other, an accomplished independent work of art (No. 46), were both in the Fairfax Murray collection. Stefano della Bella, the seventeenth-

century Florentine printmaker, is seen in a typical pen-and-wash drawing of delicate vitality (No. 47). Examples of the work of two French printmakers, both active at the Court of Lorraine at Nancy, Jacques Bellange and Jacques Callot, follow. *Diana and Orion* (No. 48) epitomizes the elegance of Bellange's draughtsmanship while the *Miracle of St. Mansuetus* (No. 49) shows Callot moving toward the dramatic pictorialism of the early Baroque. The great French expatriate artist Nicolas Poussin, who lived most of his life in Rome, is given representation in the brilliantly dramatic *Death of Hippolytus* (No. 50) and the more classically composed subject *The Holy Family* (No. 51). His near contemporary Claude Lorrain, the celebrated landscape artist who, like Poussin, lived most of his life in Rome, is generously represented by four examples of the first quality (Nos. 52–55). The survey continues with a large group of drawings included in Miss Stampfle's recent catalogue, *Rubens and Rembrandt in Their Century.* Thirteen of the fourteen sheets in the Flemish section of the present survey belong to the seventeenth century, not surprisingly in view of the sizable sequence of drawings by Rubens (Nos. 58–61) and Van Dyck (Nos. 65–67), the greatest of the Flemings. Jordaens, next in importance to these artists, is seen here in a typically colorful design for a tapestry (No. 64) and in the accomplished *Portrait of a Young Woman* (No. 63), surely one of the artist's best drawings, which was the special gift of the Fellows in honor of Miss Stampfle in 1977. Also of special note is the fresh pen-and-watercolor *View of Valenciennes* (No. 68) by Adam Frans van der Meulen which was purchased as the gift of Mrs. Charles Engelhard in memory of André Meyer in 1979, too recently to be included in the Flemish and Dutch catalogue. As was true of the Flemish section, most of the Dutch drawings included in the present volume belong to the seventeenth century; five are by Rembrandt (Nos. 74–78) and all but the new *Seated Female Nude* (No. 78) were in Miss Stampfle's recent catalogue. Notable in the Dutch group are two powerful examples of the work of the Haarlem Mannerist Hendrick Goltzius, the *Young Man with a Skull and Tulip* (No. 70), a virtuoso display of calligraphic penwork, and *The Judgment of Midas* (No. 69), a superb pictorial treatment in color of a mythological subject. The *Mountain Landscape* by De Gheyn (No. 72) provides a fascinating comparison with the earlier landscape by Pieter Bruegel. Ostade's fresh watercolor genre subject (No. 80) is typical, even superior of its kind, as is the *Portrait of a Man* by Jan Lievens (No. 79), presented to the Library by the late Benjamin Sonnenberg. With the notable exception of Jan de Bisschop's sweeping sunlit *View of Rome* (No. 85), the representation of Dutch seventeenth-century art concludes with diverse views of Holland's landscape by such artists as Koninck, Cuyp, Doomer, and Jacob van Ruisdael (Nos. 81–84). The three seventeenth-century Spanish artists represented are the brilliant Caravaggesque painter and

printmaker Jusepe de Ribera who worked in Naples (No. 86), the essentially religious painter Murillo (No. 87), and the gifted painter-architect Francisco Herrera the Younger (No. 88). The small group of Spanish drawings concludes with Francisco Goya's powerful fantasy *Pesadilla* (No. 118), the gift of Mr. and Mrs. Richard J. Bernhard, and the moving *Dejalo todo a la probidencia* (No. 119), one of a distinguished group of drawings by the artist which Mr. and Mrs. Thaw have promised to the Library.

The beautiful head personifying the Sense of Hearing for a series of the Five Senses (No. 89) is a characteristic example by Giovanni Battista Piazzetta who initiated the revitalization of Venice as the dominant center of Italian art at the beginning of the eighteenth century. Gian Paolo Pannini's impressive perspective *View of the Villa Albani, Rome* (No. 90), delightfully enhanced with watercolor, entered the Library in 1977 as the first example of the Roman artist's work in the collection. Giambattista Tiepolo, the most accomplished draughtsman of the Venetian settecento, is well represented by *Time and Cupid*, a study for the Palazzo Clerici, Milan (No. 91), and *The Triumph of Hercules* (No. 92), a complete ceiling design that is a rarity in his surviving *oeuvre*. Giambattista's son Domenico, who ably assisted his father, made an individual contribution in his portrayal of fashionable life in Venice as typified in *The Dressmaker* (No. 97), one of the charming, independent works drawn for his own amusement. Canaletto's crisp *Architectural Capriccio* from the Janos Scholz Collection (No. 93) contrasts with Guardi's flickeringly beautiful rendering of the progress of the Doge's gilded barge, the Bucintoro (No. 94). Two examples display different aspects of the art of Giovanni Battista Piranesi, the Venetian who adopted Rome as his special preserve during most of his life. The first, the airy Rococo *Gondola* of Tiepolesque lightness and invention (No. 95) which was part of Mrs. Morgan's legacy, stems from the artist's brief return to Venice around 1744. The other, a Roman architectural fantasy from the Janos Scholz Collection (No. 96), is likewise an early work, boldly conceived in pen and darkest brown ink.

The earliest and greatest French artist of the eighteenth century is Jean-Antoine Watteau. In addition to the two superb examples of the artist's drawings *à trois crayons*, that is, in black, red, and white chalks (Nos. 99–100), which have been in the collection since 1911, yet another aspect of this extraordinary draughtsman can be studied in the fascinatingly inventive design for an arabesque (No. 98) made possible by the generosity of Mr. and Mrs. von Bulow. François Boucher, the most gifted exponent of the Rococo style, is shown in a characteristic and appealing drawing *Four Heads of Cherubim* (No. 102) while Charles Natoire is represented in a personal vein by one of his charmingly colored Roman landscapes (No. 101). Gabriel de Saint-Aubin is seen working on a larger scale than usual in the beautifully worked and

posed figure of *Momus* (No. 103). The life-size *Profile Portrait of Denis Diderot* (No. 104) is an uncharacteristic but imposing example of the work of Jean-Baptiste Greuze, and Jean-Honoré Fragonard is shown in two quite different styles. The detailed working of the large sunlit landscape reflects the artist's response to Dutch seventeenth-century landscape painting (No. 105) while the particular verve of the draughtsman is exemplified in *La Récompense* (No. 106). Hubert Robert's draughtsmanship, which on occasion is almost as brilliant as Fragonard's, is demonstrated to admirable advantage in the sanguine rendering of Rome's Trevi Fountain at the time of its construction (No. 107). A surpassingly beautiful nude study in the tradition of the French Academy by Pierre-Paul Prud'hon (No. 108) was the gift in 1974 of Mr. and Mrs. Thaw from their collection. The last of the French drawings in the survey are the two perceptive portraits by Jean-Auguste-Dominique Ingres: *Guillaume Guillon Lethière* (No. 120), which was part of the bequest of Therese Kuhn Straus, and *Charles-Désiré Norry* (No. 121), which was purchased as the gift of the Von Bulows. The increasingly popular use of watercolor in eighteenth-century Holland is handsomely illustrated by Jan van Huysum's typically sumptuous *Flowerpiece* (No. 109).

A diverse range of technique and style characterizes the English drawings in the survey. William Hogarth, the famous satirist who dominates the early part of the eighteenth century, is seen in one of his workman-like preparatory studies for the engraving *Gin Street* (No. 110) which stands in token of the important group of his drawings in the collection. Gainsborough's peculiar sensitivity to medium is shown in the splendid study of a fashionable young woman (No. 112), brilliantly worked in black and white chalk. Although he made his fortune in portraiture, Gainsborough preferred to regard himself as a landscape artist, the facet of his work reflected in the *Landscape with a Cart* (No. 111), a varnished watercolor. Benjamin West's impressive study of a gnarled tree trunk (No. 113) from the important group of drawings by him and his son Raphael precedes two striking drawings by William Blake's Swiss-born contemporary Henry Fuseli (Nos. 114–115). The eccentric genius of Blake would set him apart in any age, and the Library is fortunate in its rich representation of the poet-artist. Two visionary watercolors *The Morning Stars* (No. 116), from the illustrations of the Book of Job, and *Mirth*, from the Milton series (No. 117), were chosen for inclusion in this volume. *Pear Tree in a Walled Garden* (No. 125), a work by Blake's most brilliant disciple, Samuel Palmer, may be cited here although its chronology places it at the very end of the survey. Until recently Joseph Mallord William Turner, probably the greatest of the English artists, has been represented only by a small drawing for book illustration. In 1980, however, thanks to the generous bequest of Lois Duffie Baker, the Library has acquired a beautiful

early watercolor *View of Dunster Castle* (No. 123). The breadth of vision exhibited in the Turner view is neatly balanced by John Constable's *View of Cathanger near Petworth* (No. 124), the promised gift of Mr. and Mrs. Eugene V. Thaw, who will one day also give the *Moonlit Landscape* (No. 122) by the finest exponent of German Romanticism, Caspar David Friedrich.

The selection of drawings presented here has been made by the compilers of the catalogue in conjunction with Dr. Ryskamp. We are extremely grateful to our colleagues at the Library who have given generously of their time and knowledge: Miss Felice Stampfle has been consulted to advantage at every stage of the project; Miss Jane V. Shoaf, Curatorial Assistant in the Department, has been involved and helpful throughout; Mrs. Ruth S. Kraemer has given her usual valuable assistance; Dr. John H. Plummer and William M. Voelkle, of the Department of Mediaeval and Renaissance Manuscripts, have given freely of their expertise in connection with the fourteenth-century drawings; Alexander J. Yow along with Mrs. Patricia Reyes and Timothy Herstein of the Conservation Department have assisted in the resolution of technical problems; Miss Monica Longworth and Miss Andrea L. Immel have also been helpful in several instances. Charles V. Passela, who has been assisted by C. Mitchell Carl, is responsible for the photography. Thanks are due to a number of colleagues at other institutions who have been consulted at different stages of the catalogue: Dr. Fedja Anzelewski, Direktor, Kupferstichkabinett, Staatliche Museen Preussischer Kulturbesitz, Berlin; Jacob Bean, Curator of Drawings, and Dr. Helmut Nickel, Curator of Arms and Armor, both of the Metropolitan Museum of Art; and Miss Elizabeth E. Roth, Chief of the Prints Division, the New York Public Library.

<div align="right">

Cara D. Denison

</div>

WORKS AND EXHIBITIONS CITED
IN ABBREVIATED FORM

WORKS

Bartsch
 Adam Bartsch, *Le Peintre-graveur*, 21 vols., Würzburg, 1920–1922.

Benesch, *Werk und Forschung*, 1935
 Otto Benesch, *Rembrandt: Werk und Forschung*, Vienna, 1935.

Benesch, 1954–1957
 Otto Benesch, *The Drawings of Rembrandt*, 6 vols., London, 1954–1957.

Benesch, 1973
 Otto Benesch, *The Drawings of Rembrandt*, enlarged and edited by Eva Benesch, 6 vols., London, 1973.

Berenson, 1938
 Bernard Berenson, *The Drawings of the Florentine Painters*, enlarged edition, 3 vols., Chicago, 1938.

Berenson, 1961
 Bernard Berenson, *I Disegni dei pittori fiorentini*, 3 vols., Milan, 1961.

Bernhard, *Rembrandt*, 1976
 Marianne Bernhard, *Rembrandt Handzeichnungen*, Munich, 1976.

Bernhard, *Rubens*, 1977
 Marianne Bernhard, *Rubens Handzeichnungen*, Munich, 1977.

Bock-Rosenberg, 1930
 Max J. Friedländer, ed., *Staatliche Museen zu Berlin. Die Zeichnungen alter Meister im Kupferstichkabinett: Die niederländischen Meister*, by Elfried Bock and Jakob Rosenberg, 2 vols., Berlin, 1930.

Bredius-Gerson
 A. Bredius, *Rembrandt: The Complete Edition of the Paintings*, revised by H. Gerson, 2 vols., London, 1969.

Briquet
 C. M. Briquet, *Les Filigranes: Dictionnaire historique des marques du papier*, 4 vols., Geneva, 1907.

Burchard-d'Hulst, 1963
 Ludwig Burchard and Roger-A. d'Hulst, *Rubens Drawings*, 2 vols., Brussels, 1963.

Churchill
W. A. Churchill, *Watermarks in Paper in Holland, England, France, etc., in the XVII and XVIII Centuries and their Interconnection*, Amsterdam, 1935.

Eisler, *Flemish and Dutch Drawings*, 1963
Colin Eisler, *Drawings of the Masters: Flemish and Dutch Drawings from the 15th to the 18th Century*, New York, 1963.

Fairfax Murray
J. Pierpont Morgan Collection of Drawings by the Old Masters Formed by C. Fairfax Murray, 4 vols., London, 1905–1912.

Flechsig, 1928–1931
E. Flechsig, *Albrecht Dürer: Sein Leben und seine künstlerische Entwicklung*, 2 vols., Berlin, 1928–1931.

Gerson, *Koninck*, 1936
Horst Gerson, *Philips Koninck*, Berlin, 1936.

Glück, *Van Dyck*, Klassiker der Kunst, 1931
Gustav Glück, *Van Dyck: Des Meisters Gemälde*, Klassiker der Kunst, Stuttgart, 1931.

Glück-Haberditzl, 1928
Gustav Glück and Franz Martin Haberditzl, *Die Handzeichnungen von Peter Paul Rubens*, Berlin, 1928.

Goossens, *Vinckboons*, 1954
Korneel Goossens, *David Vinckboons*, Antwerp–The Hague, 1954.

Goris-Held, *Rubens in America*, 1947
Jan Albert Goris and Julius S. Held, *Rubens in America*, New York, 1947.

Great Drawings of All Time, 1962
Ira Moskowitz, ed., *Great Drawings of All Time*, 4 vols., New York, 1962.

Held, *Selected Drawings*, 1959
Julius S. Held, *Rubens: Selected Drawings*, 2 vols., London, 1959.

Hind, *Flemish Drawings*, 1923
Arthur M. Hind, *Catalogue of Drawings by Dutch and Flemish Artists . . . in the British Museum, II: Drawings by Rubens, Van Dyck and Other Artists of the Flemish School of the XVII Century*, London, 1923.

Hofstede de Groot, *Rembrandt*, 1906
Cornelis Hofstede de Groot, *Die Handzeichnungen Rembrandts*, Haarlem, 1906.

Hofstede de Groot
Cornelis Hofstede de Groot, *A Catalogue Raisonné of the Works of the Most Eminent Dutch Painters of the Seventeenth Century Based on the Work of John Smith*, 8 vols., London, 1907–1927.

Hollstein
F. W. H. Hollstein, *Dutch and Flemish Etchings, Engravings and Woodcuts ca. 1450–1700*, 19 vols., Amsterdam, 1949–1969.

d'Hulst, *Jordaens*, 1956
> Roger-A. d'Hulst, *De Tekeningen van Jakob Jordaens*, Brussels, 1956.

d'Hulst, *Jordaens*, 1974
> Roger-A. d'Hulst, *Jordaens Drawings*, 4 vols., London–New York, 1974.

Le Blanc
> Charles Le Blanc, *Manuel de l'amateur d'estampes*, 2 vols., Amsterdam, 1970–1971 (reprint of Paris edition, 4 vols., 1854–1890).

Lippmann, 1883–1929
> Friedrich Lippmann, *Zeichnungen von Albrecht Dürer in Nachbildungen*, 7 vols., Berlin, 1883–1929.

Lugt
> Frits Lugt, *Les Marques de collections de dessins & d'estampes*, Amsterdam, 1921.

Lugt S.
> Frits Lugt, *Les Marques de collections de dessins & d'estampes: Supplément*, The Hague, 1956.

Lugt, *École flamande, Louvre*, 1949
> Frits Lugt, *Musée du Louvre. Inventaire général des dessins des écoles du nord: École flamande*, 2 vols., Paris, 1949.

Lugt, *École hollandaise, Louvre*
> Frits Lugt, *Musée du Louvre. Inventaire général des dessins des écoles du nord: École hollandaise*, 3 vols., Paris, 1929–1933.

Mauritshuis, 1977
> Mauritshuis, *The Royal Cabinet of Paintings: Illustrated General Catalogue*, The Hague, 1977.

Mongan *et al.*, 1949
> Agnes Mongan, ed., *One Hundred Master Drawings* (text on Morgan Library drawings by Felice Stampfle), Cambridge, Mass., 1949.

Morgan Library, *First* [and subsequent] *Report to the Fellows*, 1950 [etc.]
> The Pierpont Morgan Library, *First Annual Report to the Fellows of the Pierpont Morgan Library*, New York, 1950, etc. (*Reports* edited by Frederick B. Adams, Jr., through 1968; by Charles Ryskamp 1969 to date; entries on drawings by Felice Stampfle).

Morgan Library, *Review of Acquisitions, 1949–1968*, 1969
> The Pierpont Morgan Library, *A Review of Acquisitions, 1949–1968*, New York, 1969.

Oldenbourg, *Rubens*, Klassiker der Kunst, 1921
> Rudolf Oldenbourg, *P. P. Rubens: Des Meisters Gemälde*, Klassiker der Kunst, Stuttgart-Berlin, 1921.

Panofsky, 1943
> Erwin Panofsky, *Albrecht Dürer*, 2 vols., Princeton, 1943.

Popham, 1971
> A. E. Popham, *Catalogue of the Drawings of Parmigianino*, 3 vols., New Haven–London, 1971.

Reznicek, *Goltzius*, 1961
> E. K. J. Reznicek, *Die Zeichnungen von Hendrick Goltzius*, 2 vols., Utrecht, 1961.

R.K.D.
 Rijksbureau voor Kunsthistorische Documentatie, The Hague.

Roethlisberger, *Paintings*, 1961
 Marcel Roethlisberger, *Claude Lorrain: The Paintings*, 2 vols., New Haven, 1961.

Roethlisberger, *Drawings*, 1968
 Marcel Roethlisberger, *Claude Lorrain: The Drawings*, 2 vols., Berkeley–Los Angeles, 1968.

Schnackenburg, *Van Ostade*, 1971
 Bernard Schnackenburg, *Die Zeichnungen der Brüder van Ostade*, dissertation, University of Munich, 1971 (unpublished).

Stechow, *Dutch Landscape Painting*, 1966
 Wolfgang Stechow, *National Gallery of Art. Kress Foundation Studies in the History of European Art: Dutch Landscape Painting of the Seventeenth Century*, London, 1966.

Strauss, 1974
 Walter L. Strauss, *The Complete Drawings of Albrecht Dürer*, 6 vols., New York, 1974.

Thieme-Becker
 Ulrich Thieme and Felix Becker, *Allgemeines Lexikon der bildenden Künstler von der Antike bis zur Gegenwart*, 37 vols., Leipzig, 1907–1950.

Tietze, 1947
 Hans Tietze, *European Master Drawings in the United States*, New York, 1947.

Tietze and Tietze-Conrat, 1928–1938
 Hans Tietze and Erika Tietze-Conrat, *Kritisches Verzeichnis der Werke Albrecht Dürers*, 3 vols., Augsburg-Basel/Leipzig, 1928–1938.

Valentiner, 1934
 Wilhelm R. Valentiner, *Die Handzeichnungen Rembrandts*, 2 vols., New York, 1925–1934.

Van Marle, *Italian Schools of Painting*
 Raimond van Marle, *The Development of the Italian Schools of Painting*, 19 vols., The Hague, 1923–1938.

Vey, *Van Dyck*, 1962
 Horst Vey, *Die Zeichnungen Anton van Dycks*, 2 vols., Brussels, 1962.

Winkler, 1936–1939
 Friedrich Winkler, *Die Zeichnungen Albrecht Dürers*, 4 vols., Berlin, 1936–1939.

EXHIBITIONS

Albright Art Gallery, *Master Drawings*, 1935
 Albright Art Gallery, Buffalo, New York, *Master Drawings: Selected from the Museums and Private Collections of America*, 1935.

Berlin, *Bruegel*, 1975
Staatliche Museen Preussischer Kulturbesitz, Kupferstichkabinett, Berlin, *Pieter Bruegel d. Ä. als Zeichner*, catalogue by Mathias Winner *et al.*, 1975.

Cambridge–New York, *Rubens*, 1956
Fogg Art Museum, Harvard University, Cambridge, Mass., and The Pierpont Morgan Library, New York, *Drawings and Oil Sketches of Peter Paul Rubens from American Collections*, catalogue by Agnes Mongan (entries on Morgan Library drawings by Felice Stampfle), 1956.

Chicago, *Rembrandt*, 1935–1936
Art Institute of Chicago, Chicago, *Loan Exhibition of Paintings, Drawings, and Etchings by Rembrandt and His Circle*, 1935–1936.

Chicago, *Rembrandt after Three Hundred Years*, 1969
Art Institute of Chicago, Chicago, and elsewhere, *Rembrandt after Three Hundred Years*, catalogue of drawings by E. Haverkamp-Begemann and Anne-Marie Logan, 1969.

Drawings from New York Collections
Metropolitan Museum of Art, New York, and The Pierpont Morgan Library, New York, *Drawings from New York Collections, I: The Italian Renaissance*, 1965; *II: The Seventeenth Century in Italy*, 1967; *III: The Eighteenth Century in Italy*, 1971, catalogues by Jacob Bean and Felice Stampfle.

Fogg Art Museum. *Seventy Master Drawings*, 1948–1949
Fogg Art Museum, Harvard University, Cambridge, Mass., *Seventy Master Drawings: A Loan Exhibition Arranged in Honor of Professor Paul J. Sachs on the Occasion of His Seventieth Birthday*, 1948–1949.

Guildhall, London, 1895
Art Gallery of the Corporation of London, London, *Catalogue of Drawings by the Old Masters . . . , lent by Sir J. C. Robinson*, 1895.

Hartford, *Pierpont Morgan Treasures*, 1960
Wadsworth Atheneum, Hartford, Conn., *The Pierpont Morgan Treasures*, 1960.

London, *Rubens*, 1977
British Museum, London, *Rubens Drawings and Sketches*, catalogue by John Rowlands, 1977.

London, and elsewhere, *Flemish Drawings . . . Collection of Frits Lugt*, 1972
Victoria and Albert Museum, London, and elsewhere, *Flemish Drawings of the Seventeenth Century from the Collection of Frits Lugt, Institut Néerlandais, Paris*, catalogue by Carlos van Hasselt, 1972.

Los Angeles, *Old Master Drawings*, 1976
Los Angeles County Museum of Art, Los Angeles, *Old Master Drawings from American Collections*, catalogue by Ebria Feinblatt, 1976.

Lyman Allyn Museum, *Drawings*, 1936
Lyman Allyn Museum, New London, Conn., *Fourth Anniversary Exhibition: Drawings*, 1936.

Metropolitan Museum, *Rembrandt*, 1918
Metropolitan Museum of Art, New York, *Handlist of Works by Rembrandt*, 1918.

Minneapolis, *Fiftieth Anniversary*, 1965–1966
> Minneapolis Institute of Arts, Minneapolis, *Fiftieth Anniversary Exhibition, 1915–1965*, 1965–1966.

Morgan Library, *Dürer*, 1955
> The Pierpont Morgan Library, New York, *Drawings and Prints by Albrecht Dürer*, catalogue by Felice Stampfle, 1955.

Morgan Library, *Landscape Drawings*, 1953
> The Pierpont Morgan Library, New York, *Landscape Drawings and Water-Colors: Bruegel to Cézanne*, catalogue by Felice Stampfle, 1953.

Morgan Library, *Major Acquisitions, 1924–1974*, 1974
> The Pierpont Morgan Library, New York, *Major Acquisitions of The Pierpont Morgan Library, 1924–1974: Drawings*, catalogue by Felice Stampfle, 1974.

Morgan Library, *Michelangelo*, 1979
> The Pierpont Morgan Library, New York, *Michelangelo and His World with Drawings from the British Museum* [checklist of exhibition], 1979.

Morgan Library, *New York World's Fair*, 1939
> The Pierpont Morgan Library, New York, *Illustrated Catalogue of an Exhibition Held on the Occasion of The New York World's Fair*, 1939.

Morgan Library, *Piranesi*, 1949
> The Pierpont Morgan Library, New York, *Drawings by Giovanni Battista Piranesi*, catalogue by Felice Stampfle, 1949.

Morgan Library, *Piranesi*, 1978
> The Pierpont Morgan Library, New York, *Giovanni Battista Piranesi: Drawings in the Pierpont Morgan Library*, catalogue by Felice Stampfle, 1978 (revised 1949 exhibition catalogue).

Morgan Library, and elsewhere, *Drawings from the Thaw Collection*, 1975
> The Pierpont Morgan Library, New York, and elsewhere, *Drawings from the Collection of Mr. & Mrs. Eugene V. Thaw*, catalogue by Felice Stampfle and Cara D. Denison, 1975.

Morgan Library, and elsewhere, *Fiftieth Anniversary*, 1957
> The Pierpont Morgan Library, New York, and elsewhere, *Treasures from The Pierpont Morgan Library: Fiftieth Anniversary Exhibition*, 1957.

Morgan Library, and elsewhere, *Rubens and Rembrandt in Their Century*, 1979–1980
> Morgan Library, and elsewhere, *Rubens and Rembrandt in Their Century: Flemish & Dutch Drawings of the 17th Century from The Pierpont Morgan Library*, catalogue by Felice Stampfle, 1979–1980.

National Gallery of Art, Washington, D.C., *Dürer in America*, 1971
> National Gallery of Art, Washington, D.C., *Dürer in America: His Graphic Work*, catalogue edited by Charles W. Talbot, 1971.

New York, *Bloemaert*, 1973
> Metropolitan Museum of Art, New York, *Abraham Bloemaert, 1564–1651: Prints and Drawings*, [checklist by Janet S. Byrne], 1973.

New York–Cambridge, *Rembrandt*, 1960
 The Pierpont Morgan Library, New York, and Fogg Art Museum, Harvard University, Cambridge, Mass., *Rembrandt Drawings from American Collections*, catalogue by Felice Stampfle and Egbert Haverkamp-Begemann, 1960.

New York–Paris, *Rembrandt and His Century*, 1977–1978
 The Pierpont Morgan Library, New York, and Institut Néerlandais, Paris, *Rembrandt and His Century*, catalogue by Carlos van Hasselt, 1977–1978.

New York Public Library, *Morgan Drawings*, 1919
 New York Public Library, New York, *Drawings from the J. Pierpont Morgan Collection*, essay by Frank Weitenkampf [no checklist], 1919.

Paris, *Rembrandt*, 1908
 Bibliothèque Nationale, Paris, *Exposition d'oeuvres de Rembrandt*, 1908.

Philadelphia, *Masterpieces*, 1950
 Philadelphia Museum of Art, Philadelphia, *Masterpieces of Drawing: Diamond Jubilee Exhibition*, 1950–1951.

Princeton, *Rubens before 1620*, 1972
 The Art Museum, Princeton University, Princeton, *Rubens before 1620*, catalogue edited by John Rupert Martin, 1971.

Stockholm, *Morgan Library gästar Nationalmuseum*, 1970
 Nationalmuseum, Stockholm, *Pierpont Morgan Library gästar Nationalmuseum*, 1970.

Toronto, *Inaugural Exhibition*, 1926
 Art Gallery of Toronto, Toronto, *Inaugural Exhibition*, 1926.

Vassar, Poughkeepsie, *Seventeenth Century Dutch Landscapes*, 1976
 Vassar College Art Gallery, Poughkeepsie, N.Y., *Seventeenth Century Dutch Landscape Drawings and Selected Prints*, catalogue by Curtis O. Baer and students, 1976.

Worcester, *Fiftieth Anniversary Exhibition*, 1948
 Worcester Art Museum, Worcester, Mass., *Fiftieth Anniversary Exhibition*, 1948.

Worcester, *Rembrandt*, 1936
 Worcester Art Museum, Worcester, Mass., *Rembrandt and His Circle*, 1936.

CATALOGUE

Italian: Lombard School

LAST QUARTER
OF THE FOURTEENTH CENTURY

1 *Sketchbook*

Sketches of hunts, children's games, tourneys, labors of the months, daily occupations, grotesques, dancers, musicians, etc.

14 leaves, in vellum cover

Pen and brown ink, with greenish-gray washes, and also in a few instances touches of green, violet, and red on vellum

Approximately $9\frac{3}{8} \times 6\frac{3}{4}$ inches (238×171 mm.)

With some reservation Charles Fairfax Murray ascribed this fragment of a fourteenth-century pattern book to the Lombard School. While clearly recognizing its Tuscan figural prototypes, Fairfax Murray felt that the numerous grotesques and animal drawings, taken in conjunction with a contemporary inscription which he took to be in the Lombard dialect, weighted the evidence in favor of a Lombard origin. Later on Van Schendel and Pächt supported the Lombard attribution, Van Schendel observing that some of the motives were connected to the early fifteenth-century Lombard health manuscripts, the "Tacuinae Sanitatis," a point which was reinforced by Pächt. In 1963, however, R. W. Scheller took issue with the consensus that the book was Lombard in origin and argued that it was actually a work of the Central Italian School. Scheller based his opinion on further study of the Tuscan figural elements. As recently as 1968 it was the opinion of Bernhard Degenhart and Annegrit Schmitt that the book was Neapolitan rather than Northern or Central Italian. Stylistic analogies which are not entirely convincing were drawn with a cycle of wall paintings assigned to the circle of Roberto da Oderisio in

S. Maria Incoronata, Naples, and with certain Neapolitan illuminations (see Degenhart and Schmitt, figs. 237–240).

Although the figure types in the Morgan pattern book have some similarity to those in the Giottesque frescoes in Naples and in the manuscripts, the resemblance is not telling enough to make the Neapolitan attribution conclusive. Scheller's argument that the style of the book points to Central Italy is not persuasive either. Fairfax Murray's original hypothesis that the book is Lombard still remains the most convincing, and it is in fact maintained by Maria Fossi Todorow, a specialist in early North Italian painting. She dates the book at the end of the fourteenth century because of the earlier iconographic presentation of the occupations of the months which clearly antedate the Tacuina manuscripts. In this connection she draws attention to the lack of the landscape backgrounds which would appear only in the early quattrocento Tacuina manuscripts.

While by no means a master draughtsman, the artist of the sketchbook has a very distinctive style which might someday connect it with other works. There is, for instance, a peculiar tendency to characterize the faces with straight or snub noses and heavy accents of wash for modelling around the eyes. This tendency along with some of the heraldic and armorial devices used in the book also support the Lombard thesis. As Helmut Nickel, Curator of Arms and Armor at the Metropolitan Museum of Art, has commented, most armor worn in Italy in the fourteenth century was manufactured in Milan. While this gives a Lombard character to virtually all Italian armor, close parallels with actual North Italian armorial devices and tournament armor can be found in the elaborate armor worn by the knights in the jousting scenes in the Morgan sketchbook.

As Fairfax Murray observed, a considerable ability for drawing animals is shown as well, another connection with the predominantly rural life-style of the North. The opening selected for illustration here shows the occupations of the months from June through December. (For repr. of the other leaves, see Fairfax Murray.)

The book has no overall continuity or program and is such a miscellaneous gathering of subjects that it must have been part of a larger model or pattern book. These pattern books often look copied and, in most cases, are. As Scheller observes, the modern artist takes his inspiration from nature directly observed; the mediaeval artist drew upon other works of art for his, collecting motives in pattern books which then served him as visual reminders.

PROVENANCE: Eugène Piot; Charles Fairfax Murray; J. Pierpont Morgan (no mark; see Lugt 1509).

BIBLIOGRAPHY: Fairfax Murray, II, nos. 2–25, repr. (in red morocco case, Italian, late sixteenth century); R. van Marle, *L'Iconographie de l'art profane*, The Hague, 1931, *passim*, for illus.; A. van Schendel, *Le Dessin en Lombardie jusqu'à la fin du XVe siècle*, Brussels, 1938, pp. 69ff., pls. 58–62; Otto Pächt, "Early Italian Nature Studies and the Early Calendar Landscape," *Journal of the Warburg and Courtauld Institutes*, XIII, 1950, p. 38, note 1; R. W. Scheller, *A Survey of Medieval Model Books*, Haarlem, 1963, no. 20, repr.; Bernhard Degenhart and Annegrit Schmitt, *Corpus der italienischen Zeichnungen, 1300–1450*, Berlin, 1968, no. 86, repr.; Maria Fossi Todorow, *L'Italia dalle origini a Pisanello*, Milan, 1970, pp. 14, 88, fig. 16; Ulrike Jenni, *Das Skizzenbuch der internationalen Gotik in den Uffizien*, Vienna, 1976, pp. 13f., 27, 61, 78, 80; Ulrike Jenni, "Vom mittelalterlichen Musterbuch zum Skizzenbuch der Neuzeit," *Die Parler und der Schöne Stil: 1350–1400*, Cologne, 1978, III, p. 104f., repr.; Paul F. Watson, *The Garden of Love in Tuscan Art of the Early Renaissance*, Philadelphia, 1979, p. 40f., pls. 23–26, 28.

EXHIBITIONS: Morgan Library, *New York World's Fair*, 1939, no. 98; Walters Art Gallery, Baltimore, *The International Style: The Arts in Europe around 1400*, 1962, no. 13, repr.

Acc. no. II,2–25

Italian: Florentine School

LATE FOURTEENTH CENTURY

2 *The Martyrdom of S. Miniato*

Pen and brown ink, brush and brown wash, extensively heightened with white on a prepared brown ground, red wash used in the background and to describe lunette; traces of silverpoint in the architecture
$11\frac{1}{2} \times 15\frac{5}{8}$ inches (292×397 mm.)
Watermark: none visible through lining

This detailed and monumental rendering of the martyrdom of S. Miniato is one of the rare surviving examples of the draughtsmanship of the fourteenth century. The intricate modelling, high finish, and lunette form indicate that it was probably made as a *modello* or a finished drawing for the approval of the prospective donor of a fresco of the subject in one of the churches or chapels around Florence.

Although a number of scholars have ventured attributions for this attractive sheet with its Giottesque figure types so typical of the trecento, it is not certain who its artist was or precisely when it was executed. That the artist worked in Florence is self-evident inasmuch as S. Miniato is venerated almost exclusively in the city where he was tortured and eventually put to death in the year 250. Only two episodes from his life are depicted in the Morgan drawing, his arrest and his torture by the pouring of hot oil into his punctured eardrum. There is evidence that the drawing has been cut down as the incomplete hemicycle of the lunette suggests, along with the presence of the bowed head in the lower right which apparently belongs to another episode in the story, most likely the saint's beheading and subsequent death at the summit of the hill outside Florence, now commemorated by the church known as S. Miniato al Monte.

Bernard Berenson was persuaded that the drawing was a work of Spinello Aretino whose career spanned the end of the fourteenth and the beginning of the fifteenth century, a view which finds some support in the fact that the artist was active in the church of S. Miniato al Monte in the late 1380's, painting the fresco cycle of the Life of St. Benedict in the sacristy. Millard Meiss, who in 1949 was the first to publish the subject as S. Miniato, believed the drawing to date somewhat earlier, around 1370, and attributed it to an unknown artist trained in the circle of Andrea Orcagna. In 1968 Bernhard Degenhart and Annegrit Schmitt pushed the date back further still to the mid-fourteenth century and ascribed it to an artist in the

circle of Bernardo Daddi. In the most recent publications, Maria Fossi Todorow and Colin Eisler have retained the Meiss attribution to the circle of Orcagna.

PROVENANCE: George Skene; his sale, London, Sotheby's, 28 April 1898; Sir John Charles Robinson (Lugt 1433); Charles Fairfax Murray; J. Pierpont Morgan (no mark; see Lugt 1509).

BIBLIOGRAPHY: Fairfax Murray, I, no. 1, repr.; Joseph Meder, *Die Handzeichnungen: Ihre Technik und Entwicklung*, Vienna, 1923, p. 150, under note 1; Berenson, 1938, no. 2756c; Mongan *et al.*, 1949, pp. 2, 3; Leonetto Tintori and Millard Meiss, *The Painting of the Life of Saint Francis in Assisi*, New York, 1962, p. 26; *Great Drawings of All Time*, I, 1962, no. 5, repr.; Bernhard Degenhart and Annegrit Schmitt, *Corpus der italienischen Zeichnungen, 1300–1450*, Berlin, 1968, no. 30, fig. C; Maria Fossi Todorow, *L'Italia dalle origini a Pisanello*, Milan, 1970, pp. 10, 81, pl. V; Colin Eisler, *The Seeing Hand*, New York, 1974, ch. 6, pl. 2; Ulrike Jenni, *Das Skizzenbuch der internationalen Gotik in den Uffizien*, Vienna, 1976, pp. 11, 83.

EXHIBITIONS: Toronto, *Inaugural Exhibition*, 1926, no. 1; Albright Art Gallery, *Master Drawings*, 1935, no. 1, repr.; Lyman Allyn Museum, *Drawings*, 1936, no. 1; Morgan Library, *New York World's Fair*, 1939, no. 64; Fogg Art Museum, *Seventy Master Drawings*, 1948–49, no. 1; Philadelphia, *Masterpieces*, 1950–51, no. 2, repr.; Morgan Library, and elsewhere, *Fiftieth Anniversary*, 1957, no. 80; M. Knoedler and Co., New York, *Great Master Drawings of Seven Centuries*, 1959, no. 1, repr.; Los Angeles, *Old Master Drawings*, 1976, no. 5, repr.

Acc. no. I,1

Circle of Jacquemart de Hesdin (French)

c. 1400

3 *Sketchbook*

Six boxwood leaves
Metalpoint on boxwood washed with white gesso
$5\frac{1}{8} \times 2\frac{3}{4}$ inches (70×30 mm.)

The boxwood sketchbook has been in the literature of art since 1840 when Rosini published it as Giotto in his history of Italian painting; it was then in the collection of Baron Camuccini of Rome. By the early 1900's it had turned up in Paris and had been firmly assigned to the Franco-Flemish School of the late fourteenth century. The English connoisseur and art critic Roger Fry published it shortly after Mr. Morgan's acquisition of the book in 1906, and made a careful appraisal of it, con-

necting it with the French illuminator André Beauneveu on the basis of comparison with manuscript illuminations. In 1930 Pierre Lavallée reattributed the sketchbook to Jacquemart de Hesdin, Beauneveu's close contemporary, a view which has been maintained more or less since then and at present has been expanded to the circle of Jacquemart de Hesdin. While the stylistic canon of most of the drawings remains closest to Jacquemart, especially in the *Virgin and Child* illustrated here, the overall quality of the book is not consistent, and scholars now believe it may be the work of more than one artist in Jacquemart's circle. Like the Lombard sketchbook, the boxwood sketchbook may have been used as a pattern or model book. There is a strong relation between the *Virgin and Child* of the boxwood sketchbook and two contemporary manuscripts, one of which is in St. Gall (repr. Scheller, fig. 56) and the other once preserved in S. María del Mar in Barcelona (repr. Meiss, fig. 280). Both are strikingly close to the boxwood *Virgin and Child* but are far inferior to it in quality, suggesting either that they depend on the Morgan sketchbook or that all three derive from a lost prototype. Even the quality of the less spectacular leaves in the boxwood sketchbook is on a high level. As Roger Fry observed, the ensemble "is carried out with a minuteness and perfection which could not be surpassed in the miniatures for which they might serve as studies." This is nowhere more evident than in the exquisite rendering of the Virgin and Child. Here the artist has scraped away the white gesso wash around the figures casting the curvilinear silhouette of the Virgin and Child into striking relief against the light brown boxwood surface, working with differing intensity in metalpoint to achieve more subtle variations and delicacy in the modelling.

The other leaves of the sketchbook are mostly secular in subject and include depictions of courtly types crowned and wreathed in lively interaction. One leaf shows two wild men in juxtaposition with three courtiers, leading several scholars to attempt to connect the sketchbook with the events of the celebrated masked ball of 1392, of which the chronicler Froissart gave an extended account. The sketchbook has been fully illustrated several

times and most recently has been published in full color by Albert Châtelet. Under ultra-violet examination, a few drawings which had been erased can be distinguished, indicating that the boxwood leaves had been used before, an economical use of material which was commonly practiced in the late mediaeval period.

Recently Mr. William Voelkle of the Department of Mediaeval and Renaissance Manuscripts has connected another metalpoint drawing on boxwood with the sketchbook; the leaf, which depicts the Virgin and Child Enthroned, was acquired by Mr. Morgan in 1911 (M. 346A; it was first reproduced in the Cleveland Museum of Art, Cleveland, *Treasures from Medieval France*, exhibition catalogue by William D. Wixom, 1967, no. VI, 15). Despite evident similarities in technique, date, and style, the relation between the two has never been sufficiently explored. Mr. Voelkle, who plans to publish his findings shortly, has verified the connection between the two by matching the measurements and certain physical irregularities peculiar to both.

PROVENANCE: Baron Camuccini, Rome; private collection, Rome; G. Brauer, Paris; J. Pierpont Morgan (no mark; see Lugt 1509).

BIBLIOGRAPHY: Giovanni Rosini, *La Storia della pittura italiana* . . . , II, Pisa, 1840, p. 196f.; Roger E. Fry, "On a Fourteenth Century Sketchbook," *Burlington Magazine*, X, no. 43, 1906, pp. 31ff., repr.; Roger E. Fry, "A Drawing by André Beauneveu," *Burlington Magazine*, XVII, no. 85, 1910, p. 51; Pierre Lavallée, *Le Dessin français du XIIIe au XVIe siècle*, Paris, 1930, pp. 12ff., 61f., pl. VIII; Louis Dimier, "D'un Album de dessins supposé du XIVe siècle," *Mémoires de la société nationale des antiquaires de France*, LXXVIII, 1932, pp. 12ff. (as nineteenth-century forgery); Maria Th. Hasselberg, *Liber pictus A 74 der preuss. Staatsbibliothek zu Berlin: Ein Beitrag zur Erforschung mittelalterlicher Skizzen- und Musterbücher*, Zeulenroda, 1936, pp. 15, note 15, 16, note 21, 32, note 66, 53, note 29, 71ff.; K. T. Parker, *Catalogue of the Drawings in the Ashmolean Museum*, I, Oxford, 1938, under no. 371; C. P. Parkhurst, "The Madonna of the Writing Christ Child," *Art Bulletin*, XXIII, 1941, pp. 300ff.; Grete Ring, *A Century of French Painting, 1400–1500*, London [1949], p. 197; K. G. Boon, "Over Grisaille en Zilverstift," *Maandblad voor beeldende Kunsten*, XXVI, 1950, p. 267; J. Squilbeck, "La Vierge à l'encrier ou à l'enfant écrivant," *Revue belge*, XIX, 1950, pp. 127ff.; Jean Porcher, "Les Très Belles Heures de Jean de Berry et les ateliers parisiens," *Scriptorium*, VII, 1953, note 5 on p. 123; Otto Pächt, "Un Tableau de Jacquemart de Hesdin?" *Revue des arts*, VI, 1956, pp. 156, 159; R. W. Scheller, *A Survey of Medieval Model Books*, Haarlem, 1963, pp. 104ff., repr.; Helga Kreuter-Eggemann, *Das Skizzenbuch des "Jacques Daliwe,"* Munich, 1964, p. 28, figs. 44, 45; Georg Troescher, *Burgundische Malerei, Maler und Malwerke um 1400 in Burgund . . .* , Berlin, 1966, pp. 156, 158, 162f., 222ff., 232, 243, 277, 293, 299, figs. 352–360; Millard Meiss, *French Painting in the Time of Jean de Berry: The Late XIV Century and the Patronage of the Duke*, London, 1967, pp. 206f., 267, 278f., 330, figs. 279, 281–286; Albert Châtelet, "Un Artiste à la cour de Charles VI: À propos d'un carnet d'esquisses du XIVe siècle conservé à la Pierpont Morgan Library," *L'Oeil*, CCXVI, 1972, pp. 16ff., fully repr. in color; Ulrike Jenni, *Das Skizzenbuch der internationalen Gotik in den Uffizien*, Vienna, 1976, pp. 13, 27, 36, 40, 80, figs. 17, 106; Jenni, "Vom mittelalterlichen Musterbuch zum Skizzenbuch der Neuzeit," *Die Parler und der Schöne Stil: 1350–1400*, Cologne, 1978, III, pp. 139, 142, repr.

EXHIBITIONS: Burlington Fine Arts Club, London, *Illustrated Catalogue of Early English Portraiture*, 1909, p. 21, pls. XXXVII–XXXVIII; Morgan Library, *New York World's Fair*, 1939, no. 99.

M. 346

Luca Signorelli (Italian)
CORTONA C. 1441 – 1523 CORTONA

4 *Four Demons*

Black chalk
13⅞ × 11⅛ inches (352 × 283 mm.)
Watermark: none

The Library acquired Signorelli's masterful study of four demons at the Harewood sale in London in 1965. Although it was too late to include it in the exhibition of Italian Renaissance drawings from New York collections, organized and jointly catalogued by Felice Stampfle of the Library and Jacob Bean of the Metropolitan Museum of Art, it would undoubtedly have been one of the high points of this exhibition, for it is as fine an example of the work of this early quattrocento draughtsman as is known.

Although no exact parallel can be found in the frescoes, the *Four Demons* is unquestionably a preparatory study associated with Signorelli's most important work, *The Last Judgment* in the chapel of the Madonna di S. Brizio in the cathedral at Orvieto, a work of the artist's full maturity on which he was engaged between 1499 and 1506. The *Four Demons* is, as Felice Stampfle has remarked, a most powerful drawing containing as much of the essence of the extraordinary Umbro-Florentine artist as can be distilled in a single sheet.

Although he was proficient in other media as well, most of the time Signorelli drew in black chalk, a medium in which he exhibited great facility and power as the Morgan drawing amply demonstrates. Bernard Berenson, who was unstinting in his praise of the artist, felt that within this medium Signorelli was able to achieve effects of volume and mass which had never been achieved before and would never be repeated.

The history of this drawing can be traced in full from the eighteenth century when it and another drawing by Signorelli with which it has been compared, the British Museum sheet *Dante and Virgil with Count Ugolino*, were owned first by the painter-collectors Nathaniel Hone and Sir Joshua Reynolds.

PROVENANCE: Nathaniel Hone (Lugt 2793); Sir Joshua Reynolds (Lugt 2364); Thomas Banks (Lugt 2423); probably Mrs. Lavinia Banks Forster and Ambrose Poynter; Edward J. Poynter (Lugt 874); sale, London, Sotheby's, 24–25 April 1919, lot 174, repr.; Earls of Harewood; sale, London, Christie's, 6 July 1965, lot 141, repr.

BIBLIOGRAPHY: Tancred Borenius, in *Vasari Society for the Reproduction of Drawings of the Old Masters*, II, part iii, London, 1922, no. 1, repr.; Tancred Borenius, "Old Master Drawings in the Collection of Viscount Lascelles," *Apollo*, I, 1925, p. 190, repr.; Leopold Dussler, *Signorelli: Des Meisters Gemälde*, Klassiker der Kunst, Stuttgart, Berlin, and Leipzig, 1927, p. XLI, repr.; Bernard Berenson, "Les Dessins de Signorelli," *Gazette des beaux-arts*, VII, 1932, pp. 109f., fig. 24; Berenson, 1938, p. 333, no. 2509 E. 7; Andrew Martindale, "Luca Signorelli and the Drawings Connected with the Orvieto Frescoes," *Burlington Magazine*, CIII, 1961, pp. 216ff.; Morgan Library, *Fourteenth Report to the Fellows, 1965 & 1966*, 1967, pp. 98ff., repr.; Morgan Library, *Review of Acquisitions, 1949–1968*, 1969, p. 170f., pl. 48.

EXHIBITIONS: Royal Academy of Arts, London, *Italian Drawings*, catalogue by A. E. Popham, 1930, no. 97; Stockholm, *Morgan Library gästar Nationalmuseum*, 1970, no. 29, repr.; Morgan Library, *Major Acquisitions, 1924–1974*, 1974, p. xiv, no. 1, repr.

Acc. no. 1965.15
Purchased as the gift of the Fellows

Sandro Botticelli (Italian)
FLORENCE 1444/1455 – 1510 FLORENCE

5 *Horses and Spectators*

Brown and white tempera on prepared linen
12⅜ × 13¼ inches (315 × 337 mm.)

Aside from the numerous illustrations for Dante's *Divina Commedia* in Berlin, drawings by Botticelli are exceedingly rare. The Library's fragment of a study for an Adoration of the Magi and two other drawings now in the Fitzwilliam Museum, Cambridge (repr. Berenson, 1938, figs. 200–201), for the same composition, are rendered in point of brush and tempera on linen and can almost be classified as *grisaille* paintings rather than drawings; no other Botticelli drawings in the same technique survive for comparison. Although we can trace the drawings as a group only from the late eighteenth century, they were undoubtedly together from Botticelli's day until 1884. At that time they were sold at auction to three collectors: the Morgan fragment was acquired by George Salting and the fragments now together in the Fitzwilliam by W. S. Brough and Sir James Knowles. Salting is said to have traded his section to Fairfax Murray, probably after 1893 when Hermann Ullmann first connected the Morgan fragment with Botticelli—up to this time all three had been attributed to Fra Filippo Lippi. While Fairfax Murray accepted Ullmann's attribution to Botticelli, it was contested by such eminent critics as Herbert Horne and Bernard Berenson. By 1929, however, the Botticelli attribution was generally established and in 1938 Berenson recanted, accepting the drawings as autograph works of the artist and finding in them, "if only intermittently, his most personal qualities and even his touch." He went on to say that it was hard "to believe that in the Morgan fragment the horses which remind us of the greatest Sung artists, or lower down, the two profiles turning to the left, could possibly be by a lesser hand than Sandro's." The drawings are almost certainly connected with Botticelli's unfinished *Adoration of the Magi* in the Uffizi. While the Fitzwilliam fragments match the group of the Virgin and Child in the center of the painting and the group of spectators at the right, the Morgan drawing corresponds to a lesser degree to the left-hand section of the painting.

PROVENANCE: W. Young Ottley; his sale, London, T. Philipe, 11–14 April 1804, part of lot 239; Sir Thomas Lawrence (Lugt 2445); William Russell; his sale, London, Christie's, 11 December 1884, lot 395; George Salting; Charles Fairfax Murray; J. Pierpont Morgan (no mark; see Lugt 1509).

BIBLIOGRAPHY: Hermann Ullmann, *Sandro Botticelli*, Munich, 1893, p. 147; Herbert P. Horne, "A Lost 'Adoration of the Magi' by Sandro Botticelli," *Burlington Magazine*, I, 1903, pp. 69, 70; Fairfax Murray, I, no. 5, repr.; Herbert P. Horne, *Sandro Botticelli: Painter of Florence*, London, 1908, p. 47; Herbert P. Horne, "A Lost Adoration of the Magi by Sandro Botticelli," *Burlington Magazine*, XVI, 1909–1910, p. 40; Yukio Yashiro, *Sandro Botticelli*, Boston-London, 1929, pp. xxi, 241f.; Van Marle, *Italian Schools of Painting*, XII, [1931], pp. 23, 122; Berenson, 1938, p. 333, no. 569A, fig. 202; Aldo Bertini, *I Grandi Maestri del disegno: Botticelli*, Milan, 1953, p. 10, pl. 13; Carlo L. Ragghiani, "Inizio di Leonardo," *Critica d'arte*, I, 1954, p. 117, fig. 65; Fitzwilliam Museum, Cambridge, *Fifteenth & Sixteenth Century Drawings*, 1960, under no. 19; Berenson, 1961, p. 150, no. 569A, fig. 192; Philip Pouncey, in review of Berenson 1961, *Master Drawings*, II, 1964, p. 283.

EXHIBITIONS: Toronto, *Inaugural Exhibition*, 1926, no. 28; *Drawings from New York Collections*, I, 1965, no. 11, repr.

Acc. no. I,5

Francesco Francia (Italian)
BOLOGNA C. 1450 – 1517 BOLOGNA

6 *Judith and Holofernes*

Pen and brown ink, brown and green wash, some heightening in white, on vellum
14⅚×10¼ inches (363×261 mm.)

While nothing is known of the provenance of Francia's *Judith and Holofernes* prior to Fairfax Murray's ownership of it, Raphael speaks in a letter of a drawing of this very subject which Francia made for presentation to Raphael. The drawing most probably post-dates the lost wall painting depicting the story of Judith and Holofernes, which must have been well-known in its day as it is mentioned by Vasari as one of the best scenes ever painted by Francia. Several drawn versions of the subject by Francia are known, including the one in the Louvre which is very close to the Morgan sheet and, like it, also executed on vellum. The Morgan drawing and that in the Louvre on vellum—there is also an inferior red chalk rendition of the composition in the Louvre—appear to be the best versions of the subject, and their high quality along with the use of the more precious vellum rather than paper would be consistent with the tradition of the presentation drawing.

Francia, who liked to sign his paintings *Francia aurifex*, was, as his signature tells us, also ac-

tive as a goldsmith, medallist, and engraver. For most of his life he was the Director of the Mint at Bologna. The Library's drawing reflects all these concerns of the artist in its fine detail, hard outline, and the precise swirls of its drapery.

There is another drawing in the collection done in this style which depicts a sacrificial scene (repr. Fairfax Murray, I, no. 95). Although it is on the whole a less successful drawing than the *Judith and Holofernes*, it is accepted with few reservations as Francia's own.

PROVENANCE: Charles Fairfax Murray; J. Pierpont Morgan (no mark; see Lugt 1509).

BIBLIOGRAPHY: Fairfax Murray, I, no. 94, repr.; Thieme-Becker, XII, p. 323; *Metropolitan Museum of Art Bulletin*, January 1913, p. 17; *Great Drawings of all Time*, I, 1962, no. 81, repr.

EXHIBITIONS: Albright Art Gallery, *Master Drawings*, 1935, no. 18, repr.; Morgan Library, *New York World's Fair*, 1939, no. 63 (1940 ed., no. 81); Morgan Library, and elsewhere, *Fiftieth Anniversary*, 1957, no. 81; *Drawings from New York Collections*, I, 1965, no. 12, repr.

Acc. no. I,94

Bartolomeo Montagna (Italian)
NEAR BRESCIA OR VICENZA
C. 1450 – 1523 VICENZA

7 *Nude Man Standing beside a High Pedestal*

Brush and black pigment, heightened with cream-white tempera, on blue-gray paper, now faded
15¾×10⅜ inches (400×258 mm.)
Watermark: none visible through lining
Inscribed in pen and brown ink, at lower center, *21*; at lower right, *vene*

Montagna's drawing of a nude man was given to the Library in 1974 by the New York collector who lent it to the exhibition of Italian Renaissance drawings in New York in 1965, where it was first shown. It is one of the best drawings known by the Northern Italian master, the leading Renaissance painter of Vicenza. Here he works finely in point of brush and tempera to achieve an effect of crisp linearity and grave monumentality in the beautifully balanced figure of the man, whose stance, nudity, and Dionysian attributes so plainly

acknowledge his classical inspiration. The drawing is relatively large, and every detail, including the superb swag of drapery swirled around the figure's right arm which he holds behind him, is rendered with absolute control.

The figure does not seem to be connected with any known painting but, as has been observed by the authors of the 1965 exhibition catalogue, the man resembles any number of ascetic types used by the artist to depict such saints as St. John the Baptist and St. Sebastian who are often portrayed in his paintings (see, e.g., the St. Sebastian in the *Enthroned Madonna and Saints* in the Accademia Carrara, Bergamo; repr. Lionello Puppi, *Bartolomeo Montagna*, Venice, 1962, fig. 17).

Puppi did not know this drawing when he published his *catalogue raisonné* of Montagna's work in 1962, but he accepted as autograph another drawing in the Library's collection, *The Drunkenness of Noah* (repr. Fairfax Murray, I, no. 56), an opinion which is no longer supported by scholars. According to the records of the donor, he acquired the drawing of the nude man in 1947 as a work of Francesco Francia on the advice of the connoisseur Edmund Schilling, who later showed a photograph of the drawing to Philip Pouncey who is responsible for its present attribution to Montagna.

PROVENANCE: Count Erizza Minervi; The Matthiessen Gallery, London; Mario Uzielli; private collection, New York.

BIBLIOGRAPHY: Morgan Library, *Seventeenth Report to the Fellows, 1972–1974*, 1976, pp. 145, 174, pl. 13.

EXHIBITIONS: *Drawings from New York Collections*, I, 1965, no. 14, repr.; Los Angeles, *Old Master Drawings*, 1976, no. 38, repr.; Smith College Museum of Art, Northampton, Mass., *Antiquity in the Renaissance*, 1980 (exhib. 1978), no. 33, repr.

Acc. no. 1974.1
Gift of a Trustee

Filippino Lippi (Italian)
PRATO 1457/1458 – 1504 FLORENCE

8 *Christ and the Magdalene: Figure Studies for a "Noli me tangere"*

Leadpoint, heightened with white, on gray prepared paper
Verso: Youth with a sword and kneeling youth with a staff;

the figure of the standing youth on the verso is executed mainly in silverpoint
$10^5/_8 \times 7^{15}/_{16}$ inches (270×201 mm.)
Watermark: none

While few examples of Botticelli's draughtsmanship have survived to illustrate the linear tradition at its best, drawings by his most talented pupil, Filippino Lippi, the natural son of the painter Fra Filippo Lippi, are fairly numerous and of such good quality as to exemplify the manner of expression and particular grace of this exquisite school of Florentine draughtsmanship. Although two silverpoint drawings and a tiny pen sketch by Filippino had been included in the Fairfax Murray collection purchased in 1910, the Library was fortunate to acquire this singularly fresh and beautiful double-sided sheet of figure studies in 1951 with the aid of the then newly formed Association of Fellows.

The remarkable freshness of the drawing may be accounted for in large measure by its presumed inclusion in a sketchbook of figure studies. It was Alfred Scharf's observation that a number of Filippino's drawings, now scattered throughout European collections, shared common characteristics of size, subject, and technique. The Morgan drawing, for instance, is almost exactly the same size as several sheets of figure drawings in the British Museum.

Our visual perception of the graceful figures is enhanced by the delicate tint of the prepared ground on which the artist sketched, chiefly in leadpoint, heightened with white. On the verso, here illustrated in color, the silverpoint added to the figure of the standing youth at left enriches the pictorial effect of the sheet by offering the contrast of the golden tone of the silverpoint with the dark tone of the leadpoint. Both sides of the drawing are equally strong; the recto is a study for a *Noli me tangere* with Christ and the Magdalene but the verso appears to represent two independent figure studies. As Felice Stampfle has observed, the standing figure seems to show the artist's concern for drapery while his interest in balance and movement is revealed in his treatment of the kneeling youth. The flickering quality of Filippino's line in the drawings is, as Miss Stampfle notes, evidence of its probable date in the mid-

1490's when Filippino assumed a certain nervously energetic style which foreshadowed the Florentine Mannerists of the next century.

PROVENANCE: Licht; E. Czeckowiczka; his sale, Leipzig, Boerner's, 12 May 1930, lots 98, 99; Mark Oliver; C. R. Rudolf; P. & D. Colnaghi and Co., London.

BIBLIOGRAPHY: Van Marle, *Italian Schools of Painting*, XII, [1931], p. 361, note; Alfred Scharf, *Filippino Lippi*, Vienna, 1935, no. 228, p. 124; Berenson, 1938, no. 1348A, fig. 253; Morgan Library, *Third Report to the Fellows*, 1952, pp. 59–62, repr.; Berenson, 1961, no. 1353F; Morgan Library, *Review of Acquisitions, 1949–1968*, 1969, p. 154, repr.

EXHIBITIONS: P. & D. Colnaghi and Co., London, *Exhibition of Old Master Drawings*, 1951, no. 1, frontispiece; Morgan Library, and elsewhere, *Fiftieth Anniversary*, 1957, no. 82, repr.; Wildenstein, New York, *Masterpieces*, 1961, no. 59, repr.; *Drawings from New York Collections*, I, 1965, no. 21, repr.; Morgan Library, *Major Acquisitions, 1924–1974*, 1974, p. xiv, no. 2, repr.

Acc. no. 1951.1
Purchased with the assistance of the Fellows

Franco-Flemish School (?)

FIFTEENTH CENTURY

9 *Drapery Study*

Point of brush and gray tempera on prepared ocher ground, heightened with white tempera (some retouching in zinc white), preliminary indications in hard black chalk; the background painted in, in purplish-red tempera
Verso, by another hand (?): Murder of a saint kneeling before an altar
Pen and black ink
8 1/16 × 5 5/8 inches (206 × 144 mm.)
Watermark: none
Inscribed on verso at lower right, in pen and brown ink, *M S 1495*

This extraordinary study, virtually a kind of early still life, is painstakingly modelled with the point of brush in sequences of parallel strokes, gray for the shadows and white for the highlights, on the smooth ocher prepared surface of the sheet of paper; under magnification the artist's thin guidelines in hard chalk are visible. The muted burgundy background against which the drapery is so effectively silhouetted overlays the prepared ocher surface. Although it is impossible to say whether or not it is a part of the original conception, it is to be remarked that this red ground

antedates the worm holes in the paper. While the verso of the hole at the center of the right margin shows reddish staining at its edges, caused when that area of the recto suffered some water damage, others show no trace of the red on the verso as would be the case had the red wash been applied after the activity of the worms. A few areas of the white highlights at the upper left have been retouched; executed in zinc white as opposed to the older lead white, these fluoresce a bright yellow under ultra-violet light.

Although a number of authorities in the field of Northern art have inspected this sheet since its presentation to the Morgan Library in 1970, there still is no consensus as to its origin. Those scholars favoring a Germanic origin perhaps constitute a majority, if Germanic is interpreted to comprehend South Germany, Austria, and Switzerland (Konrad Witz). Advocates of this view find corroboration in the style of the pen drawing on the verso, a view in which they were preceded by a former owner who optimistically inscribed the initials of Martin Schongauer and the date 1495 at the lower right. At the same time several of the advocates of German authorship have put forward the alternate idea of a Netherlandish origin or influence. It would seem that France—where names like the Master of the Aix Annunciation and the Master of Moulins present themselves—also should not be ruled out. Until some conclusive evidence is forthcoming, the drawing is being retained under the tentative ascription (with the mention of the possible influence of Simon Marmion) that it carried in the Thaw collection.

The purpose of the drapery study is equally ambiguous. What did the artist have in ultimate view when he carefully studied this length of heavy cloth, apparently wool, held up at two points and flowing along the ground in full, undulant folds? Is the drapery to be interpreted as supported by the knees of a seated figure—perhaps the risen Lazarus with his winding sheet—or is it to be thought of as held up by the hands of a kneeling figure? Scenes of the Baptism, the Nativity with the Midwife Receiving the Infant Christ, the Presentation, the Deposition, the Angels Holding the Symbols of the Passion with reverently covered hands, all involve the manipulation of a

length of cloth for one purpose or another, but the drapery of the drawing does not seem to fit any of these uses with absolute conviction.

The drawing might be regarded as a Northern counterpart of the drapery studies described by Vasari in his life of Leonardo and surviving in a number of drawings traditionally attributed to him, but assigned by some modern scholars to Fra Bartolomeo and Ghirlandaio. If the drawing, as has been suggested by a number of scholars, is a work originating around the midpoint of the fifteenth century, it is well in advance of the drapery studies of Dürer, whose standards of precision and finish it fully meets.

PROVENANCE: Mr. and Mrs. Eugene V. Thaw, New York.
BIBLIOGRAPHY: *Sixteenth Report to the Fellows, 1969–1971,* 1973, pp. 87–88.
EXHIBITIONS: Morgan Library, *Major Acquisitions, 1924–1974,* 1974, no. 33, repr.; Morgan Library, and elsewhere, *Drawings from the Thaw Collection,* 1975, no. 1, repr.

Acc. no. 1970.14
Gift of Mr. and Mrs. Eugene V. Thaw

Bernhard Strigel (German)
MEMMINGEN C. 1460/1461 – 1528 MEMMINGEN

10 *Two Lovers*

Pen and black ink, heightened with white and some yellow (in hair of young man, and in necklace and girdle of young woman), on reddish-brown prepared paper
7$\frac{11}{16}$×6$\frac{7}{8}$ inches (195×175 mm.)
Watermark: none visible through lining
Inscribed by the artist in banderole at upper right, in pen and black ink, *Er tut Doch hupschlich*(?)
Inscribed on the verso of the old mount by Jonathan Richardson, Jr., in pen and brown ink, *Sy tue doch Scripsthuch. / Be thou then a Lamb:peice. i.e. Behave Modestly. / The Severity of which Rebuke her Eyes correct. / For, as Old Morley said (when He Courted the Heiress of the / D. of Newcastle for my L. Oxford's Son & she told him, / on his proposing this Match to Her, that she would or: / :der him to be flung into the Well,) to himself, on his / observing her Eyes, Ah! Girl I have Thee; for as He / told my Father & me, at his House at Halstead, in / telling us the whole Progress of this most Important / Business (for it occasioned the Breach between Oxford / & Bolingbroke, & of consequence probably defeated the bring: / :ing in of the Pretender, as Oxford was, now, too well pro / :vided for, to risk a Civil War) The Tongue may Lye, / but Eyes will Tell Truth. A strikly True, & most Curious / Anecdote this!* Below this, in pen and black ink, in J. C. Robinson's hand, on the left, "*Ey tut doch sauptlich*" / "*Eh touch softly*", and on the right, *The above is in the handwriting of / Jonathan Richardson Junr / Collections / J. Richardson / Rogers / Sir T. Lawrence / W Russell / JCRobinson apl 18. 1885.*

Only a handful of drawings have survived from this draughtsman who flourished in Southern Germany during the time of Albrecht Dürer and Hieronymus Bosch. As a court painter to Emperor Maximilian the Great, Strigel belonged to the generation of Northern artists who participated in the transition from the Gothic period to the Renaissance. Even though Strigel was not one of the principal initiators of this change, his work evolved under its influence.

The Morgan sheet has not always been recognized as the work of the left-handed master from Swabia. When still in the possession of Fairfax Murray, it was assigned to Strigel's contemporary fellow countryman, the prolific engraver Israhel van Meckenem (1450–1503) whose achievements depended to a large extent on the work of other artists, like the Housebook Master, Schongauer, and Dürer, all of whom he copied. This attribution was probably based on Van Meckenem's many engravings of lovers; during the late 1490's he produced a series of twelve prints on the subject of peasant genre that depicts different couples with banderoles above. In 1925, Sir Karl Parker placed the Morgan sheet among the early drawings of Strigel, comparing it to the British Museum's *Holy Family* and to the *Madonna*, then in the Koenigs Collection, Haarlem, but now listed among the German drawings lost during the Second World War. The facial type, consisting of large heavy-lidded eyes, long nose, and full mouth, as well as the bony hands, is part of the artist's vocabulary in these and other drawings of the 1490's, two of which are preserved in the Frick Collection, New York, and the Fogg Art Museum, Cambridge, Massachusetts. In her monograph on Strigel, Gertrud Otto suggests that the Morgan sheet is closer to the drawing in Berlin *A Pair of Unequal Lovers with the Devil and Cupid,* dated 1502 (Rettich says 1503). In both cases, the figures have become more substantial and reflect the beginning of the formal plasticity and monumentality associated with the Renaissance.

Like Dürer's *Kneeling Donor* (No. 33), the *Two*

Lovers represents the high point of chiaroscuro drawing practiced by the early sixteenth-century South German artists. Although the technique was known to the Italians, as shown by the Florentine drawing of *The Martyrdom of San Miniato* (No. 2), it was not as popular as in the North. The paper was first prepared with an opaque ground consisting mainly of tempera, on which the artist drew the contours in dark ink and added highlights to produce a rich image. The finished quality of this rendering made it desirable for purchase, somewhat like an inexpensive painting.

The subject of the Morgan drawing reflects the enormous popularity of the theme of love in the art and literature of Northern Europe during the late Middle Ages. By the early sixteenth century, the veneration of pure love had turned somewhat to irony. This period produced two great satires, Sebastian Brandt's *Ship of Fools* (1494) and Erasmus' *In Praise of Folly* (1509), in which the mercenary "affairs of the heart" between the young and old were treated at great length. An elderly man or woman with a money purse, embracing a young member of the opposite sex, was a frequent image in the paintings of Lucas Cranach, and appears in the prints of the Housebook Master, Albrecht Dürer, Lucas van Leyden, Hans Burgkmair, Israhel van Meckenem, and others. The couple would often be accompanied by a demon or fool to symbolize their immoral and imprudent behavior. Apart from Strigel's well-known drawing *Unequal Lovers* in Berlin, the subject is rare in the artist's *oeuvre*. He is remembered more for his religious altarpieces and portraits, including those of Emperor Maximilian, and his poet laureate—the Viennese humanist Johannes Cuspinian and his family—who was painted eighteen years earlier by Lucas Cranach. In the Morgan sheet, symbols that would taint the overt display of affection, such as a money purse, basket of eggs, or dog, are absent, and the demonstration of love seems genuine. The elegant attire of the lovers indicates that both belong to the same social class, and adds a sense of decorum to the scene.

The artist's inscription in the banderole at the upper right has been read by many art historians as "Er (ey?) tut doch hupschlich." Its meaning, according to Dr. Fedja Anzelewski, Director of

the Kupferstichkabinett, Staatliche Museen Preussischer Kulturbesitz in Berlin, is that although the young man is doing something he should not do, he is doing it in a very pleasant way. On the verso of the mount, the English collector Robinson transcribed the last word as "sauptlich," possibly connecting it with the meaning of the word "sänftlich" since he translates it as "softly." With this transcription of the word, the scroll could be read "he caresses her gently." According to the amusing inscription left by Jonathan Richardson, Jr., also on the verso of the mount, the drawing inspired another interpretation of the scene and an anecdote of some historical interest.

PROVENANCE: Jonathan Richardson, Sr. (Lugt 2184); Jonathan Richardson, Jr. (Lugt 2170 and 2997); Charles Rogers (no mark; see Lugt 624–26); Sir Thomas Lawrence (Lugt 2445); William Russell (Lugt 2648); Sir John Charles Robinson (Lugt 1433); Charles Fairfax Murray; J. Pierpont Morgan (no mark; see Lugt 1509).

BIBLIOGRAPHY: Fairfax Murray, I, no. 250, repr.; K. T. Parker and W. Hugelshofer, "Bernhard in Strigel als Zeichner," *Belvedere*, VIII, 1925, pp. 36–38, fig. 12; Sydney J. Freedberg, "A Drawing by Bernhard Strigel," *Fogg Museum Bulletin*, Harvard University, VIII, no. 1, 1938, p. 20, fig. 5; Regina Shoolman and C. E. Slatkin, *The Enjoyment of Art in America*, New York, 1942, pl. 446; Gertrud Otto, *Bernhard Strigel*, Munich, 1964, p. 30, no. 96, pl. 162; Edeltraud Rettich, "Bernhard Strigels Handzeichnungen," *Kunstgeschichtliche Studien für Kurt Bauch zum 70. Geburtstag von seinen Schülern*, 1967, pp. 103–104, 106, note 48.

EXHIBITIONS: New York Public Library, *Morgan Drawings*, 1919; Lyman Allyn Museum, *Drawings*, 1936, no. 11; Morgan Library, *New York World's Fair*, 1939, no. 82; Metropolitan Museum of Art, New York, *German Drawings*, 1956, no. 160; Los Angeles, *Old Master Drawings*, 1976, no. 170, repr.

Acc. no. I,250

Baccio della Porta, called Fra Bartolomeo (Italian)

FLORENCE 1472 – 1517 FLORENCE

11 *Monastery Church and Well among the Trees*

Pen and brown ink
Verso: View of the same monastery from another direction
11 1/16 × 8 7/16 inches (281 × 214 mm.)
Watermark: pear (Briquet 7386)

In 1957 an important and hitherto unknown al-

bum of landscape drawings by Fra Bartolomeo came to light in London. All forty-one drawings—chiefly in pen—are of outdoor subjects, including a few pure nature studies of rocks or trees. Of particular interest, however, are the exquisitely rendered views of the hill towns, farms, mills, and small monasteries which attracted the special notice of the gentle Dominican friar and artist on his travels. The album was dismembered and its contents dispersed in what proved to be an exciting and very successful sale. Despite high competition, American museums and collectors gathered a total of twelve drawings. While some of the choicer sheets entered the collections of the museums in Boston, Cleveland, Chicago, Washington, and at Smith College, New York also fared extremely well. The Morgan Library acquired the beautiful double-sided sheet shown here, and two fine drawings were purchased by Walter C. Baker and Robert Lehman which are now housed in the Metropolitan Museum of Art along with a third leaf acquired by the museum at the time of the sale. Three other New York collectors (Stephen Spector, Ian Woodner, and the late Curtis O. Baer) also purchased drawings in 1957; since then, at least two other examples have been added to the representation of leaves from the Fra Bartolomeo album now in this country.

In 1730, the Florentine connoisseur and collector Cavaliere Gabburri reportedly rescued the drawings from the convent of St. Catherine in Piazza S. Marco, Florence, and bound them into the album. According to Mariette, a Mr. Kent, an art dealer who was in Florence at the time of Gabburri's death in 1742, acquired the entire collection which he then sold in London. Little is known about the album's subsequent history until 1925 when it is said to have been purchased in Southern Ireland by the private collector who later sold it at Sotheby's. The assumption that the album remained in the British Isles during the course of two centuries was recently reinforced by the appearance on the art market of the album of copy drawings made by Robert Surtees, a gentleman collector of Durham, which included copies dated 1768 of three of the subjects from the Gabburri album (sale, London, Christie's, 18 March 1980, lot 6).

Although Fra Bartolomeo's friend the artist Lorenzo di Credi mentioned well over one hundred landscape drawings in his inventory of the artist's studio after his death, very few were known until the Gabburri album appeared in 1957, at once illuminating this important aspect of the artist's work while adding an interesting new chapter to the history of early Italian landscape draughtsmanship. It should be mentioned as a postscript to the provenance of the Gabburri album that two sheets of tree studies were included in the recent Hatvany sale in London (Christie's, 24 June 1980, lots 8–9).

Like many other Florentine artists of his day, Fra Bartolomeo was influenced by Leonardo da Vinci, and took very seriously Leonardo's advice to sketch whatever he saw of interest directly from nature.

Our drawing is unique in the album in that the artist sketched the front view of the monastery on one side while on the reverse he drew the view of the same church as seen from the back. The front shows the small monastery church with a well to one side set on a gradual incline with travellers approaching, two on foot and one on horseback. The verso shows a broader aspect of the building and it becomes apparent that the setting of the church is actually a rather steep hill. Although Fra Bartolomeo worked frequently in black chalk, he is known particularly for the fluency of his pen style. In the Morgan drawing, he is shown at his best, maintaining a perfect balance between an assured and easy naturalism and a wonderfully elastic and virtuoso pen line which can one moment miniaturize fine architectural details and people and the next moment can be stretched to outline with a few deft strokes a tall tree in the foreground. The Library has six other examples of Fra Bartolomeo's draughtsmanship, two in black chalk and four in pen and ink. Two of the pen drawings came into the collection rather recently as the gift of Mr. and Mrs. Eugene V. Thaw.

PROVENANCE: Fra Paolino da Pistoia, Florence; Suor Plautilla Nelli; Convent of St. Catherine, Piazza S. Marco, Florence; Cavaliere Francesco Maria Nicolò Gabburri, Florence; Mr. Kent, England (according to Mariette); private collection, Ireland; sale, London, Sotheby's, 20 November 1957, lot 17, repr. (catalogue by C[armen] G[ronau]).
BIBLIOGRAPHY: John Fleming, "Mr. Kent, Art Dealer, and the Fra Bartolommeo Drawings," *Connoisseur*, CXLI, 1958,

p. 227 (discussion of the provenance of the whole group); Ruth W. Kennedy, "A Landscape Drawing by Fra Bartolommeo," *Smith College Museum of Art Bulletin*, XXIX, 1959, pp. 1–12 (discussion of the whole group); Morgan Library, *Ninth Report to the Fellows, 1958 & 1959*, 1959, pp. 88–91, repr.; Morgan Library, *Review of Acquisitions, 1949–1968*, 1969, p. 130, repr.

EXHIBITIONS: *Drawings from New York Collections*, I, 1965, no. 33, repr.; Morgan Library, *Major Acquisitions, 1924–1974*, 1974, p. xiv, no. 3, repr.

Acc. no. 1957.18
Purchased as the gift of the Fellows

Michelangelo Buonarotti (Italian)

CAPRESE 1475 – 1564 ROME

12 *David Slaying Goliath*

Black chalk, a few extraneous touches of red chalk on I, 32a and I, 32d, traces of ruled gold margin at upper edge of I, 32a, left edge of I, 32c, and upper edge of I, 32d
Versos: Architectural members in black chalk
I, 32a: $2^3/_4 \times 4^3/_8$ inches (70×111 mm.); I, 32b: $2^1/_{16} \times 3^1/_4$ inches (52×82 mm.); I, 32c: $2 \times 2^{11}/_{16}$ inches (50×68 mm.); I, 32d: $2^{13}/_{16} \times 3^1/_2$ inches (72×87 mm.)
Watermark: none

Michelangelo's four small sketches of David and Goliath were probably executed on the same sheet of paper as the similar architectural elements on the versos would seem to indicate. The original sheet must have been cut apart before the sketches were acquired by Sir Joshua Reynolds as the artist-collector's mark was stamped at the lower left corner of each sketch. Despite their tiny format, the sureness of execution of these rapid compositional sketches, which trace the evolution of the artist's conception of the subject, has always marked them unquestionably as autograph works of the artist. It has been established that Daniele da Volterra, Michelangelo's disciple, used his master's sketches as preparatory for his painting in the Louvre (repr. De Tolnay, V, figs. 184–185)—and Michelangelo may well have made them to help the younger artist. Fairfax Murray correctly identified the subject as David and Goliath but it was Charles de Tolnay who pieced out the correct chronology of the Morgan drawings and concluded that Michelangelo reinterpreted his own final conceptualization in the composition of the related drawing *Samson Slaying the Philistine* in the Ashmolean Museum, Oxford (repr. De Tolnay, V, fig. 183). In the Morgan drawing a small nude (David) is shown beating a prostrate giant (Goliath), whereas the two combatants in the Ashmolean sheet are more evenly matched in size. De Tolnay's chronology of the Morgan sketches may be summarized here in brief: in the first drawing, the figures are only outlined; in the second, the form of Goliath is repeated; in the third sketch, Michelangelo repeats the posture of the second, adding indications of the musculature to the figures; and in the fourth and last drawing, he moves the figures closely together, forming a compact triangular mass which anticipates the outline of the figures in the Ashmolean sheet. The use of the soft black chalk and also the massive body type preferred by the artist in his later years accord well with De Tolnay's dating of the Library's drawings as somewhere between 1542 and 1545.

PROVENANCE: Sir Joshua Reynolds (Lugt 2364); Breadlabane (according to Fairfax Murray); Charles Fairfax Murray; J. Pierpont Morgan (no mark; see Lugt 1509).

BIBLIOGRAPHY: Fairfax Murray, I, no. 32, repr.; Karl Frey, *Die Handzeichnungen Michelagniolos Buonarroti*, Berlin, 1909–1911, no. 76a–d; H. Thode, *Michelangelo*, III, Berlin, 1908–1913, no. 367; Berenson, 1938, no. 1544 E; Ludwig Goldscheider, *Michelangelo Drawings*, London, 1951, nos. 106–107; K. T. Parker, *Catalogue of the Drawings in the Ashmolean Museum*, II, Oxford, 1956, p. 169 under no. 328; Luitpold Dussler, *Die Zeichnungen des Michelangelo*, Berlin, 1959, p. 118, no. 188, repr.; Charles de Tolnay, *Michelangelo, V: The Final Period*, Princeton, 1960, p. 199, no. 207; Berenson, 1961, no. 1544 E.

EXHIBITIONS: Toronto, *Inaugural Exhibition*, 1926, no. 34; *Drawings from New York Collections*, I, 1965, no. 37, repr.; Morgan Library, *Michelangelo*, 1979, no. III,11.

Acc. no. I,32a–d

Raffaello Santi, called Raphael (Italian)

URBINO 1483 – 1520 ROME

13 *The Meeting of Frederick III and Eleanor of Portugal*

Pen and brown ink, brown wash, and tempera, over faint indications in black chalk
$21^1/_2 \times 16^1/_4$ inches (545×410 mm.)

Watermark: eagle (Briquet 86)
Inscribed in pen and brown ink at upper margin, *Questa è la quinta*[st]*oria de papa* [Pio]

In June 1502 Bernardino Pintoricchio, then the leading painter of Siena, was commissioned by Francesco Piccolomini, at that time a Cardinal, to decorate the new library which had recently been added to the cathedral. He asked Raphael, who had recently emerged from Perugino's studio, to collaborate with him on some of the designs for the ten large-scale murals depicting the important events in the life of Pope Pius II, the most famous member of the distinguished Piccolomini family. (A year later, Francesco Piccolomini himself was elected to the papacy as Pius III.) While the young Raphael was not involved in the paintings based on his drawings, he made designs for at least three of the ten wall frescoes. The degree of his involvement in the scheme varies in Vasari's accounts of the lives of both Pinturicchio and Raphael. Four of the artist's drawings for the project actually survive: two full *modelli* and two sketches. The sketches are a study for *Enea Silvio Piccolomini Receiving the Poet's Crown* in the Ashmolean Museum at Oxford and a study for *The Departure of Enea Silvio Piccolomini for the Council of Basel* in the Uffizi, Florence (repr. Fischel, 1913, pls. 60–61, 63), and the *modelli* are *The Meeting of Frederick III and Eleanor of Portugal* and *The Departure of Enea Silvio Piccolomini for the Council of Basel*, the latter drawing (repr. Fischel, 1913, pl. 62) now in the Uffizi along with the sketch of the same subject. The four drawings, which have been in the literature since 1827, were commented on frequently during the course of the nineteenth century (see Panofsky, pp. 269ff.). While the Oxford sheet and both Uffizi drawings were accepted as authentic, many earlier writers questioned Raphael's authorship of *The Meeting of Frederick III*, and the problem was not firmly resolved until 1915 when Erwin Panofsky made a comprehensive study of Raphael's involvement in the Piccolomini project. He established beyond a doubt that the present sheet, like the Uffizi *modello*, is a full-scale compositional model made by Raphael for the Pinturicchio shop.

The drawing remained in Italian collections until it came to this country in the mid-1970's. Most recently it has been published in Konrad Oberhuber's discussion of Raphael's Colonna Altarpiece, the great monument which J. P. Morgan donated from his father's collection to the Metropolitan Museum of Art in 1916. This scholar convincingly argues that Raphael's ability to manage space and to represent action on a large scale developed more rapidly in response to the challenge of the Piccolomini Library project. His conclusion that this development of a new spatial awareness is demonstrable in a stylistic comparison of the two *modelli* can, perhaps, be disputed. In *The Meeting of Frederick III*, which he dates c. 1502, he sees the artist's first attempt to cope with the problem of manoeuvring a crowd of people within a landscape. At the center we see the Holy Roman Emperor Frederick III and his betrothed, Eleanor of Portugal, meeting for the first time in Siena; between them is Enea Silvio Piccolomini, then still a Cardinal, bestowing a blessing on the pair whose marriage he had helped to arrange. The main figures are grouped on the same plane in the foreground while the onlookers recede into a shallow distance with a circular movement. In the Uffizi *modello*, *The Departure of Enea Silvio*, which Oberhuber would date a year later, around 1503, he sees Raphael experimenting further with the dynamics of planar recession, boldly foreshortening the horsemen he located diagonally in the composition. These differences might be called into question in light of the very different character of the action represented in the two drawings: the one showing a gathering of people arranged in a circle around the monument which still stands in Siena to mark the occasion, and the other, the more dynamic subject of the departure of horsemen. Further, since Raphael was not involved in the actual painted execution of his designs, it seems logical that he would have made his drawings for the project at more or less the same time rather than a year apart.

The present sheet was in precarious condition when it entered the collection of its American owner. That it had long ago been folded into quadrants and eventually broken along the folds was evident in the clumsy reassembling of the sections when they were mounted onto a sheet of paper. This must have occurred some time in the

seventeenth century, as the watermark on the paper on which the quadrants were mounted would seem to indicate (Heawood 1352). The beauty of the draughtsmanship became more apparent when Mr. Yow, the conservator at the Morgan Library, removed the fragile sections of the drawing from its seventeenth-century support and correctly realigned the quadrants of the drawing, restoring to their original positions various fragments of the design which had been used to fill in losses in the earlier restoration.

PROVENANCE: Conte Baldeschi, Perugia; Conte Contini, Florence; Conte Contini-Bonacossi, Florence.

SELECTED BIBLIOGRAPHY: Oskar Fischel, *Raphaels Zeichnungen*, I, Berlin, 1913, pp. 74ff., no. 65, pl. 65; for previous bibliography see Erwin Panofsky, "Raffael und die Fresken in der Dombibliothek zu Siena," *Repertorium für Kunstwissenschaft*, XXXVII, 1915, pp. 278ff., fig. 7; Oskar Fischel, *Raphael*, I, London, 1948, p. 22; John Pope-Hennessy, *Raphael*, New York, 1970, p. 88, fig. 75; Konrad Oberhuber, "The Colonna Altarpiece in the Metropolitan Museum and Problems of the Early Style of Raphael," *Metropolitan Museum Journal*, XII, 1977, pp. 80ff., fig. 32.

Private collection
Promised gift to The Pierpont Morgan Library

Giovanni Antonio da Pordenone (Italian)

PORDENONE 1484 – 1539 FERRARA

14 *The Conversion of St. Paul*

Pen and brown ink, brown wash, heightened with white, on gray-green paper; pen outlines incised with the stylus for transfer

10¾×16⅛ inches (272×411 mm.)

Watermark: none visible through lining

Pordenone's very spirited and highly finished drawing of the Conversion of St. Paul has not been connected with any specific work by this master. A number of related drawings study parts of the composition (see Cohen, *Pordenone*, p. 103f.), and recently M. Jean-Pierre Durand has given the Library a contemporary copy of the full composition (Acc. no. 1975.25). The latter drawing may be identical with the drawing sold at Sotheby's in 1920 as Lattanzio Gambara (see Cohen, *Pordenone*, p. 104).

The present sheet is not preparatory for *The Conversion of St. Paul* which the artist painted in 1524 along with *The Assumption* for the organ wings of the cathedral at Spilimbergo near Udine, works which, according to Vasari, established Pordenone's reputation. It is clear, moreover, that the present sheet is stylistically more advanced and probably dates to about 1532–1533 (see Cohen, *Pordenone*, p. 103).

The Library's drawing is a complete compositional design, its action fully developed by means of a vigorous interplay of powerful yet fluently eloquent forms. The spatial relationships are established by the firmly controlled but flickering pen line which contours the forms which are then modelled in brown wash and highlighted with white. The design has been gone over with a stylus indicating that it has been traced and transferred.

The drawing passed through many distinguished collections, including—if the inscription on the mount by Sir John Charles Robinson is correct—that of the great seventeenth-century *amateur* Eberhard Jabach whose collection of about 5,000 sheets passed *en bloc* into the *Cabinet du Roi* in 1671, forming the true start of the French royal collection, now the Cabinet des Dessins of the Louvre.

Another drawing by Pordenone, a red chalk study for *The Crucifixion* which the artist painted in Cremona in 1520, came into the Library with the Fairfax Murray collection (repr. Fairfax Murray, IV, no. 69), and in recent years two more drawings have been added from the Janos Scholz Collection.

PROVENANCE: Eberhard Jabach (according to Sir John Charles Robinson's inscription on the mount); William Esdaile (Lugt 2617); Thomas Thane (according to Robinson inscription); John William Spread; his sale, London, Christie's, 27–29 April 1898, lot 123; Sir John Charles Robinson (Lugt 1433); Charles Fairfax Murray; J. Pierpont Morgan (no mark; see Lugt 1509).

BIBLIOGRAPHY: Fairfax Murray, I, no. 70, repr.; Lili Fröhlich-Bum, "Beiträge zum Werke des Giovanni Antonio Pordenone," *Münchner Jahrbuch der Bildenden Kunst*, II, 1925, pp. 85, 86; Giuseppe Fiocco, *Giovanni Antonio Pordenone*, Padua, 1943, pp. 86, 90, 154, pl. 180; Hans Tietze and E. Tietze-Conrat, *The Drawings of the Venetian Painters in the 15th and 16th Centuries*, New York, 1944, no. 1341; A. E. Popham and Johannes Wilde, *The Italian Drawings of the XV and XVI Centuries . . . at Windsor Castle*, London, 1949, p. 302, under no. 749; Charles E. Cohen, *I Disegni di Pomponio Amalteo*, Pordenone, 1975, p. 25; Caterina Furlan, "Osservazioni su alcuni modelli del Pordenone," *Il Noncello*, XLIII, 1977, p. 116, fig.

12; Charles E. Cohen, *The Drawings of Giovanni Antonio da Pordenone*, Florence, 1980, pp. 102ff., fig. 101.

EXHIBITIONS: *Drawings from New York Collections*, I, 1965, no. 53, repr.; Los Angeles, *Old Master Drawings*, 1976, no. 39, repr.; Morgan Library, *Michelangelo*, 1979, no. IV,14.
Acc. no. I,70

Italian: Florentine School
FIRST QUARTER
OF THE SIXTEENTH CENTURY

15 *The Crucified Christ*

Red chalk
14³/₈ × 11 inches (365 × 280 mm.)
Watermark: none
Inscribed in an old hand in pen and brown ink at upper right, *Il = Parmenganino*

This fine study of a slender bearded male nude, posed with arms outstretched against the outline indications of a wide cross, must have been preparatory for the figure of Christ in a Crucifixion. While it has yet to be connected with a known work or draughtsman, the beauty of the sheet has prompted a wide spectrum of opinion as to the possible identity of the artist. The drawing bears an old inscription—possibly as early as the sixteenth century—to Parmigianino, and the high quality of the drawing suggests that it is by an artist of this rank. While the Parmigianino attribution cannot be supported, modern connoisseurs recognize in this drawing the hand of an artist who was influenced by Michelangelo, the perfection of the figural proportions and the sensitive handling of the red chalk suggesting to many the work of a Florentine painter of Andrea del Sarto's generation. Perino del Vaga's name has also come up in the search for the identity of the artist, certainly an interesting possibility in light of the variety and refinement of style of this prolific draughtsman; his drawings have often been discovered, as A. E. Popham remarked, under such aliases as Correggio, Salviati, and Parmigianino. In view of certain stylistic analogies, especially the grainy character of the handling of the red chalk, Philip Pouncey attributed the drawing to Girolamo Muziano, the late Michelangelo follower of Brescian origin who studied with Romanino. The work

was at one time also attributed to Sebastiano del Piombo.

PROVENANCE: Prince Johann Georg of Saxony (according to inscription on verso); Maximilian von Heyl zu Herrnsheim (Lugt 2879); private collection, New York.
BIBLIOGRAPHY: Morgan Library, *Eighteenth Report to the Fellows, 1975–1977*, 1978, pp. 241f., 279 (as attributed to Girolamo Muziano).
EXHIBITION: Morgan Library, *Michelangelo*, 1979, no. IV, 31 (as attributed to Girolamo Muziano).
Acc. no. 1975.11
Gift of a Trustee

Andrea del Sarto (Italian)
FLORENCE 1486 – 1530 FLORENCE

16 *Youth Carrying a Sack on his Head*

Black chalk
Verso: Details of the same figure in red and black chalk
10³/₈ × 5¹/₄ inches (263 × 134 mm.)
Watermark: anchor (close to Briquet 433)

In 1854 Waagen first recognized this beautifully posed and balanced black chalk study as Andrea del Sarto's preparatory drawing for the figure of a serving man in the artist's fresco *The Visitation* in the cycle of decoration for the cloister of the barefooted monks of the Confraternity of St. John the Baptist in Florence. Andrea was engaged in the project intermittently over the course of two decades beginning as early as 1506. The fresco of the Visitation is documented by a record of payment in November 1524 and is therefore the next to the last in the series (repr. Shearman, I, pl. 131a). Andrea, who excelled in the Florentine custom of drawing from a studio model, rapidly sketched the figure, demonstrating, as A. E. Popham has observed, an unerring feeling for the underlying structure. While the model was posed thus—climbing a short flight of stairs, his left arm raised to support the bundle balanced on his head, a basket held against his hip with his right arm—Andrea turned the sheet over and drew the raised left arm and sleeve again in greater detail, making a separate sketch to study the movement of the left wrist.

There is another preparatory sheet for *The Visitation*, the red chalk drawing now in Dijon, which

studies the head and left hand of Zacharias, who appears at the left side of the composition. Both it and the Morgan drawing were apparently together in the Richardson and Reynolds collections before they were separated, presumably in the sale after Reynolds' death in 1792.

Another example of Andrea's draughtsmanship in the collection is the red chalk study for the figure of St. Michael (repr. Fairfax Murray, I, no. 31) which is preparatory for the painting of *The Four Saints* in the Uffizi.

PROVENANCE: Jonathan Richardson, Sr. (Lugt 2184); Sir Joshua Reynolds (Lugt 2364); Samuel Rogers (according to Dr. Waagen); E. A. Leatham; sale [including Leatham], London, Christie's, 2 June 1902, lot 115; Charles Fairfax Murray; J. Pierpont Morgan (no mark; see Lugt 1509).

BIBLIOGRAPHY: Jonathan Richardson, *An Account of the Statues, Bas-Reliefs, Drawings and Pictures in Italy, France, etc.*, London, 1722, p. 83; Dr. Waagen, *Treasures of Art in Great Britain*, II, London, 1854, p. 80; Bernard Berenson, *The Drawings of the Florentine Painters*, London, 1903, no. 55; Fairfax Murray, I, no. 30, repr.; Fritz Knapp, *Andrea del Sarto*, Leipzig, 1907, p. 135; Berenson, 1938, no. 141E; Tietze, 1947, no. 25, repr.; Mongan *et al.*, 1949, p. 52, repr.; James Watrous, *The Craft of Old Master Drawings*, Madison, 1957, p. 100; Berenson, 1961, no. 141E; Sidney Freedberg, *Andrea del Sarto*, Cambridge, Mass., 1963, under no. 60, figs. 93–94; John Shearman, *Andrea del Sarto*, Oxford, 1965, I, p. 150; II, pp. 305 under no. 14, 366.

EXHIBITIONS: Lyman Allyn Museum, *Drawings*, 1936, no. 23; Morgan Library, *New York World's Fair*, 1939, no. 70, repr.; Smith College Museum of Art, Northampton, Mass., *Italian Drawings, 1330–1780*, 1941, no. 44; Worcester, *Fiftieth Anniversary Exhibition*, 1948, no. 34; Fogg Art Museum, *Seventy Master Drawings*, 1948–49, no. 23; Philadelphia, *Masterpieces*, 1950, no. 33, repr.; Morgan Library, and elsewhere, *Fiftieth Anniversary*, 1957, no. 85, repr.; Newark Museum, Newark, *Old Master Drawings*, 1960, no. 11, repr.; *Drawings from New York Collections*, I, 1965, no. 60, repr.; Morgan Library, *Michelangelo*, 1979, no. IV,17, repr.

Acc. no. I,30

Antonio Allegri, called Correggio (Italian)

CORREGGIO 1489/1494 – 1534 CORREGGIO

17 *Head of a Woman Crying Out*

Charcoal, in some passages blended with white chalk, and accents in brush and black oil pigment; the sheet, made up of two pieces of paper pasted together, has irregular margins

At widest point 12⅝ × 8⅞ inches (322 × 224 mm.)

Watermark: none visible through lining

For many years this powerful study of a woman crying out lacked a firm attribution and was simply catalogued as Lombard School. In 1927 Sir Karl Parker was the first to venture an opinion; he ascribed the drawing to Ercole Roberti and suggested that it might have been preparatory for the head of a grief-stricken mother in a Massacre of the Innocents. This very plausible attribution was retained until 1957 when A. E. Popham demonstrated conclusively that the Morgan *Head* corresponded exactly with one of the weeping Marys for Correggio's roundel of the *Entombment* at S. Andrea in Mantua, one of his earliest known works. The artist fastened two pieces of paper together—a sure indication of his intention to make use of the drawing as a cartoon—and drew broadly across them in a mixture of charcoal and white chalk, later brushing in accents with a black oil pigment. The fresco roundel was in ruinous condition until the mid-1960's when it was removed from the wall of the portico for restoration, revealing the artist's *sinopia* or preliminary sketch for the painting; here again the correspondence between the cartoon and the rough outline sketch of the *sinopia* is quite apparent (repr. *Art News*, LXIV, no. 4, 1965, p. 36). The Morgan drawing is early and not representative of Correggio's mature style. It is one of only two known cartoons which survive; the other is the black chalk drawing of a beautiful upturned head at the École des Beaux-Arts, Paris, which may be preparatory for the head of an angel in one of the frescoes for the cathedral at Parma (repr. Popham, 1957, pls. LXXXIX, LXXXIV).

PROVENANCE: N. F. Haym (Lugt 1970); The Earls Spencer (Lugt 1530); Charles Fairfax Murray; J. Pierpont Morgan (no mark; see Lugt 1509).

BIBLIOGRAPHY: Fairfax Murray, IV, no. 30, repr.; K. T. Parker, *North Italian Drawings of the Quattrocento*, London, 1927, no. 27, repr.; Tietze, 1947, no. 15, repr. (as Ferrarese School about 1490); A. E. Popham, *Correggio's Drawings*, London, 1957, pp. 13, 78, 149, no. 1, pl. 2; Stefano Bottari, *Correggio*, Milan, 1961, p. 10; *Great Drawings of All Time*, I, 1962, no. 265, repr.

EXHIBITIONS: M. Knoedler and Co., New York, *Great Master Drawings of Seven Centuries*, 1959, no. 14, repr.; Hartford, *Pierpont Morgan Treasures*, 1960, no. 68, repr.; *Drawings from New York Collections*, I, no. 65, repr.; Morgan Library, *Michelangelo*, 1979, no. IV,20.

Acc. no. IV,30

Jacopo da Pontormo (Italian)

PONTORMO 1494 – 1557 FLORENCE

18 Standing Male Nude Seen from the Back, and Two Seated Nudes

Red chalk
Verso: Striding nude with upraised arms in black chalk,
with vestiges of white, over red chalk
16×8⅞ inches (406×225 mm.)
Watermark: pear (Briquet 7392)

The superb double-sided sheet of figure studies
probably dates about 1520 when Pontormo was
approximately twenty-five, having left Andrea
del Sarto's studio and gained a measure of repu-
tation of his own. His peculiar style of Mannerism
with its accent on the decorative and expressive
content of the line was emerging, although the
emphasis his former master put on naturalism is
still apparent in the attention Pontormo gave to
the articulation of form and musculature. It was
at this moment, in fact, that Pontormo was at
work along with Del Sarto and Franciabigio on
the Medici villa at Poggio a Caiano. Pontormo,
however, had finished only the lunette *Pomona and
Vertumnus* when work on the villa was brought
to an abrupt end by the death of Pope Leo X.
Stylistically, the Morgan sheet bears close com-
parison with two drawings in the Uffizi which
have traditionally been associated with Pontormo's
work at Poggio a Caiano, although only one can
definitely be connected with figures in the lu-
nette. Considering how few of Pontormo's fin-
ished works actually survive, the large number of
existing drawings is surprising. Most of these, how-
ever, are preserved in the Uffizi, Florence, and the
Corsini Gallery, Rome. Janet Cox Rearick listed
only four unquestioned examples in this country,
the Morgan sheet and three in the Fogg Art Mu-
seum, Harvard University.

The present drawing was purchased in one of
the Reitlinger sales at Sotheby's through the gen-
erosity of the Fellows with the special assistance of
Mrs. Carl Stern and Janos Scholz. It was first re-
corded in the major exhibition of drawings at the
Royal Academy in 1953 but the paraph at the
right-hand corner indicates that it belonged to the
great French connoisseur Pierre Crozat in the eigh-
teenth century. While the drawing of the three
nudes on the recto is executed in red chalk—the
favorite medium of Florentine draughtsmen of
this period—the single figure on the verso is exe-
cuted in black chalk. Although it was suggested
by the editor of the Fellows Report in 1954 that
the drawing on the verso was not altogether by
Pontormo, there is no reason to doubt that he
alone is responsible for both sides of the sheet. It
is interesting to note in this connection that one
of the artist's lesser followers, probably Naldini,
studied both recto and verso (see Rearick, A 330
and A 328) in a drawing at the Louvre.

PROVENANCE: Pierre Crozat (Lugt 2951); Henry Reitlinger;
his sale, London, Sotheby's, 9 December 1953, lot 84, repr.;
H. M. Calmann, London.
BIBLIOGRAPHY: Alfred Scharf, "The Exhibition of Old Mas-
ter Drawings at the Royal Academy," *Burlington Magazine*,
XCV, 1953, p. 352, fig. 3; Morgan Library, *Fifth Report to the
Fellows, 1954*, 1954, pp. 65–68, repr.; C. Gamba, *Contributo all
conoscenza del Pontormo*, Florence, 1956, p. 11, fig. 12; Beren-
son, 1961, no. 2256 H, fig. 905; Janet Cox Rearick, *The Draw-
ings of Pontormo*, Cambridge, Mass., 1964, nos. 188, 189, figs.
172, 178; Morgan Library, *Review of Acquisitions, 1949–1968*,
1969, p. 161, pl. 43.
EXHIBITIONS: Royal Academy of Arts, London, *Drawings
by Old Masters*, 1953, no. 55, pl. 12; Morgan Library, and else-
where, *Fiftieth Anniversary*, 1957, no. 86, pl. 53; M. Knoedler
and Co., New York, *Great Master Drawings of Seven Centuries*,
1959, nos. 20–21, pl. 11; *Drawings from New York Collections*,
I, 1965, no. 76, repr.; Morgan Library, *Major Acquisitions,
1924–1974*, 1974, p. xv, no. 4, repr.; Los Angeles, *Old Master
Drawings*, 1976, no. 25, repr.; Morgan Library, *Michelangelo*,
1979, no. IV,19.

Acc. no. 1954.4
Purchased as the gift of the Fellows with the special assistance
of Mrs. Carl Stern and Mr. Janos Scholz

Piero Buonaccorsi, called Perino del Vaga (Italian)

FLORENCE 1501 – 1547 ROME

19 The Miracle of the Loaves and Fishes

Pen and brown ink, brown wash, heightened with white
Diameter: 8⅜ inches (212 mm.)
Watermark: none visible through lining

The Morgan Library has two of the six designs

that Perino del Vaga made for the rock crystal plaques which the lapidary and medallist Giovanni Bernardi was commissioned by Cardinal Alessandro Farnese to engrave for the decoration of silver candlesticks now in the Treasury of St. Peter's. The clear outlines, comparatively shallow relief, and high finish of the design for *The Miracle of the Loaves and Fishes*, shown here, indicate that it was the *modello* from which Bernardi worked. The vigorous pen drawing in *The Pool of Bethesda* (repr. Fairfax Murray, IV, no. 47), on the other hand, lacks the brush modelling which Perino carried through in *The Miracle of the Loaves and Fishes* and would seem to show a somewhat earlier stage in the planning of the crystal design. While Bernardi's crystal plaque for *The Pool of Bethesda* can actually be found in one of the candlesticks in St. Peter's, the plaque corresponding to Perino's design for *The Miracle of the Loaves and Fishes* is known only in Vasari's description. In addition to the two subjects represented in the Morgan Library, Vasari mentions *The Transfiguration*, *The Expulsion of the Money Changers from the Temple*, *The Raising of Lazarus*, and *Christ and the Centurion*. Drawings for all but the last of these subjects have been located: designs for *The Transfiguration* and *The Expulsion of the Money Lenders* are in the Staatliche Graphische Sammlung, Munich, and the drawing for *The Raising of Lazarus* is in the Louvre. Of the existing plaques, three (including *The Pool of Bethesda*) are in candlesticks in St. Peter's, and two are in the Museum of Industrial Art in Copenhagen. The same unusual assortment of New Testament subjects is described by Vasari in connection with Perino's frescoes for the Massimi chapel in S. Trinità dei Monti, Rome. Noting the coincidence of subjects in both works, J. A. Gere made the connection between both cycles and concluded that Perino's work on the crystal plaques must post-date the frescoes. He has convincingly theorized that Cardinal Farnese, impressed by Perino's work in the Massimi chapel, commissioned the crystal plaques; since Bernardi's crystal plaques are known to have been completed by 1539, the Massimi chapel frescoes would have to be earlier, most likely 1537–1538, the presumed date of Perino's return to Rome from Genoa. Unfortunately, Perino's scheme for the Massimi chapel was re-

placed by new paintings in the middle of the nineteenth century and all that survives is his fresco *The Raising of Lazarus* (Victoria and Albert Museum, London) and a compositional drawing in the Squire collection, London. The Perino expert Bernice Davidson fully concurs with Mr. Gere's logic and further observes that the style of the remaining fresco is extremely close to that of Perino's Genoese period. The change of the composition from a format that is rectangular in the Massimi frescoes to one that is circular for the crystal plaques, taken in conjunction with the general flattening and linear quality of the crystal designs, accords well with Gere's surmise that Perino adapted the Massimi chapel schemes to suit the lapidary Bernardi's need.

One of the finest draughtsmen of his day, Perino's early training began briefly in Florence with Ridolfo Ghirlandaio, and was followed by almost three years in Raphael's studio in Rome. He was primarily a decorative painter and his development is consistent within this refined tradition. There are no awkwardnesses in his drawings, his figures are elegantly proportioned and harmoniously deployed within a dynamic and rhythmically flowing compositional style. He rarely used black chalk, preferring to work in pen, often applying white heightening for dramatic contrast as well as modelling.

PROVENANCE: Charles Fairfax Murray; J. Pierpont Morgan (no mark; see Lugt 1509).

BIBLIOGRAPHY: Fairfax Murray, I, no. 21, repr.; J. A. Gere, "Two Late Fresco Cycles by Perino del Vaga: The Massimi Chapel and the Sala Paolina," *Burlington Magazine*, CII, 1960, p. 13, fig. 10; Gabinetto Disegni e Stampe degli Uffizi, Florence, *Mostra di disegni di Perino del Vaga e la sua cerchia*, XXIII, exhibition catalogue by Bernice F. Davidson, 1966, p. 44 under no. 41.

EXHIBITIONS: Toronto, *Inaugural Exhibition*, 1926, no. 26, repr.; *Drawings from New York Collections*, I, 1965, no. 86, repr.; Morgan Library, *Michelangelo*, 1979, no. IV,10.
Acc. no. I,21

Francesco Mazzola, called Il Parmigianino (Italian)
PARMA 1503 – 1540 CASALMAGGIORE

20 *Three Putti*

Pen and brown ink, brown wash, over red chalk; left figure squared in lead for transfer, ruled border in black ink
Verso: Black chalk sketch of Diana dashing water into the face of Actaeon; touches of red chalk
6⁹⁄₁₆×6⅛ inches (157×156 mm.)
Watermark: none
Inscribed in pen and brown ink on old mount, *Parmegiano*

The Morgan Library's group of drawings by the great Mannerist painter was "assembled by C. Fairfax Murray with remarkable discernment" (so wrote A. E. Popham, the foremost authority on Parmigianino as a draughtsman). According to Popham, "Only a single drawing out of the twenty Fairfax Murray sheets can be dismissed as a copy. They were largely acquired at English sales at the end of the nineteenth century and were bought *en bloc* by J. Pierpont Morgan in 1910. The . . . Morgan drawings . . . are to be numbered among the most distinguished of the smaller collections" (1971, p. 37). This rich deposit of drawings is complemented by the Metropolitan Museum's eight, and by three in the collection of Janos Scholz (promised to the Morgan Library), thus preserving in New York an interesting and representative survey of the artist's work. The Library holdings cover Parmigianino's activities as a painter and printmaker in his native Parma, Rome, and Bologna from the early fresco decorations at Fontanellato (No. 20) to his last undertaking at S. Maria della Steccata that ended in the artist's disgrace. Many of the drawings show Parmigianino working in red chalk, a favorite medium inherited from Correggio (No. 17) whose influence on the younger artist was considerable.

Prior to his departure for Rome in 1524, the twenty-one-year-old Parmigianino was engaged in the decoration of a small chamber in the Rocca di Fontanellato near Parma, the seat of Count Sanvitale. The story of Diana and Actaeon was the theme chosen for the frescoes located on the upper part of the walls and vaulted ceiling. According to Ovid, the prince Actaeon, while hunting in the forest, discovered Diana and her nymphs bathing. As punishment for having seen the naked goddess, Actaeon was transformed into a stag and devoured by his dogs. The fragment of a preliminary sketch depicting Diana splashing Actaeon as she is about to cast her spell appears on the verso

of this double-sided sheet and shows an early conception of the scene when the artist was designing it for one of the pendentives. Eventually the figures were separated and placed in adjoining niches below the pendentives that now contain putti carrying garlands of fruit and vegetables. Two of the charming putti on the recto correspond exactly to the painted versions in the spandrels: the putto on the right is located above the two dogs on the wall in which Actaeon is shown pursuing a nymph, and the left putto is between the stag-headed Actaeon and the splashing Diana.

PROVENANCE: Earl of Arundel; N. F. Haym (Lugt 1970); The Earls Spencer (Lugt 1530); Charles Fairfax Murray; J. Pierpont Morgan (no mark; see Lugt 1509).
BIBLIOGRAPHY: Fairfax Murray, I, no. 49, repr. (recto); Sydney J. Freedberg, *Parmigianino: His Works in Painting*, Cambridge, Mass., 1950, p. 162, no. 44, p. 164, figs. a & b; A. E. Popham, *The Drawings of Parmigianino*, London, 1953, pp. 4, 5, 24–25, 55, pl. 13 (verso); A. E. Popham, "Drawings by Parmigianino for the Rocca of Fontanellato," *Master Drawings*, I, no. 1, 1963, pp. 3, 5–6, 10, no. 14, pl. 5a (verso); Popham, 1971, I, pp. 3–5, no. 313, pl. 31.
EXHIBITIONS: Smith College Museum of Art, Northampton, Mass., *Italian Drawings, 1330–1780*, 1941, no. 39; Hartford, *Pierpont Morgan Treasures*, 1960, no. 69; Allen Memorial Art Museum, Oberlin College, Oberlin, Ohio, *Youthful Works by Great Artists*, 1963, no. 7, repr. (catalogue in *Allen Memorial Art Museum Bulletin*, XX, 1963, no. 3); *Drawings from New York Collections*, I, 1965, no. 88, repr. (recto); Morgan Library, *Michelangelo*, 1979, no. IV,27.
Acc. no. I,49

21 *Apollo and Marsyas (?)*

Pen, brown ink, and wash, over faint preliminary indications in black chalk, heightened with white; silhouetted along the outline of the oval
8×5⁹⁄₁₆ inches (203×141 mm.)
Watermark: none visible through lining

This drawing, depicting the musical contest between Apollo and Marsyas, or that of Apollo and Pan, is a finished *modello* for a chiaroscuro woodcut. Parmigianino made some designs to be reproduced in this medium when he settled temporarily in Bologna, following the sack of Rome in 1527 that had scattered all the artists and printmakers working in the Eternal City. The woodcut technique was a German invention of the turn of the century, in which two or three blocks represent-

ing line and color were used to imitate chiaroscuro drawings (see No. 33); prior to this, prints were hand-colored. By the 1520's, Ugo da Carpi and others in Italy evolved their own method of producing chiaroscuro woodcuts, increasing the number of blocks to three or four in order to add more layers of color. Parmigianino was the first painter to employ woodcutters to reproduce his designs. Whether or not he hired Ugo da Carpi is not known, but the existence of the latter's print after this design shows that at least he was familiar with the drawing. Another reproduction of the Morgan sheet was made in the same medium by the eighteenth-century collector and amateur engraver Count Antonio Maria Zanetti who once may have owned the drawing (Bartsch, XII, p. 92, no. 33). It was also etched by Francesco Novelli, possibly when the drawing belonged to Baron Vivant Denon, from works in whose collection Novelli made a number of etchings. A copy of the composition attributed to Parmigianino's follower Schiavone exists in a drawing in the Janos Scholz Collection (Acc. no. 1979.59).

The subject of this sheet connects it with four oval designs from the Jabach collection in the Louvre, which are smaller in size and which represent the legend of Marsyas according to Hyginas (a Roman scholar and friend of Ovid). Marsyas, who found the flute that Minerva had made and cast into the river, challenged Apollo to a musical contest and was defeated when Apollo played his lyre upside down—in this drawing he is shown playing the violin. Marsyas was flayed alive by a Scythian for his impudence, unlike Pan who lost to Apollo in a similar contest, but fled before he could be sentenced (see *The Judgment of Midas*, No. 69). Pan, the ruler of Arcadia, invented the syrinx or reed pipes with which he is traditionally depicted. His goat's legs and goat-like face can usually be distinguished from Marsyas who appears without his satyr-like features when shown with Apollo. The connection made by Popham between the Morgan sheet and the Jabach series illustrating the myth of Marsyas does not solve the problem of identifying the right-hand figure, thought by some to be Pan.

The Library also has drawings related to Parmigianino's earliest activity as a printmaker be-

ginning in Rome where he employed the engraver Jacopo Caraglio to reproduce his designs. Two drawings for the engraved composition *Marriage of the Virgin* (Acc. nos. I,46b and I,48) are connected with this early collaboration. Parmigianino was the first Italian painter to acquire the skill of etching, presumably in Bologna, producing, according to Popham, nine prints. A sheet for one of these, *Christ Rising from the Tomb* (Bartsch, XVI, p. 6, no. 6), is in the Morgan collection (Acc. no. I,46f).

PROVENANCE: Earl of Arundel(?); Count A. M. Zanetti(?); Baron D. Vivant Denon (Lugt 780); possibly sale, Isaac Walraven, Amsterdam, de Winter Yver, 14ff. October 1765, lot 275 (bought by Fokker); possibly sale, John MacGowan, London, T. Philipe, 26ff. January 1804, lot 445, "Apollo and Marsyas, free pen and Indian ink, heightened, fine; with the print in chiaroscuro"; Sir Charles Greville (Lugt 549); George Guy, fourth Earl of Warwick (Lugt 2600); his sale, Christie's, London, 20–21 May 1896, lot 260; Charles Fairfax Murray; J. Pierpont Morgan (no mark; see Lugt 1509).

BIBLIOGRAPHY: Charles Duval, *Monuments des arts des dessins . . . recueillis par le Baron Vivant Denon*, III, Paris, 1829, pl. 174; Fairfax Murray, IV, no. 44, repr.; A. E. Popham, *Italian Drawings of the XV and XVI Centuries in the Royal Library at Windsor Castle*, London, 1950, p. 284, under no. 597; Bertha M. Wiles, "Two Parmigianino Drawings from the Aeneid," *The Art Institute of Chicago Museum Studies*, I, 1966, pp. 99–100, fig. 5; Popham, 1971, I, no. 319, and under no. 390, II, pl. 131.

EXHIBITIONS: New York Public Library, *Morgan Drawings*, 1919; Morgan Library, *Italian Exhibition*, 1936–37; Philadelphia, *Masterpieces*, 1950, no. 40, repr.; Stockholm, *Morgan Library gästar Nationalmuseum*, 1970, no. 35; Morgan Library, *Michelangelo*, 1979, no. IV,26.

Acc. no. IV,44

22 *The Infant Christ Asleep on the Lap of the Virgin*

Red chalk over preliminary indications with the dry stylus
Verso: Pen sketch of antique statue of standing male nude (Dionysus?) and, in opposite direction, detail of torso of Virgin in pen and gray-brown wash
7½×5¹¹⁄₁₆ inches (190×144 mm.)
Watermark: none

While Parmigianino was under contract to decorate the apse and vaulting of S. Maria della Steccata in Parma (1530–1539), he painted his most famous work, the *Madonna dal collo lungo* (Ma-

donna of the Long Neck), now in the Uffizi. This commission came from Elena Tagliaferri in December of 1534, and was intended for her chapel in the church of S. Maria dei Servi, also in Parma. His failure to complete both works has been attributed to a preoccupation with alchemy, particularly during the mid-1530's. The Confraternity of the Steccata finally ordered Parmigianino's arrest and imprisonment in 1539, after a succession of unfulfilled contracts. Elena Tagliaferri was more understanding in the instance of the altarpiece, despite the advance of thirty-five gold *scudi*; the painting left the artist's studio only after his death, when it was installed in the chapel in 1542.

Of the thirty or so studies listed by Popham (1971, under no. 26) that are connected with the *Madonna dal collo lungo*, this sheet focusing on the Christ Child is one of the most appealing. It complements a drawing of the Madonna in the Louvre (Popham, 1971, no. 509), in which the Child is barely indicated, and was used by Faldoni and Rosaspina for an engraving. The artist began the sketch with a stylus. Red chalk used subsequently was unable to conceal these preliminary tracings that became an intricate part of the rendition. One of the most bizarre elements in the painting is the absence of hair on the sleeping Infant's head. The indication of curly locks in the drawing suggests that the omission of hair in the painting is an unfinished passage; it is also possible that the initial concept of the artist changed during the evolution of the work. As a late drawing in the development of the composition, the pose of the Child is close to the final solution. The figure was eventually shifted to a lower and more horizontal position on the lap of the Madonna, who in turn has taken a firmer hold of the Child under the shoulder. This sheet was executed when Parmigianino was at the height of his creative power, having perfected his formula of ideal beauty that blended sensuality with aristocratic elegance.

The classical male nude on the verso, possibly inspired by an antique statue of Dionysus, has not yet been connected with any known project, whereas the drapery study is for the Madonna and was also engraved by Rosaspina together with those belonging to the British Museum (Popham, 1971, nos. 243–244).

PROVENANCE: Earl of Arundel (?); A. M. Zanetti (?); Count Gini; G. A. Armano; Sir James Knowles (according to Fairfax Murray); Charles Fairfax Murray; J. Pierpont Morgan (no mark; see Lugt 1509).

BIBLIOGRAPHY: Fairfax Murray, IV, no. 42, repr.; Tietze, 1947, no. 39, repr.; Sydney J. Freedberg, *Parmigianino: His Works in Painting*, Cambridge, Mass., 1950, p. 188, under note 143, and p. 254; A. E. Popham, *The Drawings of Parmigianino*, London, 1953, p. 42; Robert Wark, "A Sheet of Studies by Parmigianino," *Art Quarterly*, XXIII, 1959, p. 246; A. E. Popham, "Two Drawings by Parmigianino," *National Gallery of Canada Bulletin*, IV, no. 2, 1964, pp. 24–30, note 5; Maurizio Fagiolo dell'Arco, *Il Parmigianino*, Rome, 1970, under no. 37, p. 274; Popham, 1971, I, p. 26, no. 317, III, pl. 353.

EXHIBITIONS: Albright Art Gallery, *Master Drawings*, 1935, no. 31, repr.; San Francisco, *Golden Gate International Exposition: Master Drawings*, 1940, no. 75, repr.; Smith College Museum of Art, Northampton, Mass., *Italian Drawings, 1330–1780*, 1941, no. 41; Worcester Art Museum, Worcester, Mass., *Fiftieth Anniversary Exhibition*, 1948, no. 35; The Newark Museum, Newark, N.J., *Old Master Drawings*, 1960, no. 12, repr.; Fogg Art Museum, Cambridge, Mass., *Anxiety and Elegance*, 1962, no. 18; *Drawings from New York Collections*, I, 1965, no. 93, repr.; Morgan Library, *Michelangelo*, 1979, no. IV,25.

Acc. no. IV,42

Francesco dei Rossi, called Francesco Salviati (Italian)

FLORENCE 1510 – 1563 ROME

23 *Head and Shoulders of a Bearded Man*

Black chalk

11¹⁵⁄₁₆×9⁷⁄₁₆ inches (301×240 mm.)

Watermark: none

Inscribed on verso in pen and brown ink, in an old hand, *Salviati*; in pencil, *m. heemskerk*.

Accompanying the drawing is an inscription in brown ink in the hand of Jonathan Richardson Jr., presumably removed from an old mount, *Baccio Bandinelli / Il suo Rittrato / N. There was written upon on Old Pasting of this Drawing, in a good Ancient Hand, that it was / the Portrait of Baccio Bandinelli by / Martin Heimskirk; which is not unlikely, He being in / Italy in the time of Baccio, & of the Age of the Portrait; which is evidently Baccio's as ap- / pears by That of Giorgio Vasari's Life of him (Baccio 1487–1559. Heimskirk 1498–1574). / It hath also been said to be of Cecchino Salviati; which may very well be too, He being ac- / tually of the School of Baccio, & of a Time that agrees (1507–1563). This name is now / on the back, & it is in his stile of Finishing.*

The authorship of Salviati for this impressive sheet

was proposed independently by Iris Cheney and Philip Pouncey, prior to their knowledge of the mention of his name in Richardson's inscription on the old mount, which preserves the previous suggestions, not only for the artist, but the subject. The imposing Mannerist head reflects the tradition of the High Renaissance to which Salviati was exposed during his extended sojourn in Rome in the 1530's, if not earlier in Florence through his teacher Andrea del Sarto.

The intensity of the stern facial expression is heightened by the deliberate care the artist took with each line, from the tip of the man's nose to the beautifully arranged locks of his hair and beard. A certain realism is observable in the subject's countenance, which includes a mole to the left of his nose. At one time he was identified as Baccio Bandinelli, another of Salviati's teachers, suggesting that the drawing was a portrait study. But in fact this type of bearded man appears in a number of Salviati's paintings and decorative schemes, and possibly the Morgan sheet was done in preparation for some such commission. Of primary importance is the artist's overt preoccupation with *disegno* and the decorative effect of a strong two-dimensional design silhouetted on the page, slightly altering the delicate balance between the subject and the manner of expression that is so typical of High Mannerism. The Morgan sheet exhibits Salviati's "stile of Finishing"—to use Richardson's words—which is characterized by attention given to the picture surface, and the elegance and self-conscious artifice associated with the master's work.

PROVENANCE: Jonathan Richardson, Jr. (Lugt 2170); Richard Cosway (Lugt 629); Sir Thomas H. Crawley-Boevey, fifth baronet; his sale, London, Christie's, 30 July 1877 (according to inscription on mount); Charles Fairfax Murray; J. Pierpont Morgan (no mark; see Lugt 1509).

BIBLIOGRAPHY: Otto Benesch, "Eine Bildniszeichnung des Baccio Bandinelli von Melchior Lorch," *Studi Vasariani: Atti del convegno internazionale . . . Firenze 1950*, 1952, pp. 244–248, repr.; Licia Ragghianti, " 'Il Libro de' disegni' ed i ritratti per le 'vite' del Vasari," *Critica d'arte*, XVIII, no. 117, 1971, p. 62.

EXHIBITIONS: Baltimore Museum of Art, Baltimore, *Bacchiacca and His Friends*, 1961, no. 102, repr.; Stockholm, *Morgan Library gästar Nationalmuseum*, 1970, no. 36; Morgan Library, *Michelangelo*, 1979, no. IV,15.

Acc. no. I,6b

Giorgio Vasari (Italian)
AREZZO 1511 – 1574 FLORENCE

24 *Design for the Ceiling of the Sala di Lorenzo, Palazzo Vecchio, Florence*

Pen and brown ink, brown wash, over faint traces of black chalk; the center panel squared in black chalk
15½×14¼ inches (393×362 mm.)
Watermark: none visible through lining
Variously inscribed by the artist, below center panel, *PRESENTE DEL SOLDANO E DAL TRI PRINCIPI*; the frames of the blank portrait medallions, reading clockwise, (1) *IULIANUS MED DUX NEMORS* (2) *PETRUS MEDICIS* (3) *IOANNES CARDINALIS DE MEDICIS* (4) *IULIANUS MED PETRI*; the paired Virtues (1) *AUDACIA* and *BUONEVENTO* (2) *BUON GIUDITIO* and *CLE[M]EN-[T]IA* (3) *PIETA* and *FEDE* (4) *FAMA* and *VIRTU*; inscribed right, below the center panel in a later hand, *Geo: Vasari*

After George Fitch presented this elaborate Vasari design to the Library, Felice Stampfle, who had earlier recognized its connection with the Palazzo Vecchio in Florence, published it in *Master Drawings*. In her detailed study of the drawing, Miss Stampfle identified it as the artist's full preparatory scheme for the ceiling of the Sala di Lorenzo il Magnifico, one of six rooms constituting the apartments of Leo X on the first floor of the Palazzo Vecchio, with which Vasari was involved between 1556 and 1562. Each room depicts the achievements of a member of the Medici family, to which Pope Leo X himself belonged. While a number of the preparatory drawings for the project were known before, the majority of which are in the Louvre and the Uffizi with a few sheets in Stockholm, Budapest, Ottawa, and Chatsworth, the present sheet had not previously been recorded.

It is appropriate that Vasari, the artist-historian who furnished the earliest accounts of the lives of many of the Renaissance draughtsmen included in this volume, should himself be represented by a complex allegorical design such as this elegant pen-and-wash drawing. Cosimo Bartoli, the teacher of the fourth son of Duke Cosimo I de' Medici, planned the intricate program which Vasari executed in his overall design, which was then transferred to the ceiling with relatively few changes.

At the center Lorenzo is shown receiving rare gifts from—among others—the ambassadors of

the King of Naples who sent horses, and the Sultan who, it is recorded, bestowed camels and giraffes upon the prince in 1487. The central design is studied again, perhaps by a studio hand, in a sheet in the Uffizi (repr. Gabinetto Disegni e Stampe degli Uffizi, Florence, *Mostra di disegni dei fondatori dell'Accademia delle Arti del Disegno*, XV, 1963, fig. 25). The four adjacent hemicycles show Lorenzo the scholar and humanist, Lorenzo the warrior, and Lorenzo the diplomat who is twice depicted in the hemicycles at the top and bottom. A drawing at Chatsworth (repr. Stampfle, 1968, fig. 4) repeats the composition of Lorenzo the diplomat, that in which Lorenzo petitions the King of Naples for peace. The program of the ceiling concludes with four sets of paired Virtues filling the triangular spaces formed by the curve of the hemicycles from which append medallions with portraits of Lorenzo's three sons and his brother Giuliano.

Also associated with the Palazzo Vecchio is the Library's drawing *Seated Man* by Vasari (Acc. no. 1965.6) which, however, is connected with his work in the Salone dei Cinquecento which he began in 1563 but did not complete until 1573. The roundel of *The Annunciation* which Fairfax Murray attributed to Bronzino was later identified as Vasari's by Philip Pouncey (repr. *Drawings from New York Collections*, I, 1965, no. 104).

PROVENANCE: E. Guntrip, Tonbridge; George H. Fitch, New York.

BIBLIOGRAPHY: Felice Stampfle, "A Ceiling Design by Vasari," *Master Drawings*, VI, 1968, pp. 266ff., pls. 32, 33; Morgan Library, *Fifteenth Report to the Fellows, 1967 & 1968*, 1969, pp. 94f., Morgan Library, *Review of Acquisitions, 1949–1968*, 1969, p. 174.

EXHIBITIONS: Art Gallery, University of Notre Dame, Notre Dame, Ind., and University Art Gallery, State University of New York at Binghamton, *The Age of Vasari*, 1970, no. D39, repr. on cover and on p. 27 in color; Morgan Library, *Major Acquisitions, 1924–1974*, 1974, p. xv, no. 6, repr.; Morgan Library, *Michelangelo*, 1979, no. IV,18.

Acc. no. 1967.25
Gift of Mr. George H. Fitch

Jacopo Robusti, called Tintoretto (Italian)

VENICE 1518 – 1594 VENICE

25 *Head of the "Emperor Vitellius"*

Charcoal, heightened with white, on gray paper

13 1/16 × 9 13/16 inches (332 × 250 mm.)
Watermark: none visible through lining

Not only the large number of drawings, nearly twenty, made from the head, but also the artist's specific mention of it in his will, indicate that Tintoretto owned a plaster cast after the head of the so-called Emperor Vitellius. The antique original of the head was included in the group of ancient sculpture which Cardinal Domenico Grimani gave to Venice in 1523. Tintoretto's biographers, including the seventeenth-century artist Carlo Ridolfi, report that the painter liked to draw from casts in his studio at night, experimenting with illumination and different angles of view. The numerous copies of the so-called Vitellius head—not only by the artist, but also by his studio—attest to Tintoretto's interest in the play of light and shade. All the heads have an aspect of three-dimensional reality about them, which is belied only by the blank unfinished eyes. In the Morgan drawing, the artist has drawn the massive head from below, imparting an aura of quasi-nobility to it which is not present in the original, now preserved in the Museo Archeologico, Venice, and he has chosen to bring the head closer to life by adding indications of the iris to the eyes. Here Tintoretto has sketched the head in a coarse black charcoal, most of his bold shading strokes applied to the thick neck, the light apparently hitting the broad countenance directly, as indicated by the concentration of the white chalk highlighting on the face. The traditional identification of the head as Vitellius, which goes back even to Tintoretto's day, is not consistent with modern archaeological studies.

Three other examples of Tintoretto's draughtsmanship are included in the collection (Acc. nos. IV,75, 1959.17, and 1966.14).

PROVENANCE: P. & D. Colnaghi and Co., London.

BIBLIOGRAPHY: Morgan Library, *Tenth Report to the Fellows*, 1960, pp. 50f., repr.; Morgan Library, *Review of Acquisitions, 1949–1968*, 1969, p. 173; Staatliche Graphische Sammlung, Munich, *Italienische Zeichnungen des 16. Jahrhunderts aus eigenem Besitz*, 1977, note 6 under no. 92.

EXHIBITIONS: *Drawings from New York Collections*, I, 1965, no. 114, repr.; Stockholm, *Morgan Library gästar Nationalmuseum*, 1970, no. 37; Morgan Library, *Major Acquisitions, 1924–1974*, 1974, p. xvi, no. 7, repr.

Acc. no. 1959.17
Purchased as the gift of Mr. and Mrs. Carl Stern

Paolo Caliari,
called Paolo Veronese (Italian)
VERONA C. 1528 – 1588 VENICE

26 *Studies for a Finding of Moses*

Pen and brown ink, brown wash
$6^3/_4 \times 7^5/_{16}$ inches (171 × 186 mm.)
Watermark: none visible through lining

It has often been remarked that Veronese's most interesting drawings are less painterly than might be expected of this master, whose harmoniously balanced compositions were emulated by generations of Venetian artists. The Morgan sheet of figure studies has long been associated with *The Finding of Moses*, now in the Prado (repr. Pignatti, fig. 560), which the artist painted around 1570. Here—in a kind of elegant shorthand—Veronese sketched some of his ideas for the placement of the figures of Pharaoh's daughter, her attendants, and the infant Moses, at the moment of discovery. The apparent haste with which these figures were sketched, chiefly in pen accented occasionally with brush, may indicate the speed at which the artist's imagination conceived the subject. While the group at the left of the drawing—especially Pharaoh's daughter, standing hands on hips looking down at Moses—most closely approximates Veronese's arrangement of these figures in the painting, there is also some correspondence between the sketchy architectural elements and bridge at the top of the sheet and the city depicted at the left of the Prado composition.

The drawing entered the collection with another sheet of studies by the artist (repr. Fairfax Murray, I, no. 90). The collectors' marks on the two drawings indicate that they were both once in the Reynolds and Aylesford collections.

PROVENANCE: Thomas Hudson (Lugt 2432); Sir Joshua Reynolds (Lugt 2364); Heneage Finch, fifth Earl of Aylesford (Lugt 58); Charles Fairfax Murray; J. Pierpont Morgan (no mark; see Lugt 1509).

BIBLIOGRAPHY: Fairfax Murray, IV, no. 81, repr. (also reproduced on a smaller scale in I, no. 90); Tancred Borenius, "A Group of Drawings by Paul Veronese," *Burlington Magazine*, XXXVIII, no. 215, 1921, p. 54; Detlev F. von Hadeln, *Venezianische Zeichnungen der Spätrenaissance*, Berlin, 1926, p. 27; Percy H. Osmond, *Paolo Veronese: His Career and Work*, London, 1927, p. 100; Giuseppe Fiocco, *Paolo Veronese*, Bologna, 1928, p. 209; Hans Tietze and E. Tietze-Conrat, *The Drawings of the Venetian Painters in the 15th and 16th Centuries*, New York, 1944, no. 2121, pl. CLXI,3; Lisa Oehler, "Eine Gruppe von Veronese—Zeichnungen in Berlin und Kassel," *Berliner Museen, Berichte aus den ehem. preussischen Kunstsammlungen*, III, 1953, p. 31; *Great Drawings of All Time*, I, 1962, no. 233, repr.; Terisio Pignatti, *Veronese*, Venice, 1976, p. 146 under no. 240, fig. 561; National Gallery, London, *Venetian Seventeenth Century Painting*, exhibition catalogue by Homan Potterton, 1979, under no. 37.

EXHIBITIONS: New York Public Library, *Morgan Drawings*, 1919; Toledo Museum of Art, Toledo, *Four Centuries of Venetian Painting*, 1940, no. 97; Worcester Art Museum, Worcester, Mass., *Fiftieth Anniversary Exhibition*, 1948, no. 38; Art Gallery of Toronto, Toronto, *Titian, Tintoretto, Paolo Veronese*, 1960, no. 48, repr.; Hartford, *Pierpont Morgan Treasures*, 1960, no. 70; *Drawings from New York Collections*, I, 1965, no. 126, repr.

Acc. no. IV,81

Federico Zuccaro (Italian)
S. ANGELO IN VADO 1540/1541 – 1609 ANCONA

27 *The Emperor Frederick Barbarossa Kneeling before Pope Alexander III in Front of S. Marco in Venice*

Pen and brown ink, brown wash, over black chalk
$10^3/_8 \times 8^7/_{16}$ inches (263 × 213 mm.)
Watermark: none

This drawing is an early design for a panel in the Sala del Gran Consiglio in the Doges' Palace, Venice, that had been damaged by fire in 1577. Originally painted by Tintoretto in 1553 and 1562, the panel depicted the coronation and excommunication of Barbarossa. Federico received the commission in 1582 during his banishment from Rome (1581–1583) by Pope Gregory XIII—a sentence resulting from a lawsuit brought against the artist for his satirical allegory, the *Porta Virtutis* (*The Gate of Virtue*). Zuccaro's finished work, completed in 1603 on another visit, shows the scene of Barbarossa and Pope Alexander III in reverse and viewed from a different direction than in the Morgan sheet, with the lagoon and the Isola di S. Giorgio in the background instead of the Torre del Orologio. According to J. A. Gere, Federico's compositional solution was a "deliberate attempt to emulate the lost painting by Tintoretto which had

been in the same room" and which he had undoubtedly seen during his first sojourn in Venice (1563–1565). There is, in fact, another drawing by Federico still in the possession of Mr. Scholz that is rendered in black and red chalks and was thought by E. Tietze-Conrat to copy Tintoretto's painting of the *Coronation* (Gere, 1970, p. 131, no. 20). In the Morgan drawing, the architecture surrounding the scene is rendered with a rich and decorative use of line and wash that conveys the pomp and majesty of the subject in a manner that is rarely seen in Zuccaro's work. More often than not, his style is characterized as dry and restrained, conforming to the acceptable formula of the Counter Reformation in Rome during the second half of the sixteenth century.

There are only two other known studies to survive from this project, both executed later and in reverse of the Morgan sheet, the earliest of all three. The first is a studio(?) copy preserved at Christ Church, Oxford, corresponding closely to the final version; the other, owned by a private collector in London, is in the hand of the artist and varies slightly from the Oxford composition by excluding the decorative pillar in the foreground.

The Morgan drawing is one of a group of Zuccaro drawings that the Library has acquired from the Janos Scholz Collection; four of the eight sheets are in the hand of the more talented brother, Taddeo. Those by Federico include *The Canonization of St. Hyacinth by Pope Clement VIII*, which is a preparatory drawing for a fresco in a chapel of S. Sabina, Rome, dated about 1600 (Acc. no. 1973. 30); a sheet of chalk studies of two young boys (Acc. no. 1974.24); and one of three surviving drawings for the large painted cartoon, the *Porta Virtutis* (Acc. no. 1974.25; Morgan Library, *Seventeenth Report to the Fellows, 1972–74*, 1976, pp. 185–188). Both artists are represented in the Library's original holdings from the Fairfax Murray collection, to which two more drawings by Federico were added in the 1960's: *Portrait of a Young Man* (Acc. no. 1965.7), formerly in the Hermitage collection at Leningrad, and *Allegory of Sin* (Acc. no. 1968.5).

PROVENANCE: Sir Thomas Lawrence (Lugt 2445); Samuel Woodburn (no mark; see Lugt 2584); Lawrence-Woodburn sale, London, Christie's, 4–8 June 1860, part of lot 1074; Sir

Thomas Phillipps, Cheltenham, England (no mark; see Lugt S. 924b); his daughter, Mrs. Katherine Fenwick; her son, T. Fitzroy Phillipps Fenwick; A. S. W. Rosenbach, New York; Janos Scholz, New York (no mark; see Lugt S. 2933b).
BIBLIOGRAPHY: J. A. Gere, "The Lawrence-Phillipps-Rosenbach 'Zuccaro Album'," *Master Drawings*, VIII, 1970, p. 132, no. 21, pl. 14; National Gallery of Art, Washington, D.C., and elsewhere, *Venetian Drawings from American Collections* (exhibition circulated by the International Exhibitions Foundation), 1974–1975, under no. 31; Morgan Library, *Seventeenth Report to the Fellows, 1972–1974*, 1976, pp. 185–186, pl. 15; Janos Scholz, *Italian Master Drawings 1350–1800 from the Janos Scholz Collection*, New York, 1976, no. 65, repr.
EXHIBITIONS: National Gallery of Art, Washington, D.C., and The Pierpont Morgan Library, New York, *Sixteenth Century Italian Drawings from the Collection of Janos Scholz*, catalogue by Konrad Oberhuber and Dean Walker, 1973–1974, no. 11, repr. (includes previous exhibition history); Los Angeles, *Old Master Drawings*, 1976, no. 114, repr.; Dallas Museum of Fine Arts, Dallas, and Museum of Fine Arts, Houston, *Drawings from the Janos Scholz Collection*, 1977–1978, no. 65, repr.
Acc. no. 1973.29
The Janos Scholz Collection. Gift of Mr. Scholz

Antoine Caron (French)
BEAUVAIS C. 1527 – 1599 PARIS

28 *The Water Festival at Bayonne, 24 June 1565*

Black chalk, pen and brown ink, and some black ink, gray-brown wash, heightened with white
13¹¹⁄₁₆×19³⁄₈ inches (348×492 mm.)
Watermark: none visible through lining

A suite of six drawings by Antoine Caron recording some of the major Valois court festivals between 1562 and 1573 came to light in the 1950's when five of the six drawings, including the present sheet, appeared on the London art market. While the Library acquired *The Water Festival at Bayonne*, two drawings, *Running at the Quintain* and *The Tournament at Bayonne between the Knights of Great Britain and Ireland*, were purchased for the Courtauld Institute; the American collector Winslow Ames bought *The Festival for the Polish Ambassadors*—a drawing which he subsequently presented to the Fogg Art Museum, Harvard University—and the fifth in the series, *A Hunting Scene at the Chateau d'Anet*, was purchased for the Louvre. The sixth drawing, *The Water Festival at Fontainebleau*, had been previously recorded in the

collection of the National Gallery of Scotland at Edinburgh (the six drawings repr. Yates, 1959, pls. IX–XI). All six drawings depict the sort of well-documented political "magnificences" well-loved by the refined and superficially-minded Valois court, as directed by Catherine de' Medici, and all were used as the models for the famous set of Valois tapestries now in the Uffizi, Florence. (One of Catherine de' Medici's granddaughters, Christine de Lorraine, married the Grand Duke of Tuscany in 1589, about six or seven years after the tapestries were woven, and they most probably went to Italy at this time.) There are, however, eight tapestries (repr. Yates, 1959, pls. I–VIII), suggesting that there might be two more Caron drawings in the series. While Caron's designs served as the inspiration for the tapestries, the textile artist transformed them into large-scale and more detailed accounts of these elaborate ceremonial occasions.

The early training of Caron at Beauvais was as a cartoon designer for stained glass. Around 1540, he went to Fontainebleau where, under the influence of Primaticcio and, above all, Nicolò dell'Abate, he acquired his basically Italianate style. He became painter to Catherine de' Medici—her favorite, it is said—making something of a specialty of painting and planning royal festivals. The taste for water spectacles is reflected in two of Caron's drawings, including the Morgan sheet. The water festival at Fontainebleau was not as elaborate as that enacted at Bayonne a year later, which was designed to underscore what was intended to be an historic meeting of the French and Spanish courts.

France had just signed the Treaty of Amboise concluding the first of the religious wars between Protestants and Catholics. In a misguided effort to stress peace and plenty in the realm rather than discord and depletion, Catherine de' Medici embarked in 1564 with her son Charles IX on a *grand voyage du court* accented with elaborate fêtes, culminating in the entertainments at Bayonne. Where Catherine de' Medici's policy towards the Protestants was moderate—she had offered them an Edict of Toleration—that of her powerful son-in-law, Philip II of Spain, was not in the least conciliatory. Philip himself did not go to Bay-

onne. Instead he sent his wife and the Duke of Alva with specific directions to offer the French court an alliance only to stamp out heresy. This frustration of the political goals, however, does not seem to have diminished the splendor of the Bayonne festivities according to the contemporary accounts.

At the end of several days of festivities the water spectacle was presented as the *pièce d'occasion*. The Library's drawing summarizes what the accounts tell us: the notables of both courts present boarded a magnificent boat in the shape of a castle and sailed through various canals witnessing spectacles along the way to an island in the river. The first tableau was a mock whale hunt which lasted half an hour; then the spectators saw six tritons, dressed in cloth of gold, playing trumpets on the back of a huge sea turtle. Next came Neptune in a great chariot pulled by sea horses, followed by Arion on a dolphin's back and three sirens who sang songs celebrating Charles IX's meeting with his sister, the Queen of Spain. After this they landed on the island where shepherds and shepherdesses served a banquet which was followed by a ballet danced by nine nymphs accompanied by six violins; then the royal party returned as they had come.

PROVENANCE: P. & D. Colnaghi and Co., London.

BIBLIOGRAPHY: Jean Ehrmann, "Caron et les tapisseries des Valois," *Revue des arts*, VI, 1956, p. 10; Ehrmann, "Les Tapisseries des Valois du Musée des Offices à Florence," *Les Fêtes de la Renaissance*, ed. J. Jacquot, I, Paris, 1956, p. 98, fig. 2; Ehrmann, "Dessins d'Antoine Caron pour les tapisseries des Valois du Musée des Offices à Florence," *Bulletin de la Société de l'Histoire de l'Art français*, Nov. 1956, pp. 118f.; Morgan Library, *Seventh Report to the Fellows*, New York, 1957, pp. 65ff., repr.; Ehrmann, "Drawings by Antoine Caron for the Valois Tapestries in the Uffizi, Florence," *The Art Quarterly*, XXI, 1958, pp. 54, 57, fig. 7; Frances Yates, *The Valois Tapestries*, London, 1959, fig. Xa; Morgan Library, *Review of Acquisitions, 1949–1968*, 1969, p. 136; Roy Strong, *Splendor at Court*, Boston, 1973, pp. 134ff., fig. 104; Victor E. Graham and W. McAllister Johnson, *The Royal Tour of France by Charles IX and Catherine de' Medici: Festivals and Entries, 1564–6*, Toronto, 1979, pp. 58ff., fig. 24.

EXHIBITIONS: Museum Boymans-van Beuningen, Rotterdam, and elsewhere, *French Drawings from American Collections*, 1959, no. 1, repr.; Morgan Library, *Major Acquisitions, 1924–74*, 1974, p. xx, no. 23, repr.; Bell Gallery, Brown University, Providence, *Festivities: Ceremonies and Celebrations in Western Europe, 1500–1790*, 1979, no. 31, repr.

Acc. no. 1955.7
Purchased as the gift of the Fellows

Maître de Flore (French)
WORKING AT FONTAINEBLEAU, SECOND
HALF OF THE SIXTEENTH CENTURY

29 *Procris and Cephalus*

Brush and brown wash, some pen and brown ink, heightened
with white, over preliminary indications in black chalk
$8\frac{5}{8} \times 12\frac{1}{8}$ inches (219×308 mm.)
Watermark: none visible through lining

Procris and Cephalus is one of the best-known and
widely published drawings of the School of Fon-
tainebleau. It exemplifies the preference for myth-
ological subjects and Mannerist stylistic devices;
at the same time it transcends the purely decora-
tive, conveying an aura of mystery and ethereal
charm which is at the heart of the most evocative
examples of the art of this school.

First catalogued in 1923 as Primaticcio by Lili
Fröhlich-Bum, the drawing was later assigned by
Charles Sterling to the small *oeuvre* of an anony-
mous master known as the Maître de Flore because
of the subject matter of two of the paintings which
have been ascribed to him. One, *Flora and Zephyr*,
its present location unknown, was formerly in the
Albenas collection in Montpellier; the other com-
position, *The Triumph of Flora*, is in a private col-
lection in Italy (repr. *L'École de Fontainebleau*, 1973,
no. 130). The same hand has also been identified
in *The Birth of Cupid* at the Metropolitan Museum
(repr. Charles Sterling, *The Metropolitan Museum
of Art: A Catalogue of French Paintings, XV–XVIII
Centuries*, Cambridge, Mass., 1955, p. 49). The
pose and type of the Venus in this painting closely
resemble the reclining Procris of the Morgan
drawing. One other painting by the master, a
copy of *The Concert* from the ballroom at Fon-
tainebleau, is preserved at the Louvre. Drawings
are so rare that only one other work, an *Annun-
ciation* in the Albertina, is known in addition to
the *Procris and Cephalus*. Here, the artist has chosen
to illustrate Ovid's tale of the young couple whose
marriage ended in the tragic death of Procris (*Met-
amorphoses*, 7: 795–866). She was unintentionally
killed by her husband, Cephalus, who, upon hear-
ing a noise in the forest, cast the magic spear which
never missed its mark. In the drawing the elon-
gated, gracefully disposed figure of Procris re-

moves the fatal spear from her breast with an
exaggerated gesture of her finely tapering fingers;
Cephalus is depicted in the background, his hunt-
ing dog at his side, still armed with a bow and
quiver, his pose suggesting that he has just hurled
the spear which, ironically, Procris had given to
him.

Whether the drawing was made in preparation
for a tapestry or a painting is not known. The
figure of Procris has a sculptural solidity in con-
trast to the more painterly background of the
forest and shrubbery against which the scene is
laid, suggesting that the work may have been in-
cluded in a mixed stucco and painted decoration
of the sort much practiced at Fontainebleau.

PROVENANCE: Comte de Southesk (according to 1973 Fon-
tainebleau exhibition catalogue); Henry Reitlinger (no mark;
see Lugt S. 2274a); his sale, London, Sotheby's, 14 April 1954,
lot 307; Mr. and Mrs. Germain Seligman, New York.

BIBLIOGRAPHY: Lili Fröhlich-Bum, "Ein unbekanntes Bild
von Primaticcio," *Belvedere*, III, 1923, p. 207, repr.; Agnes
Mongan, "De Clouet à Matisse: Les Americans, Collection-
neurs de dessins français," *Le Jardin des arts*, LI, 1959, repr.
p. 185; Sylvie Béguin, *L'École de Fontainebleau*, Paris, 1960,
p. 73, p. 141, note 60; Béguin, "Le Maître de Flore de l'École
de Fontainebleau," *Arts de France*, I, 1961, pp. 301f.; Béguin,
"La Charité," *L'Oeil*, CX–CXI, 1972, pp. 12ff., 80f., repr.;
Béguin, "L'École de Fontainebleau," *La Revue du Louvre*,
XXII, no. 405, 1972, p. 402, repr.

EXHIBITIONS: Museum Boymans–van Beuningen, Rotter-
dam, and elsewhere, *French Drawings from American Collections*,
1959, no. 11, pl. 8; Grand Palais, Paris, and National Gallery
of Canada, Ottawa, *L'École de Fontainebleau*, 1972–1973, no.
132, repr.

Acc. no. 1978.34
Purchased as the gift of the Fellows with the special assistance
of Miss Alice Tully, Miss Julia Wightman, and the Thorne
Foundation

Hieronymus Bosch, attributed to (Dutch)
'S HERTOGENBOSCH C. 1450 –
1516 'S HERTOGENBOSCH

30 *Group of Ten Spectators*

Pen and brown ink
$4\frac{7}{8} \times 4\frac{15}{16}$ inches (124×126 mm.)
Watermark: none visible through lining

Charles de Tolnay, in his 1937 monograph on
Bosch, listed the Morgan sheet among the seven-

teen which in his opinion constituted all the known drawings by the artist. He followed Friedländer's suggestion that it was an early work of the period when Bosch painted the *Ecce Homo* preserved in the Städelsches Kunstinstitut at Frankfurt-am-Main, a painting now believed to be a copy. Baldass proposed that the drawing, whether a preparatory sketch or copy after a painting, might provide a clue to the reconstruction of a Crucifixion scene in a lost triptych, also an early work. This idea was later abandoned in favor of Fraenger's supposition that the drawing was a study of a group of heretics in a lost painting described by Carel van Mander, which depicted the dispute between the monks and heretics. Combe, Gibson, Swarzenski, and the authors of the 1967 exhibition catalogue all agree that the drawing is an original work by the master, the ten figures variously identified as Pharisees, Jews, executioners, or spectators at a Crucifixion.

The more recent opinions regarding this sheet, summarized in the Bruegel catalogue of 1975, question it as a work in Bosch's own hand. As Reuterswärd observed, there is a certain awkwardness in the rendering of the hands; the figure in the foreground seems to have only one leg, and those of the figure behind him function poorly. Nevertheless, the gothic character of the master's work and the functional purpose of his brittle lines are reflected strongly in the Morgan drawing.

PROVENANCE: Jan van Rijmsdijk (Lugt 2167); Tighe (according to Fairfax Murray); Charles Fairfax Murray; J. Pierpont Morgan (no mark; see Lugt 1509).

BIBLIOGRAPHY: Fairfax Murray, I, no. 112, repr.; Walter Cohen, "Hieronymus Bosch," in Thieme-Becker, IV, p. 390; Ludwig Baldass, "Betrachtungen zum Werke des Hieronymus Bosch," *Jahrbuch der kunsthistorischen Sammlungen in Wien*, I, 1926, pp. 109, 111; Max J. Friedländer, *Die altniederländische Malerei*, V, Berlin, 1927, p. 126 (1969, English ed., pp. 68–69); M. D. Henkel, *Le Dessin hollandais*, Paris, 1931, p. 9; Ludwig Baldass, "Die Zeichnungen im Schaffen des Hieronymus Bosch unter der Frühholländer," *Die graphischen Künste*, II, 1937, p. 24, fig. 7; Charles de Tolnay, *Hieronymus Bosch*, Basel, 1937, p. 109, no. 1, pl. 99 (right); Jacques Combe, *Jheronimus Bosch*, Paris, 1946, p. 46, repr.; W. Fraenger, *Die Hochzeit zu Kana: Ein Dokument semitischer Gnosis bei Hieronymus Bosch*, Berlin, 1950, pp. 62–67; Hanns Swarzenski, "An Unknown Bosch," *Bulletin of the* [Boston] *Museum of Fine Arts*, LIII, February 1955, p. 5, fig. 4; Charles de Tolnay, *Hieronymus Bosch*, Baden-Baden, 1965, I, pl. 317, no. 1, II, p. 387, no. 1; G. Lemmens and E. Taverne, "Hieronymous Bosch naar aanleiding van de expositie in 's Hertogenbosch,"
Simiolus, II, no. 2, 1967–1968, p. 84, note 24, fig. 14; Patrik Reuterswärd, *Hieronymus Bosch*, Stockholm, 1970, p. 192, fig. 2; Walter S. Gibson, *Hieronymus Bosch*, New York-Washington, 1973, p. 26, fig. 12; Rosemarie Schuder, *Hieronymus Bosch*, Berlin, 1975, p. 183, pl. 109.

EXHIBITIONS: New York Public Library, *Morgan Drawings*, 1919; Morgan Library, *New York World's Fair*, 1939, no. 81; Hartford, *Pierpont Morgan Treasures*, 1960, no. 66, pl. III; Noordbrabants Museum, 's Hertogenbosch, the Netherlands, *Jheronimus Bosch*, 1967, no. 55, repr.; Berlin, *Bruegel*, 1975, no. 9, repr.; Los Angeles, *Old Master Drawings*, 1976, no. 208, repr.

Acc. no. I,112

Pieter Bruegel the Elder (Flemish)

BREUGHEL NEAR BREDA(?) C. 1525 – 1569 BRUSSELS(?)

31 *Mountain Landscape with a River, Village, and Castle*

Pen and brown ink, brown wash
14⅟₁₆×17½ inches (357×444 mm.)
Watermark: faintly discernible fleur-de-lis surmounted by crown
Inscribed in brown ink at lower right, partially effaced, *P. BREUG. . .L*

This magnificent rendering of a mountain panorama was virtually unknown until 1952 when it was acquired at a London auction. The drawing had previously been in the possession of the descendants of the Reverend Thomas Carwardine of Earl's Colne Priory, Essex, an eighteenth-century clergyman who may have bought it while travelling through France with the artist George Romney. It is the largest of Bruegel's pen-and-ink drawings of landscapes that were inspired by his journey through the Alps on the way back from Italy via the Lago Maggiore and the Tyrol (1553–1554). The late Otto Benesch was of the opinion that the village at the lower left could be identified as Ruis and the castle as Jörgensberg, situated on the upper Rhine east of Waltensburg, between Truns and Ilanz in the Swiss canton of Graubünden or Grisons. The fact that this composition was created in the artist's studio, and combined different views and motives from sketches made after nature—for example, the *View of Waltersspurg* in the Bowdoin College Museum of Art, Brunswick,

Maine—accounts for the hesitation among the various Bruegel authorities to agree on the exact location. The date of execution has likewise been variously proposed, as 1553–1554 when the artist returned to Antwerp, and 1555–1560 when the celebrated series of large landscapes was etched for his publisher Hieronymus Cock.

The majestic view is in his characteristic style of delicate sobriety. By varying the shade of ink and length of the pen strokes, Bruegel created a panorama that appears almost to have been woven out of a single fabric. The aerial perspective of earlier landscape painters, like Patinir, has been discarded in favor of a view taken from the side of a slope, at the same height as the castle, from which one looks down into the river valley and up into the endless rolling mountains against the sky. A few tiny figures dot the river boats, added to stress the overwhelming scale of Nature and its seeming indifference to the inhabitants who dwell there.

PROVENANCE: Rev. Thomas Carwardine and descendants, including Colonel Oliver Probert; his sale, London, Christie's, 16 May 1952, lot 41.

BIBLIOGRAPHY: Morgan Library, *Third Report to the Fellows*, 1952, pp. 64–67, repr.; Otto Benesch, review of Charles de Tolnay, *Die Zeichnungen Pieter Bruegels*, in *Kunstchronik*, VI, 1953, p. 79; Fritz Grossmann, "The Drawings of Pieter Bruegel the Elder in the Museum Boymans and Some Problems of Attribution," *Bulletin Museum Boymans Rotterdam*, V, no. 2, 1954, p. 41, note 4, and p. 54, note 43; Grossmann, "The Drawings of Pieter Bruegel the Elder in the Museum Boymans: Postscript, Notes on the Landscape Drawings of Bruegel," *Bulletin Museum Boymans Rotterdam*, V, no. 3, 1954, p. 76, under note 3, repr., and p. 84; Grossmann, "New Light on Bruegel, I: Documents and Additions to the Oeuvre; Problems of Form," *Burlington Magazine*, CI, no. 678/79, 1959, p. 345; Grossmann, "Bruegel," *Encyclopedia of World Art*, II, London, 1960, p. 634; Charles de Tolnay, "Remarques sur quelques dessins de Bruegel l'ancien et sur un dessin de Bosch récemment réapparus," *Bulletin Musées Royaux des Beaux-Arts, Bruxelles*, IX, nos. 1–2, 1960, pp. 13–16, fig. 9; Ludwig Münz, *Pieter Bruegel: The Drawings*, London, 1961, no. 21, pl. 18; *Great Drawings of All Time*, II, 1962, no. 499, repr.; Colin Eisler, *Flemish and Dutch Drawings*, New York, 1963, p. 18, pl. 27; H. G. Franz, *Niederländische Landschaftsmalerei im Zeitalter des Manierismus*, Graz, 1969, fig. 199; Morgan Library, *Review of Acquisitions, 1949–1968*, 1969, p. 135, pl. 36; Wolfgang Stechow, *Pieter Bruegel the Elder*, New York, 1969, pp. 34–35, fig. 28; Time-Life Books, ed., *Seven Centuries of Art: Survey and Index*, New York, [1970], p. 66, repr.; Curtis O. Baer, *Landscape Drawings*, New York, 1974, no. 34, repr.; Daniel M. Mendelowitz, *A Guide to Drawing*, New York, 1976, p. 241, fig. 335.

EXHIBITIONS: The Pierpont Morgan Library, New York,

Landscape Drawings & Watercolors: Bruegel to Cezanne, 1953, catalogue by Felice Stampfle, pp. 3, 7, no. 48, pl. I; Morgan Library, and elsewhere, *Fiftieth Anniversary*, 1957, no. 87, pl. 54; Morgan Library, *Major Acquisitions, 1924–1974*, 1974, p. xxiv, no. 36, repr.; Berlin, *Bruegel*, 1975, no. 57, fig. 88.

Acc. no. 1952.25
Purchased with the assistance of the Fellows

Albrecht Dürer (German)
NUREMBERG 1471 – 1528 NUREMBERG

32 *Adam and Eve*

Pen and brown ink, brown wash, corrections in white; the two figures, now partially silhouetted, were executed on separate sheets of paper which were then cut by Dürer and joined together by a third strip of paper that had been trimmed from the original Adam sheet; he added a dark brown wash to the background, as he had done earlier in the individual drawings
9⁹⁄₁₆×7⅞ inches (243×200 mm.)
Watermark: none
Signed at lower left with monogram, and dated *1504*.
Inscribed in pencil on verso, at lower right, *Amt. Gsell / N°586*; and in lower left and right corners, *119*

Despite the modest size of the Morgan Library's collection of German drawings, its nucleus of eight sheets by Albrecht Dürer is the largest single group of drawings by the artist in this country. They represent Dürer as engraver and theorist, painter and portraitist, designer of murals and metalwork, and they range in date from 1504 to 1521—his most productive years. Of the eight studies, only two came from the Fairfax Murray collection and both the *Design for the Pommel Plate of a Saddle* and *Design for Mural Decoration* have been included here (Nos. 34 and 35). Another four were acquired from the Baron von Lanna sale in 1910 by Junius S. Morgan for his uncle, J. Pierpont Morgan: *Adam and Eve* (No. 32), *Kneeling Donor* (No. 33), *Abduction on Horseback*, and *Constructed Head of a Man in Profile*. The seventh, the *Portrait of Endres Dürer*, was the gift (one-half undivided interest) of Mrs. Alexander Perry Morgan and her children in honor of her late husband who was the son of Junius. The eighth sheet, a design for the corner ornament of a book cover, was given to the Library as recently as 1976 by a donor who has been consistently generous to the Library for many years.

The earliest drawing in the group is one of the preparatory studies for the 1504 engraving the *Fall of Man* (Bartsch, 1). The celebrated print evolved from a long, systematic study in which the artist attempted to discover the "secret" formula underlying the ideal proportions of the human form. Dürer embarked on this project in 1500 when Jacopo de' Barbari, the North Italian artist who became court painter to Emperor Maximilian the Great, showed Dürer his "constructed" drawings of an ideal man and woman without revealing his method. With compass and ruler, Dürer consulted Vitruvius and made copies after the Apollo Belvedere and Medici Venus before arriving at his own version of human perfection. The controversial series of drawings known as the "Apollo group" scattered among the major museums in London, Vienna, Berlin, Dresden, and New York (Metropolitan Museum, *Poynter Apollo*) to which the present drawing also belongs, documents Dürer's methodical "constructions" of the male figure after the classical prototype. It was the artist's first intention to depict the man and woman separately, however, the final idea of representing the two figures together as Adam and Eve before the Fall made the nude more palatable to the retardataire taste of the North. Even more innovative for a Northern artist of the time was the pair of oil panels executed in 1507, now preserved at the Prado in Madrid, in which Dürer repeated the theme on a monumental scale.

The Morgan sheet represents the culmination of Dürer's long labors in perfecting the individual figures which he first silhouetted against a dark background, then cut and pasted together, adding another layer of dark wash to bring out the contours of the united pair. The final step of combining the figures with primeval forest and animals symbolizing the Four Temperaments of Man in the engraving does not survive as a drawing, even though the artist's meticulous methods presuppose the execution of such a drawing.

Contact with Leonardo's theories during his second sojourn in Italy (1505–1507) contributed to Dürer's subsequent change of attitude towards absolute beauty. His later years were devoted to collecting empirical data on individual figure types and five of these were selected to represent a mul-

tiple standard of beauty. These studies were incorporated in his important treatise, *Vier Bücher von menschlicher Proportion*, that was published just after Dürer's death in 1528 specifically for the guidance of aspiring German artists. The Library's double-sided sheet depicting the constructed head of a man in profile, dating about 1512, belongs to this series.

Before they came into the possession of Baron von Lanna, this and the following drawing (No. 33) at one time belonged to General Andréossy, Napoleon's military governor of Vienna in 1809, who, like Baron Dominique Vivant Denon, Napoleon's Directeur Général des Musées Impériaux, is known to have removed many treasures from the Imperial Library. The two Morgan drawings may well have been part of this booty. The *Adam and Eve* has been traced back further to Willibald Imhoff, member of the important merchant and banking family in Nuremberg, comparable in stature to the Fuggers in Augsburg. As the grandson and namesake of Willibald Pirckheimer, Dürer's oldest and closest friend, Willibald Imhoff inherited the contents of Dürer's studio which originally had been left to the artist's widow. Following the death of Agnes Dürer, the contents went to Dürer's brother Endres, who in turn sold them to Pirckheimer. Many drawings in the possession of the Imhoff family were purchased by Emperor Rudolph II for his renowned *Kunstkammer*. In 1783 this collection was transferred to the Imperial Library, and is now in the Albertina. One would like to think that the Morgan study for the engraving the *Fall of Man* was a favorite drawing of the artist since it was one with which Dürer never parted.

PROVENANCE: Agnes Dürer, the artist's wife; Endres Dürer, the artist's brother; Willibald Pirckheimer; Willibald Imhoff; Emperor Rudolph II, Prague; Imperial Library, Vienna; Count Antoine-François Andréossy; probably his sale, Paris, Hôtel Drouot, 13–16 April 1864, p. 16, lot 62, "Très-beau dessin exécuté à la plume, sur papier teinté de sépia, signé et daté 1504" (2500 fr. to Posonyi); F. J. Gsell (Lugt 1108); Baron Adalbert von Lanna, Prague (Lugt 2773); his sale, Stuttgart, Gutekunst, 6–11 May 1910, Part II, lot 211, pl. XV (to Pierpont Morgan for 65,000 DM); J. Pierpont Morgan (no mark; see Lugt 1509).

SELECTED BIBLIOGRAPHY: Joseph Heller, *Das Leben und die Werke Albrecht Dürers*, Bamberg, 1827, p. 84, no. 92; Charles Ephrussi, *Albert Dürer et ses dessins*, Paris, 1882, pp. 70–72, 364; Lippmann, 1883–1929, II, no. 173, repr.; Ludwig

Justi, *Konstruierte Figuren und Köpfe unter den Werken Albrecht Dürers*, Leipzig, 1902, pp. 5, 9–10, 14, repr.; Heinrich Wölfflin, *Albrecht Dürer, Handzeichnungen*, Munich, 1914 (and later editions), no. 20, repr.; Joseph Meder, *Die Handzeichnungen: Ihre Technik und Entwicklung*, Vienna, 1923, pp. 353–354, repr.; Flechsig, 1928–1931, II, p. 324; Tietze and Tietze-Conrat, 1928–1938, I, no. 257, repr., mentioned under no. 258, II, mentioned under no. 257a; Winkler, 1936–1939, II, no. 333, repr.; Panofsky, 1943, I, p. 262, II, no. 458; Tietze, 1947, no. 30, repr.; Mongan *et al.*, 1949, p. 36, repr.; Christopher White, *Dürer: The Artist and His Drawings*, New York, 1971, no. 35, repr.; Strauss, 1974, II, no. 1504/17, repr.; Joseph Meder, *The Mastery of Drawing*, translated and revised by Winslow Ames, New York, 1978, I, p. 125, II, p. 58, repr.

EXHIBITIONS: New York Public Library, *Morgan Drawings*, 1919; Albright Art Gallery, *Master Drawings*, 1935, no. 22, repr.; Morgan Library, *New York World's Fair*, 1939, no. 83, repr.; M. Knoedler and Co., New York, *Classics of the Nude*, 1939, no. 2, repr.; Fogg Art Museum, *Seventy Master Drawings*, 1948–1949, no. 16; Philadelphia, *Masterpieces*, 1950, no. 28, repr.; Morgan Library, *Dürer*, 1955, pp. 6, 10; Morgan Library, and elsewhere, *Fiftieth Anniversary*, 1957, no. 83, repr.; National Gallery of Art, Washington, D.C., *Dürer in America*, 1971, no. XII, repr., mentioned under nos. VII, VIII; Germanisches Nationalmuseum, Nuremberg, *Albrecht Dürer, 1471–1971*, 1971, no. 483.

Acc. no. I,257d

33 *Kneeling Donor*

Brush and black ink, heightened with white on blue paper
12¹¹⁄₁₆ × 7¹³⁄₁₆ inches (323 × 198 mm.)
Watermark: none
Signed with monogram at lower left center, and dated *1506*

On his second visit to Venice (1505–1507) Dürer was commissioned by the local German merchants to paint an altarpiece for S. Bartolomeo, their national church. The painting, executed between February and September 1506, depicts the brotherhood of Christianity, that is, clergy and laymen alike, receiving garlands of red and white roses symbolic of the beads of the rosary—hence the title *Feast of the Garlands* or *Rosenkranzfest*. The Morgan drawing is a preparatory study for one of the principal donors of the painting; he kneels in the right foreground behind Emperor Maximilian who is being crowned by the Virgin. The figure has not yet been identified, although attempts have been made by scholars to connect him with the affluent banking family the Fuggers, who were undoubtedly among those who commissioned the work.

This sheet is one of some thirty surviving drawings from Dürer's two-year sojourn that were executed with the point of brush in tempera on blue Venetian paper called *carta azzura*. The studies, which are of large-scale figures, as well as details of heads, hands, and drapery, represent a temporary departure from the artist's usual choice of medium, style, and subject matter. Under the influence of Venetian painting, greater attention has been given to the play of light and shadow conveyed by the softer point of the brush in contrast to the sharp line of the pen. Details have been subdued to create images of monumental strength that approach painting itself. The Venetian paper, dyed blue in its manufacture, obviously appealed to the Northern artist who until then had used paper which he himself prepared with a tinted ground. Dürer is credited with having introduced the new paper to the North upon his return to Nuremberg. The painting, referred to by Panofsky (p. 113) as the first High Renaissance work produced by Dürer, survives in fragile condition in the State Gallery at Prague.

PROVENANCE: Count Antoine-François Andréossy; Sir Thomas Lawrence (Lugt 2445); Robert Staynor Holford (Lugt 2243); his sale, London, Christie's, 11–14 July 1893, p. 56, lot 630 (to Charles Fairfax Murray for £60); Baron Adalbert von Lanna, Prague (Lugt 2773); his sale, Stuttgart, Gutekunst, 6–11 May 1910, Part II, lot 220, pl. XVII (to Colnaghi for 29,700 DM for Junius Morgan?); J. Pierpont Morgan (no mark; see Lugt 1509).

SELECTED BIBLIOGRAPHY: Charles Ephrussi, *Albert Dürer et ses dessins*, Paris, 1882, p. 116; Lippmann, 1883–1929, IV, no. 428, repr.; Flechsig, 1928–1931, II, p. 350; Tietze and Tietze-Conrat, 1928–1938, II, 1, no. 311, repr.; Winkler, 1936–1939, II, no. 384, repr.; Panofsky, 1943, II, no. 740; Mongan *et al.*, 1949, p. 38, repr.; *Great Drawings of All Time*, II, 1962, no. 345, repr.; Strauss, 1974, II, no. 1506/18, repr.

EXHIBITIONS: Royal Academy of Arts, London, *The Lawrence Gallery: Eighth Exhibition*, May 1836, p. 16, no. 44, "A Priest—on his knees, counting his beads; the drapery admirably drawn: black chalk, heightened with white; on blue paper, with the monogram; dated 1506. Capital;" Burlington Fine Arts Club, London, *Exhibition of Early German Art*, 1906, no. 4; New York Public Library, *Morgan Drawings*, 1919; Albright Art Gallery, *Master Drawings*, 1935, no. 24, repr.; Lyman Allyn Museum, *Drawings*, 1936, no. 40; Morgan Library, *New York World's Fair*, 1939, no. 85; Fogg Art Museum, *Seventy Master Drawings*, 1948–1949, no. 17; Morgan Library, *Dürer*, 1955, pp. 5–6, 10; Morgan Library, and elsewhere, *Fiftieth Anniversary*, 1957, no. 84, repr.; National Gallery of Art, Washington, D.C., *Dürer in America*, 1971, no. XIV, repr.; National Gallery of Art, Washington, D.C., *Paper in Prints*, catalogue by Andrew Robison, 1977, no. 77, p. 28.

Acc. no. I,257c

34 Design for the Pommel Plate of a Saddle

Pen and brown ink
8⅝ × 11⅝₆ inches (220 × 287 mm.)
Watermark: none visible through lining
Artist's monogram and date inscribed in a later hand, in brown ink at upper center, *1517 AD*. Inscribed by J. C. Robinson on verso of old lining, in black ink at lower right corner, *Bought at Sale of Miss James' / Collection of drawings at Christie's June 23 1891 / for 101 guineas against Gutekunst / for the Berlin Museum. / JCRobinson.*

Dürer's occasional designs for silver objects, table fountains, and armor reflect an early familiarity with the art of metal engraving. The artist's childhood years were spent in the workshop of his father, a goldsmith who taught his son the basic skills of his craft. This drawing for the decoration of the pommel of a saddle has long been thought to be connected with a suit of silvered armor ordered by Emperor Maximilian in 1516 from Koloman Colman, an Augsburg armorer. The project was never completed due to the Emperor's sudden death in 1519 and the remains of the armor have since disappeared. On 6 September 1515, Dürer was appointed court painter to Maximilian. His collaboration with other artists on the monumental woodcut prints for Maximilian's *Triumphal Procession* and *Triumphal Arch*, as well as the marginal pen-and-ink decorations for the celebrated *Gebetbuch* (Prayerbook), fall into this brief period (1515–1519). Although no mention of Dürer is made in the documents concerning the armor, the imperial devices depicted in this drawing, a double-headed eagle possibly holding a pomegranate in each claw, undoubtedly refer to the Emperor of the Hapsburg dynasty and help to suggest that Dürer, as court painter, was involved in designing the ornament on the commissioned armor. Four other drawings in pen and brown ink survive from this project: two at the Albertina in Vienna and two in the Kupferstichkabinett at Berlin, executed in what Panofsky calls the "decorative style." A manner which combined Italian Renaissance humanism with Gothic realism, not unique to Dürer, was an appropriate style for these secular court commissions. The five drawings, including designs for the visor of a helmet, standing neck-guard, and part of a scabbard, are

united by the use of the grapevine motif. Rendered here with artful liveliness, the motif, which frequently appeared on Augsburg armor, was cleverly manipulated by Dürer to enhance the metal surface with glittering ornament as well as to connect the various symbols that served to glorify the Emperor.

PROVENANCE: Baron D. Vivant Denon (Lugt 779); possibly his sale, Paris, Pérignon, 1–19 April 1826, p. 162, lot 625, "Trois feuilles d'études; deux d'ornements à la plume sur papier blanc . . ."; Miss James, London (according to inscription on verso); her sale, London, Christie's, 22–23 June 1891, lot 196, "An ornamental design of Grotesque Animals and Figures"; Sir John Charles Robinson (Lugt 1433); Charles Fairfax Murray; J. Pierpont Morgan (no mark; see Lugt 1509).

SELECTED BIBLIOGRAPHY: Lippmann, 1883–1929, IV, no. 406, repr.; Tietze and Tietze-Conrat, 1928–1938, II, 1, no. 685, repr.; Flechsig, 1928–1931, II, no. 109; Winkler, 1936–1939, III, no. 680, repr., mentioned under no. 678; Paul Post, "Zum 'Silbernen Harnische' Kaiser Maximilians I. von Koloman Colman mit Aetzentwürfen Albrecht Dürers," *Zeitschrift für historische Waffen und Kostümkunde*, N.F. VI, 1939, pp. 253–258, repr.; Hermann Warner Williams, Jr., "Dürer's Designs for Maxmilian's Silvered Armor," *Art in America*, XXIX, 1941, pp. 73–76, repr.; Panofsky, 1943, II, no. 1450; Tietze, 1947, no. 31, repr.; Strauss, 1974, III, no. 1517/5, repr.

EXHIBITIONS: Burlington Fine Arts Club, London, *Exhibition of Early German Art*, 1906, no. 9; Walker Art Gallery, Liverpool, *The Art of Albrecht Dürer*, catalogue by Sir William Martin Conway, 1910, no. 684; Kunsthalle, Bremen, *Die Kunst Albrecht Dürers*, catalogue by Gustav Pauli, 1911, no. 868; Morgan Library, *Dürer*, 1955, p. 11; Worcester Art Museum, Worcester, Mass., *The Virtuoso Craftsman: Northern European Design in the 16th Century*, catalogue by John David Farmer, 1969, no. 5, repr.; National Gallery of Art, Washington, D.C., *Dürer in America*, 1971, no. XXIV, repr.

Acc. no. I,256

35 Design for Mural Decoration

Pen and brown ink; watercolors in varying tints of blue, yellow, and pink; silhouetted and mounted on another sheet of paper probably by the artist
10⅟₁₆ × 13¾ inches (255 × 350 mm.)
Watermark: none visible through lining
Signed in pen and brown ink with monogram, and dated *1521* within wreath at lower center

Following Dürer's return from the Netherlands in 1521, the city council of Nuremberg commissioned him to design the murals in the Town Hall. This pen drawing, enhanced by delicate washes of watercolor, is a study for part of the south

wall. Friedländer's suggestion in 1895 that the drawing was a study for the façade of the house of Tomaso Bambelli, a Genoese silk merchant in Antwerp and good friend of Dürer, was superseded in 1904 by Ernst Mummenhoff's publication in which he made the connection with Nuremberg. The size and shape of the windows in the drawing support such a premise.

The power of women over men is the underlying theme in the scenes portrayed in the roundels; from left to right are David and Bathsheba, Samson and Delilah, and Aristotle and Phyllis. The design appears to continue beyond the sheet that was obviously trimmed, and may have included a representation of Solomon's idolatry in the fourth medallion. Existing prints by Dürer's contemporaries, such as Hans Burgkmair, often depict these four subjects as a series or separately, demonstrating the downfall of men, even of the wisest, who are unable to resist the charm and cunning of a woman. Bathsheba's beauty led King David of Israel to commit adultery and murder, and Delilah rendered Samson powerless before his enemies the Philistines by cutting his hair, the source of his strength. In Aristotle's attempt to convince his pupil Alexander the Great that women were the undoing of strong men, the aged philosopher himself was outwitted and made a fool of by Alexander's favorite courtesan. Having suffered sudden neglect by her lover, she sought revenge by arousing Aristotle's passion and then demanding she be allowed to ride on his back as proof of his love for her. The popularity of these allegories in the art and literature of Northern Europe during the late Middle Ages reflects a pervasive negative attitude towards the fair sex— the symbol of temptation and inspiration since Adam and Eve.

In the Morgan drawing, the scenes were thought by some art historians to be inconsistent with the activities of the council chamber. According to Panofsky, however, the hall, which extended the length of ten windows, was also used for dances and thus would have required many more themes to fill the entire room. The designs for the hall were not executed by Dürer, and it is not certain if this drawing was ever employed for the decoration. The Albertina preserves the only other surviving drawing by Dürer for this project; it depicts the *Calumny of Apelles*, a composition which figured in the final decoration of the north wall. The ornamental motives in the Morgan sheet, including the satyrs, bear close stylistic resemblance to the artist's design for a saddle (No. 34). The pelican piercing its breast to feed its young, appearing below the scene of David and Bathsheba, symbolizes the sacrifice of Christ; the same subject is incorporated in Dürer's design for a bookcover (Acc. no. 1977.40) in the Library's collection, also believed to be of this period.

SELECTED BIBLIOGRAPHY: Lippmann, 1883–1929, IV, no. 407, repr.; Max J. Friedländer, "Ein Entwurf Dürers zu einer Wanddekoration," *Jahrbuch der preussischen Kunstsammlungen*, XVI, 1895, pp. 240–243, repr.; Ernst Mummenhoff, "Dürers Anteil an den Gemälden des grossen Rathaussaals und der Ratsstube," *Mitteilungen des Vereins für Geschichte der Stadt Nürnberg*, XVI, 1904, pp. 244–253; Heinrich Wölfflin, *Die Kunst Albrecht Dürers*, Munich, 1905, p. 301, repr.; Flechsig, 1928–1931, II, p. 347; Tietze and Tietze-Conrat, 1928–1938, II, no. 870, repr.; Winkler, 1936–1939, IV, no. 921, repr.; Panofsky, 1943, II, no. 1549; Strauss, 1974, IV, no. 1521/62, repr.

Jörg Breu the Younger (German)
AUGSBURG AFTER 1510 – 1547 AUGSBURG

36 *Horseman Attacking a Fallen Warrior*

Pen and black ink, heightened with pen and white ink, some brush work in both black and white ink, on paper brushed with a dark gray wash
8¾ × 6¹¹/₁₆ inches (222 × 171 mm.)
Watermark: bear (see Briquet 12.278)
Signed with monogram and dated *1543* at lower center in pen and white ink

Little can be added to the observations of Campbell Dodgson who first published this German Renaissance drawing in 1931 when it was in the possession of Mrs. Alfred Noyes, wife of England's poet laureate. The more than forty years that have elapsed since its publication have not dimmed the pristine quality of its preservation, on which Dodgson remarked, nor has anyone come forth with any further suggestions for the identification of the curious subject of a horseman attacking a fallen warrior with the assistance of his mount, which fiercely bites the head of the victim. Dodgson suggested the possibility that the drawing represents the death of the Consul Caius Flaminius at the hands of the Insubrian horseman Ducarius at the Battle of Lake Trasimenus in 217 B.C. (Livy XXII, Ch. 6), where, however, there is no mention of the action of the horse.

That the subject was of some familiarity to a sixteenth-century audience is suggested by the recent reappearance of a second version, a drawing in pen and brown ink (198×141 mm.). Coming from the collection of Mrs. A. K. M. Boerlage-Koenigs, it was sold at Sotheby's, London, on 26 June 1969, as lot 74, and has since been acquired by the Morgan Library (Acc. no. 1974.10). It is likewise by a German artist, a draughtsman in the neighborhood of the Nuremberg artist Virgil Solis (whose monogram has been added to the drawing along with the notation *V.72*). The two drawings, similar in the essentials of the composition but differing considerably in details of setting, the dress of the figures, and the horse trappings, would appear to be based on a common prototype, which is still to be traced. Dodgson tentatively suggested that the horse's action might have been an invention of Breu, but the presence of the motif in the second drawing would seem to rule out such an idea.

The Morgan drawing is important as a monogrammed and dated work, and as a somewhat rare example in this technique. There is another specimen in the Leipzig Museum der bildenden Künste (Inv. no. N1 42), a design for the decoration of a dagger sheath on a gray ground, likewise signed with the monogram and dated 1545 (see the exhibition catalogue *Altdeutsche Zeichnungen*, Dresden, 1963, no. 52, repr.; for another

drawing see no. 50); a further drawing in the Boymans–van Beuningen Museum at Rotterdam, a representation of Marcus Curtius, on a bright red ground, attributed to the younger Breu by Byam Shaw on the basis of comparison with the present drawing; and a drawing of a horseman, on a dark red ground, attributed to the younger Breu in the 1956 catalogue of Gutekunst and Klipstein (no. 36, repr.). Ordinarily, Breu seems to have drawn with the pen without the preparation of a colored ground and the elaboration of the ornamental white heightening. The high finish of the present drawing plus the fact that it is signed with the monogram and dated would make it suitable as a presentation piece. The monogram, it might be noted, is the Breu workshop mark, which the younger Breu took over from his father.

Like his better-known father before him, the short-lived younger Breu was active as a painter and more particularly as a draughtsman designing for woodcuts and glass. He was also employed as an illuminator. His woodcut work began in 1530 and by 1540 he was working as an illuminator of manuscripts such as Eton College's *Antiquitates* written by his brother-in-law, the architect Hans Tirol. In 1543, the year he executed the present drawing, Breu is recorded as having three assistants and two years later double that number, an indication of the productivity and prosperity of the workshop that was cut short by his death in 1547.

PROVENANCE: Thomas Weld, Lulworth Castle, Dorset; Mrs. Alfred Noyes, London; Baskett & Day, London; Mr. and Mrs. Eugene V. Thaw, New York.

BIBLIOGRAPHY: Campbell Dodgson, "Jörg Breu the Younger," *Old Master Drawings*, VI, June 1931, p. 15, pl. 15; Dodgson, "Ein Miniaturwerk Jörg Breus d.J.," *Münchner Jahrbuch der bildenden Kunst*, N.F.XI, no. 2, 1934–1935, p. 203, note 20; Friedrich Thöne, *Tobias Stimmer Handzeichnungen*, Freiburg im Breisgau, 1936, p. 81, note 405; sale, London, Sotheby's, 26 June 1969, under lot 74; Rotterdam, Boymans–van Beuningen Museum, *Duitse Tekeningen, 1400–1700*, exhibition catalogue by A. W. F. M. Meij, 1974, under no. 20.

EXHIBITIONS: Baskett & Day, London, *Exhibition of Thirty Old Master Drawings*, 1974, no. 8, repr.; Morgan Library, and elsewhere, *Drawings from the Thaw Collection*, 1975, no. 10, repr.

Acc. no. 1978.38
Gift of Mr. and Mrs. Eugene V. Thaw in honor of Charles Ryskamp on the occasion of his tenth anniversary as Director

Tobias Stimmer (Swiss)

SCHAFFHAUSEN 1539 – 1584 STRASBOURG

37 *The Crucifixion*

Pen and black ink, extensively heightened with white, on brown prepared paper, varnished

16⅞ × 12¼ inches (429 × 311 mm.)

Watermark: none visible through lining

Signed, dated, and inscribed by the artist, *Thobias Stimmer de Scaffusia fecit op. Sperat autem, illis non ad opus, / qui illud abusunt, et qui causa sunt, ut abusaretur. Scilicet pingitores. 1562*

This drawing is an early work, executed two years after Stimmer became a master painter in Schaffhausen at the age of twenty-one. Among the extant hundred and twenty drawings from the hand of the Swiss artist, it is one of the largest known. Much of Stimmer's reputation has depended on his book illustrations and drawings because his most celebrated works, the façade paintings for the *Haus zum Ritter* (Schaffhausen 1567–1569) and the astronomical clock in the Strasbourg cathedral (1570–1574), have not survived.

The reddish-brown background and elaborate use of white heightening appear in many of his drawings during the 1560's. These recall the chiaroscuro drawings of an earlier generation in Switzerland that included, for example, Hans Baldung Grien, Hans Leu the Younger, and Nikolaus Manuel Deutsch, all of whom ultimately were inspired by the work of Albrecht Dürer. Stimmer may have encountered the strong influence of the Nuremberg master when he travelled north to Austria and Southern Germany during his *Wanderjahre* as a journeyman (1557–1561), prior to the date of this drawing. The artist's vigorous parallel- and cross-hatching was rarely used by Swiss draughtsmen at this time, many of whom were designers of stained glass windows and employed only simple contour lines and gray wash—a method borrowed from Hans Holbein the Younger. A few awkward passages in the lower half of the composition interfere somewhat with the spatial recession, showing that the artist had not yet fully mastered foreshortening and confirming the early date of the drawing. The long form of the artist's signature, which differs from later drawings signed with a simple monogram, is as unusual as his cautionary Latin inscription, which reads: *Tobias Stimmer from Schaffhausen made this work. He hopes however not for those who misuse it and who are the cause that it may be misused. Namely, painters.* (Translation by P. O. Kristeller.)

Although Stimmer's drawings are usually preparatory studies for a project or commission, the quality of completeness in this sheet suggests that it probably was intended as a finished work in itself. The *horror vacui* in the ambitiously conceived scene taking place around the foot of the Cross is characteristically Mannerist in style. At the lower left, St. John the Evangelist is supporting the swooning Virgin Mary who is being revived, while to the right are the Pharisees and Roman soldiers tossing for Christ's robe; Longinus, holding the lance, appears to the left of the Cross which is effectively silhouetted against the backdrop of Jerusalem and the sky.

By the end of the decade, after his travels to Northern Italy, Stimmer's drawings would become suffused with light, the compositions greatly simplified, and the figures broadly rendered in a manner often characterized as proto-Baroque. In fact, his designs for the 170 woodcut illustrations to an illustrated Bible, *Neue künstliche Figuren Biblischer Historien* (Basel, 1576) became an important source of inspiration to the greatest exponent of the Baroque style, Peter Paul Rubens.

According to Dr. Thöne, there is an unsigned copy of this drawing in the same size and technique in the Kunstmuseum, Basel (Inv. no. 1910.18; Thöne, no. 151).

PROVENANCE: Possibly Balthasar Künast, Strasbourg; C. Anton Milani, Frankfurt-am-Main; Alfonso Milani, Eltville, Germany.

BIBLIOGRAPHY: Heinrich Schreiber, *Denkmale deutscher Kunst des Mittelalters*, III, Karlsruhe, 1828, p. 91; J. H. Bäschlin, *Schaffhauser Glasmaler des XVI. und XVII. Jahrhunderts*, II, Schaffhausen, 1880, p. 5; Gabriel von Térey, "Eine Kunstkammer des 17. Jahrhunderts [Balthasar Künast zu Strassburg]," *Repertorium für Kunstwissenschaft*, XIX, 1896, p. 35; Friedrich Thöne, *Tobias Stimmer: Handzeichnungen*, Freiburg im Breisgau, 1936, p. 103, no. 335; Morgan Library, *Sixteenth Report to the Fellows, 1969–1971*, 1973, pp. 89–91, 121–122, pl. 19.

EXHIBITIONS: Glaspalast, Munich, *Katalog für die Ausstellung der Werke älterer Meister*, II, 1876, p. 302, no. 2549; Morgan Library, *Major Acquisitions, 1924–1974*, 1974, no. 37, repr.

Acc. no. 1971.7

Purchase

Annibale Carracci (Italian)

BOLOGNA 1560 – 1609 ROME

38 *Eroded River Bank with Trees and Roots*

Pen and brown ink
15$\frac{13}{16}$×11$\frac{1}{16}$ inches (402×280 mm.)
Watermark: none visible through lining
Inscribed in an old hand in pen and brown ink at lower
center, *Anibbale Carracci*

This powerful nature study—which in the eighteenth century belonged to the famous collector-connoisseur P.-J. Mariette as well as to Count Moriz von Fries—was part of the celebrated group of drawings assembled by the English painter Sir Thomas Lawrence. After his death Lawrence's collection of Carracci drawings was sold *en bloc* to Sir Francis Egerton, who became the first Earl of Ellesmere. It passed thereafter to successive generations of the family, including the Duke of Sutherland, until it was dispersed at auction in one of the great drawings' sales of the 1970's. At that time the Library was fortunate to be able to add this superb sheet to the impressive group of landscape drawings from both Northern and Southern Europe already in its collection.

While it is traditionally ascribed to Annibale—as even the old inscription on the recto indicates—the drawing was reassigned to his brother Agostino by Bodmer in 1934. Some twenty years later, however, it was rightly restored to Annibale by Tomory and Mahon, and the latter convincingly dated the sheet around 1590–1592, shortly before Annibale was called to Rome to work on the decoration of some of the rooms of the Palazzo Farnese in 1595. All three Carracci—the brothers Agostino and Annibale and their cousin Ludovico—were involved in printmaking, especially Agostino. He characteristically drew in pen and ink with a printmaker's concern for detail and linear effect whereas Annibale—the greatest draughtsman of the three—drew in either pen or chalk with greater economy and a natural verve and freedom. Although Annibale did not fully develop as a painter of landscapes until later in Rome, he drew landscapes throughout his life, revealing a steadfast interest in natural phenomena. In this closely observed study of an eroded river bank Annibale was primarily concerned with the detailed examination of the exposed roots of trees and an old stump, but he included a glimpse of the river itself with a man in a small boat placed in the middle distance and a few indications of a distant town. These devices which provide spatial definition would occur often in his later paintings with river landscapes.

PROVENANCE: P.-J. Mariette (on remnant of his mount; Lugt 1852); Count Moriz von Fries (Lugt 2903); Sir Thomas Lawrence (Lugt 2445); Samuel Woodburn (no mark; see Lugt 2584); Francis Egerton, first Earl of Ellesmere (Lugt S. 2710b) and descendants; sale, London, Sotheby's, 11 July 1972, lot 54, repr.

BIBLIOGRAPHY: *Catalogue of the Ellesmere Collection of Drawings at Bridgewater House*, London, 1898, no. 74; Heinrich Bodmer, "Drawings by the Carracci: An Aesthetic Analysis," *Old Master Drawings*, VIII, 1934, pl. 63 (as Agostino); Morgan Library, *Seventeenth Report to the Fellows, 1972–1974*, 1976, pp. 145, 157f.

EXHIBITIONS: Royal Academy of Arts, London, *The Lawrence Gallery: Sixth Exhibition*, 1836, no. 60; Royal Academy of Arts, London, *Seventeenth Century Art in Europe*, 1938, no. 362; Leicester Museum, Leicester, *The Ellesmere Collection of Old Master Drawings*, 1954, catalogue by P. A. Tomory, no. 65, pl. XIX; P. & D. Colnaghi and Co., London, *A Loan Exhibition of Drawings by the Carracci and Other Masters*, 1955, no. 31; Palazzo dell'Archiginnasio, Bologna, *Mostra di Carracci: Disegni*, 1956, catalogue by Denis Mahon, no. 239; Newcastle upon Tyne, *The Carracci: Drawings and Paintings*, 1961, no. 97; Metropolitan Museum of Art, New York, *Drawings and Prints by the Carracci*, 1973, catalogue by Jacob Bean, no. 25; Morgan Library, *Major Acquisitions, 1924–1974*, 1974, p. xvi, no. 8, repr.; Los Angeles, *Old Master Drawings*, 1976, p. 66, no. 91, repr.; Cleveland Museum of Art, Cleveland, *Sixteenth Century Italian Drawings: Late Renaissance Studios and Styles*, catalogue by Edward Olszewski, 1980 (exhib. 1979), no. 36, repr.

Acc. no. 1972.6
Purchase

Guido Reni (Italian)

CALVENZANO (BOLOGNA) 1575 – 1642 BOLOGNA

39 *Study for Christ on the Cross*

Black and white chalk, with a few strokes of red chalk, on gray paper
14$\frac{5}{8}$×9$\frac{15}{16}$ inches (371×252 mm.)
Watermark: none
Inscribed on verso of an old lining, apparently trimmed, in pen and brown ink, *Guido Reni per il Crocifisso dei Cappucini di Bologna uno dei più*

This beautiful drawing of a male torso is preparatory for the figure of Christ in *The Crucifixion* which Reni painted for the church of the Capuchin friars in Bologna around 1616, now preserved in the Pinacoteca, Bologna. The artist, working chiefly in black chalk, studied the male nude from life, and he avoided academic contours with a vibrant sketchy stroke while modelling the form with a cross-hatching technique that has a slight resemblance to fish-scales. As Felice Stampfle observed at the time the drawing was acquired, the modulations of the surfaces of the torso are "detailed with soft finesse, and the nude is generally characterized by elegance at the same time that the angle of the faintly indicated head, the compression of the limbs, and especially the pull of the outstretched arms convey a suggestion of the pathos of the subject for which the figure was ultimately intended."

It is difficult to reconcile the sublime quality and sensitivity of the Morgan sheet with the somewhat differently posed figure in red chalk in the Kunsthalle, Bremen, which the late Walter Vitzthum connected with the same *Crucifixion*. It is possible that the Bremen drawing represents a less inspired moment in the artist's preparation for the painting.

The black chalk drawing in a recent sale (London, Christie's, 25–26 June 1974, lot 179) which was identified as Reni's study for Christ's figure in this painting—while bearing a superficial resemblance to Reni's style—does not appear to be an autograph work by the artist. Other drawings which may be associated with the work are the two studies in the Louvre for the head of Christ and a drawing for the Virgin—present location unknown—which was mentioned by Otto Kurz in his article on Reni (see *Jahrbuch der kunsthistorischen Sammlungen in Wien*, XI, 1937, p. 189); Vitzthum connected another drawing for the Virgin in the Museo di Capodimonte, Naples (Inv. no. 865).

A few other examples of Reni's draughtsmanship are included in the Library's holdings; chief among these is the large composition study of *Solomon's Idolatry* (repr. Fairfax Murray, IV, no. 163) executed in pen and ink.

PROVENANCE: Count Moriz von Fries (Lugt 2903); Marquis de Lagoy (Lugt 1710); probably Thomas Dimsdale; Sir Thomas Lawrence (Lugt 2445); Herbert Bier.

BIBLIOGRAPHY: Morgan Library, *Eleventh Report to the Fellows, 1961*, 1961, pp. 82–83; Denis Mahon, "Stock-taking in Seicento Studies," *Apollo*, LXXXII, 1965, pp. 384, 386, fig. 7; Walter Vitzthum, review of Detroit exhibition, *Master Drawings*, III, 1965, p. 407; Vitzthum, review of "Gunter Busch: ... Handzeichnungen ... aus dem Besitz der Kunsthalle Bremen," *Master Drawings*, IV, 1966, p. 185; Morgan Library, *Review of Acquisitions, 1949–1968*, 1969, p. 164, pl. 45.

EXHIBITIONS: Detroit Institute of Arts, Detroit, *Art in Italy, 1600–1700*, 1965, no. 86, repr.; *Drawings from New York Collections*, II, 1967, no. 20, repr.; Morgan Library, *Major Acquisitions, 1924–1974*, 1974, pp. xvif., no. 9, repr.

Acc. no. 1961.34
Purchased as the gift of the Fellows

Domenico Zampieri, called Domenichino (Italian)
BOLOGNA 1581 – 1641 NAPLES

40 *Head of an Angel*

Black and white chalk on blue-gray paper, the outlines pricked; a strip of paper added along the left side by the artist; corners cut diagonally
$16^3/_4 \times 13^3/_4$ inches (425 × 350 mm.)
Watermark: none visible through lining
Inscribed in pen and brown ink in an old hand on verso of mount, *U/N° 10*

Fifteen years after St. Cecilia's tomb was opened and her body was found miraculously intact, Domenichino received a commission from Daniel Polet to execute a cycle of frescoes representing the saint's life for a chapel in the French national church in Rome, S. Luigi dei Francesi (1615–1617). Fifty-three of the sixty-eight drawings connected with the project that were listed in the inventory of Domenichino's studio are now preserved at Windsor Castle, along with over seventeen hundred other drawings by the Bolognese master. It is all the more rare for a New York collection to own this large-scale cartoon fragment for the head of an angel from the ceiling composition of the Polet chapel, showing the *Glorification of St. Cecilia*. The sheet is one of many cartoons the artist made in preparation for the frescoes and one of the few to survive.

These cartoons were full-scale working drawings from which Domenichino transferred the de-

sign to the wall before commencing to paint. They were often damaged during this procedure, but in some cases were reused, studied and copied by pupils and studio assistants until the tattered remains had to be discarded. A cartoon for the entire *Glorification* scene, formerly in the Mariette collection, is now preserved at the Louvre; two fragments from the same composition, but slightly larger than the Morgan sheet, depict the head and shoulders of the saint (collection of J. A. Gere, London), and the head of the angel who appears on the right carrying the saint's organ (Museum of Fine Arts, Budapest). According to Richard Spear's convincing hypothesis proposed in an article in 1968 ("Preparatory Drawings by Domenichino," *Master Drawings*, VI, pp. 114–16), the London and Budapest sheets were part of an earlier cartoon, one that preceded the final solution in the Louvre drawing. Dissatisfied with his initial attempt, the artist seems to have transferred the design to another sheet by pricking and pouncing the main contours of the drawing to indicate the guidelines for the revised rendering.

The Morgan *Head of an Angel*, appearing to the left of the saint in the *Glorification*, was unknown to Professor Spear at the time he published his article. It is another fragment from the first cartoon, exhibiting the same chalk on blue-gray paper and the same pin holes of the pricking process that are found in the other two studies. The beautiful sheet is a model example of the *ideale classico* adhered to by Domenichino when he executed this commission at the peak of his classical period. The artist has endowed the angel with a Praxitelean elegance conveyed with soft, subtle modelling and graceful reiterated contours.

Domenichino's important role in the development of landscape painting is also represented in the Library's holdings by a double-sided sheet from the Fairfax Murray collection (Acc. no. IV, 166a and b) and one from that of Janos Scholz (Acc. no. 1976.37), both executed in pen and ink.

PROVENANCE: The Earls Spencer (Lugt 1532); private collection, England.

BIBLIOGRAPHY: Paris, Musée du Louvre, Cabinet des Dessins, *Cartons d'artistes du XVe au XIXe siècle*, exhibition catalogue by Roseline Bacou, 1974, under no. 16; Morgan Library, *Seventeenth Report to the Fellows, 1972–1974*, 1976, p. 185, pl. 14.

EXHIBITION: Morgan Library, *Major Acquisitions, 1924–1974*, 1974, p. xvii, no. 11, repr.
Acc. no. 1973.18
Purchased as the gift of Miss Alice Tully

Bernardo Strozzi (Italian)
GENOA 1581 – 1644 VENICE

41 *Head of Christ*

Black and red chalk, heightened with white, on buff paper
$15^5/_8 \times 10^1/_4$ inches (396×262 mm.)
Watermark: fleur-de-lis in a circle
Inscribed in pen and brown ink on verso at upper right, *P. G. nº 50*

In this highly expressive drawing Strozzi studies the head of Christ for his painting *Christ and the Woman of Samaria*, now in the Bob Jones University Museum, Greenville, South Carolina (repr. Mortari, fig. 275). The artist painted at least one other version of this relatively unusual subject which is presently in the collection of Viscount Scarsdale, Kedleston Hall (repr. Mortari, fig. 276). While numerous paintings by Strozzi survive, his drawings are rare; among these the Morgan sheet is outstanding. Here Christ's ascetic countenance is shown in profile, lips parted as if in speech, His features and especially His hair emphatically rendered in undulating strokes of black and red chalk, occasionally accented in moistened black chalk. The charismatic quality of Christ's presence is suggested in Strozzi's portrayal which evokes a certain eerie fascination. The uncanniness of this effect was perhaps not intended since it is entirely missing in both painted compositions. It has more to do with the artist's Mannerist antecedents, especially those from the North, notably Terbrugghen and Liss, from whom Strozzi's types ultimately derive. The artist, known as *il Cappuccino* or *il prete genovese*, joined the Capuchin order when he was eighteen years old and in the main painted religious subjects throughout his life. In 1631, he left Genoa and went to Venice. Although some scholars have dated *Christ and the Woman of Samaria* in the late 1620's before Strozzi left Genoa, it seems more likely, as both Luisa Mortari and Mary Newcome Schleier have main-

tained, that the work was executed in Venice. This is supported by the Venetian character of some of the sketches on the verso of the sheet. Aside from the study of a crowned head of a woman, there are two other sketches including a Tintorettoesque figure study and a sketch of a sculptured bust. The crowned head of a woman has been connected with St. Catherine of Alexandria—a subject which Strozzi painted several times—and most closely resembles the version in the Wadsworth Atheneum in Hartford (repr. Mortari, fig. 111). The drawing of a sculptured head may be connected with the artist's *Allegory of Sculpture* painted in the Biblioteca Marciana, Venice, in 1635 (repr. Mortari, fig. 337).

PROVENANCE: Borghese (Lugt S.2103a); Maurice Marignane; Seiferheld and Co., New York, and Jean-Pierre Selz, Paris.

BIBLIOGRAPHY: Morgan Library, *Seventeenth Report to the Fellows, 1972–1974*, 1976, pp. 145f., 182, pl. 16; Mary Newcome Schleier, *Biblioteca di Disegni, X: Maestri genovesi dal cinque al settecento*, Florence, 1977, p. 9, no. 14, repr.; National Gallery, London, *Venetian Seventeenth Century Painting*, exhibition catalogue by Homan Potterton, 1979, under no. 22.

EXHIBITION: Morgan Library, *Major Acquisitions, 1924–1974*, 1974, p. xviii, no. 12, repr.

Acc. no. 1973.1
Purchased as the gift of the Fellows

Giovanni Francesco Barbieri, called Guercino (Italian)
CENTO 1591 – 1666 BOLOGNA

42 *The Virgin Giving the Scapular to St. Albert*

Pen and brown ink, brown and gray-brown wash, over preliminary indications in black chalk, squared for transfer in black chalk
15¾×10½ inches (401×267 mm.)
Watermark: none
Inscribed in pen and black ink in an old hand at lower right, *Guerchin 1100*; numbered on verso in black chalk, *416*; ruled margin lines in red chalk

The group of around twenty authentic drawings by Guercino in the Morgan Library makes possible the study of most aspects of his draughtsmanship. The prolific and extraordinarily gifted Bolognese is represented in this volume by two

examples: one, the early compositional drawing in pen and wash shown here; the other, the suavely accomplished presentation drawing *The Holy Family*, unusual in Guercino's use of a variety of colored chalks.

The Carmelite saint receiving the scapular has been alternatively recognized as St. Simon Stock or St. Albert, but Pasqualini's contemporary engraving after Guercino's painting of the subject is inscribed *Beatissima Vergine del Carmine et S. Alberto / in Cento Sup Permiss 1623 . . .* , leaving little doubt as to the identity of the saint.

Although squared for transfer, only the figure of St. Albert remains unaltered in the painting in the Pinacoteca at Cento which Denis Mahon has dated around 1616 (repr. Palazzo dell'Archiginnasio, Bologna, *Il Guercino: Dipinti*, catalogue by Denis Mahon, 1968, fig. 7). Two other studies for the painting exist, another compositional study at Chatsworth and a red chalk study for the Virgin and Child in Dublin. The drawing is an especially fine example of Guercino's spectacular use of pen and wash. The figures are secured in an odd but dynamic—almost sculptural—spatial juxtaposition by Guercino's skillful management of the areas of light and shadow produced by the alternation of wash and brilliantly contrasting reserves of the white paper on which he drew.

PROVENANCE: Sir Peter Lely (Lugt 2092); Jonathan Richardson, Sr. (Lugt 2184); Sir Joseph Hawley (according to the Fairfax Murray Notebooks); [Sir Henry Hawley] sale, London, Christie's, 16 July 1891, part of lot 218; Charles Fairfax Murray; J. Pierpont Morgan (no mark; see Lugt 1509).

EXHIBITIONS: *Drawings from New York Collections*, II, 1967, no. 36, repr.; Palazzo dell'Archiginnasio, Bologna, *Il Guercino: Disegni*, catalogue by Denis Mahon, 1968, p. 45, no. 9, repr.; Mount Holyoke College Art Museum, South Hadley, Mass., *Drawings by Guercino and his Circle*, 1974, no. 1, repr.

Acc. no. IV,168a

43 *The Holy Family*

Colored chalks (black, red, blue, brown, ochre), blue-gray wash
14⅟₁₆×10⅟₁₆ inches (358×268 mm.)
Watermark: three hills surmounted by tree within a shield (cf. Heawood 3951)
Inscribed in pen and brown ink at upper left, *ZAMC*

Guercino as a virtuoso draughtsman was one of

the earliest artists to practice the art of drawing as an end in itself and he made many drawings for sale or presentation to his patrons and friends. *The Holy Family*, which obviously falls into this category, is exceptional if not unique in the finesse of its rendering and the use of color. Guercino, who usually worked in pen and wash, often chose chalk for these special drawings, usually black chalk with some red. Occasionally he worked in watercolor as well. Here, however, he drew with very pleasing effect in a wide range of colored chalks, finishing the work with an application of blue-gray wash.

The Holy Family has always been admired; it was engraved by Bartolozzi while it was in the collection of the noted Venetian *amateur* and collector Antonio Maria Zanetti. Another great connoisseur, P.-J. Mariette, singled the drawing out for special notice in his personal copy of *Nuova Raccolta di alcuni disegni del Barbieri da Cento, detto el Guercino*, Rome, 1764. In Baron Vivant Denon's sale in 1826, the cataloguer, who inexplicably listed the drawing under Gennari's name, spoke highly of the work: "Dessin capital aux crayons rouge et noir, avec un peu de pastel et d'aquarelle sur papier blanc. . . . On ne peut pousser plus loin le charme de l'effet que dans ce dessin." In the nineteenth century the drawing belonged to the English collector Robert Staynor Holford.

PROVENANCE: Antonio Maria Zanetti; Baron Dominique Vivant Denon (Lugt 779); Robert Staynor Holford (Lugt 2243); Charles Fairfax Murray; J. Pierpont Morgan (no mark; see Lugt 1509).

BIBLIOGRAPHY: P.-J. Mariette, *Abécédario de P.-J. Mariette et autres notes inédites de cet amateur sur les arts et les artistes*, I, Ph. de Chennevières and A. de Montaiglon, ed., Paris, 1851, p. 63; Fairfax Murray, I, no. 99, repr.

EXHIBITIONS: Hartford, *Pierpont Morgan Treasures*, 1960, no. 74; *Drawings from New York Collections*, II, 1967, no. 48, repr.; Palazzo dell'Archiginnasio, Bologna, *Il Guercino: Disegni*, catalogue by Denis Mahon, 1968, p. 176, no. 188, repr.; Mount Holyoke College Art Museum, South Hadley, Mass., *Drawings by Guercino and his Circle*, 1974, no. 17.

Acc. no. I,99

Pietro Berrettini, called Pietro da Cortona (Italian)

CORTONA 1596 – 1669 ROME

44 *Woman Holding the Papal Tiara*

Black and red chalk
8¹¹⁄₁₆ × 10⅞ inches (220 × 277 mm.)
Watermark: none visible through lining

Between 1632 and 1639 Pietro da Cortona was engaged on his greatest decorative project, the ceiling of the Gran Salone of the Palazzo Barberini in Rome. Only a few of the many preparatory drawings which such an undertaking must have entailed are known, and of these the study now in the Morgan Library is undoubtedly among the most beautiful. The woman who holds the papal tiara personifies Rome according to Rosichino's contemporary description of the room published in 1640, a year after the completion of Cortona's decorative scheme. She appears holding the tiara above the papal keys in the central panel of the ceiling, the overall program of which was, of course, designed to glorify the Barberini family.

The Morgan sheet is exceptionally appealing in its beauty. The luminous quality of the black chalk, characteristic of the artist, has been enhanced by a light flush of red chalk, and to his usual high standard of performance in this medium, Cortona has achieved an extra measure of assurance in the absolute perfection of the rendering.

The artist is represented in the collection by five other examples covering a range of styles and media.

PROVENANCE: Robert Udney (Lugt 2248); Thomas Banks (Lugt 2423); probably Mrs. Lavinia Banks Forster and Ambrose Poynter; Edward J. Poynter (Lugt 874); his sale, London, Sotheby's, 24 April 1918, lot 31, repr. (as Ludovico Carracci); Earl of Harewood; sale, London, Christie's, 6 July 1965, lot 123, repr.

BIBLIOGRAPHY: Sidney Colvin in *The Vasari Society for the Reproduction of Drawings by Old Masters*, first series, VI, London, 1910–1911, pl. 14 (as Ludovico Carracci); Tancred Borenius, "Drawings and Engravings by the Carracci," *Print Collector's Quarterly*, IX, 1922, p. 112, repr. p. 109; "Old Master Drawings in the Collection of Viscount Lascelles," *Apollo*, I, 1925, pp. 192f., repr. (as Ludovico Carracci); S. von Below, *Beiträge zur Kenntnis Pietro da Cortonas*, Munich, 1932, p. 107; Charles de Tolnay, *History and Technique of Old Master Drawings*, New York, 1943, pp. 122f., fig. 108; Musée du Louvre, Paris, *Dessins romains du XVIIe siècle*, 1959, under no. 22; Giuliano Briganti, *Pietro da Cortona, o della pittura barocca*, Florence, 1962, pp. 203, 307; Morgan Library, *Fourteenth Report to the Fellows, 1965 & 1966*, 1967, pp. 116f., repr.; Morgan Library, *Review of Acquisitions, 1949–1968*, 1969, p. 139, pl. 37.

EXHIBITIONS: Royal Academy of Arts, London, 1879, no. 35; Burlington Fine Arts Club, London, *Italian Art of the Seventeenth Century*, 1925, pp. 41, 48, no. 9, pl. 17 (apparently the first publication of the Cortona attribution by A. G. B.

Russell, who presumably also connected the drawing with the Barberini ceiling); Royal Academy of Arts, London, *Italian Art*, 1930, catalogue by A. E. Popham, 1931, no. 302, pl. 253b; Royal Academy of Arts, London, *Seventeenth Century Art in Europe*, 1938, no. 421; Wildenstein and Co., London, *Artists in 17th Century Rome*, 1955, no. 32; Fitzwilliam Museum, Cambridge, *17th Century Italian Drawings*, 1959, no. 29; *Drawings from New York Collections*, II, 1967, no. 59, repr.; Stockholm, *Morgan Library gästar Nationalmuseum*, 1970, no. 38, repr.; Morgan Library, *Major Acquisitions, 1924–1974*, 1974, pp. xviif., no. 13, repr.

Acc. no. 1965.16
Purchased as the gift of the Fellows with the special assistance of Mr. and Mrs. Carl Stern

Gian Lorenzo Bernini (Italian)
NAPLES 1598 – 1680 ROME

45 *Portrait of Cardinal Scipione Borghese*

Red chalk and graphite
9¹⁵⁄₁₆×7¼ inches (253×184 mm.)
Watermark: none visible through lining

Inscribed on verso of lining in pencil in a modern hand at upper left corner, *Lot 223–8–/265*; in pen and brown ink in the hand of one of the Richardsons (probably Richardson, Sr.) at top, *Card. Scipio Borghese Nephew of P. Paul V / The Bust is in the Villa Borghese made when / Bernini was very young, but is nevertheless much / esteemed;* in the same hand, below, partially cut, – *lo stesso Bernini, che un giorno vi fu col Card. Antonio Barberino, dopo qua / . . . vederle proruppe in q̄te parole: Oh quanto poco profitto à fatto io nell'arte della Sco . . . / ingo corso di anni, mentre io conosco, che da fanciullo maneggiano il marino in questo mo . . . / Baldinucci nella sua Vi . . .;* in pencil in Charles Fairfax Murray's hand, a translation of the above, across the center, *Bernini when one day with Cardinal Antº Barberini after-/ observing it broke out in these words, "How little progress I have made / in sculpture / in the long course of years, when I see that as a boy I managed the / marble in this manner" / Baldinucci / Life of Bernini / coll: Richardson sr / Lawrence;* in pen and brown ink at lower right, *the 12th night, Lot 41.*

This vivid portrait of Cardinal Scipione Borghese is Bernini's preparatory study for the marble portrait bust of the cardinal which the artist executed in 1632. Of the many life studies that Bernini must have drawn, this is the only authentic example that is known. There is an intimate quality in the drawing that is lacking in the bust, but this contrast is no doubt the result of function rather than of art. The marble presents the idealized formal aspect of the man in his high official capacity as churchman. The drawing is a render-

ing of the cardinal out of office so to speak, the man whom Bernini had long known both as patron and as personal friend. As the bust approached completion, a crack developed in the forehead obliging the sculptor to execute a second version which he accomplished with amazing speed. Both busts are in the Borghese Gallery, Rome.

Graphite, rather than the usual black chalk, is used with red chalk, and its textural richness is employed to advantage in the rendering of the hair and beard. Bernini may have discovered the potential of graphite from his work in architecture but as a drawing medium it remained uncommon until later in the century.

PROVENANCE: Jonathan Richardson, Sr. (Lugt 2184); Sir Thomas Lawrence (Lugt 2445); sale ["Well-Known Amateur"] (Hope, according to the Fairfax Murray Notebooks), London, Sotheby's, 20 June 1891, lot 185; Charles Fairfax Murray; J. Pierpont Morgan (no mark; see Lugt 1509).

BIBLIOGRAPHY: Fairfax Murray, IV, no. 176, repr.; Heinrich Brauer and Rudolf Wittkower, *Die Zeichnungen des Gianlorenzo Bernini*, Berlin, 1931, pp. 29, 30, 156, pl. II; Wittkower, *Gian Lorenzo Bernini: The Sculptor of the Roman Barroque*, London, 1955, pp. 15, 195, pl. 52; Howard Hibbard, *Bernini*, Harmondsworth, England, 1965, p. 93, pl. 46.

EXHIBITION: *Drawings from New York Collections*, II, 1967, no. 68, repr.

Acc. no. IV,176

46 *Portrait of Sisinio Poli*

Black, red, and white chalk on light brown paper
10⁹⁄₁₆×8⅛ inches (268×207 mm.)
Watermark: none visible through lining

Accompanied by two inscriptions: one in pen and brown ink on a thin leaf of wood, and another, on paper, copied in pen and brown ink from the first, and attached below the drawing, *Eques Laurentius Berninus / Die vigesima octava Aprilis 1638 /Delineavit / Effigies Sisinij Poli Anno etatis suae / Decimo octavo*

Unlike the *Portrait of Cardinal Scipione Borghese*, the *Portrait of Sisinio Poli* is an independent work of art. Its high finish in three colors of chalk and the accompanying inscription clearly indicate that a presentation drawing was intended. Most of Bernini's surviving portrait drawings represent his own countenance, but a few, such as the present example, depict other sitters. The young man's name, Sisinio Poli, is given in the inscription; and one may assume that the sitter was probably some-

one Bernini knew well. The fact that day, month, and year are specified in the inscription along with the youth's age make it likely, as Felice Stampfle has observed, that Poli's eighteenth birthday was the occasion for the drawing. This information along with the attribution to Bernini is inscribed on the thin wooden leaf apparently always preserved with the drawing. The date was transcribed with varying accuracy on a sheet of paper pasted to the lower edge of the sheet, a modification that probably took place in the eighteenth century.

Another Bernini drawing, a preliminary study in brush and brown wash for the marble tomb of Cardinal Domenico Pimentel, was purchased by the Library in London through the generosity of the Association of Fellows (Acc. no. 1958.18; see *Drawings from New York Collections*, II, 1967, no. 70, repr.).

PROVENANCE: Charles Fairfax Murray; J. Pierpont Morgan (no mark; see Lugt 1509).

BIBLIOGRAPHY: Fairfax Murray, IV, no. 174, repr.; Heinrich Brauer and Rudolf Wittkower, *Die Zeichnungen des Gianlorenzo Bernini*, Berlin, 1931, p. 156, pl. 16.

EXHIBITIONS: Detroit Institute of Arts, Detroit, *Art in Italy, 1600–1700*, 1965, no. 28, repr.; *Drawings from New York Collections*, II, 1967, no. 69, repr.; Stockholm, *Morgan Library gästar Nationalmuseum*, 1970, no. 40, repr.

Acc. no. IV,174

Stefano della Bella (Italian)

FLORENCE 1610 – 1664 FLORENCE

47 *Stag Hunt*

Pen and brown ink, graphite. The pinkness of the sheet is due to its having been rubbed with red chalk on the verso, probably in anticipation of tracing
5¼×9⁹⁄₁₆ inches (133×240 mm.)
Watermark: none visible through lining
Inscribed on verso of lining in pencil and brown ink with various numbers and notations

This drawing of a hunter pursuing a deer is one of Stefano's preparatory drawings for the series of nine etchings (De Vesme 732–740) depicting scenes of the hunt. The artist apparently began his drawing in graphite with the sheet oriented in the reverse direction before turning it around and proceeding to complete the design.

Although preliminary to the etching (De Vesme 739), the *Stag Hunt* has an airiness and vitality which is not usually found in the art of most printmakers. The roseate glow of the red chalk which was rubbed on the verso of the sheet, probably in anticipation of tracing, shows through to the recto enhancing the overall appearance of the drawing.

Related drawings for the series of hunting prints are to be found in the Uffizi and the Albertina. The Morgan Library has one other (Acc. no. IV,179a), and a sketch for a wolf hunt is privately owned by Robert and Bertina Suida-Manning.

PROVENANCE: Thomas Dimsdale (Lugt 2426); A. Donnadieu (Lugt 725); Dr. Barry Delany (Lugt 350); Charles Fairfax Murray; J. Pierpont Morgan (no mark; see Lugt 1509).

BIBLIOGRAPHY: Fairfax Murray, IV, no. 179, repr.; Alexandre de Vesme, *Stefano della Bella*, introduction and additions by Phyllis Dearborn Massar, New York, 1971, p. 56; John Baskett, *The Horse in Art*, London, 1980, p. 80, repr.

EXHIBITION: *Drawings from New York Collections*, II, 1967, no. 88, repr.

Acc. no. IV,179

Jacques Bellange (French)

ACTIVE 1602 – 1616

48 *The Hunter Orion Carrying Diana on his Shoulders*

Pen and brown ink, brown wash; extraneous spots of red chalk and green paint
13¾×7⅞ inches (350×200 mm.)
Watermark: none
Inscribed in pen and brown ink at lower right corner, *Belange*

The highly personal French Mannerist style of Bellange is strikingly exemplified in *The Hunter Orion Carrying Diana on his Shoulders*. The subject is depicted in an elegant, almost choreographic pose. Astride his shoulders sits the lithe and slender goddess adorned with draperies at the shoulder and armed with bow and quiver at her back. Although Nicole Walch has tried to make a case for the work being a representation of the blinded Orion carrying Kedalion, this alternative identification seems unconvincing in light of Bellange's related etching (Robert-Dumesnil XI, 36) where

Diana is represented with her traditional attributes of quiver and bow.

Moreover, Bellange's etching is somewhat reminiscent of Giorgio Ghisi's print of 1553 after Luca Penni (Bartsch XV, 43) in which the same subject is similarly depicted. Felice Stampfle has convincingly argued against Walch's reinterpretation in her detailed discussion of this controversy in the *Report to the Fellows*. In 1606 the artist was at work on a series of hunting scenes for the ducal palace gallery at Nancy and in 1611 he was involved in depicting subjects from Ovid to decorate another gallery of the same residence.

In his time Bellange was popular as a painter and decorator at the Court of Lorraine, and as an etcher he was highly regarded. Interest in his work, however, has been slight until fairly recently.

PROVENANCE: John S. Thacher.

BIBLIOGRAPHY: François G. Pariset, "Dessins de Jacques Bellange," *Critica d'arte*, VIII, 1950, pp. 351f., fig. 302; Regina Shoolman and Charles E. Slatkin, *Six Centuries of French Master Drawings in America*, New York, 1950, p. 34, pl. 20; Colin Eisler, "A New Drawing by Jacques Bellange at Yale," *Master Drawings*, I, no. 4, 1963, p. 35; Graphische Sammlung Albertina, Vienna, *Die Kunst der Graphik IV: Zwischen Renaissance und Barock*, 1968, p. 254, under no. 380; Nicole Walch, *Die Radierungen des Jacques Bellange*, Munich, 1971, p. 142, no. 165; Morgan Library, *Sixteenth Report to the Fellows, 1969–1971*, 1973, pp. 96ff., pp. 108f., pl. 21.

EXHIBITIONS: Carnegie Institute, Pittsburgh, *French Painting*, 1951, no. 137, repr.; Yale University Art Gallery, New Haven, *Pictures Collected by Yale Alumni*, 1956, no. 188; Metropolitan Museum of Art, New York, *French Drawings from American Collections*, 1959, p. 35, no. 14, pl. 13; Morgan Library, *Major Acquisitions, 1924–1974*, 1974, p. xx, no. 24, repr.

Acc. no. 1971.8
Purchased as the gift of the Fellows

Jacques Callot (French)

NANCY 1592 – 1635 NANCY

49 *The Miracle of St. Mansuetus*

Pen and brown ink, brown wash, over black chalk
Design measuring 8¼ × 7⅟₁₆ inches (209 × 180 mm.), on sheet measuring 9³⁄₁₆ × 7⅛ inches (233 × 180 mm.)
Watermark: none
Numbered in an old hand in pen and brown ink on verso at lower left, *N 4096*

Like Bellange, Callot, too, worked at the Court of Lorraine. Primarily a printmaker, his influence as an artist was very great and made itself felt even on Rembrandt. The artist executed four preparatory studies in pen and brush for the etching *The Miracle of St. Mansuetus*. Aside from the present sheet, these are at the Musée Historique, Nancy, the Museum of Fine Arts, Boston, and the Nationalmuseum, Stockholm. The somewhat obscure St. Mansuetus was a fourth-century Scottish bishop sent to Lorraine to convert the pagan community to Christianity. The event depicted is the recovery from the river of the body of the son of the governor of Toul, a city on the Moselle River in Lorraine. The actual miracle concerns the raising of the child from the dead by divine power invoked through the prayer of the saint, and the subsequent conversion of the community to Christianity by reason of this extraordinary display of supernatural influence.

The theatrical ambience of Florence, where Callot received his artistic training, no doubt influenced the artist in his habit of making several different studies for a work in which the action and poses of the figures undergo the changes that a stage director might consider in the manipulation of the living actors in a play. The Morgan drawing, second in the sequence of the four studies, shows a very marked increase in clarity over the first in the delineation of the figures and the adjustment of their placement. The saint is in the center, his two disciples at the right. To the left the rescuer is seen holding the drowned boy. The drama of the tableau lies in the contrast between the mixture of hope and uncertainty on the faces of the subsidiary figures and the otherworldliness and conviction of faith which the face of the saint conveys. With fingers upraised in the child's direction, he is on the point of performing the miracle of raising the dead.

Callot's style here is seen in the transitional phase from Florentine Mannerism to the dramatic pictorialism of the early Baroque. A full discussion of this sheet in relation to the others in the series and the etching (Lieure 378, Miaume 641) can be found in Anne Blake Freedberg's article.

PROVENANCE: Jonkheer Johan Goll van Franckenstein the Younger (1756–1821); his *No. 4096* in brown ink on verso, Lugt 2987); Jonkheer Pieter Hendrik Goll van Franckenstein

(1787–1832); Lord Delamere; his sale, London, Sotheby's, 13 April 1926, lot 362; H. S. Reitlinger; his sale, London, Sotheby's, 14 April 1954, lot 294; Mr. and Mrs. Germain Seligman, New York.

BIBLIOGRAPHY: Anne Blake Freedberg, "A 4th Century Miracle by a 17th Century Artist," *Bulletin of Boston Museum of Fine Arts*, LV, no. 304, 1957, pp. 40f., repr.; Petit Palais, Paris, *Le XVIIe siècle français: Chef-d'oeuvres des musées de Provence*, 1958, under no. 183; Daniel Ternois, *Jacques Callot: Catalogue complet de son oeuvre dessiné*, Paris, 1962, no. 571, repr.; The Pierpont Morgan Library, New York, *Drawings from Stockholm: A Loan Exhibition from the Nationalmuseum*, 1969, under no. 84.

EXHIBITIONS: Kunstmuseum, Bern, *Das 17. Jahrhundert in der französischen Malerei*, 1959, no. 110, pl. 35; The Museum of Art, Rhode Island School of Design, Providence, *Jacques Callot*, 1970, no. 58, repr.

Acc. no. 1978.35
Purchased as the gift of Mrs. Kenneth Spencer

Nicolas Poussin (French)
LES ANDELYS 1594 – 1665 ROME

50 *The Death of Hippolytus*

Pen and brown ink, brown wash, over faint indications in black chalk
Verso: Asclepius Restoring Hippolytus to Life, in pen and brown ink over black chalk
$8\frac{7}{8} \times 13\frac{1}{16}$ inches (224 × 332 mm.)
Watermark: none

In their *catalogue raisonné* of the artist's drawings, Friedlaender and Blunt have characterized *The Death of Hippolytus* as "one of the freest and most dramatic ever produced by Poussin." No painting is known of this unusual subject which the artist, who had a lifelong fascination with antiquity, drew from Ovid's *Metamorphoses*. It has been dated between the late 1630's and early 1640's because of the presence of stylistic features characterizing Poussin's manner of drawing in both decades. In the thirties, he worked mainly in line achieving movement and liveliness, then applying broad areas of wash for modelling and dramatic lighting effects. While line is preserved here along with the artist's especially brilliant use of wash throughout the drawing, Poussin—in the manner of his work of the forties—modelled the foreground figures with careful and repeated applications of wash with the point of the brush.

Hippolytus, wrongly accused by his stepmother, Phaedre, to his father, Theseus, is struck down by Poseidon who, responding to the angry Theseus, sends a bull from the sea to frighten the horses of the youth and wreck his chariot against a high rock. The drawing, which is striking in its dramatic intensity, represents the moment following the crash when two witnesses to the disaster rush to quiet the terrified horses and a third lifts Hippolytus' body from underneath the overturned chariot. Continuing the story on the verso of the sheet, the artist sketched solely in pen the even more rarely depicted subject of Asclepius restoring Hippolytus to life.

PROVENANCE: Antonio Cavaceppi (according to Ottley's inscription); Camuccini (according to Ottley's inscription); William Young Ottley; Thomas Dimsdale (Lugt 2426); Sir Thomas Lawrence (Lugt 2445); Robert Staynor Holford (Lugt 2243); Sir John Charles Robinson (Lugt 1433); Charles Fairfax Murray; J. Pierpont Morgan (no mark; see Lugt 1509).

BIBLIOGRAPHY: William Young Ottley, *The Italian School of Design*, London, 1823, no. 80, 2nd plate beyond p. 68; Fairfax Murray, I, no. 267, repr.; Regina Shoolman and Charles E. Slatkin, *Six Centuries of French Master Drawings in America*, New York, 1950, p. 22, pl. 14; Walter Friedlaender and Anthony Blunt, *The Drawings of Nicolas Poussin*, III, London, 1953, no. 222, pl. 169; *Great Drawings of All Times*, III, 1962, no. 655, repr.; Anthony Blunt, *Nicolas Poussin*, New York, 1967, pp. 132f., fig. 124; Blunt, *The Drawings of Poussin*, New Haven–London, 1979, pp. 68ff., figs. 74–75.

EXHIBITIONS: Royal Academy of Arts, London, *The Lawrence Gallery: Third Exhibition*, 1835, no. 83; Albright Art Gallery, *Master Drawings*, 1935, no. 42; Lyman Allyn Museum, *Drawings*, 1936, no. 54; Morgan Library, *New York World's Fair*, 1939, no. 91 (1940 ed., no. 109); Cincinnati Art Museum, Cincinnati, *Nicolas Poussin – Peter Paul Rubens*, 1948, no. 26; Philadelphia, *Masterpieces*, 1950, no. 58, repr.; Morgan Library, and elsewhere, *Fiftieth Anniversary*, 1957, no. 91, repr.; M. Knoedler and Co., New York, *Great Master Drawings of Seven Centuries*, 1959, no. 50; Musée du Louvre, Paris, *Nicolas Poussin*, 1960, no. 179; Wildenstein & Co., New York, *Gods and Heroes: Baroque Images of Antiquity*, 1968–1969, no. 30, repr.; Stockholm, *Morgan Library gästar Nationalmuseum*, no. 49, repr.

Acc. no. I,267

51 *The Holy Family*

Pen and brown ink, brown wash over slight indications in black chalk
$7\frac{1}{4} \times 9\frac{7}{8}$ inches (184 × 251 mm.)
Watermark: none visible through lining

Although the peaceful, somewhat static, theme of

the Holy Family was not really suited to Poussin's gifts for representing dramatic action, he painted the subject to pleasing effect a number of times over the course of his career. The Morgan drawing is preparatory for the artist's rendering of the subject known as *The Madonna of the Steps*, the painting of around 1648 which is today part of the Kress Collection in the National Gallery, Washington (repr. Friedlaender and Blunt, fig. 11). The figures are posed in a broad triangular composition on the first step of a short flight of stairs which raises them to a *sotto di sù* viewpoint. The steps, pillar with potted plant, and the screening wall indicate a partition of the space by intersecting planes, a structural device noted by Friedlaender and Blunt as typical of Poussin at this time. The drawing which lacks a few of the major elements of the painting, notably the flight of stairs in the background behind St. Joseph at the right of the composition, was probably executed as one of a series of compositional refinements shortly before the painting. The drawing in the Louvre in which the compositional elements are fairly complete must be slightly later than the Morgan drawing. (See Friedlaender and Blunt, pp. 25ff., for a discussion of the entire group of related drawings.)

By the 1640's, Poussin had developed a bad tremor in his hand which imparts, as Anthony Blunt has observed, a nervous vivacity to some of his drawings. Perhaps the tremor is evident here, as Blunt remarks, but the drawing is nevertheless striking in the richness of its dark washes, the brilliant effect of the lighting of the group from below, and the intricate but sound construction of its composition.

PROVENANCE: P. Fréart de Chantelou (Lugt 735); Sir John Charles Robinson (Lugt 1433); Charles Fairfax Murray; J. Pierpont Morgan (no mark; see Lugt 1509).

BIBLIOGRAPHY: Fairfax Murray, III, no. 71, repr.; Walter Friedlaender and Anthony Blunt, *The Drawings of Nicolas Poussin*, I, London, 1939, no. 46, pl. 30; Regina Shoolman and Charles E. Slatkin, *Six Centuries of French Master Drawings in America*, New York, 1950, p. 24, pl. 15; Georg Kauffmann, *Poussin-Studien*, Berlin, 1960, pl. 3; Herbert von Einem, "Poussins 'Madonna an der Treppe,'" *Wallraf-Richartz-Jahrbuch*, XXVIII, 1966, pp. 37ff., fig. 25; Anthony Blunt, *The Drawings of Poussin*, New Haven–London, 1979, pp. 56, 71, 73, fig. 82.

EXHIBITIONS: Morgan Library, *New York World's Fair*, 1939, no. 89; Cincinnati Art Museum, Cincinnati, *Nicolas Poussin – Peter Paul Rubens*, 1948, no. 25, repr.; Museum Boymans–van Beuningen, Rotterdam, and elsewhere, *French Drawings from American Collections*, 1959, no. 30, repr.; Musée du Louvre, Paris, *Nicolas Poussin*, 1960, no. 213.

Acc. no. III,71

Claude Gellée, called Claude Lorrain (French)
CHAMAGNE NEAR MIRECOURT 1600 – 1682 ROME

52 *Landscape with Shepherd and Flock at the Edge of a Wood*

Pen, brush and brown ink, over graphite
8 7/16 × 13 inches (217×330 mm.)
Watermark: none
Signed and dated in pen and brown ink on the verso, *Claudio Gellée / fecit et inventor / Roma 1645*

Without question Claude was one of the most celebrated landscape painters of all time. Like Poussin, he left France as a very young man and lived most of his life in Rome. His drawings, many of which found their way into English collections, as witness the vast holdings numbering more than five hundred sheets in the British Museum, have had a profound influence on generations of subsequent artists; Turner, to mention but one example, aspired to be as great as Claude. Although some scholars look upon him as an Italian artist by reason of his having spent the greater part of his life in Rome, Claude's romantic orientation to the Italian landscape is basically Northern in temperament, recalling the work of other Northerners in Rome, notably Elsheimer and Bril, rather than that of the more academic Italian landscape artists such as the Carracci. There is magic in his pen combined with subtlety and expressive power akin to that of Rembrandt. Until the Odescalchi album came to this country, the group of fifteen or so drawings in the Morgan Library was the most extensive on this side of the Atlantic.

Sandrart, the artist and writer who was Claude's friend, tells us that during the early years in Rome, Claude roamed the Campagna, painting and sketch-

ing from dawn until dark. His account is supported by the evidence of many drawings especially those of the late 1630's and early 1640's, which are direct observations of nature, some with identifiable views around Tivoli, Frascati, the Lake of Nemi, and Subiaco.

The drawing shown here belongs to another large category of Claude's drawings, the studio composition. Nevertheless, the elements which he invented are here arranged to create a mood of idyllic tranquillity and demonstrate the strength of his ability to render effects of massed foliage and marked contrasts of light and shade, evoking the long shadows of late afternoon and the fading prospect of distant hills.

PROVENANCE: Rev. Henry Wellesley (1791–1866), Oxford; his sale, London, Sotheby's, 25 June – 10 July 1866, lot 664; Charles Fairfax Murray; J. Pierpont Morgan (no mark; see Lugt 1509).

BIBLIOGRAPHY: Fairfax Murray, III, no. 82, repr.; A. M. Hind, *Drawings of Claude Lorrain*, 1925, p. 11; Eckhart Knab, "Die Zeichnungen Claude Lorrains in der Albertina," *Alte und Neue Kunst*, II, no. 4, 1953, p. 146, under no. 17; Knab, "Der heutige Bestand an Zeichnungen Claude Lorrains im Boymans Museum," *Bulletin Museum Boymans*, VII, no. 4, 1956, p. 112; Bernard Berenson, *Seeing and Knowing*, Greenwich, Conn., 1968, repr. p. 86; Marco Chiarini, *Claudio Lorenese Disegni*, Florence, 1968, pl. XLVIII; Roethlisberger, *Drawings*, 1968, I, no. 592, II, repr.

EXHIBITIONS: New York Public Library, *Morgan Drawings*, 1919; Morgan Library, *Landscape Drawings*, 1953, no. 25, pl. VII; Morgan Library, and elsewhere, *Fiftieth Anniversary*, 1957, no. 94, repr.; Munson-Williams-Proctor Institute, Utica, New York, *Masters of Landscape: East and West*, 1963, no. 27, repr.

Acc. no. III,82

and wash with no fine detail work at all visible. The idealized setting with the group of figures preceded by musicians crossing a bridge is quite similar to that in Claude's painting *The Temple of Apollo at Delphi*, Galleria Doria-Pamphili, Rome (repr. Roethlisberger, *Paintings*, 1961, II, fig. 207), a connection which was first observed by Eckhart Knab. While acknowledging the basic correspondence of setting between the painting and the drawing, Marcel Roethlisberger believes that the proportions and overall effect are so different in the two works that the precise relation of one to the other is obscure. This very lovely drawing must date around 1650, the date of the painting. Although the Morgan sheet may not be considered precisely preparatory for the painting, the artist must certainly have had this composition in mind when he made the drawing, perhaps as a variation on the theme.

PROVENANCE: Sir Charles Greville (Lugt 549); George Guy, fourth Earl of Warwick (Lugt 2600); his sale, London, Christie's, 20 May 1896, lot 74; Charles Fairfax Murray; J. Pierpont Morgan (no mark; see Lugt 1509).

BIBLIOGRAPHY: Fairfax Murray, III, no. 76, repr.; Eckhart Knab, "Die Zeichnungen Claude Lorrains in der Albertina," *Alte und Neue Kunst*, II, no. 4, 1953, p. 146, under no. 18; Knab, "Der heutige Bestand an Zeichnungen Claude Lorrains im Boymans Museum," *Bulletin Museum Boymans*, VII, no. 4, 1956, p. 112; Roethlisberger, *Paintings*, 1961, p. 295; Knab, *Studies in Western Art*, III, Princeton, 1963, p. 114; Roethlisberger, *Drawings*, 1968, I, no. 683b, II, repr.

EXHIBITIONS: New York Public Library, *Morgan Drawings*, 1919; Albright Art Gallery, *Master Drawings*, 1935, no. 46, repr.; Lyman Allyn Museum, *Drawings*, 1936, no. 56.

Acc. no. III,76

53 *Landscape with Procession Crossing a Bridge*

Black chalk and graphite with brush and brown wash on paper tinted a pinkish brown

7⅞ × 10½ inches (200 × 266 mm.)

Watermark: six pointed star

Inscribed on the verso in pen and brown ink, *IVR Claude Gelee*

The poetic beauty of this work may be due in part to the dark silhouetting of the trees and figures against the luminous pinkish-brown background, the effect of which is enhanced by the execution of the forms only in soft black chalk

54 *Apollo Watching the Herds of Admetus*

Pen and brown ink, brown wash, heightened with white tempera, over preliminary indications in black chalk; the piper (Apollo), cattle, and foliage in foreground, partially picked out in fine pen and black ink

8½ × 11⁄₁₆ inches (216 × 282 mm.)

Watermark: none visible through lining

Inscribed at bottom right in pen and brown ink, *Claudio Gillee invenit fecit Roma 1663*

The scene depicted here, a favorite subject of the artist, is taken from Ovid. The story is straightforward and needs little elucidation. Apollo, in the

guise of a shepherd, is set to guard the herds of Admetus. While Apollo is absorbed in his piping, the herd strays, enabling Mercury, seen in the left background, to steal them. Although Claude painted this subject twice in 1660 and again in 1666 in the paintings in the Wallace Collection, London, and in the collection of Major-General E. H. Goulburn, there is no relation between these works and the Morgan drawing which Claude himself dated 1663. The refinement of the artist's execution of the drawing in complex media is unusually effective. What sets it apart from the conventional is that particular lyric quality by which Claude was able to invest ordinary landscape with poetry, raising it above the level of the naturalistic and placing it in the realm of art.

PROVENANCE: Jonathan Richardson, Jr. (Lugt 2170); H. C. Jennings (Lugt 2771); Charles Fairfax Murray; J. Pierpont Morgan (no mark; see Lugt 1509).

BIBLIOGRAPHY: Fairfax Murray, I, no. 271, repr.; Eckhart Knab, "Die Zeichnungen Claude Lorrains in der Albertina," *Alte und Neue Kunst*, II, no. 4, 1953, p. 154; Knab, "Der heutige Bestand an Zeichnungen Claude Lorrains im Boymans Museum," *Bulletin Museum Boymans*, VII, no. 4, 1956, p. 121, 122, note 29; Roethlisberger, *Paintings*, 1961, p. 402; Roethlisberger, *Drawings*, 1968, I, no. 896, II, repr.

EXHIBITION: Stockholm, *Morgan Library gästar Nationalmuseum*, 1970, no. 51, repr.

Acc. no. I,271

55 Landscape with Aeneas and Achates Hunting the Stag

Pen and brown ink, washed with brown and heightened with white; divided into quadrants in black graphite
9⅞×13⅞ inches (251×353 mm.)
Watermark: only partly legible
Signed and dated in lower left foreground, *Claudio inv facit* [sic] / *Roma 1669*. Inscribed on old mount, in pen and brown ink, in Roupell's hand, *RPR* / *Claude* / *one of the fifty drawings selected by Messrs Woodburn for Exhibition in 1835–* / *It forms no 28 of the Claude drawings from Sir T. Lawrences collection. The* / *description in this Catalogue is as follows.* / *"Landscape. a rich woody and rocky scene near the ocean—on the right an Eminence* / *" crowned with trees and a Sybils Temple – In the centre on a platform of rock near* / *"a large tree Aeneas accompanied by Achates is seen shooting at the herd of deer in the* / *"valley – The ships of Aeneas are seen at anchor in the creek – a most magnificent* / *"composition. free pen and bistre wash – Superb."* / *From collections of the Marquis Vindé – Sir T. Lawrence* / *Mr Esdaile.*

Marcel Roethlisberger has observed that of all the classical themes which Claude depicted, there are only two hunting subjects: those involving Aeneas and his son Ascanius. The elaborate drawing of 1669 shown here is regarded as one of Claude's preparatory drawings for the painting of *Aeneas Hunting* in the Musée des Beaux-Arts, Brussels (repr. Roethlisberger, *Paintings*, 1961, II, fig. 294) which was not actually executed by the artist until 1672. Although Claude apparently thought of the Morgan drawing—which is exceedingly detailed in its fine penwork and has been divided into quadrants for transfer—as his final preparation for the painting, he was to revise the composition extensively during the intervening three years. Three other drawings, a figure study in the Metropolitan Museum of Art and two other full compositional drawings, are preparatory for the Brussels painting. There is a fine painterly quality to the Morgan sheet which is worked up in many subtle gradations of grays and browns, conveying a sense of pervasive atmosphere. Aeneas is seen with his companion Achates on a rocky platform shooting at the herd of deer in the valley below. At the left, in the middle distance, Claude has given a glimpse of the harbor with Aeneas' fleet and a rock arch, beyond which the distant horizon of open sea is indicated.

PROVENANCE: Paignon-Dijonval (1708–1792), Paris; Charles-Gilbert, Vicomte Morel de Vindé (according to Roupell's inscription on mount; no mark; see Lugt 2520); Samuel Woodburn (no mark; see Lugt 2584); Thomas Dimsdale (Lugt 2426); Sir Thomas Lawrence (Lugt 2445); Samuel Woodburn; William Esdaile (Lugt 2617); his sale, London, Christie's, 30 June 1840, lot 61 (to Hodgson for £21); Rev. Henry Wellesley (1791–1866), Oxford; his sale, London, Sotheby's, 25 June – 10 July 1866, lot 1241; Robert P. Roupell (Lugt 2234); his sale, London, Christie's, 12–14 July 1887, lot 1283; Alphonse W. Thibaudeau; his sale, London, Sotheby's, 9–13 December 1889 (sold for £9 10s); Charles Fairfax Murray; J. Pierpont Morgan (no mark; see Lugt 1509).

BIBLIOGRAPHY: M. Bénard, *Cabinet de M. Paignon Dijonval: État détaillé et raisonné des dessins et estampes . . .*, Paris, 1810, no. 2597; Fairfax Murray, I, no. 273, repr.; Eckhart Knab, "Der heutige Bestand an Zeichnungen Claude Lorrains im Boymans Museum," *Bulletin Museum Boymans*, VII, no. 4, 1956, p. 126 and note 38; Roethlisberger, *Paintings*, 1961, p. 425; Marco Chiarini, *Claudio Lorenese Disegni*, Florence, 1968, pl. LXVII; Roethlisberger, *Drawings*, 1968, I, no. 990, II, repr.

EXHIBITIONS: Royal Academy of Arts, London, *The Lawrence Gallery: Third Exhibition*, 1835, no. 28; Morgan Library, New York World's Fair, 1939, no. 93; Morgan Library, *Landscape Drawings*, 1953, no. 22; Hartford, *Pierpont Morgan Treasures*, 1960, no. 76.

Acc. no. I,273

Paul Bril

ANTWERP 1554 – 1626 ROME

56 *Wooded Ravine with Distant Harbor View*

Pen and brown ink, brown, gray, and blue washes, heightened with white; a few small losses at left margin, one tinted green

7¼ × 10¹³/₁₆ inches (184 × 275 mm.)

Watermark: none visible through lining

Inscribed on verso of the mount, in graphite in an eighteenth-century hand, *No 9 paul bril*; in another hand, *36 frs*

Mariette in his comments in the sale catalogue of the Crozat collection (Paris, 10 April 1741) remarked that Paul Bril's drawings were as much sought after by collectors as his paintings, adding that this explained why some of his drawings are carefully finished works of "belle exécution" ("La réputation de Paul Bril s'accrut à un tel point, que non-seulement on fut curieux de ses tableaux; mais qu'on voulut aussi avoir de ses Desseins. Les principaux amateurs lui en demandèrent avec empressement, & voilà pourquoi l'on en trouve qui sont d'une si belle exécution; car ne les faisant pas pour son Etude particulière, il se donnoit tout le tems qu'il falloit pour les terminer avec soin," pp. 108–09). It is to this category of finished works that the present sheet belongs although it is neither signed nor dated as are a great many of the artist's finished drawings, including a sizable number among the half a hundred sheets in the Cabinet des Dessins at the Louvre. The regard in which the Morgan landscape has justly been held in the past is suggested by the existence of at least two other versions or copies: one formerly in the collections of the Duke of Rutland and Dr. J. G. Adami, was presented in 1919 by the latter to the Montreal Museum of Fine Arts (see Hamilton exhibition catalogue, no. 3, repr.); and a weaker version, undoubtedly a copy, was owned by Charles Duits, London, in 1950 (reproduction in R.K.D.). Furthermore, the Morgan drawing, or one of the other versions, appears to have been engraved, in the reverse, by the Comte de Caylus (1692–1765). At the time Caylus made his engraving his model was, as he indicated in his print, in the Cabinet du Roi with a proper ascription to

Paul Bril. This would seem to mean that earlier the Morgan sheet or an identical replica had belonged to the great collector Eberhard Jabach (1618–1695), originally of Cologne but resident in Paris for nearly sixty years, and it therefore must have been among the drawings that Jabach sold to Louis XIV in 1671. One cannot overlook the fact, however, that Jabach is known to have had copies made of some of the originals he owned (Roseline Bacou in *Collections de Louis XIV*, Orangerie des Tuileries, Paris, 1977, pp. 17–18; in at least one instance the original of a drawing he had sold to the King was found in his possession after his death). This may possibly be the explanation for the existence of one or more of the versions of the Morgan drawing noted above.

The drawing, in its general compositional scheme, particularly the left half with the arched bridge over a winding river, the round tower, and rocky mountains, has much in common with *Landscape with St. Jerome*, a small painting on copper, formerly in the collection of J. C. Morris, London, and later sold at Sotheby's (26 March 1969, lot 82, repr.). This painting is signed with Bril's monogram and dated 1592, and it could well be that the Morgan sheet also originated in the last decade of the sixteenth century since its ornamental Mannerist character is so pronounced. The great tree at the left with its tangle of exposed roots and vines winding up its trunk and all its fellows whose varying silhouettes act as a repoussoir in so many of Bril's landscape compositions may go back to the large British Museum drawing of a single noble specimen most likely studied from nature (Popham, *Dutch and Flemish Drawings*, 1932, V, p. 137, no. 3). A drawing attributed to Maerten de Cock in the Museum Boymans–van Beuningen at Rotterdam incorporates the left half of the Morgan composition.

PROVENANCE: Presumably Eberhard Jabach (possibly trace of his paraph at lower center edge; Lugt 2959–60): possibly Cabinet du Roi, i.e., Louis XIV (according to engraving by Caylus); Charles Fairfax Murray; J. Pierpont Morgan (no mark; see Lugt 1509).

BIBLIOGRAPHY: Fairfax Murray, III, no. 144, repr.; Art Gallery of Hamilton, Hamilton, Ontario, *Man and Nature: A View of the Seventeenth Century*, exhibition catalogue by Glenn T. Scott, 1980, under no. 3.

EXHIBITIONS: Morgan Library, *Landscape Drawings*, 1953,

no. 51, repr.; Hartford, *Pierpont Morgan Treasures*, 1960, no. 71; Morgan Library, and elsewhere, *Rubens and Rembrandt in Their Century*, 1979, no. 2, repr.

Acc. no. III,144

David Vinckboons (Flemish)
MALINES 1576 – 1632 AMSTERDAM

57 *Landscape with Susanna and the Elders*
Apocrypha, History of Susanna 12–64

Pen and brown ink, gray and blue washes; outlines incised with the stylus for transfer
14⅛ × 19¹¹⁄₁₆ inches (359 × 500 mm.)
Watermark: fleur-de-lis

Like a number of Vinckboons' drawings, this one was made with an engraving in view. It is part of a series of large, elaborately worked landscapes with small-scale biblical scenes that were engraved by Jan van Londerseel (1570/75–1624/25), who worked extensively after Vinckboons' designs. Hollstein (XI, pp. 100–102) lists around two dozen subjects which Van Londerseel reproduced after Vinckboons for popular distribution.

The Morgan drawing is particularly diverting in its representation of an early seventeenth-century formal garden with its parterres, its arbors and trellises, and its fountains. The variety of birds and animals brings to mind Carel van Mander's report that Vinckboons, still a young man at the time of the publication of the *Schilderboeck* in 1604, "made miniatures of such subjects as small animals, birds, fish, and trees which he did from life." The peacocks, the swans, and the turkey that are so at home in Susanna's garden may well have been first studied in such miniatures, and the same was perhaps true of the less exotic creatures like the stag, the rabbits, and the goats. The stag, it is interesting to note, was replaced by a doe in Van Londerseel's print, possibly with iconographic intent just as the mating rabbits may be a deliberate reference to the implications of the subject of Susanna and the Elders. The female satyrs of the fountain and the herms of the pergola would also seem to be allusive as well as orna-

mental in their presence. Van Londerseel's engraving (Hollstein, XI, p. 100, no. 7), which is in the reverse of the drawing, follows the drawn design very faithfully in the first two states with the exception of the change of the stag to a doe and the addition of another tree on that side of the composition; the engraver did, however, allow himself one small and unsuccessful liberty in attempting to show the full spread of the turkey's tail from the back without altering its profile pose and also chose, for reasons of his own, to add a beard to one of the female satyrs. There was a major change, however, in the third state of the engraving where the group of Susanna and the Elders has been transformed into Bathsheba at the Fountain, a contingency perhaps anticipated in the presence of a figure on the balcony of the château in the Morgan drawing. Such a figure would then be identified as David. Other comparable large Vinckboons drawings, with small biblical scenes, which were engraved by Van Londerseel are the *Healing of the Man Born Blind*, Rijksmuseum, Amsterdam (Inv. no. 1948:30. L. C. J. Frerichs, *Keuze van tekeningen bewaard in het Rijksprentenkabinet*, Amsterdam, 1963, no. 36, repr.; see Hollstein, XI, p. 101, no. 24, where the subject is changed to *Healing of the Man Possessed of a Devil*); *Temptation of Christ*, Kunsthalle, Hamburg (Inv. no. 22648. Konrad Renger in exhibition catalogue, Berlin, *Pieter Bruegel*, 1975, no. 279, pl. 306; Hollstein, XI, p. 101, no. 17); *Agony in the Garden*, British Museum (Inv. no. 1930.4.14.5. Goossens, *Vinckboons*, 1954, p. 31, fig. 15; Hollstein, XI, p. 101, no. 26); *Three Marys at the Tomb*, British Museum (Inv. no. 1946.7.13.135. Goossens, *Vinckboons*, 1954, p. 32, fig. 16); *Christ and His Disciples on the Way to Emmaus*, Fondation Custodia, Institut Néerlandais, Paris (Inv. no. 1972-T.1. New York–Paris, *Rembrandt and His Century*, 1977–1978, no. 118, pl. 29; Hollstein, XI, p. 101, no. 28). Of these drawings, only the Amsterdam example is dated (1601), but it seems plausible that the entire series was produced around the same time, surely within the same decade. There is a small drawing of Bathsheba, signed with the monogram and dated 1618, in an album in the Kupferstichkabinett, Berlin (Robert Oertel, "Ein Künstlerstammbuch vom Jahre 1616," *Jahr-*

buch der Preussischen Kunstsammlungen, LVII, 1936, p. 101, fig. 3), but it does not appear to have any connection with the change of subject in the third state of Van Londerseel's print.

The artist's draughtsmanship is represented in the Library's collection by two other watercolor drawings; see 1979 catalogue, nos. 8, 9, repr.

PROVENANCE: Private collection, Belgium; Clifford Duits, London; H. Terry-Engell Gallery, London; Sven Gahlin, London; Seiferheld & Co., New York.

BIBLIOGRAPHY: Morgan Library, *Fourteenth Report to the Fellows, 1965 & 1966*, 1967, pp. 115–116; Morgan Library, *Review of Acquisitions 1949–1968*, 1969, p. 175; New York–Paris, *Rembrandt and His Century*, 1977–1978, under no. 118.

EXHIBITIONS: Morgan Library, *Major Acquisitions, 1924–1974*, 1974, no. 40, repr.; Morgan Library, and elsewhere, *Rubens and Rembrandt in Their Century*, 1979, no. 7, repr.

Acc. no. 1964.6
Purchased as the gift of the Fellows

Peter Paul Rubens (Flemish)

SIEGEN, GERMANY 1577 – 1640 ANTWERP

58 *Study for the Portrait of Marchesa Brigida Spinola Doria*

Pen and brown ink, occasionally point of brush, brown wash, preliminary indications in black chalk; also further work in black chalk; crease at upper center; loss at lower right corner and also along right margin

12⁷⁄₁₆×7⁷⁄₁₆ inches (315×178 mm.)

Watermark: none

Inscribed by the artist in pen and brown ink: on cornice, *gout* (gold; formerly read as *hout* [wood]); below first capital, *goudt* (gold); on curtain, *Root* (red)

Very few compositional sketches establishing the pose and costume, and sometimes the setting for a painted portrait, have survived among Rubens' drawings. This full-length study is one such rare example and is further unusual in that it relates to his activity as a portraitist in Genoa, a period for which drawings of any kind are in short supply. As L. Baldass was the first to note (according to Burchard, 1950), the drawing is preparatory for the radiant painting of the Marchesa Brigida Spinola Doria, now in the Kress Collection, National Gallery, Washington, D.C. (see Eisler, pp. 101ff., figs. 95–96), which bears an inscription on the

verso giving the name and age (22) of the sitter and the date 1606. The Marchesa, baptized on 9 May 1583, was married on 9 July 1605 to her cousin Giacomo Massimiliano Doria after the granting of the requisite papal dispensation for consanguinity. The resplendent white satin gown in which she is portrayed in the Washington picture has given rise to the surmise that she may have been represented in her wedding finery, the portrait conceivably having been commissioned in connection with her marriage in the summer of 1605, but delayed in completion until 1606.

Norris, followed by Held and Müller Hofstede, suggested that the head in the drawing shows the countenance of an older attendant of the young Brigida who relieved her mistress of the chore of posing, but the pretty painted face for all its polished elegance and perfection of contour still shares an intangible kinship of expression with the quickly indicated countenance of the drawing. Irregularities of contour which suggest age are possibly little more than the accidents of the swiftly moving pen, which similarly did not pause to regularize the outlines of architectural detail. Perhaps, as Jaffé remarks, "the face in the drawing could be Brigida's own, not yet glamourized for the painting."

Whether or not Brigida or a lady-in-waiting posed for Rubens, he undoubtedly must have made a separate true portrait study of the young woman's head, very likely in the red and black chalk of the life-size likenesses of the young Gonzaga princes, the drawings now in Stockholm, made in 1604. It was in black chalk that the artist first plotted the outlines of the Morgan figure and setting before taking up his pen and then his brush, and somewhere along the way perhaps again using chalk to shade certain areas. Occasionally, as in the detail of foliage, he drew hastily with the point of the brush. Within this mix of chalk, ink, and wash, all suggestive of speed in their application, he brought into focus the volume of the stately figure and even managed to convey textures. If the young woman did not pose for Rubens on the terrace off the *piano nobile* of the Doria Palace, it is surroundings of comparable grandeur that the artist obviously suggests. In his essay on Rubens' portrait paintings in Italy, in the

catalogue of the 1977 exhibition in Cologne, Müller Hofstede remarks that, as far as he knows, none of the architectural motives in the Genoese portraits can be specifically identified (p. 75, note 26). It is nevertheless puzzling that Rubens should have bothered to designate the color of the gold capital and cornice, and to describe the curtain as red if he himself were, so to speak, the designer of the painted architecture. Rubens' interest in Genoese architecture is, of course, well known through his publication *Palazzi antichi di Genova, palazzi moderni di Genova*, Antwerp, 1622. Eisler (p. 102) calls attention to the fact that an early nineteenth-century print of the palace (1818) shows urns similarly placed on a balustrade on a terrace of the *piano nobile* of a wing added by the Spinola to the Doria Palace that might be compared with the similar feature in the drawing (see Pasquale Rotonda, *Il Palazzo di Antonio Doria a Genova*, Genoa, 1958, p. 194, fig. 137). On the whole the drawing and painting are remarkably close, but one very noticeable omission in the drawing is the lack of any hint of the gown's numerous jeweled fasteners on the sleeves, bodice, and skirt, and the heavy rope of jewel-studded ornament worn baldric fashion, or the striping of the undersleeves, and the hair ornaments. All ornament is also lacking in the related "*modello*" drawing in the École des Beaux-Arts, Paris, which Müller Hofstede first published in 1965 in the Baden-Württemberg yearbook (p. 110) as an anonymous copy after Rubens but wishfully upgraded as an original in the recent Cologne catalogue (no. 40). Presumably the representation of the ornaments would have been undertaken at some stage in the actual execution of the painting.

The Kress painting unfortunately has been cut down, but the drawing, like the lithograph made after the uncut painting in 1848 by Pierre-Frédéric Lehnert (Eisler, text fig. 21), preserves the full composition. The lithograph shows slightly more of the composition at the left and at the lower edge than the drawing, which has itself probably been slightly trimmed at the lower edge and two sides. Where the drawing shows only six vase forms or balusters in the balustrade, for example, there are seven indicated in the lithograph. The lithograph reveals that the painting

originally bore at lower left the inscription BRIGIDA SPIVOLA [sic] DORIA / ANN: SAL: 1606 / AET. SUAE 22, and when the painting was cut down this information was apparently transferred to the verso much to the advantage of future art historians.

PROVENANCE: Mario Uzielli, Switzerland; Dr. Edmund Schilling, London (acquired in Paris); private collection, New York (acquired from Schilling in the 1950's).

BIBLIOGRAPHY: Christopher Norris, "Rubens in Retrospect," *Burlington Magazine*, XCIII, 1951, pp. 4 and 7, repr.; Julius S. Held, "Rubens' Pen Drawings," *Magazine of Art*, XLIV, 1951, p. 286; Michael Jaffé, "A Sheet of Drawings from Rubens' Second Roman Period and His Early Style as a Landscape Draughtsman," *Oud Holland*, LXXII, 1957, pp. 2 and 6, fig. 4; Held, *Selected Drawings*, London, 1959, pp. 32 and 127, no. 73, pl. 84; Justus Müller Hofstede, "Bildnisse aus Rubens' Italienjahren," *Jahrbuch der staatlichen Kunstsammlungen im Baden-Württemberg*, II, 1965, pp. 110–111, fig. 64; Bernhard, *Rubens*, 1977, pp. 33 and 185, repr.; Christopher Brown, *Dutch and Flemish Painting*, Oxford, 1977, no. 12, repr.; Colin Eisler, *Paintings from the Samuel H. Kress Collection: European Schools Excluding Italian*, Oxford, 1977, pp. 101–103, note 5, text fig. 20; Michael Jaffé, *Rubens and Italy*, Oxford, 1977, pp. 77 and 115, note 22, fig. 261; Frances Huemer, *Portraits*, I, Corpus Rubenianum Ludwig Burchard, XIX, Brussels, 1977, p. 170, no. 41a, fig. 121; Palazzo Ducale, Genoa, *Rubens e Genova*, 1977–1978, pp. 152, 176 note 23, 187 fig. 56; Morgan Library, *Eighteenth Report to the Fellows*, 1975–1977, 1978, pp. 243, 290–291, pl. 13.

EXHIBITIONS: Wildenstein and Co., London, *A Loan Exhibition of Works by Peter Paul Rubens*, catalogue by Ludwig Burchard, 1950, no. 55, repr.; London, *Rubens*, 1977, no. 29, repr.; Wallraf-Richartz-Museum, Cologne, *Peter Paul Rubens, Katalog I, Rubens in Italien*, catalogue by Justus Müller Hofstede, 1977, no. 39, repr.; Morgan Library, and elsewhere, *Rubens and Rembrandt in Their Century*, 1979, no. 10, repr.

Acc. no. 1975.28
Gift of a Trustee

59 *Seated Nude Youth*

Black chalk heightened with white tempera on light gray paper
19¹¹/₁₆ × 11¾ inches (500 × 299 mm.)
Watermark: serpent?

Rubens' gifts as a draughtsman find most eloquent expression in his large-scale chalk studies which are preparatory for the figures of his paintings. Happily, they constitute a large section of the surviving drawn *oeuvre*. Such studies, usually from the model, were executed to fix and refine details of figure and costume after the overall

composition had been worked out in exploratory sketches in pen and wash or in a fluid oil sketch. In some cases these studies were intended for the use of workshop assistants who frequently carried out the master's designs in great part, but they were also a stage in Rubens' customary working procedure when he was executing a painting in its entirety, especially in his earlier periods. The figure of Daniel was definitely a drawing for his own guidance. The superb study of a powerful youth, with his eyes upturned in supplication and his hands locked in prayer, was employed for the principal figure in the painting *Daniel in the Lions' Den*, formerly in the Hamilton Palace collection (sale, London, Christie's, 6–7 November 1919, no. 57) and since 1966 in the National Gallery, Washington, D.C. The painting was specifically described by the artist in his famous letter of 18 April 1618, addressed to Sir Dudley Carleton, the English diplomat and connoisseur, in connection with the negotiations for the exchange of Carleton's collection of antique marbles for paintings by Rubens: "Daniel in the midst of many lions, done from nature; original work entirely by my hand" (Ruth Magurn, *The Letters of Peter Paul Rubens*, Cambridge, Massachusetts, 1955, p. 60). Since details of the painting appear in Jan Brueghel's *Noah and his Family Leading the Animals into the Ark* in the Wellington Museum, Apsley House, London, which is signed and dated 1615 (Jaffé, 1970, pp. 8–9, fig. 2) and also figure in Brueghel's *Allegory of Sight* of 1617 in the Prado, it is assumed that the preparatory drawings for the National Gallery painting were made around 1614–1615.

While Rubens surely drew the Morgan figure from life, it may well be, as Jaffé remarked, that he posed his model with clasped hands and crossed legs on the inspiration of the figure of St. Jerome in a drawing at the Louvre by the sixteenth-century Italian artist Girolamo Muziano (Lugt, *École flamande, Louvre*, 1949, II, no. 1219); this sheet, a study for the altarpiece of the *Penitent St. Jerome*, Bologna, is a drawing that he might himself have owned, or equally he may have known and owned the print *St. Jerome in the Wilderness* (1573) by Cornelis Cort after Muziano (Le Blanc, II, p. 52, no. 102).

The young long-haired studio model, who may perhaps be recognized in other studies as distinct from an older short-haired model, is here invested with extraordinary physical vitality and, at the same time, imbued with the intensity of feeling—tellingly focused in the upturned face and the strong, blunt-fingered hands—that the Bible story demands. The figure called forth a tribute from the late Ludwig Burchard, the distinguished Rubens specialist who was a scholar not given to superlatives. When he saw the drawing in the original for the first time, he remarked, "it is the highest one could desire in a Rubens drawing." The other drawings which have been connected with the National Gallery's painting are all studies of lions, the most celebrated of which are the two in the British Museum (Glück-Haberditzl, nos. 98–99). A drawing of a sleeping lion, executed in black chalk, that recently entered the Morgan collection is believed by Michael Jaffé to be another study for the Rubens painting (see 1979 catalogue, no. 13, repr.).

PROVENANCE: William Bates (Lugt 2604); his sale, London, Sotheby's, 19 January 1887, probably part of lot 337, "P. P. Rubens. Various Studies and Sketches (7)" (to Robinson for £1.8) or possibly part of lot 242, "Large Drawings by Old Masters (12)" (to Robinson for £1.18); Sir John Charles Robinson; by exchange, 3 March 1890, to Charles Fairfax Murray (according to his autograph manuscript notebooks, University of Texas, Austin); J. Pierpont Morgan (no mark; see Lugt 1509).

BIBLIOGRAPHY: Émile Michel, *Rubens: Sa vie, son oeuvre et son temps*, Paris, 1900, p. 190; Fairfax Murray, I, no. 232, repr.; Glück-Haberditzl, 1928, p. 41, no. 97, repr.; Goris-Held, *Rubens in America*, 1947, p. 41, no. 95, repr.; Tietze, 1947, p. 122, no. 61, repr.; Agnes Mongan *et al.*, 1949, p. 70, repr.; Julius S. Held, *Peter Paul Rubens*, Library of Great Painters, New York, 1953, p. 10, repr.; Michael Jaffé, "Rubens en de Leeuwenkuil," *Bulletin van het Rijksmuseum*, III, no. 3, 1955, p. 64, fig. 8; Ruth S. Magurn, *The Letters of Peter Paul Rubens*, Cambridge, Mass., 1955, p. 441, letter 28, note 2; Held, *Selected Drawings*, 1959, I, no. 85, II, pl. 95; *Great Drawings of All Time*, II, 1962, no. 527, repr.; Burchard-d'Hulst, 1963, II, no. 110, repr.; Achilles Stubbe, *Peter Paul Rubens*, New York, 1966, p. 86, repr. p. 38; Michael Jaffé, "Some Recent Acquisitions of Seventeenth-Century Flemish Painting," *National Gallery of Art: Report and Studies in the History of Art, 1969*, Washington, D.C., 1970, p. 17, fig. 18; Bernhard, *Rubens*, 1977, p. 283, repr.; Cecile Kruyfhooft and Simone Buys, "P. P. Rubens et la peinture animalière," *Zoo Antwerpen*, 1977, p. 67, repr. p. 14.

EXHIBITIONS: Detroit Institute of Arts, Detroit, *An Exhibition of Sixty Paintings and Some Drawings by P. P. Rubens*, 1936, section V, no. 4; Worcester Art Museum, Worcester, Mass.,

Art of Europe during the XVIth–XVIIth Centuries, 1948, no. 41; Fogg Art Museum, *Seventy Master Drawings*, 1948, no. 30; Philadelphia, *Masterpieces*, 1950, no. 51, repr.; Cambridge–New York, *Rubens*, 1956, no. 14, repr.; Morgan Library, and elsewhere, *Fiftieth Anniversary*, 1957, no. 90, repr.; Wildenstein and Co., New York, *Masterpieces*, 1961, no. 66, repr.; Princeton, *Rubens before 1620*, 1972, pp. 140 and 168, no. 12, repr.; London, *Rubens*, 1977, no. 69, repr.; Morgan Library, and elsewhere, *Rubens and Rembrandt in Their Century*, 1979, no. 12, repr.

Acc. no. I,232

60 Studies for "The Descent from the Cross"

Mark 15:42–46

Pen and brown ink, brown wash, and occasionally point of brush, on light brown paper
Verso: Full-length figure of St. Andrew; slight indication of a head in black chalk
13 9/16 × 9 1/16 inches (345 × 233 mm.)
Watermark: none
Numbered in brown ink at upper right, *3*; in graphite at lower left in a more modern hand, *6*; in graphite on verso at lower left, *2*

Nowhere are Rubens' thought processes in the evolution of a composition better illustrated than in the intricate web of line and wash on this single sheet. Julius Held has logically analyzed this fascinating complex, showing the sequence in which Rubens most likely developed his ideas. He points out that the artist must have begun with the sketch of the isolated head of Christ now visible upside down in the lower left quadrant, then for reasons of his own turned the sheet in the opposite direction and drawn the group of Christ and the two women, giving, even at this early stage of invention, beautiful expression to the emotion of the woman supporting the upper body of the Christ. One observes that this time Rubens was careful to place the head of Christ nearer the upper margin of the sheet to allow more space for the full group, but in the end he was still short of space and was compelled to work on a smaller scale in the final version at the lower right, where he added the cross and the three male figures on ladders.

It was this last solution of the problem that the artist employed in the main for the picture now

at the Hermitage in Leningrad (Oldenbourg, *Rubens, Klassiker der Kunst*, 1921, no. 90), one of the two paintings of the subject to which the recto of the drawing is related. In the Leningrad painting, a work in which Rubens' studio participated, the female figure on the left stands rather than kneels and the horizontal member of the cross is missing, but the three men and the ladders appear much as indicated in the drawing though the youthful St. John is substituted for the bearded St. Joseph of Arimathaea on the ladder at the right. Sir Karl Parker was the first to connect the drawing not only with the Leningrad painting but also with the painting in the museum at Lille (Oldenbourg, no. 89; Grand Palais, Paris, *Le Siècle de Rubens*, 1977–1978, pp. 201–202, no. 53, repr.), a studio work known to have been in progress in March 1617. There the relationship is primarily in the figure of the Christ, which, although in the reverse direction, is perhaps closer to the figures of the Thaw sheet than is the figure of the Leningrad picture where the head, being supported by St. John, does not fall so far downward. It is interesting in this connection that the figure of Christ is the section of the Leningrad picture worked by Rubens' own hand.

Such dual use of a drawing was not unusual with Rubens and his studio, and in this instance the sheet was put to further service since the verso, as Dobroklonsky first pointed out, bears the impressive preparatory study for the figure of St. Andrew on the outside of the right wing of the triptych of the Miraculous Draught of Fishes in Nôtre Dame au delà de la Dyle, Malines, Belgium, painted for the Fishmongers Guild in 1618–1619 (Oldenbourg, no. 174). The study is the last in a sequence of three related drawings that as a group are also instructive in Rubens' working procedures. The first, in the Staatliche Graphische Sammlung, Munich, is simply a black chalk study from life of a powerful bearded man in a short, heavy tunic, and the second, the sheet in the Statens Museum for Kunst, Copenhagen, carries two black chalk sketches showing the transformation of the model into St. Andrew with his long voluminous robe and x-shaped cross. The likeness of the model still lingers in the head of the Thaw figure, which also retains the position of his left arm and the

empty hand that in the painting holds a fish. The faintly indicated head in black chalk at the top of the sheet and the scarcely visible chalk lines at the back of the saint's head and in the area of the left foot show that Rubens began this drawing in the same medium as that of the Munich and Copenhagen sheets.

In view of the drawing's connection with these several paintings and the consistency of style on recto and verso, it has been possible to place it with reasonable confidence in the years 1617–1618.

PROVENANCE: Mrs. G. W. Wrangham; Edward Wrangham; Baskett & Day, London.

BIBLIOGRAPHY: Karl T. Parker, "Some Drawings by Rubens and His School in the Collection of Mrs. G. W. Wrangham," *Old Master Drawings*, III, June 1928, pp. 1–2, pl. I; M. V. Dobroklonsky, "Einige Rubenszeichnungen in der Eremitage," *Zeitschrift für bildende Kunst*, LXIV, 1930–1931, p. 32; Karl T. Parker, "Peter Paul Rubens (1577–1640): Study of a Standing Man," *Old Master Drawings*, XI, December 1936, pp. 50–51, pl. 46; Hans G. Evers, *Rubens und sein Werk*, Brussels, 1943, p. 137, pl. 45; Rubenshuis, Antwerp, *Tekeningen van P. P. Rubens*, exhibition catalogue by Ludwig Burchard and Roger-A. d'Hulst, 1956, under no. 65; Held, *Selected Drawings*, 1959, I, p. 22, II, p. 109, under no. 36, no. 42, pl. 39; Burchard-d'Hulst, 1963, pp. 160–161, under no. 96; Julius S. Held, "Some Rubens Drawings—Unknown or Neglected," *Master Drawings*, XII, 1974, pp. 252–253; M. Varshavskaya, *Rubens' Paintings in the Hermitage Museum*, Leningrad, 1975, pp. 104–113, under no. 14, repr. p. 108; Anne-Marie Logan, "Rubens Exhibitions 1977," review, *Master Drawings*, XV, 1977, p. 409, cat. no. 146.

EXHIBITIONS: Baskett & Day, London, *Exhibition of Drawings*, 1972, no. 8, repr.; Morgan Library, and elsewhere, *Drawings from the Thaw Collection*, 1975, no. 11, repr.; Koninklijk Museum voor Schone Kunsten, Antwerp, *P. P. Rubens Paintings – Oil Sketches – Drawings*, 1977, no. 146, repr.; Morgan Library, and elsewhere, *Rubens and Rembrandt in Their Century*, 1979, no. 14, repr.

Mr. and Mrs. Eugene V. Thaw
Promised gift to The Pierpont Morgan Library

61 *Angel Blowing a Trumpet, Facing Right*

Black chalk, heightened with white tempera, some lines partially accented in pen and black ink; squared for enlargement in black chalk; old tear at upper right; long vertical crease in right quarter
9¹¹⁄₁₆ × 11³⁄₁₆ inches (245 × 285 mm.)
Watermark: illegible fragment

Rubens' most important commission in Antwerp

was his work for the then new Jesuit church of St. Charles Borromeo. The cornerstone was laid on 15 April 1615 and the church was dedicated on 12 September 1621. Built by the Jesuit architect Pieter Huyssens in succession to François Aguilon and originally dedicated to St. Ignatius of Loyola, the church was famed as one of the most beautiful and opulent of the Jesuit order until the fire of 1718. Rubens' contribution comprised not only the two great paintings for the high altar, now in the Kunsthistorisches Museum, Vienna, and the extensive cycle of thirty-nine ceiling paintings for the aisles and galleries, but designs for the decorative elements of the façade as well. Few preparatory drawings for these extensive projects survive. According to Martin, only two drawings and a handful of oil sketches for the interior cycle are known (Corpus Rubenianum Ludwig Burchard, I, 1968, pp. 33, 37). Drawings connected with Rubens' work for the decoration of the façade are scarcely much more numerous. Burchard-d'Hulst in the 1956 catalogue under no. 67 and in the 1963 catalogue under no. 116 tallies seven in all. The Morgan sheet (preserved together with its pendant, *Angel Blowing a Trumpet, Facing Left*, Acc. no. 1957.1) and the *Cartouche Supported by Cherubs* in the British Museum (Held, *Selected Drawings*, 1959, no. 172, fig. 58) are the most impressive of the group. As Ludwig Burchard was the first to observe some years ago, the Morgan *Angels* served as models for the relief sculptures in the spandrels of the central portal of the church (Held, fig. 60), above which is the relief of the great cartouche with the monogram of Christ (Held, fig. 59) based on the British Museum design. The Morgan sheets, rhythmically drawn in black chalk, are experimentally accented here and there in black ink in successful furtherance of the effect of relief, and in the drawing for the left spandrel Rubens has used a compass to plot the first member of the moldings of the arch. Both drawings, like the London sheet are squared for enlargement, presumably for the purpose of the execution of large-scale cartoons that the sculptor must have required for his guidance. Who the sculptor was is not known for certain. He has been variously identified as Hans van Mildert and as Colijns de Nole (or members of the De Nole

family). Rubens' full-bodied angels, Baroque descendants of the winged victories on the great Roman arches of Constantine and Titus, unfortunately suffered in translation into stone.

The two Morgan drawings were separated for more than two hundred years until in 1957 the angel of the right spandrel was reunited in New York with its companion of the left spandrel. As far as is known, they were last together in the collection of Jonathan Richardson, Sr., the English painter-collector.

Among the Library's drawings by Rubens not included here are designs for the Roman Missal published by the Plantin-Moretus Press (Acc. nos. I,230 and III,183), and studies for a proposed book on antique gems and coins (Acc. no. III,162).

PROVENANCE: Jonathan Richardson, Sr. (Lugt 2184); Charles Fairfax Murray; J. Pierpont Morgan (no mark; see Lugt 1509).

BIBLIOGRAPHY: Fairfax Murray, I, no. 233, repr.; Glück-Haberditzl, 1928, p. 46, no. 128; Goris-Held, *Rubens in America*, 1947, p. 42, no. 106; Julius S. Held, "Drawings and Oil Sketches by Rubens from American Collections," review in *Burlington Magazine*, XCVIII, 1956, p. 123, fig. 25; Michael Jaffé, "Rubens' Drawings at Antwerp," *Burlington Magazine*, XCVIII, 1956, p. 314, note 5; Held, *Selected Drawings*, 1959, I, no. 144, II, pl. 149; Christopher White, *Rubens and His World*, London, 1968, p. 54, repr.; John Rupert Martin, *The Ceiling Paintings for the Jesuit Church in Antwerp*, Corpus Rubenianum Ludwig Burchard, I, Brussels, 1968, pp. 28–29; Frans Baudouin, *Rubens en zijn eeuw*, Antwerp, 1972, p. 104, fig. 59; John Rupert Martin, *The Decorations for the Pompa Introitus Ferdinandi*, Corpus Rubenianum Ludwig Burchard, XVI, Brussels, 1972, p. 102; Konrad Renger, "Rubens dedit dedicavitque: Rubens' Beschäftigung mit der Reproduktionsgrafik," *Jahrbuch der Berliner Museen*, XVI, 1974, p. 140, note 58; Frans Baudouin, *Pietro Pauolo Rubens*, New York, 1977, p. 154, fig. 108; E. Mitsch, *Die Rubenszeichnungen der Albertina*, Vienna, 1977, p. 84, under no. 34.

EXHIBITIONS: Detroit Institute of Arts, Detroit, *An Exhibition of Sixty Paintings and Some Drawings by P. P. Rubens*, 1936, section V, no. 3; Cambridge–New York, *Rubens*, 1956, p. 21, no. 19, repr.; Rubenshuis, Antwerp, *Tekeningen van P. P. Rubens*, catalogue by Ludwig Burchard and Roger-A. d'Hulst, 1956, p. 68, no. 67, repr.; The Newark Museum, Newark, N.J., *Old Master Drawings*, 1960, no. 33a; Allentown Art Museum, Allentown, Penn., *Gothic to Baroque*, 1960, no. 94; Art Department, University of Iowa, Iowa City, *Drawing and the Human Figure, 1400–1964*, 1964, no. 58; Stockholm, *Morgan Library gästar Nationalmuseum*, 1970, no. 60; Princeton, *Rubens before 1620*, 1972, p. 142, no. 14, repr.; London, *Rubens*, 1977, no. 140, repr.; Morgan Library, and elsewhere, *Rubens and Rembrandt in Their Century*, 1979, no. 15, repr.

Acc. no. I,233

Flemish School — Formerly attributed to Rubens
c. 1610

62 *Landscape with Farm Buildings: "[Het] Keysers Hof"*

Pen and brown ink, watercolor in blue, green, yellow, and red, over faint indications in black chalk; old loss at lower edge somewhat to right of center
$9^{1}/_{8} \times 18^{15}/_{16}$ inches (232 × 480 mm.)
Watermark: hunting horn (cf. Briquet 7837–7839)
Inscribed in pen and brown ink at lower left, *P. P. Rubens*; on verso below center, in a seventeenth-century Flemish hand, *dits keyzers hof*

This fresh landscape is among the most brilliant of a group of nine sizable drawings in horizontal format, all representing views of Flemish farms executed in pen and watercolor. Earlier collectors and scholars credited the group to Rubens, accepting the tradition represented by the neatly inscribed "P. P. Rubens" that five of the sheets, the Morgan one included, bear in the lower left corner, but critical opinion in the main now rejects his authorship on the basis of style and a conflict of date. Jaffé and Held further suggest that the drawings, now scattered among the collections of Amsterdam, Antwerp, Berlin, Edinburgh, London, New York, and Paris, may be the work of more than one hand. With one exception each drawing carries on the verso a note of identification in a contemporary Flemish hand, once thought to be Rubens', and including in most instances a date ranging from 1606 to 1610. The sites referred to are all small places near Antwerp, notably Deurne, Ruggeveld, and Zwijndrecht. In connection with the last-named place, Ludwig Burchard, in a lecture in 1926 at the Kunstgeschichtliche Gesellschaft in Berlin, pointed out that Rubens owned property here and elsewhere, some inherited from his mother, and it seemed a plausible assumption that the drawings might record the artist's exploration of the countryside near Antwerp during the years immediately following his return from Italy late in 1608 when he was summoned home by the last illness of his mother.

Just who the unknown Flemish draughtsman was remains a problem. The proposed author-

ship of Jan Wildens has been rejected by Professor Held. Dr. Wolfgang Adler remains convinced that these landscapes are the work of Rubens and discusses them in his recent book on Jan Wildens (*Jan Wildens, der Landschaftsmitarbeiter des Rubens*, Fridingen, 1980, pp. 52ff., no. 231, repr.).

The other drawings of the group are *Het Crayenhof te Zwijndrecht* (1606) in the Rijksprentenkabinet, Amsterdam; *De hoeve bij de luÿthagen* (1609) in the Cabinet des Estampes de la Ville d'Anvers (Musée Plantin-Moretus), Antwerp; *Moated Grange with Bridge-House* (1606) and *De gastes*[?] *hoef duer dueren* (1609) in the Print Room, British Museum; *Baseliers Hof* (1609) and *De hoeve byet ruhgen velt* (1610) in the Kupferstichkabinett, Berlin; *Het huys Bekelaar . . .* (1609) in the Cabinet des Dessins, Musée du Louvre; and *De hoeve bij Swyndrecht* (undated) formerly in the collection of Robert von Hirsch (sale, London, Sotheby's, 21 June 1978, lot 33) and now in the National Gallery of Scotland, Edinburgh. Another drawing, at one time in an English private collection (sale, Amsterdam, Sotheby Mak van Waay, 29 October 1979, lot 152), now belongs to Mrs. Christian H. Aall of New York. In their catalogue of European drawings in the Yale University Art Gallery, Haverkamp-Begemann and Logan attribute the drawing *Meadows and Trees near Duren* (no. 590) to the circle of the draughtsman of this group of drawings whom they refer to as the "Master of the Farm Landscapes." They also make the suggestion that no. 591 of the Yale catalogue is a copy after a lost drawing by the "Master." The most comprehensive summary of all these drawings is that of Mielke and Winner in their recent critical catalogue of the Rubens drawings in the Kupferstichkabinett, Berlin.

PROVENANCE: Sir John Charles Robinson (Lugt 1433); his sale ("Well-Known Amateur"), London, Christie's, 12–14 May 1902, lot 337; Charles Fairfax Murray; J. Pierpont Morgan (no mark; see Lugt 1509).

BIBLIOGRAPHY: Max Rooses, *Rubens*, London, 1904, I, p. 52; Fairfax Murray, I, no. 231, repr.; Hind, *Flemish Drawings*, 1923, II, p. 33, no. 107; Bock-Rosenberg, 1930, I, pp. 253–54, under no. 1540; A. J. J. Delen, *Catalogue des dessins anciens: Écoles flamande et hollandaise (Cabinet des Estampes de la Ville d'Anvers)*, Brussels, 1938, I, under no. 190; Bryan Holme, ed., *Master Drawings*. New York, 1943, no. 63, repr.; Goris-Held, *Rubens in America*, 1947, p. 44, no. 125, repr.; Agnes Mongan et al., 1949, p. 68, repr.; A. M. Frankfurter, "Arcadia on Paper"

Art News, LI, February 1953, p. 45, repr.; Thomas Craven, *Rainbow Book of Art*, New York, 1956, p. 35, repr.; Julius S. Held, "Drawings and Oil Sketches by Rubens from American Collections," review in *Burlington Magazine*, XCVIII, 1956, p. 123, repr.; Michael Jaffé, "A Sheet of Drawings from Rubens' Second Roman Period and His Early Style as a Landscape Draughtsman," *Oud Holland*, LXXII, 1957, no. 1, pp. 9, 14–18; Held, *Selected Drawings*, 1959, I, p. 9; E. Haverkamp-Begemann and Anne-Marie Logan, *European Drawings and Watercolors in the Yale University Art Gallery 1500–1900*, Yale University, New Haven–London, 1970, under no. 590; Julius S. Held, "Rubens and the *Vita Beati P. Ignatii Loiolae* of 1609," in Princeton, *Rubens before 1620*, 1972, p. 132, fig. 64; Bernhard, *Rubens*, 1977, p. 206, repr.; Hans Mielke and Matthias Winner, *Die Zeichnungen alter Meister im Berliner Kupferstichkabinett: Peter Paul Rubens, kritischer Katalog der Zeichnungen*, Berlin, 1977, pp. 119–120, under no. 46 (entry by Mielke).

EXHIBITIONS: Johns Hopkins University, Baltimore, Md., *Exhibition of Landscape Painting from Patinir to Hubert Robert*, catalogue by Georges de Batz, 1941, no. 17; Fogg Art Museum, *Seventy Master Drawings*, 1948, no. 31; Minneapolis Institute of Arts, Minneapolis, *Watercolors by the Old Masters*, 1952, no. 10; Morgan Library, *Landscape Drawings*, 1953, no. 54, pl. VI; Cambridge–New York, *Rubens*, 1956, p. 15, no. 9, repr.; Morgan Library, and elsewhere, *Fiftieth Anniversary*, 1957, p. 41, no. 89, repr; Morgan Library, and elsewhere, *Rubens and Rembrandt in Their Century*, 1979, no. 19, repr.

Acc. no. I,231

Jacob Jordaens (Flemish)
ANTWERP 1593 – 1678 ANTWERP

63 *Portrait of a Young Woman*

Black and red chalk, some pen and brown ink, especially in the hair, gray and brown wash over traces of charcoal, on paper tinted with light brown wash except in areas reserved for highlights, such as the collar and face. Losses at all corners
$16^{1}/_{2} \times 10^{15}/_{16}$ inches (419×277 mm.)
Watermark: none visible through lining
Inscribed in graphite at lower right, barely visible, *P. P. Rubens*. Inscribed in pen and red ink on old blue mount at lower left, *P. P. Rubens.*; at lower right, *Provenant des collections Crozat, Nourri, St. Maurice etc.* Inscribed on verso of mount in graphite in an old hand, *Lit. R.*; in pen and brown ink at lower center, *N° 45. [95?] P. P. Rubens*; in pen and a different brown ink at lower right, *pierre paul Rubens N°5 / des collections Crozat, Nourri / et S^t Maurice,* at lower left in pen and red ink in the same hand as on recto of mount, *180 florins*

The drawing shows an affluent young woman of the bourgeoisie, seated to the left on a chair and wearing a broad-brimmed hat, her gaze directed towards the spectator. In the background at the left are the shaft and base of a column resting on

a wall or pedestal, and sweeping diagonally across the right corner behind the young woman is a heavy drapery. This architectural element and the drapery constitute the kind of setting in which Jordaens customarily placed his bourgeois subjects in order to give them a suitable dignity. The sitter has yet to be identified.

This splendid sheet, formerly ascribed to Rubens, was first attributed to Jordaens by Frits Lugt. (Opposite the description of the drawing in his copy of the sale catalogue of the Marquis de Biron [9–11 June 1914, lot 56], where the sheet is listed under Rubens' name, Lugt wrote in Dutch: "is Jordaens. Eerst aan Cossiers gedacht." [It] is Jordaens. First thought of Cossiers.) Though the drawing is clearly a study and not a finished, independent work, no painted portrait based on it is known. Style and technique as well as costume indicate that the sheet was executed c. 1635–1640. It is best compared with the *Portrait of a Young Man* in the Boymans–van Beuningen Museum at Rotterdam, a drawing likewise begun in black and red chalk and heightened with white chalk (d'Hulst, *Jordaens*, 1974, I, no. A132; III, pl. 145).

PROVENANCE: Pierre Crozat (no mark; see Lugt 2951–2952); his sale, Paris, Mariette, 10 April 1741, perhaps in lots 837–842; Nourri; possibly his sale, Paris, Folliot, 27 February 1785, lot 852, "[Pierre-Paul Rubens] un Buste de Femme du caractère de tête le plus agréable, coëffée en cheveux., portant fraise et collerette á l'Espagnole; Il est dessiné au crayon noir, à la sanguine, lavé, au bistre et rehaussé de blanc. Hauteur 9 pouces 9 lignes, largeur 7 pouces 6 lignes" (to Constantini for 214 francs); Saint Maurice (Charles-Paul-Jean-Baptiste Bourgevin Vialart de Saint-Morys [1743–1795]); possibly his sale, Paris, Paillet, 6 February 1786, part of lot 787, "Huit dessins par Rubens, Jordans et Vandick. Des Etudes de Têtes et différens Portraits; dessinés à la plume et lavés, d'autres au crayon noir et à la sanguine" (to Lenglier for 12 francs 1); Marquis de Biron; his sale, Paris, Galerie Georges Petit, 9–11 June 1914, lot 56 (as Rubens; to Lucien Guiraud for 14,600 francs); M. d'Ormesson; E. Marich, Paris; Adolphe Stein, London and Paris; C. G. Boerner, Düsseldorf.

BIBLIOGRAPHY: Morgan Library, *Eighteenth Report to the Fellows, 1975–1978*, 1978, pp. 243, 271; Jeremy Wood, review of *Rubens and Rembrandt . . .* exhib., *Pantheon*, XXXVIII, no. 1, 1980, p. 19; R.-A. d'Hulst, "*Jordaens Drawings*: Supplement I," *Master Drawings*, XVIII, no. 4, 1980, no. A132a, pl. 21.

EXHIBITION: Morgan Library, and elsewhere, *Rubens and Rembrandt in Their Century*, 1979, no. 22, repr.

Acc. no. 1977.42
Purchased as the gift of the Fellows with the special assistance of a number of Fellows and Trustees in honor of Miss Felice Stampfle

64 *The Satyr and the Peasant*

Watercolor and tempera in blue, red, green, brown, and yellow, over black chalk; squared for enlargement in black chalk

12 × 9⅝ inches (303 × 245 mm.); sheet extended at top and bottom by the artist

Watermark: none

When Jordaens was received as a master in the Guild of St. Luke in Antwerp in 1615, it was as a *waterschilder*, a painter working in watercolor and tempera who on occasion produced large-scale works on canvas that were an inexpensive substitute for tapestry. Though none of Jordaens' works in this category survives, his attractive use of watercolor and tempera is demonstrated in such sheets as the present one. It was used in preparation for an actual tapestry in his suite of eight pieces, each illustrating a Flemish proverb. It was not used, however, without alteration. The scene as shown here illustrates one of the fables of Aesop (Ben Edwin Perry, *Aesopica*, Urbana, Illinois, 1952, p. 335, no. 35). The satyr, astounded that the peasant first blows on his hands to warm them and then on his spoonful of porridge to cool it, is used to point the moral that those who blow first hot and then cold are not to be trusted. In the seventh tapestry of Jordaens' series of eight, the replacement of the satyr with two children, one eating grapes and one placing a wreath around the neck of a goat, transforms the scene into an illustration of the proverb *De natuur is met weinig tevreden* (*Nature is content with little*). As in the Morgan drawing, the scenes illustrated in the tapestries are represented as themselves being on hangings suspended from an architectural support, a tapestry within a tapestry, so to speak, an illusionistic device which had as precedent Rubens' cycle of Eucharist tapestries. The same figures appear in little more than half-length in a painting in the Musées Royaux des Beaux-Arts de Belgique at Brussels (*Catalogue de la peinture ancienne*, 1959, p. 70, no. 238). D'Hulst (1974, under I, A38) cites the sketch on the verso of a drawing in the Louvre (Inv. no. 20.028) as one of Jordaens' earliest versions of this popular theme.

Two sets of the tapestries, for the cartoons of which Jordaens signed an agreement on 22 Sep-

tember 1644, are known: one is in the former Schwarzenberg palace at Hluboká, Czechoslovakia, and the other, an enlarged suite, is in the Museo Diocesano, Tarragona, Spain. Two cartoons at the Musée des Arts Décoratifs and at least five other drawings relating to the tapestry project are listed by d'Hulst (1974, II, cat. nos. A416–417; and I, nos. A188, A190–192). The Proverbs tapestry suite was only one of Jordaens' commissions in this area, which included designs for the cycles The History of Alexander the Great, Scenes from Country Life, The Story of Ulysses, and The History of Charlemagne.

Other examples of Jordaens' draughtsmanship in the collection include representations of religious and mythological subjects. Some of these were recently published in the 1979 catalogue, nos. 24, 25, 26, repr.

PROVENANCE: Charles Fairfax Murray; J. Pierpont Morgan (no mark; see Lugt 1509).

BIBLIOGRAPHY: Max Rooses, *Jacob Jordaens*, London, 1908, pp. 58–60, 186, and 292, repr.; Fairfax Murray, I, no. 236, repr.; Leo van Puyvelde, *Jordaens*, Paris, 1953, pp. 180, note 141, and 231; d'Hulst, *Jordaens*, 1956, pp. 236, 365, no. 107, fig. 155; Michael Jaffé, "Reflections on the Jordaens Exhibition," *National Gallery of Canada Bulletin*, no. 13, 1969, p. 33; d'Hulst, *Jordaens*, 1974, I, pp. 276 and 286–287, no. A200, III, pl. 215.

EXHIBITIONS: Koninklijk Museum voor Schone Kunsten, Antwerp, *Tentoonstelling Jacob Jordaens*, 1905, no. 123; Hartford, *Pierpont Morgan Treasures*, 1960, no. 73; Rubenshuis, Antwerp, and Museum Boymans–van Beuningen, Rotterdam, *Tekeningen van Jacob Jordaens*, catalogue by R.-A. d'Hulst, 1966–1967, no. 78, repr.; National Gallery of Canada, Ottawa *Jacob Jordaens 1593–1678*, catalogue by Michael Jaffé, 1968–1969, p. 199, no. 220, repr., p. 364; Stockholm, *Morgan Library gästar Nationalmuseum*, 1970, no. 61; Morgan Library, and elsewhere, *Rubens and Rembrandt in Their Century*, 1979, no. 23, repr.

Acc. no. I,236

Anthony van Dyck (Flemish)

ANTWERP 1599 – 1641 LONDON

65 *Diana and Endymion*

Pen and point of brush, brown ink and brown wash, heightened with white tempera on gray-blue paper
7½×9 inches (190×228 mm.)
Watermark: none visible through lining
Inscribed on old mount, in the hand of the collector Jacob de

Vos Jbzn, in pencil, *K Dec 65* (date, 1865, of one of the art historical conferences in *Arti et Amicitiae* at Amsterdam where the collector showed his drawings); in red ink, */r[?].t.e.*

Within the swirling pattern of pen and brush strokes in this interesting study sheet, two designs for a composition of Diana and Endymion can be discerned, one above the other. It is not too difficult to retrace the artist's course of action. There is little doubt that he first quickly and lightly sketched in the lower group with his pen, showing the moon goddess kissing the cheek of the sleeping shepherd whose beauty had drawn her to earth. He then tried a variant pose above; there Diana, clearly identified by the crescent diadem, only watches the youth as he sleeps, his body now more definitely relaxed in a reclining position and his legs shown crossed. Alternate positions for Diana's left arm were considered, but in the end the artist turned again to the first sketch and carried it further with rapid applications of wash. With the point of his brush he drew another cherub at the left and emphasized the fluttering draperies that suggest the *glissando* movement of the goddess "sliding from her sphere." The white highlighting in the upper sketch is perhaps suggestive of the moonlight appropriate to the scene and the cupid with the smoking torch is a further indication of the night setting. The drawing, if not from Van Dyck's Italian years 1621–1627, must have been executed soon after his return to Antwerp.

In earlier years the subject of the Morgan sheet was wrongly identified as Venus and Adonis. Fairfax Murray noted this error on page 96 of his autograph manuscript notebooks, University of Texas, Austin, after he had acquired the drawing in 1891 from Seymour Haden's sale where it was so catalogued.

No related picture is known; the very different version of the theme in Madrid (Glück, *Van Dyck*, Klassiker der Kunst, 1931, p. 141) is thought to be a much earlier work than this drawing.

PROVENANCE: William Young Ottley (no mark; see Lugt 2662–2665); Samuel Woodburn (no mark; see Lugt 2584); Sir Thomas Lawrence (Lugt 2445; not in *Lawrence Gallery: Second Exhibition*, 1835); Jacob de Vos Jbzn (Lugt 1450); his sale, Amsterdam, Roos, Muller . . . , 22–24 May 1883, lot 145 (to Thibaudeau for 510 florins); Sir Francis Seymour Haden (Lugt 1227); his sale, London, Sotheby's, 15–19 June 1891,

lot 546 (to Murray for £4.4); Charles Fairfax Murray; J. Pierpont Morgan (no mark, see Lugt 1509).

BIBLIOGRAPHY: Fairfax Murray, I, no. 240, repr.; Tietze, 1947, p. 124, under no. 62; *Great Drawings of All Time* II, 1962, no. 548, repr.; Vey, *Van Dyck*, 1962, I, no. 132, II, pl. 173; Eisler, *Flemish and Dutch Drawings*, 1963, pl. 43; Julius S. Held, review of Vey, *Art Bulletin*, XLVI, 1964, p. 566.

EXHIBITIONS: Lyman Allen Museum, *Drawings*, 1936, no. 71; Morgan Library, *New York World's Fair*, 1939, no. 79 (1940 ed., no. 96); M. Knoedler and Co., New York, *Great Master Drawings of Seven Centuries*, 1959, no. 45, pl. XXXI; Wildenstein and Co., New York, *Gods and Heroes: Baroque Images of Antiquity*, 1968–1969, no. 56, repr.; Morgan Library, and elsewhere, *Rubens and Rembrandt in Their Century*, 1979, no. 30, repr.

Acc. no. I,240

66 *View of Rye from the Northeast*

Pen and brown ink
7¹⁵⁄₁₆ × 11⁹⁄₁₆ inches (201 × 294 mm.)
Watermark: none visible through lining
Inscribed and signed by the artist in brown ink at lower right, *Rie del naturale li 27 d'Augt 1633 A vand[yck]*

While Van Dyck seems to have painted no landscapes—at least none can be traced today although they are sometimes mentioned in old sources—he did turn to landscape in his drawings, sketching in *plein air*, probably for his own pleasure when he was at leisure. Interestingly enough, he took pains to sign a number of these landscape sheets. Only one example is unquestionably a souvenir of his Italian sojourn (1621–1627), Windsor Castle's pure landscape which he inscribed *fuori de Genua quarto* (Vey, I, no. 282, II, pl. 334); but there are a number of drawings that can be associated with both the Flemish and English countryside. Some of the drawings are definitely topographical, including the 1632 view of his native city of Antwerp (Vey, I, no. 287, II, pl. 339) now in the Royal Library at Brussels (Amsterdam, Sotheby Mak van Waay, 3 April 1978, lot 109), and this view of Rye in Sussex. Thanks to the artist's explicit inscription that he made the present drawing on the spot on 27 August 1633, the sheet provided the key for the identification of three other sketches of different aspects of Rye, one of the towns added to the original Cinque Ports, the ancient association of seaports in Kent and Sussex formed for the defense of the English

coast. Rye today retains much of its original character since its thriving seventeenth-century trade came to an end when the harbor silted up early in the nineteenth century, leaving the town three miles from the sea.

The Morgan drawing gives a full view of the picturesque town, rising steeply on a sharp eminence above the sea and crowned by the mediaeval church of St. Mary's. Below and slightly to the left of the church in the midst of the houses mounting the hillside, one can see the Landgate built in 1329, the only surviving city gate from the time of Edward III; to the right of the gate is the chapel of the Austin friars; very much to the left, on the edge of the hill just before it slopes down to the water, is the Ypres Tower, one of the oldest surviving fortifications of the Cinque Ports. Van Dyck made two separate drawings of the Tower on the sheets now in the Boymans–van Beuningen Museum, Rotterdam (Vey, I, no. 291, II, pl. 342) and the Fitzwilliam Museum, Cambridge (Vey, I, no. 290, II, pl. 343), as well as a nearer view of St. Mary's from the southeast in the drawing in the Uffizi (Vey, I, no. 289, II, pl. 341). Since the Uffizi and Fitzwilliam drawings record aspects of the town as seen from the sea, it is assumed that Van Dyck drew them aboard ship, possibly a three-masted vessel such as that seen in the left distance in the Morgan sheet or that sketched from a closer vantage point in the drawing in the possession of Michael Kroyer, London (Vey, I, no. 292, II, pl. 344). With the exception of the Fitzwilliam drawing of the Ypres Tower, which appears in the background of Van Dyck's portrait of Eberhard Jabach in the Hermitage at Leningrad (Glück, *Van Dyck*, Klassiker der Kunst, 1931, p. 355), none of the landscape drawings was utilized in paintings.

The Morgan drawing served as a model for Wenzel Hollar's washed silverpoint drawing formerly in the collection of Sir Bruce S. Ingram and now in the Huntington Library and Art Gallery, San Marino, California (see F. Sprinzels, *Hollar Handzeichnungen*, Vienna, 1938, no. 367, fig. 234). When Hollar etched the composition in 1659 at the upper left of his *Map of Kent*, he acknowledged his debt in the inscription: *Sir Anthony Van Dyck Delineavit* (see further G. Par-

they, *Wenzel Hollar: Beschreibendes Verzeichnis seiner Kupferstiche*, Berlin, 1853, no. 665c).

It is interesting to note that at least a dozen of Van Dyck's landscapes bear the mark of the eighteenth-century English artist and collector Jonathan Richardson, Sr.

PROVENANCE: Jonathan Richardson, Sr. (Lugt 2183; Richardson's pressmarks inscribed in brown ink on verso of the mount, *P97. / Tk. 13. / L.8 / G.*; above this, perhaps in another hand, *A1F* [Lugt 2983–2984]); Jan van Rijmsdijk (Lugt 2167); Charles Fairfax Murray; J. Pierpont Morgan (no mark; see Lugt 1509).

BIBLIOGRAPHY: Fairfax Murray, III, no. 178, repr.; A. M. Hind, "Van Dyck and English Landscape," *Burlington Magazine*, LI, 1927, p. 297; G. Vertue, "Vertue Note Books, IV," *Walpole Society*, XXIV, 1936, p. 114, and V, XXVI, 1938, p. 60; A. M. Hind, in *The London Illustrated News*, 20 March 1937, pp. 484–485, fig. 2; Ludwig Burchard, "A View of Rye by Anthonie Van Dyck," *Old Master Drawings*, XII, March 1938, pp. 47–48, fig. 51; Paul Wescher, *Alte Städte in Meisterzeichnungen aus fünf Jahrhunderten*, Frankfurt am Main, 1938, no. 27, repr.; Paul Oppé, "Sir Anthony van Dyck in England," *Burlington Magazine*, LXXIX, 1941, p. 190; Horst Vey, "De Tekeningen van Anthonie van Dyck in het Museums Boymans," *Bulletin Museum Boymans*, 1956, p. 88 and note 7; Fitzwilliam Museum, Cambridge, *Seventeenth Century Flemish Drawings and Oil Sketches*, exhibition catalogue by Carlos van Hasselt, 1958, under no. 15; *Great Drawings of All Time*, II, 1962, no. 556, repr.; Vey, *Van Dyck*, 1962, I, p. 56, no. 288, II, pl. 340; Eisler, *Flemish and Dutch Drawings*, 1963, pl. 44; Martin Hardie, *Water-colour Painting in Britain*, I, 1966, p. 57; London, and elsewhere, *Flemish Drawings . . . Collection of Frits Lugt*, 1972, under nos. 34 and 35; Morgan Library, and elsewhere, *European Drawings from the Fitzwilliam*, exhibition catalogue by Michael Jaffé, Duncan Robinson, and Malcolm Cormack, 1976–1977, under no. 69.

EXHIBITIONS: Morgan Library, *New York World's Fair*, 1939, no. 78 (1940 ed., no. 97); Johns Hopkins University, Baltimore, Md., *Landscape Painting from Patinir to Hubert Robert*, catalogue by Georges de Batz, 1941, no. 23; Worcester Art Museum, Worcester, Mass., *Art of Europe during the XVIth–XVIIth Centuries*, 1948, no. 43, repr.; Morgan Library, *Landscape Drawings*, 1953, no. 58; Morgan Library, and elsewhere *Fiftieth Anniversary*, 1957, no. 92, pl. 59; Rubenshuis, Antwerp, and Museum Boymans–van Beuningen, Rotterdam, *Antoon van Dyck: Tekeningen en olieverfschetsen*, catalogue by R.-A. d'Hulst and Horst Vey, 1960, no. 100, pl. LXI; Stockholm, *Morgan Library gästar Nationalmuseum*, 1970, no. 63, repr.; The Tate Gallery, London, *The Age of Charles I*, catalogue by Oliver Millar, 1972, no. 122; Morgan Library, and elsewhere, *Rubens and Rembrandt in Their Century*, 1979, no. 32, repr.

Acc. no. III,178

67 *Study for the Dead Christ*

Black chalk heightened with white chalk on gray-blue paper
10⅞ × 15⁷⁄₁₆ inches (276 × 393 mm.)
Watermark: none visible through lining

After Van Dyck removed to England in 1632 as chief court painter to Charles I, he made several trips back to his native Flanders. On an extended visit in 1634–1635 he appears to have been busy with commissions for the diplomat Abbot Cesare Alessandro Scaglia, then a rich man and connoisseur living in Brussels, his career as ambassador of the House of Savoy to the major courts of Europe having ended in disfavor. In addition to the full-length painted portrait of the abbot in Viscount Camrose's collection (Glück, *Van Dyck*, Klassiker der Kunst, 1931, p. 426) and a portrait drawing in the collection of Frits Lugt, Institut Néerlandais, Paris (repr. in the exhibition catalogue *Flemish Drawings of the Seventeenth Century . . .*, 1972, no. 32, pl. 54), Van Dyck executed two religious paintings for the abbot: the *Virgin and Child Adored by the Abbot Scaglia*, the oval painting in the National Gallery, London, and the *Lamentation* (Glück, p. 367), which Scaglia commissioned and presented to the monastery of the Friars Minor or Recollects of the Franciscan order in Antwerp where he was to retire shortly after September 1637, and to be buried in 1641. The sensitive, moving representation of the dead Christ in the Morgan drawing is a study for this last painting, long since removed from the Recollects' chapel of Our Lady of the Seven Sorrows and now in the Koninklijk Museum voor Schone Kunsten at Antwerp. In the catalogue of the recent Princeton exhibition (p. 172), it is suggested that the painting was executed in England in 1636 or 1637 and shipped to Antwerp for installation in the altarpiece.

Van Dyck's style finds very personal expression in this luminous study from a slender model although not without strong Venetian overtones in the harmony of the soft chalks and blue paper. There is no likelihood of confusing it with Rubens' manner as sometimes happens in the earlier pen sketches. The slightly angular quality of Van Dyck's line is very different from the broad sweeping rhythms of the chalk drawings of the older artist. Van Dyck tried two positions for the left arm, which, in the painting, St. John lifts to point out the wound to a pair of mourning angels, but in the end Van Dyck chose his first solution of the lower position. The diagonal of the upper position was clearly an afterthought for its black

chalk outlines cross the white heightening. There is also a partial indication of a still higher placement of the arm that was not pursued. The head, only partially indicated in the drawing, is heavily bearded in the painting and rests on the Virgin's lap. There is another larger painting of the subject of the Lamentation in the Antwerp Museum, and another of the theme in Berlin, both vertical compositions in contrast to the horizontal of the Scaglia picture; there is a figure study of the Christ for the Berlin picture in the British Museum (Vey, I, no. 130, II, pl. 169).

Religious themes appear in other drawings in the collection, such as the Mystic Marriage of St. Catherine (Acc. no. I,245a) and the Martyrdom of St. Lawrence (Acc. no. III,177); a quick study of a mother and daughter represents the artist in his most influential and celebrated role as portrait painter (Acc. no. I,244). See 1979 catalogue, nos. 28, 29, and 31.

PROVENANCE: Possibly Samuel van Huls, former burgomaster of The Hague; his sale, The Hague, Swart, 14 May 1736, Album M, lot 535, "Antoine van Dyck: Un Christ mort en un St. Jérôme"; William Young Ottley (no mark; see Lugt 2662–2665); possibly sale, [Ottley], London, T. Philipe, 11–14 April 1804, one of three in lot 429, "Three. Dead Christ, black chalk, on blue paper, heightened; St. John Preaching, free pen, Indian ink, and bistre, sketches on the back; and another"; George William Reid (no mark; see Lugt 1210); his sale, George William Reid, Esq. F.S.A., Late Keeper of the Prints and Drawings at the British Museum, London, Sotheby's, 26 February – 1 March 1890, lot 585, "A. van Dyck. Study for a Dead Christ, black and white chalk, on grey paper" (to Murray for 6 shillings,); Charles Fairfax Murray; J. Pierpont Morgan (no mark; see Lugt 1509).

BIBLIOGRAPHY: Fairfax Murray, I, no. 243, repr.; Vey, *Van Dyck*, 1962, I, no. 141, II, pl. 179; A. Monballieu, "Cesare Alesandro Scaglia en de 'Bewening van Christus' door A. Van Dijck," *Jaarboek van het Koninklijk Museum voor Schone Kunsten Antwerpen*, 1973, p. 263, fig. 10.

EXHIBITIONS: Morgan Library, and elsewhere, *Fiftieth Anniversary*, 1957, no. 93; The Art Museum, Princeton University, Princeton, N.J., *Van Dyck as Religious Artist*, catalogue by John Rupert Martin and Gail Feigenbaum, 1979, no. 50, repr. (represented in the exhibition by a photographic facsimile); Morgan Library, and elsewhere, *Rubens and Rembrandt in Their Century*, 1979, no. 33, repr.

Acc. no. I,243

Adam Frans van der Meulen (Flemish)

BRUSSELS 1632 – 1690 PARIS

68 *View of Valenciennes*

Pen and brown ink, watercolor, over faint indications in black chalk

10⅟₁₆ × 19¼ inches (277 × 489 mm.)

Watermark: none

Inscribed, in pen and brown ink, presumably by the artist, at upper margin, *Veue De Valenciennes Du coste De La porte de Nre Dame. N.4.*; at top center, *porte de nostredamme;* at right margin, *porte de Cambr*[*ai*] (trimmed); at left margin, *Le cluse dan La ville;* on verso in a different ink and hand, possibly Lugt, at center, *N.⁰⁴/veue de valenciennes du Coste dela porte nostre dam* (trimmed); at upper right, *numero 17*

It was at the recommendation of Charles Le Brun, first painter to the King and founder of the Royal Academy in Paris, that this Flemish artist was invited to Paris in 1664 to become the official history painter for Louis XIV. In this capacity, Van der Meulen accompanied the King on nine military campaigns (1667–1677), making drawings of cities and landscapes, camps and battles. These drawings were later used for the backgrounds of paintings, tapestries, and engravings celebrating the glory of the Sun King. Le Brun is known to have added figures to the foreground of the drawings before they were passed on to the painters and engravers.

This delicate rendering of Valenciennes, a city located at the junction of the Scheldt and Rhônelle rivers near the Belgian border, was made on the artist's seventh trip, the "voyage de Cambray," when the Flemish city was conquered by the forces of Louis XIV; in the Treaty of Nijmegen it was ceded to France. According to Frits Lugt, the city appears in six other drawings by Van der Meulen: two at the Louvre, two at Versailles, and one each in the Bibliothèque Nationale and the museum at Valenciennes. The siege took place on 16 March 1677 and was commemorated by the artist in a painting that now hangs at Versailles. An engraving of the subject by R. Bonnard (*Chalcographie du Louvre*, Paris, no. 724) was made after his design for the *Cabinet du Roi*, a collection of engravings glorifying Louis XIV that was published in Paris in 1743, in twenty-three volumes; volumes XV and XVII contain the engravings made after Van der Meulen.

In the Morgan sheet, the artist chose to depict that part of Valenciennes seen from the meadows beyond the moat that once surrounded the strongly fortified city. To the left one sees the tip of a small

island known as the *citadelle;* at center, the gate tower or gate house called the *porte de Nôtre Dame* which leads to the large church on the left, the Nôtre Dame du St. Cordon. The steeple visible just to the left of the gate is that of the Nôtre Dame de Chaussie. At the far right of the view is another entrance to the city known as the *porte de Cambray.* Since the seventeenth century, the moat has been filled in to accommodate urban expansion; the section depicted in the drawing has become the Boulevard Carpeaux, Boulevard Watteau, and Boulevard Pater, named in honor of the sculptor and the two painters who were natives of the city.

PROVENANCE: Philippe de Chennevières (Lugt 2072); possibly his sale, Paris, Roblins, 4–7 April 1900, part of lot 333; Chavagnac collection (?); Galerie de Bayser, Paris.

BIBLIOGRAPHY: Lugt, *École flamande, Louvre,* 1949, I, p. 97, under no. 847 (as drawing in Chennevières sale).

EXHIBITION: Morgan Library, *Rubens and Rembrandt in Their Century,* 1980 (*hors de catalogue*).

Acc. no. 1979.27
Purchased as the gift of Mrs. Charles W. Engelhard in memory of André Meyer

Hendrick Goltzius (Dutch)
MÜHLBRACHT (LIMBURG) 1558 – 1617 HAARLEM

69 *The Judgment of Midas*

Pen and brown ink, red-violet, brown, and gray watercolor, green tempera, with some heightening in white tempera
$15^3/_4 \times 26^{13}/_{16}$ inches (400 × 681 mm.)
Watermark: none visible through lining
Signed with monogram and dated at right, *HG.* (interlaced) / *Fecit* / *A° 1590*

The most famous member of the group of Mannerist artists flourishing in Haarlem in the 1580's was the young draughtsman and engraver Hendrick Goltzius. In the last years of that decade and the first year of the following (1588–1590), he was much occupied with the designs for three series of engravings illustrating the *Metamorphoses* of Ovid. He produced the preparatory drawings for two series of twenty illustrations each and one of twelve, all engraved anonymously; only a handful of his drawings for these projects survive (Reznicek, I, nos. 99–104, II, pls. 119–124; I, 100a, II,

pl. 451). Quite independent of these series though, perhaps the culmination of his interest in the *Metamorphoses,* is the present large, elaborate drawing of 1590. With its mood of elegant artifice, it stands at the end of the early phase of his activity when the inspiration of the art of Bartholomaeus Spranger had not completely disappeared.

It represents Apollo and his strings victorious over Pan in the musical contest in which the oak-wreathed Tmolus and King Midas were judges. Midas is identified by the ass's ears which were bestowed upon him when he voted against Apollo (Ovid, *Metamorphoses,* XI, 156ff.). Grouped in a semi-oval in the right half of the scene are the Muses. Seated in the foreground is a figure holding a sphere and compasses, whom one would ordinarily identify as Urania (Muse of astronomy), but Goltzius, as Ann Lowenthal kindly pointed out, in his engraved series of the individual figures of the nine Muses executed in 1592 labels the figure with these same attributes as Erato. Usually, the attribute of Erato as Muse of lyric and love poetry is a musical instrument like a lyre or tambourine. What the artist's authority was for such a departure from traditional iconography remains to be ascertained. On Erato's right are Terpsichore (dancing and song), holding her lute face down, and Thalia (comedy, pastoral poetry), identified by the fool's baton and bladder beside her foot. Standing at the right is Euterpe (music, lyric poetry), with her flute, in the company of Urania (astronomy), the figure with an armillary sphere at her feet. In the middle ground are the goddess Athena with her owl, and Clio (history) with a book; further to the left, behind Apollo, are the remaining Muses, Calliope (epic poetry) with a scroll, Melpomene (tragedy), and Polyhymnia (sacred song and rhetoric) holding a caduceus, which, since it sometimes signifies Eloquence and Reason, is an attribute that is not inappropriate though again a departure from the tradition that assigns an organ or other musical instrument to this Muse. Ovid in his account of the contest between Apollo and Pan in the *Metamorphoses* makes no mention of the presence of Athena and the Muses, but the goddess and her nymphs were present at the contest between Apollo and Marsyas in Ovid's account in the *Fasti,* VI, 697ff. In

such details as Apollo's head "wreathed with laurel of Parnassus and his mantle dipped in Tyrian dye [which] swept the ground," Goltzius closely adhered to the text of the *Metamorphoses* though he took the liberty of giving the god a viol rather than a lyre "inlaid with gems and Indian ivory."

Goltzius translated this drawing into an engraving of equally impressive measurements dedicating it to Floris van Schoterbosch, an art patron of The Hague who had just returned from a trip to Constantinople. Shortly thereafter, in October 1590, Goltzius himself left for a trip to Italy, which was to alter the course of his development. The drawing, which is in reverse of the engraving (Bartsch, no. 140), is, in its painterly quality, an unusual preparation for an engraving; it might be said to forecast the interest Goltzius was to take in painting for a period after 1600. The artist seldom created two more beautiful figures than the graceful pair of Muses standing at the right, Euterpe in her red-violet gown and her companion in green.

PROVENANCE: John MacGowan (no mark; see Lugt 1496); his sale, London, T. Philipe, 26 January – 1 February 1804, no. 266, ". . . a capital design. . ." (to Ottley for 11 shillings); William Young Ottley (no mark; see Lugt 2662–2665); Sir Thomas Lawrence (no mark; see Lugt 2445–2446); Samuel Woodburn (no mark; see Lugt 2584); Lawrence-Woodburn sale, London, Christie's, 4–8 June 1860, lot 435 (13 shillings); Dr. John Percy (Lugt 1504); his sale, London, Christie's, 15–18 and 22–24 April 1890, lot 1462; Charles Fairfax Murray; J. Pierpont Morgan (no mark; see Lugt 1509).

BIBLIOGRAPHY: Fairfax Murray, I, no. 228, repr.; K. T. Parker, *Catalogue of the Collection of Drawings in the Ashmolean Museum*, Oxford, I, 1938, p. 23, under no. 54; Reznicek, *Goltzius*, 1961, I, pp. 19, 74–75, 273–274, no. 107, II, pls. 127, 129–130; University of Warsaw, Warsaw, *Rysunki z Kręgu Manierystów Niderlandzkich XVI i Początku XVII Wieku, ze zbiorów Gabinetu Rycin, Biblioteki Uniwersyteckiej w Warszawie, Muzeum Pomorskiego w Gdańsku i Muzeum Narodowego w Poznaniu*, exhibition catalogue by Stanisława Sawicka, 1967, p. 29, under no. 13; John Shearman, *Mannerism*, Harmondsworth, 1967, p. 192, under no. 7; J. R. Judson, *Dirck Barendsz.*, 1970, pp. 92–93, fig. 103; Walter Strauss, ed., *Hendrick Goltzius, 1558–1617: The Complete Engravings and Woodcuts*, New York, 1977, II, p. 504, under no. 285; Cabinet des Estampes, Musée d'art et d'histoire, Geneva, *Dieux et héros*, 1978, p. 104, under no. 103.

EXHIBITIONS: Morgan Library, and elsewhere, *Fiftieth Anniversary*, 1957, no. 88, pl. 55; Museum Boymans, Rotterdam, and Teylers Museum, Haarlem, *Hendrick Goltzius als Tekenaar*, 1958, no. 12, repr.; Morgan Library, and elsewhere, *Rubens and Rembrandt in Their Century*, 1979, no. 36, repr.

Acc. no. I,228

70 *Young Man Holding a Skull and a Tulip*

Pen and brown ink
18⅛ × 13¹⁵⁄₁₆ inches (460 × 354 mm.)
Watermark: none visible through lining
Signed and dated at upper left, with monogram. *HG* (interlaced) / *1614*. Lettered in pen and brown ink, by the artist at right center, *QVIS EVADET / NEMO*

Goltzius' virtuosity with the pen is spectacularly demonstrated by this drawing executed in the manner of an engraving at a period when he had long ceased to work with the graver on copper, in part because of the deterioration of his eyesight. (He engraved only occasionally after he had begun to paint around 1600.) The artist's virtuosity in the production of these large *Federkunststücke* is all the more remarkable when one remembers that he could not spread the fingers of the crippled hand that guided his pen. This life-size "fantasy portrait," together with the *Portrait of Jan Govertsen as St. Luke*, in Coburg, drawn in the same year (Reznicek, I, no. 70, II, pl. 442), is the last of these large showpieces which he had produced throughout his career. The series began in 1586 with the *Marcus Curtius* in Copenhagen (Reznicek, I, no. 142, II, pl. 74) and found its most celebrated expression in the "*Sine Cerere et Baccho friget Venus*" of 1593 in the British Museum, London (Reznicek, I, no. 129, II, pls. 224–226), with which, as Reznicek remarked (p. 130), the Morgan sheet is on a par in artistic quality and, above all, in technique; likewise similar in style and extraordinary in its size is the *Bacchus, Venus, and Ceres* of 1604 in the Hermitage, Leningrad (Reznicek, I, no. 128, II, pl. 387). It might also be said that in the rendering of the feathers and hair of the young man in the Morgan example, Goltzius rivals the expertness of Dürer, whose engraved work he had earlier copied and imitated to the point of deception as related by Van Mander (p. 365).

As the Latin inscription (*Who escapes? No man*) and the symbols of the hourglass, the skull, and the tulip show, the drawing is a *memento mori*, a reminder of the transience of existence. Even the vital richly-dressed young man will not escape the fate of him whose skull he holds, and with the passing of time, marked by the hourglass, he,

too, will fade and decay like the shortlived flower. The drawing was prophetic of the artist's death just two years later on 29 December 1616 or perhaps on 1 January 1617.

An engraving of 1594 (Bartsch, no. 10) designed by Goltzius also carries the motto *Quis evadet*; it represents a putto, seated against a skull, blowing bubbles. (See H. W. Janson, "The Putto with the Death's Head," *Art Bulletin*, XIX, 1937, pp. 446–447, fig. 21.)

The collection has a fine landscape drawing by Goltzius that was inspired by his journey through the Alps in 1590–1591; see 1979 catalogue, no. 37, repr.

PROVENANCE: John MacGowan (Lugt 1496); his sale, London, T. Philipe, 26 January – 2 February 1804, lot 267, ". . . masterly pen" (£1); William Mayor (Lugt 2799); Robert Prioleau Roupell (no mark; see Lugt 2234); his anonymous sale, Frankfurt, Prestel, 6 December 1888, lot 55 (440 marks); Jeffrey Whitehead (see under Lugt 2799); his sale, Munich, Helbing, 19 June 1897, lot 340, repr.; sale [unnamed but including some drawings from the collection of the late William Mayor], London, Christie's, 19 April 1909, one of four in lot 5 (the lot to Agnew for £25); Charles Fairfax Murray; J. Pierpont Morgan (no mark; see Lugt 1509).

BIBLIOGRAPHY: *A Brief Chronological Description of a Collection of Original Drawings and Sketches, by the Most Celebrated Masters of the Different Schools of Europe, From the Revival of Art in Italy in the XIIIth to the Middle of the XVIIIth Century; Formed by and Belonging to Mr. Mayor, the Result of Upwards of Forty Years Experience and Research*, London, 1871, no. 341; *A Brief Chronological Description of a Collection of Original Drawings and Sketches by the Old Masters . . . Formed by the Late Mr. William Mayor of Bayswater Hill*, London, 1875, no. 599; Fairfax Murray, III, no. 145, repr.; Reznicek, *Goltzius*, 1961, I, pp. 130, 389, no. 332, II, pl. 443; Christopher Brown, *Dutch and Flemish Painting*, Oxford, 1977, no. 3, repr.

EXHIBITIONS: Montreal Museum of Fine Arts, Montreal, *Five Centuries of Drawings*, 1953, no. 119; Wildenstein and Co., New York, *Masterpieces*, 1961, no. 65, repr.; Stockholm, *Morgan Library gästar Nationalmuseum*, 1970, no. 57; Morgan Library, and elsewhere, *Rubens and Rembrandt in Their Century*, 1979, no. 39, repr.

Acc. no. III,145

Abraham Bloemaert (Dutch)

DORDRECHT 1564 – 1651 UTRECHT

71 *St. Roch*

Red tempera over faint traces of black chalk, heightened with white tempera
$11\frac{3}{8} \times 8\frac{1}{2}$ inches (290×215 mm.)

Watermark: partly visible through lining but illegible (horn?)

St. Roch, an historical figure, was born in Montpellier, France, about 1350 and died in Angera, Lombardy, around 1378 or 1379. Orphaned early, he travelled to Italy as a pilgrim in 1367 and became known for his care and healing of the sick, especially those afflicted with the plague. In the following century when the dread disease was still prevalent, its arrest in Ferrara in 1439 was attributed to his intercession and led to his veneration as the patron saint of sufferers of the plague. He himself is said to have been one of its victims. Usually he is represented as Bloemaert shows him, dressed as a pilgrim with staff and wallet, and lifting his tunic to display the plague spot on his thigh. At his side is the faithful dog who brought him bread when he retreated to the wilderness to die; above is the angel who watched over him until he recovered.

Only a few monochrome works such as this one are known in Bloemaert's *oeuvre*. *The Wedding of Peleus and Thetis* in the Mauritshuis in The Hague, signed and dated 159[4?], is executed in red and white oil on canvas (*Mauritshuis*, 1977, p. 43, no. 1046, repr.), and Marilyn Aronberg Lavin in *Oud Holland* (LXXX, Part 2, 1965, pp. 123–135) mentions two small tondo paintings attributed to Bloemaert, *Apollo and Daphne* in the Busch-Reisinger Museum, Harvard University, Cambridge, Massachusetts, and *Arachne* in the collection of Dr. Giulio Bilancioni in Mexico, both done in "pinkish-purple grisaille." At the time Mrs. Lavin wrote, *The Wedding of Peleus and Thetis* at The Hague was in the collection of Dr. H. Becker of Dortmund from whom it was acquired by the Mauritshuis in 1973. The purpose of such monochrome works is unknown. In the case of the highly polished Morgan example, it is not inconceivable that it was made as an independent work of art—perhaps a devotional piece —to be enjoyed as an end in itself.

For other drawings by Bloemaert in the Library's collection, see 1979 catalogue, nos. 40, 42, 43, repr.

PROVENANCE: Sir Charles Greville (Lugt 549); George Guy, fourth Earl of Warwick (Lugt 2600); his sale, Christie's, London, 20–21 May 1896, one of two in lot 33; Charles Fairfax Murray; J. Pierpont Morgan (no mark; see Lugt 1509).

EXHIBITIONS: New York, *Bloemaert*, 1973, no. 21; Morgan Library, and elsewhere, *Rubens and Rembrandt in Their Century*, 1979, no. 41, repr.

Acc. no. I,229b

Jacques de Gheyn II (Dutch)
ANTWERP 1565 – 1629 THE HAGUE

72 *Mountain Landscape*

Pen and brown ink, over very faint indications in black chalk; vertical fold through center
$11^{1}/_{2} \times 15^{5}/_{16}$ inches (292 × 389 mm.)
Watermark: none
An inscription on verso in pen and brown ink at lower right margin trimmed to illegibility

This extraordinary drawing, made perhaps four to five decades after Pieter Bruegel's Alpine landscapes of the 1550's (see No. 31), encompasses a sweeping view over a tremendous expanse of rugged mountainous terrain. Off to the right, hills and valleys stretch in almost infinite peregrination, merging finally at the horizon in a wide, populated plain. Meandering rivers and streams course the valleys of their creation, and here and there in this successor to the "world landscapes" of Patinir are farms, towns, a castle, a convent, and an arched bridge. Beyond the prominent fortified town—so crystalline and sharp in its delineation that one can trace its streets and chart its ramparts—is a range of ancient, worn peaks. In the immediate foreground, in an effect of bold repoussoir, the draughtsman records his appreciation of the eroded forms of rock and earth, ornamentally tufted with grasses and leafy growths. The pen stroke, rich and varied in accent in this area, modulates with infinite finesse until it fades out in the mist of the distance. The draughtsman, one realizes, must have paused many times to sharpen or renew his crowquill pen before the final filament of golden line dropped from its point.

The attribution of this panoramic landscape is not without some question and the problem is complicated by the existence of an extraordinarily close version, inscribed *de Gheÿn*, in the Nationalmuseum at Stockholm. Ever since the Morgan drawing was first exhibited seventy-one years ago at the galleries of Messrs. Obach in London, however, it has been associated with the name of De Gheyn. In 1932, the late J. Q. can Regteren Altena discussed its relationship with the forgotten artist Jan van Stinemolen (1518 – after 1582) and with the version in Stockholm; he proposed among other possibilities that both drawings were copies of a lost drawing by Stinemolen, the Library's by De Gheyn, the Stockholm sheet by Goltzius. In a more recent letter he remarked that it "can hardly be anything else than a genuine De Gheyn drawing." The catalogue of the Royal Academy's 1953 exhibition, in which the Morgan drawing—then owned by James Murray Usher—was shown as no. 265, records the preference of A. E. Popham for the attribution to De Gheyn. In the Nationalmuseum's catalogue of its 1953 exhibition of Dutch and Flemish drawings, Nils Lindhagen and Per **Bjurstöm** noted that "the Stockholm drawing (no. 24) is in certain respects inferior in quality to the English one [the Morgan drawing], e.g., in regard to the accuracy of form, the omission of some details, etc. On the other hand, the details, etc., are in a higher degree fused into a painterly whole, with a certain accentuation of the atmospheric perspective by the aid of a slight wash...." Visitors to the important exhibition *Drawings from Stockholm*, on view at the Library early in 1969, had a unique opportunity to test this statement in the presence of the two drawings themselves. Most critics felt that the confrontation favored the Morgan landscape.

It is debatable whether this landscape had its origin in reality. If the draughtsman was working from nature, it has been suggested that his model might have been in the locale of the volcanic hills of central Italy. A town like La Civita, near Bagnoregio, for example, a small settlement cresting an isolated tufa plateau (repr. Italian Touring Club volume on Lazio, Milan, 1943, p. 141), could have been in the draughtsman's recollection, if not within his actual range of vision, when he created the mountain town of the drawing.

PROVENANCE: Mrs. Murray Baillie, Ilston Grange, near Leicester; James Murray Usher; sale (Alexandrine de Rothschild, and others [including James Murray Usher]), London, Sotheby's, 6 July 1967, lot 6, repr.; R. M. Light & Co., Boston.
BIBLIOGRAPHY: Campbell Dodgson, "Staynemer: An Unknown Landscape Artist," *Burlington Magazine*, XXI, 1912, p. 35; J. Q. van Regteren Altena, "Vergeten Namen: III.

Staynemer of Stinemolen," *Oud Holland*, XLIX, 1932, pp. 91ff.; J. Q. van Regteren Altena, *The Drawings of Jacques de Gheyn*, Amsterdam, 1936, p. 55; Nils Lindhagen and Per Bjurström, *Dutch and Flemish Drawings in the Nationalmuseum and Other Swedish Collections*, Stockholm, 1953, under no. 24; P. & D. Colnaghi and Co., London, *Old Master Drawings: A Loan Exhibition from the National Gallery of Scotland*, exhibition catalogue by Keith Andrews, 1966, under no. 13; Morgan Library, *Fifteenth Report to the Fellows, 1967–1968*, 1969, pp. 95–98, repr.; Morgan Library, and elsewhere, *Drawings from Stockholm: A Loan Exhibition from the Nationalmuseum*, 1969, under no. 47; Morgan Library, *Review of Acquisitions, 1949–1968*, 1969, p. 147, pl. 39.

EXHIBITIONS: Messrs. Obach, London, 1908 (apparently without catalogue); Royal Academy of Arts, London, *Drawings by Old Masters*, 1953, no. 265; Académie de France à Rome, Villa Medici, Rome, *Il Paesaggio nel disegno del cinquecento europeo*, catalogue by Françoise Viatte, Roseline Bacou, and Giuseppina delle Piane Perugini, 1972–1973, no. 131, repr.; Morgan Library, *Major Acquisitions, 1924–1974*, 1974, p. xxv, no. 39, repr.; Berlin, *Bruegel*, 1975, no. 163, fig. 302; Morgan Library, and elsewhere, *Rubens and Rembrandt in Their Century*, 1979, no. 44, repr.

Acc. no. 1967.12
Purchased as the gift of the Fellows

73 *Design for a Garden Grotto*

Pen and brown ink, gray wash, over slight indications in black chalk
7⅛ × 11⅞ inches (181 × 302 mm.)
Watermark: cockatrice with little house (similar to Heawood 842)

Jacques de Gheyn II, the most gifted member of the family that for three generations produced an artist bearing this name, is usually thought of as engraver and painter, but towards the end of his life he was also employed as a landscape architect. He worked in this capacity in the court garden of the palace at The Hague, first for Prince Maurits of Nassau, who died in 1625, and then for Prince Frederik Hendrik, the younger brother of Maurits. This we know on the authority of his friend and neighbor, the Dutch statesman and poet Constantijn Huygens who was secretary to Frederik Hendrik. Huygens in his *Autobiography* praises De Gheyn's design for the garden pavilion and his "introduction of ornaments such as hedges, flower beds, fountains, and other such decorations," and then remarks that De Gheyn "left unfinished the work on which he had begun, of imitating in the Italian manner high rocks stand-

ing in water, and transferred both the work and the reward to his only son" (quoted from J. Q. van Regteren Altena, *The Drawings of Jacques de Gheyn*, Amsterdam, 1936, pp. 18–19). Conceivably, such a remark might have applied to a rocky grotto like that represented in the Library's drawing which in its ultimate inspiration must go back to gardens of the previous century in Italy.

The design is a blend of the fantastic and weird, something in the spirit of drawings like the *Witches' Sabbaths* at Berlin and Oxford (Judson, *De Gheyn II*, 1973, pls. 101 and 96). But the fantasy is carried a step further in that the whole design is a double-image conceit. The composition when viewed in a certain way resolves itself into one monstrous visage, of which the lateral caverns form the eye-sockets, and the curled tails of the long-nosed beasts, its nostrils, while the bearded central figure is seen to be engulfed within its rocky jaws. A similar face on a lesser scale manifests itself when the curled tails of the small monsters are interpreted as eyes.

De Gheyn's design owes a debt to the work of a fellow artist of Antwerp, Cornelis Floris II (1514–1575), who had spent some time in Italy in the late 1530's and 1540's, and on his return to Antwerp produced designs for several books of engravings that helped to introduce the Roman *opera grottesca* to The Netherlands. The first series of engravings, *Veelderleij veranderinghe van grotissen ende compertimenten . . . Libro primo*, appeared in 1556 and was quickly followed by *Veelderleij nieuwe inventien van antijcksche sepultueren diemen nou zeere ghebruijkende is met noch zeer fraeije grotissen ea compertimenten zeer beqwame voer beeltsniders, antijcksniders schilders en alle constenaers ghedruckt bij mij Ieronijmus Cock, C. Floris Invent., Libro secundo*, 1557. It was one of the eight plates devoted to "grotesque" and "compartments" in the 1557 publication that furnished the starting point for the Morgan drawing, namely, the plate showing in the lower center the figure of a nude man ensconced in shell draperies and seated astride the head of a sea monster.

De Gheyn made something quite different of the rigid central figure of the engraving when he adopted it as the focal point of his watery grotto. His skillful pen quickened and enlivened

with free fancy, creating forms that are at once close to nature and ornamental. The device of the double-image is his own contribution. That he had the full series of Cornelis Floris' *Veelderleij nieuwe inventien* at hand is suggested by the fact that the placement of the arms of the old man in the drawing is similar to that of those of the figure on the title page of the engraved series, and the drawing's variety of sea creatures is not unlike that found in the engraved plate showing Neptune. The free, loose style of the drawing is quite in keeping with the lateness of the period in the artist's life at which it must have been executed, possibly sometime in the early or middle 1620's. De Gheyn carried his design a step further in a very large, elaborately colored drawing in the British Museum (Sloane, Inv. no. 54.5237), where he made a number of changes and introduced various other creatures, both real and fanciful, denizens of the land as well as of the sea. Whether or not De Gheyn's design was ever executed is not known.

A third drawing in the Morgan Library by the artist, connected with a military manual for the Dutch army published in 1607, shows a soldier preparing to load his caliver (Acc. no. 1979.1; see 1979 catalogue, no. 46, repr.).

PROVENANCE: Dr. Edmund Schilling, London; H. M. Calmann, London.

BIBLIOGRAPHY: Morgan Library, *Fifth Report to the Fellows*, 1954, pp. 68–70, repr.; Felice Stampfle, "A Design for a Garden Grotto by Jacques de Gheyn II," *Master Drawings*, III, 1965, pp. 381–383, pl. 27; Morgan Library, *Review of Acquisitions, 1949–1968*, 1969, p. 147, repr.; J. Q. van Regteren Altena, "Grotten in de tuinen der Oranjes," *Oud Holland*, LXXXV, no. 1, 1970, p. 34, fig. 2; J. Richard Judson, *The Drawings of Jacob de Gheyn II*, New York, 1973, p. 12, pl. III.

EXHIBITIONS: Stockholm, *Morgan Library gästar Nationalmuseum*, 1970, no. 58; Los Angeles, *Old Master Drawings*, 1976, no. 188, repr.; Morgan Library, and elsewhere, *Rubens and Rembrandt in Their Century*, 1979, no. 45, repr.

Acc. no. 1954.3
Purchased as the gift of Walter C. Baker

Rembrandt Harmensz. van Rijn (Dutch)

LEYDEN 1606 – 1669 AMSTERDAM

74 *Woman Carrying a Child Downstairs*

Pen and brown ink, brown wash
$7^3/_8 \times 5^3/_{16}$ inches (187×132 mm.)
Watermark: none
Inscribed at lower right corner in pen and brown ink, *N:*

This vital observation of a young mother swiftly descending a stair with a heavy, fretful child in her arms might well have graced Jan van de Cappelle's portfolio of 135 Rembrandt drawings entitled "The Life of Women with Children." Its air of tender family intimacy is strong enough to have led scholars to identify the subject as the artist's wife, Saskia, and her first child, Rumbartus, who was baptized 15 December 1635, and the drawing has universally been dated towards the end of the following year on the basis of the apparent age of the child. The archival research of I. H. van Eeghen in the register of funerals of the Zuiderkerk, Amsterdam, however, showed that one of Rembrandt's children was buried on 15 February 1636, and though no name was given in the register, it is assumed that this child was Rumbartus ("De Kinderen van Rembrandt en Saskia," *Amstelodamum*, XLIII, 1956, pp. 144ff.). Saskia's two daughters, Cornelia I (baptized 22 July 1638 – buried 14 August 1638) and Cornelia II (baptized 29 July 1640 – buried 12 August 1640), each lived for just a few weeks; only Titus, who was baptized 22 September 1641, survived to maturity (d. 1668). Saskia herself died in June 1642, when Titus was only nine months old. The image of her wasted features in certain of the drawings and etchings indicates that she was ill for some months prior to her death, eliminating the possibility that the drawing could represent her with Titus.

Were it not for these facts, one might be tempted to see a resemblance to Rembrandt himself in the child's broad countenance. Certainly the child and the mother, too, in their facial types bear some resemblance to their counterparts in *The Naughty Boy*, the drawing in the Berlin Kupferstichkabinett (Benesch, 1954–1957, II, no. 401, fig. 459 [1973, fig. 485]) and perhaps also that in Budapest, *Woman with a Child, Frightened by a Dog* (Benesch, 1954–1957, II, no. 411, fig. 460 [1973, fig. 494]). Benesch, when he included the Morgan drawing in his *Rembrandt as a Draughtsman* (no. 21), was aware of Van Eeghen's researches,

but maintained the association of the drawing with Saskia though he queried the identity of the child as Rumbartus. In all these drawings there is a sense of personal engagement on the part of the artist. This suggests that he was not just an objective observer of the scene and that the participants may in some way have been associated with his family circle.

From a stylistic point of view, the drawing conforms to the accepted norm of Rembrandt's manner of about 1636.

PROVENANCE: Charles Fairfax Murray; J. Pierpont Morgan (no mark; see Lugt 1509).

BIBLIOGRAPHY: Fairfax Murray, I, no. 191, repr.; W. R. Valentiner, *Rembrandt und seine Umgebung, zur Kunstgeschichte des Auslandes*, Strasbourg, 1905, XXIX, p. 29; Richard Graul, *Rembrandts Zeichnungen*, Leipzig, 1906 (2nd ed., 1924), no. 14; Wilhelm Bode and W. R. Valentiner, *Handzeichnungen altholländischer Genremaler*, Berlin, 1907, no. I, repr.; F. Schmidt-Degener, "Tentoonstelling van Rembrandts teekeningen in de Bibliothèque Nationale te Parijs," review of Paris 1908 exhibition, *Onze Kunst*, XIV, 1908, p. 101; A. M. Hind, *Rembrandt* (Charles Eliot Norton Lectures), Cambridge, Mass., 1932, p. 36, pl. XIV; Valentiner, 1934, II, no. 675, repr.; Benesch, *Werk und Forschung*, 1935, p. 22; Regina Shoolman and Charles E. Slatkin, *The Enjoyment of Art in America*, New York, 1942, pl. 395; Otto Benesch, *A Catalogue of Rembrandt's Selected Drawings*, London, 1947, p. 24, no. 79; Tietze, 1947, no. 64, repr.; Paul J. Sachs, *The Pocket Book of Great Drawings*, New York, 1951, p. 71, pl. 45; Theodore Rousseau, "Rembrandt," *Metropolitan Museum of Art Bulletin*, IX, no. 3, 1952, p. 89, repr.; Ludwig Goldscheider, "A Rembrandt Self Portrait," *Connoisseur*, CXXXII, 1953, p. 158; Benesch, 1954–1957, II, no. 313, fig. 347 (1973, fig. 378), and I, under no. 117; Jakob Rosenberg, "Rembrandt the Draughtsman with Consideration of the Problem of Authenticity," *Daedalus*, LXXXVI, 1956, p. 128; Willi Drost, *Adam Elsheimer als Zeichner*, Stuttgart, 1957, p. 172, no. 179; J. G. van Gelder, *Dutch Drawings and Prints*, New York, 1959, no. 60, repr.; Jakob Rosenberg, *Great Draughtsmen from Pisanello to Picasso*, Cambridge, Mass., 1959, p. 76, fig. 140; Otto Benesch, *Rembrandt as a Draughtsman*, London, 1960, no. 21, pl. 21; Claude Roger Marx, *Rembrandt*, Paris, 1960, p. 152, repr.; J. G. van Gelder, "The Drawings of Rembrandt," review of Benesch, *Burlington Magazine*, CIII, 1961, p. 150; Walther Scheidig, *Rembrandt als Zeichner*, Leipzig, 1962, pp. 41, 77, pl. 29; J. E. Schuler, ed., *Cento capolavori: L'Arte del disegno da Pisanello a Picasso*, Milan, 1962, p. 148, repr.; *Great Drawings of All Time*, II, 1962, no. 575, repr.; Nigel Lambourne, *Rembrandt van Rijn: Paintings, Drawings, and Etchings*, London, 1963, pl. 34; David M. Robb and J. J. Garrison, *Art in the Western World*, New York, 1963, p. 543, fig. 465; Eisler, *Flemish and Dutch Drawings*, 1963, pl. 72; Robert Beverly Hale, *Drawing Lessons from the Great Masters*, New York, 1964, pp. 252–253, repr.; Roberta M. Capers and Jerrold Maddox, *Images and Imagination*, New York, 1965, p. 261, fig. 10–18; Marcel Brion *et al.*, *Rembrandt*, Paris, 1965, fig. 51; Robert Wallace, *The World of Rembrandt*, New York, 1968, pl. 53; Henry Bonnier, *L'Univers de Rembrandt*, Paris, 1969, p. 13, repr.; Werner Sumowski, "Beiträge zu Willem Drost," *Pantheon*, XXVII, no. 6, 1969, p. 374, fig. 5; Doris Vogel-Köhn, *Rembrandts Kinderzeichnungen*, dissertation, Würzburg, 1974, pp. 192–193, no. 38, repr.; B. Haak, *Rembrandt Zeichnungen*, Cologne, 1974, pl. 18; Bernhard, *Rembrandt*, 1976, II, p. 187, repr.; Kenneth Clark, *An Introduction to Rembrandt*, London, 1978, p. 76, fig. 73.

EXHIBITIONS: Paris, *Rembrandt*, 1908, no. 400; Metropolitan Museum, New York, *Rembrandt*, 1918, no. 24; Albright Art Gallery, *Master Drawings*, 1935, no. 48, repr.; Chicago, *Rembrandt*, 1935–1936, no. 26, repr.; Worcester, *Rembrandt*, 1936, no. 25, repr.; Morgan Library, *New York World's Fair*, 1939, no. 88; Worcester Art Museum, Worcester, Mass., *Art of Europe during the XVIth–XVIIth Centuries*, 1948, no. 50; Wildenstein and Co., New York, *Rembrandt*, 1950, no. 30, pl. 25; Philadelphia, *Masterpieces*, 1950, no. 52, repr.; Morgan Library, and elsewhere, *Fiftieth Anniversary*, 1957, no. 95; New York–Cambridge, *Rembrandt*, 1960, no. 23, pl. 19; Rijksmuseum, Amsterdam, *Rembrandt 1669–1969*, 1969, no. 44, repr.; Morgan Library, and elsewhere, *Rubens and Rembrandt in Their Century*, 1979, no. 68, repr.

Acc. no. I,191

75 *Two Mummers on Horseback*

Pen and brown ink, brown wash, with yellow and red chalks; white tempera on ruffs
8⅜ × 6¹⁄₁₆ inches (212 × 153 mm.)
Watermark: none visible through lining
Inscribed on mount, at upper left in graphite, *81*; on verso of mount at upper center, in pen and brown ink, *6*; at lower center, in pen and black ink, in Robinson's hand, *J C Robinson / July 18 1893 / from Lrd Aylesford Coll^n*

The costumes of the two horsemen, particularly the high cylindrical hat and cartwheel ruff of the fiercely moustachioed cavalier on the left, are typical of the first two decades of the seventeenth century. The late Hyatt Mayor once spoke of them as being Spanish. It is therefore supposed that this drawing and the three related sketches, one representing another horseman (British Museum; Benesch, 1954–1957, II, no. 367, fig. 415 [1973, fig. 443]) and the two others, negro drummers and trumpeters (British Museum; Benesch, 1954–1957, II, no. 365, fig. 412 [1973, fig. 442]. Feilchenfeldt, Zürich; Benesch, 1954–1957, II, no. 366, fig. 413 [1973, fig. 441]), record figures from a festival or pageant which Rembrandt witnessed. Van Regteren Altena cited the tournament and other festivities attendant on the wedding of Wolfert van Brederode with Louise Christine van Solms, a sister of the Princess of Orange, at The

Hague in February 1638, as a possible source of Rembrandt's colorful personages of an earlier time (J. Q. van Regteren Altena, "Retouches to our Conception of Rembrandt: The Concord of State II," *Oud Holland*, LXVII, 1952, pp. 59–63). Rembrandt views the pompous make-believe of the mounted mummers of the Morgan drawing with a pointed humor not manifested in the other drawings of the group. All four drawings were once together in the collection of Jonathan Richardson, Sr.

Technically, the drawing is an interesting example of the complex range of drawing materials the artist used in a single drawing. Watrous analyzed it as follows: "Rembrandt . . . introduced natural red chalk strokes into the plume of a hat and applied moistened red chalk to the boots and along the slits in one of the costumes while the remainder of the drawing was completed with quill pen and bistre ink, bistre washes, yellow ochre fabricated chalk, and semi-opaque whites applied with a brush." The artist's use of this particular combination of pen and wash with colored chalks appears to be confined to this group of drawings and to the copies after Indian miniatures (Acc. nos. I,207 and I,208), making them as unusual in technique as in subject.

PROVENANCE: Jonathan Richardson, Sr. (Lugt 2184); Thomas Hudson (Lugt 2432); possibly his sale, London, Messrs. Langford, 15–26 March 1779, one of three in lot 52 (according to manuscript note in British Museum copy, "The Drummers etc. to Mr. Willett for £6.15.0"); Heneage Finch, fifth Earl of Aylesford (Lugt 58); his sale, London, Christie's, 17–18 July 1893, lot 265 (to Sir Charles Robinson for £6 according to priced copy at R.K.D.); Sir John Charles Robinson (according to inscription on verso of mount); his sale ["Well-Known Amateur"], London, Christie's, 12–14 May 1902, lot 355 (£42); Charles Fairfax Murray; J. Pierpont Morgan (no mark; see Lugt 1509).

BIBLIOGRAPHY: Fairfax Murray, I, no. 201, repr.; Hofstede de Groot, *Rembrandt*, 1906, no. 1109; Valentiner, 1934, II, no. 790, repr.; Benesch, *Werk und Forschung*, 1935, p. 41; Benesch, 1954–1957, II, no. 368, fig. 414 (1973, fig. 444); James Watrous, *The Craft of Old Master Drawings*, Madison, Wisc., 1957, pp. 96, 152, repr.; Walther Scheidig, *Rembrandt als Zeichner*, Leipzig, 1962, pp. 44, 79, fig. 47; B. Haak, *Rembrandt Zeichnungen*, Cologne, 1974, pl. 3; Bernhard, *Rembrandt*, 1976, II, p. 230, repr.; Nigel Konstam, "Over het gebruik van modellen en spiegels bij Rembrandt," *De Kroniek van het Rembrandthuis*, 1978, no. 1, p. 27, fig. 8 (the substance of this article originally appeared in *Burlington Magazine*, CXIX, 1977, pp. 94–98).

EXHIBITIONS: Guildhall, London, 1895, no. 45; Royal Academy of Arts, London, *Old Masters*, 1899, no. 110; Paris, *Rembrandt*, 1908, no. 433; Museum Boymans, Rotterdam, and Rijksmuseum, Amsterdam, *Rembrandt: Tekeningen*, 1956, no. 74, fig. 22; New York–Cambridge, *Rembrandt*, 1960, no. 31, pl. 26; Chicago, *Rembrandt after Three Hundred Years*, 1969, no. 112, pp. 165–166, 212, repr.; Stockholm, *Morgan Library gästar Nationalmuseum*, 1970, no. 65, repr.; Morgan Library, and elsewhere, *Rubens and Rembrandt in Their Century*, 1979, no. 71, repr.

Acc. no. I,201

76 Three Studies for a "Descent from the Cross"
Mark 15:42–46

Quill and reed pen, and brown ink; repair along upper margin
7½ × 8⅟₁₆ inches (190 × 205 mm.)
Watermark: none

Throughout his life, Rembrandt was concerned with the illustration of scenes from the Life and Passion of Christ, but he was particularly preoccupied with these themes in his drawings and etchings of the first half of the 1650's, the period to which this remarkably expressive sheet of studies is assigned. As in the instance of the Thaw *Descent from the Cross* by Rubens (see No. 60), it is possible here to trace the artist's development and refinement of his ideas, both formally and psychologically. He appears to have first drawn the right group of the Christ and the compassionate supporter of His dead body, which is still suspended from the Cross by one hand; then he seems to have revised the original position of Christ's left forearm and back, pressing heavily on the broad nibs of his reed pen to produce the bold outlines. In the smaller sketch at the upper left he incorporated the new position of the forearm and clarified that of the shoulder, at the same time altering the relationship of the two heads so that Christ's head no longer overlaps the other. Finally, moving his pen to the lower left, he studied the new juxtaposition of the heads on a larger scale. As befits the nocturnal setting of the event, the sensitive face of the Christ is now effectively illumined against the shadowed countenance of the young man, perhaps intended as St. John and possibly bearing a faint reminiscence of the fea-

tures of Rembrandt's son Titus. (Compare the portrait *Titus Reading* in the Kunsthistorisches Museum, Vienna [Bredius-Gerson, no. 122].) The other lightly indicated heads may have been first thoughts for spectators at the scene of the Deposition, the upper two possibly extraneous notations that were already on the sheet when Rembrandt began these moving studies of the dead Christ and His sorrowing young disciple who performs his poignant task with infinite tenderness. Campbell's assertion that Rembrandt in the Thaw drawing was inspired by Marcantonio Raimondi's print after Raphael's *Deposition* is not as convincing as his association of *The Standing Old Man and Seated Young Man* (Benesch, 1954–1957, II, no. 348, fig. 400 [1973, fig. 421]) with Marcantonio's print after Raphael's *St. Paul Preaching in Athens*.

Critics have associated the Thaw drawing with the etching of 1654 (Bartsch, no. 83) and also with the painting in the National Gallery, Washington, D.C. (Bredius-Gerson, no. 584; Gerson refers to the painting as the work of a "pupil who based himself on Rembrandt"; Dr. Rosenberg always maintained that the painting is a "highly important" work from Rembrandt's own hand). It cannot be said that the Thaw drawing is directly connected with either work although compositionally it would seem nearer to the painting than to the etching with which Benesch related it.

PROVENANCE: George Guy, fourth Earl of Warwick (according to Benesch; no mark; see Lugt 2600); Thomas Halstead; Dr. A. Hamilton Rice, New York; Mr. and Mrs. Louis H. Silver, Chicago; M. Knoedler and Co., New York; Robert Lehman, New York; Norton Simon Foundation, Los Angeles; R. M. Light & Co., Boston.

BIBLIOGRAPHY: Valentiner, 1934, II, no. 493, repr.; Benesch, *Werk und Forschung*, 1935, p. 55; Benesch, 1954–1957, V, no. 934, fig. 1145 (1973, fig. 1211); Jakob Rosenberg, review of Benesch, 1954–1957, *Art Bulletin*, XLI, 1959, p. 114; unsigned review of exhibition, "Rembrandt Drawings from American Collections," *Arts*, XXXIV, 1960, p. 29, repr.; Colin Campbell, "Raphael door Rembrandts pen herschapen," *De Kroniek van het Rembrandthuis*, XXVII, 1975, p. 28.

EXHIBITIONS: New York–Cambridge, *Rembrandt*, 1960, no. 68, pl. 57; Chicago, *Rembrandt after Three Hundred Years*, 1969, no. 133, repr.; Morgan Library, and elsewhere, *Drawings from the Thaw Collection*, 1975, no. 30, repr.; Morgan Library, and elsewhere, *Rubens and Rembrandt in Their Century*, 1979, no. 72, repr.

Mr. and Mrs. Eugene V. Thaw
Promised gift to The Pierpont Morgan Library

77 *Canal and Bridge beside a Tall Tree, a Couple Seated on the Bank*

Pen and brown ink, brown wash, on paper darkened to a brown tone through exposure to light
5⁹⁄₁₆×9⁹⁄₁₆ inches (141×243 mm.)
Watermark: none visible through lining
Inscribed in pen and brown ink at upper right, *C*[?]

Rembrandt appears to have first set down this idyllic landscape motif of quiet water and bright boscage, and subsequently added the shorthand notation of the couple seated on the embankment as a counteraccent for the darks of the canal and bridge. One is reminded of similar pairs of lovers who appear less conspicuously in corners of such landscape etchings as the *Three Trees* (Bartsch, no. 212) and the *Omval* (Bartsch, no. 209). The little footbridge was almost as typical of the seventeenth-century Dutch scene as the windmill. Its reflection in the water adds another strong vertical to this balanced composition of upright and horizontal elements; though less obvious, the diagonals of the design formed by the canal and the path along the embankment converge effectively at the foot of the dominant tree. The device of a single tall tree as a central focal point was sometimes used by Rembrandt in his landscape paintings as well as his drawings. Compare the romantically composed painting *Stormy Landscape with an Arched Bridge*, in the Staatliche Museen Preussischer Kulturbesitz, Berlin (Bredius-Gerson, no. 445). The present drawing is a characteristic example of Rembrandt's landscapes of the first half of the 1650's where he achieves wonderful effects of vibrant light and airiness by delicate manipulation of a half-dry pen, here combined with washes. Though many of the sites Rembrandt sketched were identified by Frits Lugt in his charming book *Mit Rembrandt in Amsterdam* (1920), this peaceful glimpse of Dutch countryside cannot be localized.

While Rembrandt appears occasionally to have used a drawing paper which he had himself tinted a light brown, just as he experimented with different papers for his etchings, the original white or cream paper here appears to have darkened through exposure to strong light during the centuries. Such exposure is in a way a sign of past

owners' regard for the drawing since it must have been displayed on the wall.

PROVENANCE: Heneage Finch, fifth Earl of Aylesford (no mark; see Lugt 58); his sale, London, Christie's, 17–18 July 1893, lot 260, "A Landscape with a slight bridge over a dyke" (to Salting for £12.10); George Salting (no mark; see Lugt 2260–2261); Charles Fairfax Murray; J. Pierpont Morgan (no mark; see Lugt 1509).

BIBLIOGRAPHY: Fairfax Murray, I, no. 202, repr.; Hofstede de Groot, *Rembrandt*, 1906, no. 1094; Benesch, *Werk und Forschung*, 1935, p. 58; Otto Benesch, *A Catalogue of Rembrandt's Selected Drawings*, London, 1947, no. 226, repr.; Franz Winzinger, *Rembrandt Landschaftszeichnungen*, Baden-Baden, 1953, no. 32, repr.; Benesch, 1954–1957, VI, no. 1343, fig. 1577 (1973, fig. 1655).

EXHIBITIONS: Paris, *Rembrandt*, 1908, no. 469; Metropolitan Museum, New York, *Rembrandt*, 1918, no. 34; Wildenstein and Co., New York, *Rembrandt*, 1950, no. 34; Morgan Library, *Landscape Drawings*, 1953, no. 65; William Rockhill Nelson Gallery, Kansas City, Mo., *Twenty-fifth Anniversary Exhibition*, 1958, no. 15 (Patrick Kelleher in *Nelson Gallery and Atkins Museum Bulletin*, I, no. 2, 1958, p. 8); New York–Cambridge, *Rembrandt*, 1960, no. 54, pl. 46; Minneapolis, *Fiftieth Anniversary*, 1965–66, n.p.; Morgan Library, and elsewhere, *Rubens and Rembrandt in Their Century*, 1979, no. 74, repr.

Acc. no. I,202

78 *Seated Female Nude*

Pen and brown ink, brown wash
8 × 6³⁄₁₆ inches (203 × 157 mm.)
Watermark: none visible through lining

Although the female nude was not a dominant theme in the work of Rembrandt, when it became the subject of an etching or that of a painting, like the *Danaë* (1636; Hermitage, Leningrad), the results were always powerful and unlike the approach of any other artist. Whether he borrowed from Titian (*Venus and Cupid*, Uffizi, for *Danaë*) or relied strictly on his own studies from nature, Rembrandt refrained from the kind of sensuous idealism that became the hallmark of Titian and Rubens and instead created a more personal and unorthodox image, conceived with frank realism.

This drawing is a late work that represents the culmination of Rembrandt's study of the nude, and belongs to the last of three brief periods that were devoted to the subject. While the male nude appears in etchings and drawings dated around 1646, the female nude can be found both in earlier drawings executed in black chalk of about 1632, and in later ones, predominantly worked in pen and ink with wash, that were produced around the time Rembrandt executed the six etchings of nudes, from 1658 to 1661 (Bartsch 197, 199, 200, 202–203, 205). In the Morgan sheet, the interest of the artist in the broadly rendered model is equal to his concern for the overall pictorial effect of the drawing. The dry brush strokes, applied casually but no less effectively, convey the soft plasticity of the nude as well as the light and atmosphere that envelop her. The figure is viewed from below, seated on a pedestal that is covered with drapery, her arms raised as if to adjust a comb in her coiffure. This drawing belongs to a group of over twenty sheets that are distributed among the museums of Europe and the United States (Benesch, nos. 1107–1129); the nude model is studied seated, standing, kneeling, and reclining, with or without props. The Morgan study bears close resemblance to the only other drawings from the series in this country, the two in the Art Institute of Chicago (Benesch, nos. 1122 and 1127).

PROVENANCE: E. Rodrigues, Paris; Mario Uzielli, Switzerland; Dr. Edmund Schilling; private collection, New York (acquired from Schilling in March 1948).

BIBLIOGRAPHY: Benesch, 1954–1957, V, no. 1128, fig. 1349 (1973, fig. 1424).

EXHIBITIONS: New York–Cambridge, *Rembrandt*, 1960, no. 73, pl. 65; Morgan Library, *Rubens and Rembrandt in Their Century*, 1980 (hors de catalogue).

Acc. no. 1979.28
Gift of a Trustee in honor of Charles Ryskamp on the occasion of his tenth anniversary as Director

Jan Lievens the Elder (Dutch)

LEYDEN 1607 – 1674 AMSTERDAM

79 *Portrait of a Man*

Black chalk
9⁵⁄₈ × 7⁵⁄₈ inches (244 × 195 mm.)
Watermark: foolscap with five points (close to Heawood 1921–1922)
Signed with monogram in black chalk at lower right, *IL*. Inscribed on verso in graphite at lower left, *Nº 112*; below this in pen and brown ink, *N 4144*; further below, in another

hand (possibly Engelbert Michael Engelberts, 1773–1843), in graphite, 3[?]L: HS ao-KP

Lievens' drawings, for the most part, fall into two main categories: the many portraits executed in black chalk, usually of an oily consistency, and the even more numerous landscapes drawn with the pen in brown ink. As a portrait draughtsman of the first rank, he captured the character and mood of his sitters without seeming effort. Usually his subjects are men of parts delineated with little or no indication of accessories or setting. In addition to his fellow artists, Lievens portrayed various Dutch patricians and distinguished men of science and letters, among them René Descartes, the French philosopher (Groningen Museum, Groningen; Hans Schneider and R. E. O. Ekkart, *Jan Lievens: Sein Leben und seine Werke*, 2nd ed., 1973, no. z.56), the poet and dramatist Joost van den Vondel (Teylers Museum, Haarlem, no. z.76), and Constantijn Huygens, the diplomat and poet (British Museum, London, no. z.60). Somewhat more than half of his sitters, however, remain anonymous.

We have no clue to the identity of the open-faced man of the Morgan portrait who posed in easy relaxation as he turned the full force of his intelligent, half-amused gaze on the artist; he is portrayed with a spontaneity and sympathy that possibly betokened a bond of friendship. In this and Lievens' other black chalk portraits, unlike his early works of the Leyden period, there is no trace of the influence of Rembrandt, his friend and senior by one year, but rather an allegiance to the style of Van Dyck whom he knew in Antwerp. Van Dyck drew Lievens' portrait sometime during the Dutch artist's extended sojourn in Antwerp (1635–1643). While some of Lievens' chalk portraits were preparatory for etchings, others were apparently independent works as this one seems to be. Its free but decisive execution would suggest that it is a work of the artist's full maturity, possibly around 1645–1650.

The artist's landscape drawings are well represented in the collection; two of them are described in the 1979 catalogue, nos. 82, 83, repr.

PROVENANCE: Jonkheer Johan Goll van Franckenstein the Younger (1756–1821); his *No. 4144* in brown ink on verso, Lugt 2987); Jonkheer Pieter Hendrik Goll van Franckenstein

(1787–1832); his sale, Amsterdam, 1 July 1833, Album K, p. 44, one of two in lot 29 (to Engelberts for 5 florins); possibly Engelbert Michael Engelberts (1773–1843); Baroness de Conantré; Baroness de Ruble; Mme de Witte; Marquise de Bryas; Cailleux, Paris; Benjamin Sonnenberg, New York.

BIBLIOGRAPHY: Morgan Library, *Eighteenth Report to the Fellows, 1975–1977*, 1978, pp. 243, 273; Rolf Quednau, "Zu einem Porträt von Jan Lievens," *Zeitschrift für Kunstgeschichte*, XLIII, no. 1, 1980, p. 104, note 52.

EXHIBITIONS: Vassar College Art Museum, Poughkeepsie, and Wildenstein and Co., New York, *Centennial Loan Exhibition: Drawings & Watercolors from Alumnae and Their Families*, 1961, no. 49, repr.; Morgan Library, and elsewhere, *Rubens and Rembrandt in Their Century*, 1979, no. 81, repr.

Acc. no. 1976.49
Gift of Benjamin Sonnenberg

Adriaen van Ostade (Dutch)
HAARLEM 1610 – 1685 HAARLEM

80 *Strolling Violinist at an Ale House Door*

Pen and brown ink, watercolor in varying tints of green, gray, violet, blue, brown, red, etc., and some tempera (in faces)
$13^7/_8 \times 12^3/_{16}$ inches (350×308 mm.)
Watermark: Strasbourg lily (cf. Churchill 427)
Signed and dated in pen and brown ink at lower left, *Av.* (interlaced) *Ostade. 1673.* Inscribed on verso at lower left corner in pen and brown ink, *C J Nieuwenhuys 1840*

As a draughtsman Ostade has several manners, the rough, vigorous pen style in which he sketched his first ideas and compositional studies, and the gentler combination of refined pen outlines and restrained watercolors he employed for the drawings he made and sold as independent works of art. These watercolors are mainly a product of his later years, notably the decade of the seventies. The elaborate Morgan drawing is a prime example of its kind. Frits Lugt in conversation once remarked of this drawing that it is one of the most beautiful of Ostade's watercolors and one of which Charles Fairfax Murray was very proud. Its distinguished provenance goes back to Jonas Witsen, burgomaster of Amsterdam, and possibly even earlier to the Amsterdam silk manufacturer and collector Constantijn Sennepart (1625–1703), who owned a number of Ostade watercolors later ac-

quired by the burgomaster as reported by Houbraken (*De groote schouburgh der Nederlantsche konstschilders en schilderessen* . . . , Amsterdam, 1718–1721, I, p. 347). It was engraved in the first quarter of the nineteenth century by Ploos van Amstel and then by Josi who explains in his text that the color of the former's plate was unsatisfactory. A comparison of the drawing and Josi's plate shows that he, too, failed to achieve complete success. At the time it was engraved, it was owned by Goll van Franckenstein the Younger and later described as "de aller beste kwaliteit" in the 1833 sale of his collection where it fetched one of the highest prices.

As was his frequent practice, Ostade translated the subject of this watercolor to oils. The painting now hangs in the Mauritshuis in The Hague (Hofstede de Groot, III, p. 271, no. 429; *Mauritshuis*, 1977, p. 173, no. 129, repr.). Not too much larger than the drawing (18×16½ inches, 450×420 mm.), it is signed and dated the same year (1673) as the drawing.

The popularity of Ostade's watercolors led to imitations by his contemporaries and successors, among them the various members of the Chalon family. A collection of 106 drawings by Christina Chalon (1748–1808), beginning with a drawing made at age five, is preserved in an album from the collection of J. van Buuren, now in the Morgan Library.

There are a number of other drawings of genre subjects by the artist and his younger brother Isaac in the Morgan holdings; see 1979 catalogue, nos. 88, 89, 91, repr.

PROVENANCE: Burgomaster Jonas Witsen, Amsterdam (to C. Ploos van Amstel for 126 louis, according to Josi); Cornelis Ploos van Amstel Jb Czn (no mark; see Lugt 2034; the drawing of this subject which was lot 9 in his sale, Amsterdam, 3 March 1800, Album M, which was bought by Versteegh for 35 florins, is apparently a copy after the Morgan drawing); Jonkheer Johan Goll van Franckenstein the Younger (1756–1821; his *No. 3954* in brown ink on verso, Lugt 2987); Jonkheer Pieter Hendrik Goll van Franckenstein (1787–1832); his sale, Amsterdam, 1 July 1833, Album A, lot 2 (to Van Idsinga for 1515 florins according to Lugt 2987); I. van Idsinga (the drawing was not in the I. van Idsinga sale, Amsterdam, 2–6 November 1840); C. J. Nieuwenhuys, Brussels, Belgium, and Oxford Lodge, Wimbledon, England; Robert Stayner Holford (Lugt 2243); his sale, London, Christie's, 11–14 July 1893, lot 655 (to Salting for £255); George Salting (no mark;

see Lugt 2260–2261); Charles Fairfax Murray; J. Pierpont Morgan (no mark; see Lugt 1509).

BIBLIOGRAPHY: C. Ploos van Amstel and C. Josi, *Collection d'imitations de dessins d'après les principaux maîtres hollandais et flamands* . . . , Amsterdam and London, 1821–1827; Rudolph Weigel, *Die Werke der Maler in ihren Handzeichnungen*, Leipzig, 1865, p. 445, no. 5290; Fairfax Murray, I, no. 134, repr.; Schnackenburg, *Van Ostade*, 1971, no. 171; *Mauritshuis*, 1977, p. 173, under no. 129.

EXHIBITIONS: Hartford, *Pierpont Morgan Treasures*, 1960, no. 78; Stockholm, *Morgan Library gästar Nationalmuseum*, 1970, no. 68, repr.; Morgan Library, and elsewhere, *Rubens and Rembrandt in Their Century*, 1979, no. 90, repr.

Acc. no. I,134

Philips Koninck (Dutch)
AMSTERDAM 1619 – 1688 AMSTERDAM

81 *View of the Buitenhof at The Hague*

Pen and brown ink, brown wash; diagonal crease at upper center
4¹¹⁄₁₆×11¼ inches (119×285 mm.)
Watermark: illegible fragment
Inscribed variously on verso, at lower center, in a contemporary hand, perhaps that of the artist, in pen and brown ink, *den 7 martij 1660*; at lower left in graphite, *A.S.*[?] / 7; below that, in another hand, *273*; in pen and black ink, the signature *J. C. Robinson*, written over inscription in graphite, *Het Hof te 's Gravenhage*

Considerable interest attaches to this drawing topographically since it depicts the Buitenhof in The Hague, the outer court or open space before the western section of the irregular pile of buildings that in earlier times constituted the palace of the Counts of Holland. At the time the drawing was made the section of the building adjoining the square tower was known as the Stadtholders' Quarter, having been constructed in 1620–1621 for Stadtholder Prince Maurits of Orange (1567–1625); the tower itself was built between 1568 and 1598. The site today still retains much of the same character and the complex is used for government purposes. Visitors and government workers today enter the Binnenhof or inner court through the same archway as that seen in the drawing to the left of the single tree by the crenellated wall; street cars now run in the area where the draughtsman saw fowls scratching. The trees at the far left border the ornamental rectangular lake, the

Vijver, as do their twentieth-century successors, providing a pleasant walk for students of Dutch art today using the Rijksbureau voor Kunsthistorische Documentatie (R.K.D.), which is housed in the building at the far end of the Vijver that appears in the drawing as the white house to the rear and at the left of the square tower. It was built in 1634–1636 by Arent Arentsz. Gravesande, pupil of Jacob van Campen, to serve as a meeting place for the members of the Militia Company of St. Sebastian. At the beginning of the present century it housed the Gemeentemuseum. (For earlier and more detailed views of this historic site by Buytewech, see Haverkamp-Begemann's monograph [no. 116, pl. 94] and the catalogue of the Buytewech exhibition at Rotterdam and Paris, 1974–1975, nos. 104–105, pls. 116–117. Thanks are also due to Professor Haverkamp-Begemann for his assistance in the identification of the buildings in the present drawing.)

Because of the distinctive nature of the subject, it is possible to trace this drawing's progress through a long sequence of collections beginning with an anonymous Amsterdam sale in 1772. The attribution of the drawing has fluctuated between Philips Koninck and Rembrandt although the earliest reference that has been traced, the 1772 sale, ascribed it to Koninck working in the manner of Rembrandt. The possibility of Rembrandt's authorship was properly discarded after the middle of the nineteenth century. It was apparently Fairfax Murray who introduced the name of Jacob Koninck, the older brother and teacher of Philips, but this was rejected by Byam Shaw and later by Gerson in his monograph in favor of Philips. More recently scholars have tended to discount the traditional attribution to Philips Koninck but it seems advisable to retain the drawing under his name until further light is shed on the individual style of the Rembrandt pupils and followers, for example, on that of Abraham Furnerius, who was Philips' brother-in-law.

PROVENANCE: Anonymous sale, Amsterdam, 20–28 January 1772, lot 555, "Gezigt van 't Buitenhof in 's Hage, met Roed gewassen, door Koning, in de manier van Rembrand" (to Busserus, with lot 556, for 0.10 florins, according to Gerson); Hendrik Busserus; his sale, Amsterdam, 21 October 1782, Album 11, p. 76, lot 686, "Gezigt van het Buitenhof in 's Hage, met Roet geteekent, door Rembrandt" (4 florins);

Abraham Saportas, sale, Amsterdam, 14 May 1832, Album A, lot 37 (according to Gerson); sale, Gérard Leembruggen Jz., Amsterdam, 5 March 1866, lot 335 (as Philip de Koningh), "La résidence des Princes d'Orange à la Haye: à la plume et au bistre. Coll. Muller." (to De Vos for 21 florins); Jacob de Vos Jbzn (Lugt 1450); his sale, Amsterdam, 22–24 May 1883, lot 273 (as Philippe de Koning), "Vue de la cour extérieur ('Buitenhof') à La Haye. Dessin remarquable nous conservant quelques particularités des édifices de la Cour Intérieur [sic], que nous n'avons pas rencontrées ailleurs. Au revers, la date du dessin: *Den 7 Martii 1660*" (to Thibaudeau for 170 florins); Sir Francis Seymour Haden (Lugt 1227); his sale, London, Sotheby's, 15–19 June 1891, lot 563 (as Ph. de Koning.), "View of the 'Buitenhof' at The Hague, bistre washed, dated at the back, 17 [sic] March 1660. From the De Vos collection" (to Sir John Charles Robinson for £6); Sir John Charles Robinson (signature on verso; see Lugt 1433); Charles Fairfax Murray; J. Pierpont Morgan (no mark; see Lugt 1509).

BIBLIOGRAPHY: Fairfax Murray, I, no. 210, repr. (as Jakob Koninck); J. Byam Shaw, "Philips Koninck (1619–1688)," *Old Master Drawings*, V, September 1930, p. 41; Gerson, *Koninck*, 1936, pp. 65 and 145, no. z.70.

EXHIBITION: Morgan Library, and elsewhere, *Rubens and Rembrandt in Their Century*, 1979, no. 98, repr.

Acc. no. I,210

Aelbert Cuyp (Dutch)

DORDRECHT 1620 – 1691 DORDRECHT

82 *Landscape with a Watermill*

Black chalk, heightened with white tempera, yellow wash and some gray wash; old vertical crease left of center
$7\frac{1}{4} \times 12\frac{1}{16}$ inches (184×306 mm.)
Watermark: fragment of fleur-de-lis within a shield (close to Heawood 1743)

Inscribed in graphite in a later hand at upper right, *A. Cuyp*. Inscribed on verso, at center, in black chalk, *105*; at lower left, in graphite, *CUYP / 454*; and at lower left corner in another hand (Engelberts'?), in graphite, *CJ120: / IS ls / dJ / RS⊕XLO*

This drawing, focusing on an old watermill in a somewhat barren setting, would appear to be a transcript from nature. J. W. Niemeijer suggested that the artist may have made the drawing in the vicinity of Bentheim, in the northwest region of Germany near the Dutch border. Strangely enough, none of Cuyp's paintings, as far as could be checked, depicts a subject of this kind. J. G. van Gelder feels the *Watermill* is near in time to the drawing of a building at the water's edge, possibly a toll house, in the Teylers

Museum at Haarlem, which he places around 1642–1644 (see the exhibition catalogue *Aelbert Cuyp en zijn familie: Schilders te Dordrecht*, Dordrecht, Dordrechts Museum, 1977–1978, p. 134, no. 51, repr.). In such an early drawing the influence of Jan van Goyen is perhaps still to be discerned in the handling of the foliage. Josi appears to have been referring to this drawing when he wrote, "J'ai fourni en 1820 à M. de Roveray à Londres un des plus beaux dessins coloriés que je connaise d'*Albert Cuyp*; il représente un site avec un moulin à l'eau entouré d'arbres" (C. Ploos van Amstel and C. Josi, *Collection d'imitations de dessins d'après les principaux maîtres hollandais et flamands . . .* , I, Amsterdam and London, 1821–1827, p. 108). Cuyp's use of black chalk, heightened with white tempera in combination with a distinctive mustardy yellow wash, is almost a trademark for him.

PROVENANCE: Christian Josi (c. 1765–1828), London; M. de Roveray (according to Josi); possibly Engelbert Michael Engelberts (1773–1843); Charles Fairfax Murray; J. Pierpont Morgan (no mark; see Lugt 1509).

BIBLIOGRAPHY: Fairfax Murray, III, no. 185, repr.

EXHIBITIONS: Morgan Library, *Landscape Drawings*, 1953, no. 74; Morgan Library, and elsewhere, *Rubens and Rembrandt in Their Century*, 1979, no. 104, repr.

Acc. no. III,185

Lambert Doomer (Dutch)
AMSTERDAM 1624 – 1700 AMSTERDAM

83 *The Spring at Cleves*

Pen and brown ink, brown, gray, and ochre washes, over faint indications in black chalk, very slight corrections in white tempera
Verso: Small sketch, in pen and brown ink, at left center, of the Swan Tower of Schwanenburg Castle at Cleves
$8^7/_8 \times 14^1/_4$ inches (226×363 mm.)
Watermark: none

Inscribed by the artist on verso in pen and brown ink, *aen de Springh te Kleef*. Inscribed on verso of old mount at lower right corner, in graphite, in three different hands, *Doomer / Domer / From Lord Palmerston's colln;* at right center, in pen and black ink, in J. C. Robinson's hand, *Jan doomer / From Lord Palmerston's colln / formed 1770–1801 / sold at Christie's Apl 24 1891 / J. C. Robinson*

Like so many of his fellow artists of the period, Doomer travelled extensively. Unlike most of

them, however, he did not go south to Italy but journeyed instead to France and Germany. In France where he visited his two brothers at Nantes in 1646, he was accompanied on the return journey by the painter Willem Schellinks (c. 1627–1678), the two young artists travelling via the Loire valley and Paris. Schellinks' diary of their tour is preserved in the Royal Library at Copenhagen (Ny Kgl s.370). In Germany, Doomer travelled—possibly on more than one occasion—in the region of the Lower and Middle Rhine, visiting at one point the birthplace of his father in the village of Anrath near München-Gladbach. His Rhine journey has been variously placed between 1648 and 1670; the most recent proposal is 1663, the date advanced with cogent arguments by Schulz in his recent monograph on the artist's drawings (pp. 24–25).

Doomer was in the main a topographical draughtsman and he recorded his journeys in numerous drawings made en route, annotating but seldom dating them. Doomer probably reached Cleves early in the course of his travels along the Rhine which took him as far south as Bingen; he paused there at least long enough to make four drawings. He drew a panoramic view of the city now in the British Museum; a view of the castle square in the collection of N. Henriot-Schweitzer, Louveciennes; a view of the amphitheatre in the British Museum; and the present drawing of a woodland path above the amphitheatre (Schulz, 1974, nos. 192–196, figs. 98–101). Without the view of the amphitheatre in the British Museum and one of Doomer's usual inscriptions on the verso of the Morgan drawing, it would be difficult to place its locale. The drawing shows only the uppermost tip of the arcaded amphitheatre and the small structure housing the chalybeate spring supplying the water for the fountain and pond. Doomer's curiosity apparently led him to investigate and record this unusual view of one of the sights of Cleves. Characteristically he shows himself or another artist, sketchbook in hand, standing before the "springhouse," just as in the British Museum view of the amphitheatre he showed himself seated sketching in one corner. Although Doomer produced a great many replicas of his drawings, especially after 1680, no other version

of the Morgan landscape is known. Its pristine condition makes it possible to enjoy the colorful effects Doomer achieved with his blended washes, ranging from brown to olive to gray and contrasting with the creamy whiteness of the paper which has retained its original freshness. On the verso there is a small sketch of the top of the famous Swan Tower of the Schwanenburg, the Cleves castle associated with the Lohengrin legend.

Another drawing in the collection, originating from Doomer's travels along the Rhine, depicts the fortress at Ehrenbreitstein seen from a courtyard in Coblenz, situated on the opposite side of the river; see 1979 catalogue, no. 113, repr.

PROVENANCE: Henry Temple, second Viscount Palmerston (1793–1802; according to inscription on mount); Hon. Evelyn Ashley (by bequest from Lord Palmerston); possibly his sale, London, Christie's, 24 April 1891, one of four in lot 157, "Landscapes by Doomer"; Sir John Charles Robinson (according to inscription on verso of mount; Lugt 1433); his sale ["Well-Known Amateur"], London, Christie's, 12–14 May 1902, lot 100, "Landscape with man on a road in foreground, and building to right – pen and bistre, and indian ink wash. From Lord Palmerston's Collection. Exhibited at the Guildhall, 1895"; Charles Fairfax Murray; J. Pierpont Morgan (no mark; see Lugt 1509).

BIBLIOGRAPHY: Fairfax Murray, I, no. 218, repr.; Friedrich Gorissen, *Conspectus Cliviae: Die klevische Residenz in der Kunst des 17. Jahrhunderts*, Cleves, 1964, no. 172, repr., no. 147 (verso), repr.; H. Dattenberg, *Niederrheinansichten holländischer Künstler des 17. Jahrhunderts*, Düsseldorf, 1967, no. 106, repr., no. 107 (verso), repr.; Wolfgang Schulz, *Lambert Doomer, 1624–1700: Leben und Werk*, dissertation, Berlin, 1972, I, p. 54, and II, no. 280; Wilhelm Diedenhofen, "Trophäen im Park," *Bulletin van het Rijksmuseum*, XXI, 1973, p. 122, note 25, fig. 7; Wolfgang Schulz, *Lambert Doomer: Sämtliche Zeichnungen*, Berlin, 1974, no. 196, pl. 100.

EXHIBITIONS: Guildhall, London, 1895, no. 57; North Carolina Museum of Art, Raleigh, N.C., *Rembrandt and His Pupils*, catalogue by W. R. Valentiner, 1956, p. 116, no. 16; Stockholm, *Morgan Library gästar Nationalmuseum*, 1970, no. 69; Vassar, Poughkeepsie, *Seventeenth Century Dutch Landscapes*, 1976, no. 38, repr.; Morgan Library, and elsewhere, *Rubens and Rembrandt in Their Century*, 1979, no. 112, repr.

Acc. no. I,218

Jacob Isaacsz. van Ruisdael (Dutch)

HAARLEM 1628/1629 – 1682 AMSTERDAM

84 *Sun-Dappled Trees on a Stream*

Point of brush, black and gray washes, over slight indications in black chalk

$10^3/_8 \times 7^{11}/_{16}$ inches (264 × 196 mm.)

Watermark: none

Signed in brush and black ink, at lower right with monogram, *JVR* (interlaced). Inscribed on verso in pen and brown ink, at upper center at left margin, *Ruydael*; at lower left corner, in another hand (Engelberts'?), in graphite, *a /mk$_k^n$ / SL: AS ⊕ COV:*

Van Ruisdael, the forest painter *par excellence*, in the course of his career produced around one hundred and forty wooded landscapes, beginning with this theme in his very earliest works. These, as Stechow aptly remarked, "led him first to the edge of the forest and then afterwards into the thicket" (Stechow, *Dutch Landscape Painting*, 1966, p. 71). It is at the edge of the forest that he paused to make this early drawing, a straightforward reflection of the flat countryside near his native Haarlem.

Aside from a few skimming outlines in black chalk, the drawing is worked entirely in brush. The cool washes of Chinese ink, which Van Ruisdael consistently employed, modulate from light transparent grays to the strong blacks of the accents. The subject is simple, a corner of sunwashed woodland, edged by a placid pond and dominated by a sturdy, weathered oak twisting skyward. Van Ruisdael composes in terms of pure landscape—tree forms, foliage, grasses, clouds, water, and light. He is fascinated by the patterning of thorny branch and leaf against the sky. The silhouettes of the airy foliage masses are distinguished in an alternation of the irregular and the rounded outlines of the different kinds of trees. Clouds, which figure so magnificently in the later paintings, are an essential element of the design, and the luminous gray washes which give them form are important in the scale of values. The interlacing grasses in the sandy soil at the foot of the big tree are rendered with delicate calligraphic brush strokes, and among them the artist camouflaged his monogram. The mood is one of sun and solitude, undisturbed by any movement. There is no stir of human figures, and even the flight of birds high in the sky is too distant to affect the summer stillness. Van Ruisdael's drawings—scanty in number, fewer than a hundred being known—seldom relate directly to his pictures, and the Morgan drawing is no exception. It probably belongs

to the late forties, the years between 1646 and
1649 before the artist travelled to Germany.

PROVENANCE: Possibly Engelbert Michael Engelberts (1773–
1843); John, Earl of Northwick (no mark; see Lugt 2445), by
descent to Captain E. Spencer-Churchill, Northwick Park;
his sale, London, Sotheby's, 1–4 November 1920, lot 201
(to Sabin for £26); Martin B. Asscher, London.

BIBLIOGRAPHY: Morgan Library, *Eighth Report to the Fel-
lows*, 1958, pp. 72–73, repr.; Felice Stampfle, "An Early Draw-
ing by Jacob van Ruisdael," *The Art Quarterly*, XXII, no. 2,
1959, pp. 160–163, repr.; Morgan Library, *Review of Acquisi-
tions, 1949–1968*, 1969, p. 166.

EXHIBITIONS: Allen Memorial Art Museum, Oberlin, Ohio,
Youthful Works by Great Artists, 1963 (catalogue in *Allen Me-
morial Art Museum Bulletin*, XX, no. 3, no. 14, repr.); Morgan
Library, *Major Acquisitions, 1924–1974*, 1974, no. 42, repr.;
Vassar, Poughkeepsie, *Seventeenth Century Dutch Landscapes*,
1976, no. 39, repr.; Morgan Library, and elsewhere, *Rubens
and Rembrandt in Their Century*, 1979, no. 117, repr.

Acc. no. 1957.2
Purchased as the gift of the Fellows with the special
assistance of Mr. and Mrs. H. Nelson Slater

Jan de Bisschop (Dutch)

AMSTERDAM 1628 – 1671 THE HAGUE

85 *View of Rome*

Pen and brown ink, brown, reddish-brown, and blue-gray
washes, over preliminary indications in black chalk. Origi-
nally the drawing was executed on two sheets of paper joined
together; the join is evident to the left of center. Some time in
the eighteenth century or earlier the drawing was cut to the
right of this join and divided into two equal parts.

Watermark on each sheet: fleur-de-lis within a shield, sur-
mounted by a crown; countermark, cross with letters *IHS*
(Heawood 1785)

Part 1: 14 × 19⅝ inches (355 × 500 mm.); traces of old vertical
fold to left of center

Inscribed by the artist on verso, in pen and brown ink across
lower half, reading in the order of the monuments repre-
sented on the recto, *Horti Medicei; S. Trinità de' Monti; Pala-
tium Pontifi / cis in Quirinali; Mons Pincius olim Collis hortu-
lorum; Capitolium; Columna Antonini; Aventinus; il Giesù; Pan-
theon / hod. La Rotonda; S. Andrea della Valle; S. Agnese;
S. Maria del'Anima*. Inscribed at upper center edge of verso,
in an old hand, in graphite, *N⁰ 789*; on mount, in another
hand, at lower right corner, in pen and brown ink, *n⁰ 24*

Part 2: 13¹⁵⁄₁₆ × 19¾ inches (352 × 502 mm.); traces of old
vertical fold slightly to left of center

Inscribed by the artist on verso, in pen and brown ink at
upper right, *Gesicht van Romen buyten Porta del popolo*; in
another hand in black chalk just below preceeding inscrip-
tion, *Door Joan De Bisschop*. Further inscribed by the artist in
pen and brown ink, across lower half, *Monte Mario; S. Maria*

*in Valli / cella vulgo La Chiesa Nova; Palatium / Sfortiaᵉ;
S. Maria del popolo; Porta del popolo seu Flaminia; Montes . . .
Vaticani; S. Gio. Battᵃ de' Fiorentini; Castel S. Agnolo seu /
Moles Adriani; S. Spirito in Sassia; Palatium Columnensium;
Santo Officio; Tiberis; S. Pietro in Vaticano; Prata Quintia vulgo
sed rectius Neroniana; Belvedere*. At lower left center, in black
chalk, possibly in Ploos van Amstel's hand, *h. 13d / b. 40d*.
Inscribed in another hand on mount, at lower right within
border, in graphite, *Lₐ̧:ao:-;* and in lower right corner, out-
side border, in pen and brown ink, *n⁰24*

Jan de Bisschop, a lawyer by profession who
lived chiefly in The Hague, was, like his friend
Constantijn Huygens the Younger, a highly tal-
ented amateur draughtsman. Eventually devot-
ing himself almost exclusively to his art, he pro-
duced two handbooks for artists and *amateurs*
containing his etchings after classical sculpture
and works principally by Italian masters under
the titles *Signorum veterum Icones*, which appeared
in two parts in 1668 and then in 1669, and *Para-
digmata graphices variorum artificum*, 1671.

This sunlit panorama of Rome, viewed from
the Porta del Popolo, is of a quality and freedom
to suggest that it was drawn on the spot, or at
least compiled from sketches made from nature,
and certainly the quantity of De Bisschop's draw-
ings devoted to Italian subjects argues that he
must have visited Italy. It has been proposed that
he travelled to Italy some time before his mar-
riage in 1653 or shortly thereafter in 1654–1655,
or perhaps 1657.

On the verso of the drawing, the artist in his
fastidious calligraphy carefully annotated the pro-
cession of majestic monuments that punctuate the
long horizon line of the drawing. Beginning at
the left, one sees in the distance, beyond the sun-
tipped foliage and occasional ruin of the fore-
ground, the enclosure of the Medici gardens and
the twin towers of S. Trinità de' Monti; the Pa-
lazzo del Senatore, the Column of Marcus Aurelius,
and Il Gesù; the low-lying dome of the Pantheon
and the churches of S. Andrea della Valle and
S. Agnese; the larger shape of S. Maria del Popolo
(which was closer to the draughtsman), the Tiber,
and the Castel S. Angelo with the girandole; and
then at the far right St. Peter's and the Vatican.
Curiously, St. Peter's is shown with Bernini's ill-
fated south tower still in place, and, since it was
pulled down in 1646, its inclusion by De Bisschop
poses a problem as to the date of his Italian visit.

Could he at eighteen—his probable age in 1646 —have produced such an accomplished work? Could he have worked on the spot in Rome in the fifties and then completed certain individual details like the façade of St. Peter's from an engraving of earlier date still showing the tower? Or could he have miraculously transformed an engraved model into this lovely *plein-air* vista?

There are two other drawings of the same view, one in the Louvre (Lugt, *École hollandaise, Louvre*, II, 1931, p. 38, no. 767, pl. LI) and one in the De Grez Collection, Musées Royaux des Beaux-Arts de Belgique, Brussels (*Catalogue*, 1913, no. 3681); both were apparently copied after De Bisschop's drawing by Jan van der Ulft (1621–1689), who seems to have made a practice of repeating De Bisschop's drawings. It is to be remarked that Bernini's tower does not appear in either of these repetitions.

The Library also owns two typical examples of De Bisschop's drawings copied after other artists' work, both of them portraits after Van Dyck, one signed with the latinized form of his name, J. Episcopius.

PROVENANCE: Sale, Jeronimus Tonneman, Amsterdam, 21 October 1754, Album B, p. 19, lot 10, "Une Vue de Rome du côté de la Porte del Populo . . ." (to Kok for 19 florins); Gerrit Braamcamp (according to partially obliterated inscription in black chalk[?] on verso of part 2, beginning *N.21 komt uit Gerrit Braamkamps Verk* . . .); his sale, Amsterdam, 31 July 1771, Album A, p. 137, lot 21, "Een Gezicht van een hoogte over de Stad Romen te zien; zeer uitvoerig getekend door J. Bisscop. Hoog. 14, en breed 39 duim"; Johan van der Marck AEgzn (the inscription in graphite on verso of part 2 reading *Door Joan De Bisschop* is in his hand; Lugt 3001); his sale, Amsterdam, 29 November 1773, lot 1999 (to C. Smitt); sale, Coenraad Smitt, Amsterdam, 4 December 1780, Album K, lot 713, "'t Gezigt van de Stad Romen, buiten Porto del Popolo, naar 't Leeven, met de pen en roet geteekend, h. 13, br. 40 duim." (to "Metijer" [Metayer]); Louis Metayer (not identifiable among the summarily described Roman views by De Bisschop in his sale, Amsterdam, 17 February 1799); Cornelis Ploos van Amstel Jb Czn (according to J. Q. van Regteren Altena; possibly on his mount; Lugt 3004); possibly his sale, Amsterdam, 3 March and days following, 1800, II, p.300, Album NNN, containing 170 drawings "door den grooten Kunstenaar JOANNES DE BISSCHOP" including views of Rome, statues, bas-reliefs, medallions, etc.; John MacGowan (Lugt 1496); his sale, London, T. Philipe, 26 January – 4 February 1804, lot 57, "A long view of Rome, on two sheets, representing the whole extent of that renowned city, as it was about 170 years ago; freely executed with an exquisite light pen. The foreground is mostly covered with trees, which are shaded with bistre, and the city and distant ground are in

fine keeping, skilfully and lightly tinged with indigo, the whole in perfect harmony. The names of the principal edifices are marked on the back. A curious and rare design." (to Williams for £1.1); Sir William Forbes; presumably descendants of Sir William Forbes, including Mrs. Peter Somervell, Fettercairn House, Kincardineshire; sale, London, Sotheby's, 28 March 1968, lot 89, repr.

BIBLIOGRAPHY: Ekhart Berckenhagen, "Zeichnungen von Nicolas Poussin und seinem Kreis in der Kunstbibliothek Berlin," *Berliner Museen*, N.F. XIX, no. 1, 1969, p. 26, detail illus. p. 25; Morgan Library, *Review of Acquisitions, 1949–1968*, 1969, p. 131; J. G. van Gelder, "Jan de Bisschop 1628–1671," *Oud Holland*, LXXXVI, no. 4, 1971, p. 209, fig. 32 (detail); Morgan Library, *Sixteenth Report to the Fellows, 1969–1971*, 1973, pp. 100–101, 109; Staatliche Museen Preussischer Kulturbesitz, Berlin, *Die holländischen Landschaftszeichnungen, 1600–1740*, exhibition catalogue by Wolfgang Schulz, 1974, p. 9, under no. 19.

EXHIBITIONS: Morgan Library, *Major Acquisitions, 1924–1974*, 1974, no. 43, repr.; Vassar, Poughkeepsie, *Seventeenth Century Dutch Landscapes*, 1976, no. 43, repr.; Metropolitan Museum of Art, New York, *Roman Artists of the Seventeenth Century: Drawings and Prints* [checklist by Jacob Bean and Mary L. Myers], 1976–1977, n.p.; Morgan Library, and elsewhere, *Rubens and Rembrandt in Their Century*, 1979, no. 118, repr.

Acc. no. 1968.6
Purchased as the gift of the Fellows

Jusepe de Ribera (Spanish)
JÁTIBA 1590 – 1652 NAPLES

86 *The Martyrdom of St. Bartholomew*

Pen and brown ink, brown wash, over faint traces of black chalk
7×5⅜ inches (177×132 mm.)
Watermark: none visible through lining
Inscribed at lower edge, in pen and brown ink, *Giuseppe Ribera L'anno 1649 –*

During a period of about twenty-five years— between 1624 and 1649—Ribera was at intervals concerned with the theme of the martyrdom of St. Bartholomew. His etching of 1624 appears to be his first working of the subject. Three paintings were to follow: one in 1628 and two more in 1644. The first is now in the Pitti Palace, Florence; another is in the Museo de Arte Catalán, Barcelona; and the third is in the Nationalmuseum, Stockholm. The Morgan drawing is dated 1649 and is still another variation on the theme.

A Spaniard by birth who lived most of his

working years in Naples, Ribera was an influential exponent of Caravaggesque painting, inspiring such followers as Luca Giordano and Salvator Rosa. In general, his draughtsmanship is much more spontaneous than the considered, painstaking craftsmanship evident in the beautiful chiaroscuro paintings and prints. The Morgan drawing is delicately rendered in pen and wash, and it bears a close stylistic correspondence to the less detailed sketch *St. Bartholomew Bound to a Tree* at Christ Church, Oxford (repr. Byam Shaw, 1976, pl. 762).

In 1976 the Library was able to acquire another example of Ribera's draughtsmanship, an unusual subject *The Flaying of Marsyas*, executed in red chalk (Acc. no. 1976.48).

PROVENANCE: Charles Fairfax Murray; J. Pierpont Morgan (no mark; see Lugt 1509).

BIBLIOGRAPHY: Fairfax Murray, I, no. 106, repr.; J. Byam Shaw, *Drawings by the Old Masters at Christ Church, Oxford*, Oxford, 1976, under no. 1498.

EXHIBITIONS: Wadsworth Atheneum and Morgan Memorial, Hartford, *Exhibition of Italian Painting of the Sei- and Settecento*, 1930, no. 46; The Art Museum, Princeton University, Princeton, and Fogg Art Museum, Harvard University, Cambridge, Mass., *Jusepe de Ribera: Prints and Drawings*, catalogue by Jonathan Brown, 1973–1974, p. 31, no. 35, pl. 62.

Acc. no. I,106

Bartolomé Esteban Murillo (Spanish)

SEVILLE 1618 – 1682 SEVILLE

87 *The Immaculate Conception*

Pen and brown ink, brown wash, over black chalk
13⅛×9 inches (333×229 mm.)
Watermark: none visible through lining
Inscribed variously, numbered at upper right, *116*; at lower left, *Murillo f.ᵗ*

Primarily a religious painter, the Seville-born Murillo executed several paintings of the Immaculate Conception, but scholars are in disagreement as to whether the surviving works are autograph or copies. At least two drawings and perhaps three are preparations for the same composition. One of these was formerly in the collection of the Countess of Rosebery at Mentmore (repr. *Murillo & His Drawings*, 1976–1977, fig. 38); another is the Morgan drawing. It is a matter of opinion as to whether the third, in the Hispanic Society,

New York, is authentic or a copy (repr. *Spanish Baroque Drawings in North American Collections*, 1974, fig. 2). Although the repetition of the same composition in two drawings is unusual, there is nothing within either the Rosebery or the Morgan work to arouse doubt as to their authenticity. The style and high quality of both are characteristic of Murillo at his best; the manner of hatching and the vibrant sketchy strokes used for definition are typical of Murillo's drawing style throughout his career. According to Jonathan Brown, the Morgan sheet was once included in a volume of at least 116 Murillo drawings, or so the number *116* on the upper right corner would suggest.

Another drawing by Murillo in the collection (repr. Fairfax Murray, I, no. 110) is preparatory for the painting *The Vision of St. Felix of Cantalice* dating around 1668–1669, now in the Museo Provincial de Bellas Artes, Seville (repr. *Murillo & His Drawings*, 1976–1977, fig. 61).

PROVENANCE: Robert Staynor Holford (Lugt 2243); Charles Fairfax Murray; J. Pierpont Morgan (no mark; see Lugt 1509).

BIBLIOGRAPHY: Fairfax Murray, I, no. 111, repr. (as *Assumption*); E. Lafuente Ferrari, "Dibujos de maestros andaluces," *Archivo español de arte y arqueología*, XXXVII, 1937, p. 18, fig. 10; Elizabeth du Gué Trapier, "Notes on Spanish Drawings," *Notes Hispanic*, I, 1941, p. 36; Diego Angulo Iñiguez, "Murillo: Varios dibujos de la 'Concepción' y de 'Santo Tomás de Villanueva,'" *Archivo español de arte*, XXXV, 1962, p. 231, pl. 1, no. 3.

EXHIBITIONS: University of Kansas Museum of Art, Lawrence, *Spanish Baroque Drawings in North American Collections*, catalogue by Gridley McKim-Smith, 1974, no. 29, repr.; The Art Museum, Princeton University, Princeton, *Murillo & His Drawings*, catalogue by Jonathan Brown, 1976–1977, no. 54, repr.

Acc. no. I,111

Francisco Herrera the Younger (Spanish)

SEVILLE 1622 – 1685 MADRID

88 *Design for a Processional Sculpture with Five Variant Plans; The Vision of St. John on Patmos*

Pen and brown ink, brown wash, over preliminary indications in graphite
Verso: Seated male nude, sketches of ornament, and light

sketch of another seated figure; plan in pen and brown ink and graphite

10¾×7¹³⁄₁₆ inches (273×198 mm.)

Watermark: none

Inscribed in pen and brown ink in the plan at lower left, D[on] *fran.ᶜᵒ de herrera*, and in faint black chalk to the left of St. John, *herrera*

In this spirited drawing for a processional sculpture, the Spanish painter-architect Herrera the Younger fully demonstrates his best qualities as a draughtsman. The Morgan drawing was probably a design for one of the Spanish religious festivals although it cannot be connected with any specific sculpture. According to Hispanic experts such a sculpture was probably executed in wood, silver, or some even less permanent material. Since candlesticks figure prominently in the design, it has been suggested that the sculpture may have had something to do with St. John in his role as patron of candlemakers.

Born in Seville, Herrera the Younger received his early training from his father who was also an artist. He continued his study in Rome until the death of his father in 1654 or 1657 recalled him to Spain. A number of his paintings survive to attest Herrera's considerable mastery of the Baroque style. In 1672 he was made painter to Charles II; it was, however, his skill as an architect which in 1677 won him the highly influential post of Master of the Royal Works, an office which he held until his death in 1685. Other drawings by the master can be found in the Albertina, the Biblioteca Nacional, Madrid, the Louvre, and the Uffizi.

PROVENANCE: H. M. Calmann, London.

BIBLIOGRAPHY: Morgan Library, *Eleventh Report to the Fellows, 1961*, 1961, pp. 89ff., repr.; *Great Drawings of All Time*, IV, 1962, no. 945, repr.; F. J. Sánchez Cantón, *Great Drawings of the World: Spanish Drawings of the 10th to 19th Century*, New York, 1964, pl. 58; Morgan Library, *Review of Acquisitions, 1949–1968*, 1969, p. 149; Jonathan Brown, "Pen Drawings by Herrera the Younger," *Hortus Imaginum: Essays in Western Art*, ed. by Robert Enggass and Marilyn Stokstad, Lawrence, Kansas, 1974, pp. 137f., note 38g; Eleanor M. Garvey, "Francisco Herrera the Younger: A Drawing for a Spanish Festival Book," *Harvard University Bulletin*, XXVI, no. 1, 1978, p. 35.

EXHIBITIONS: Morgan Library, *Major Acquisitions, 1924–1974*, 1974, pp. xxiif., no. 31, repr.; Los Angeles, *Old Master Drawings*, 1976, no. 228, repr.

Acc. no. 1960.12

Purchased as the gift of Walter C. Baker

Giovanni Battista Piazzetta (Italian)
VENICE 1682 – 1754 VENICE

89 *Young Woman Holding a Jingle Ring*

Black chalk, heightened with white, on faded blue paper

16⅞×13½ inches (429×343 mm.)

Watermark: none

Inscribed on verso, at lower left, in graphite, *43*

The suggestion of Otto Benesch that this drawing and two others in the collection belong to a series of the Five Senses still remains viable. The present sheet represents the Sense of Hearing, the *Young Woman Holding a Pear* (Acc. no. IV,89) the Sense of Taste, and the third drawing depicting a young woman touching her breast (Acc. no. IV,91) may possibly be interpreted as the Sense of Touch, although she differs from the first two in physical type. There is a fourth drawing of a young woman holding a rose in the Gallerie dell'Accademia, Venice, that may signify the Sense of Smell.

Regrettably, the original effect of a drawing on blue paper rarely survives over the centuries when exposure to light alters the blue color to gray or green. This sheet was not spared this loss nor that of some foxing caused by the mold promoted by the damp climate of Venice. Nevertheless, Piazzetta's velvety touches of black chalk, heightened with accents of white, still convey beautifully the sensuous charm of his Venetian subject.

PROVENANCE: Charles Fairfax Murray; J. Pierpont Morgan (no mark; see Lugt 1509).

BIBLIOGRAPHY: Fairfax Murray, IV, no. 90, repr.

EXHIBITIONS: Lyman Allyn Museum, *Drawings*, 1936, no. 104; Metropolitan Museum of Art, New York, *Tiepolo and his Contemporaries*, 1938, no. 34; Morgan Library, *New York World's Fair*, 1939, no. 74; The Baltimore Museum of Art, Baltimore, *The Age of Elegance: The Rococo and its Effects*, 1959, no. 214; *Drawings from New York Collections*, III, 1971, no. 43, repr.

Acc. no. IV,90

Giovanni Paolo Pannini (Italian)
PIACENZA 1691/1692 – 1765 ROME

90 *View of the Great Vaulted Portico of the Villa Albani, Rome*

Pen and black ink, watercolor, and some graphite, including perspective points, some rendered by compass
19×27⅝ inches (483×701 mm.)
Watermark: none visible through lining

The artist rendered this magnificent Neoclassical portico with the precision and finesse worthy of the position he held as Professor of Perspective at the French Academy in Rome. Pannini taught there from 1732 until his death, and his pupils included Joseph Vernet, Hubert Robert, and Charles Michel-Ange Challe. This highly finished drawing, embellished with transparent washes of gray and delicate watercolor, transmits the noble grandeur of the elegant portico decorated with antique statues. The villa was built for Cardinal Alessandro Albani, patron of the German Neoclassical theorist Winckelmann who, as his librarian, assisted the Cardinal in assembling an extensive collection of ancient sculpture. It is in the main room which exhibits this collection that Anton Raphael Mengs painted his *Parnassus* (1760–1761), the important work which was undoubtedly conceived under the influence of Winckelmann. As is characteristic of many architectural interiors rendered by Pannini, the scale in this drawing is slightly exaggerated and the portico appears larger and longer than it actually is.

PROVENANCE: Kate de Rothschild and Yvonne Tan Bunzl, London.

BIBLIOGRAPHY: Andrea Busiri Vici, *Trittico paesistico romano del '700*, Rome, 1976, p. 45, fig. 39; Morgan Library, *Eighteenth Report to the Fellows, 1975–1977*, 1978, pp. 242, 281, repr.

Acc. no. 1977.43
Purchased as the gift of the Fellows with the special assistance of Mr. Rowland Burdon-Muller, Mrs. W. Rodman Fay, Mrs. Enid A. Haupt, Mrs. Gerard B. Lambert, Mr. Robert B. O'Connor, and Mr. John S. Thacher

Giovanni Battista Tiepolo (Italian)
VENICE 1696 – 1770 MADRID

91 *Time and Cupid*

Pen and brown ink, brown wash, over black chalk
10⁹⁄₁₆×12⁷⁄₁₆ inches (268×315 mm.)
Watermark: letters *b V* (cf. Heawood 3102)

It was the custom of the Tiepolos to mount their drawings systematically into albums, many of which then passed *en bloc* from collection to collection after the death of Giambattista's son Domenico in 1804. The English *amateur* Edward Cheney managed to obtain nine of these volumes of mounted drawings from Count Algarotti-Corniani in 1852. One of the volumes was acquired by Charles Fairfax Murray, after the Cheney sale in 1885, whence it passed intact in 1910 into the Morgan collection.

Time and Cupid is one of the most sparkling of the more than one hundred drawings in the Morgan album, the individual drawings of which have subsequently been mounted separately. Executed in pen and various shades of brown wash, it relates to Giambattista's work in the Palazzo Clerici, Milan, painted in 1740, where this brilliant study was used with very little alteration for the figures of Time and Cupid in the group with Venus located in the south portion of the great ceiling (repr. Antonio Morassi, *G. B. Tiepolo*, New York, 1955, pls. 25–27). The Palazzo Clerici project is an exuberant Baroque fantasy wherein Giambattista buoyantly allegorized the ravishing of Beauty by Time as personified by Venus and Saturn.

PROVENANCE: Count Francesco Algarotti (and thence presumably to his brother and heir, Count Bonomo Algarotti; his daughter, Maria Algarotti-Corniani; her son, Count Bernardino Corniani); Edward Cheney; his brother-in-law, Colonel Alfred Capel Cure; sale, London, Sotheby's, 29 April 1885, presumably part of lot 1024; Charles Fairfax Murray; J. Pierpont Morgan (no mark; see Lugt 1509).

BIBLIOGRAPHY: Fairfax Murray, IV, no. 125, repr.; Otto Benesch, *Venetian Drawings of the Eighteenth Century in America*, New York, 1947, no. 30, repr.

EXHIBITIONS: Fogg Art Museum, Harvard University, Cambridge, Mass., *Venice in the Eighteenth Century*, 1948, no. 36; Hartford, *Pierpont Morgan Treasures*, 1960, no. 81; *Drawings from New York Collections*, III, 1971, no. 91, repr.

Acc. no. IV,125

92 *Design for a Ceiling: The Triumph of Hercules*

Pen and brown ink, brown wash, over black chalk; some corrections in brush and white tempera
18⅛×24 inches (458×610 mm.)
Watermark: circle
Inscribed on verso, in pen and brown ink, at upper right, *660–661*

This drawing is perhaps unique in Giambattista's

surviving *oeuvre* as the only known scheme for a ceiling design complete with both figures and ornament. The illusionistic architectural setting is rendered in steep perspective opening out into the clouds. There Hercules sits in triumph, embraced by Fame with her trumpet, the scene witnessed from above by the hero's personified attribute of Strength or Fortitude. Airy balconies centered on each of the four sides of the ceiling are crowded with a variety of attendants including musicians, soldiers, Virtues, cherubs, and even a monkey. The corners of the ceiling are occupied by vases mounted on arches and Rococo cartouches. It was Byam Shaw's observation that the proposed decorative scheme must have been made with a relatively small ceiling in mind; otherwise the figures around the edge would have had to be heroic.

A drawing in the Horne Foundation in Florence repeats some of the same figural motives that appear in the Morgan design, but they are arranged in a different manner so as to focus attention on the personifications of War and Peace. The subject of the Horne drawing has been loosely connected with *The Triumph of Hercules*, the ceiling originally in the Palazzo Canossa at Verona, painted in 1761–1762, some twenty years later than the Morgan project, which must date around 1740.

PROVENANCE: Guggenheim, Venice; his sale, Munich, Hugo Helbing, 30 September 1913, lot 1152, repr.; Adrien Fauchier-Magnan; his sale, London, Sotheby's, 4 December 1935, lot 55 [withdrawn]; sale, Paris, Palais Galliéra, 16 June 1966, lot 7, repr.; Gian Carlo Baroni, Florence; E. Viancini, Venice.

BIBLIOGRAPHY: Morgan Library, *Review of Acquisitions, 1949–1968*, 1969, p. 172; George Knox, "Italian Drawings in New York," *Burlington Magazine*, CXIII, 1971, p. 291; J. Byam Shaw, "Tiepolo Celebrations: Three Catalogues," *Master Drawings*, IX, 1971, p. 276, note 12; Morgan Library, *Sixteenth Report to the Fellows, 1969–1971*, 1973, pp. 104f., 122; Terisio Pignatti, *Tiepolo: Disegni scelti e annotati*, Florence, 1974, pl. XVIII; George Knox, review of Pignatti, *Burlington Magazine*, CXVIII, 1976, p. 166.

EXHIBITIONS: *Drawings from New York Collections*, III, 1971, no. 69, repr.; Morgan Library, *Major Acquisitions, 1924–1974*, 1974, p. xix, no. 16, repr.; Birmingham Museum of Art, Birmingham, Ala., and elsewhere, *The Tiepolos: Painters to Princes and Prelates*, 1978, no. 78, repr. in color.

Acc. no. 1968.8
Purchased as the gift of the Fellows

Antonio Canal, called Canaletto (Italian)
VENICE 1697 – 1768 VENICE

93 *Architectural Capriccio*

Pen and brown ink, gray wash, over traces of graphite
Verso: Architectural sketch in graphite
11¼ × 8⅟₁₆ inches (285 × 204 mm.)
Watermark: illegible fragment
Inscribed on verso, in pen and brown ink, presumably in the hand of MacGowan, *Canaletti / presented me by J. Hayes*

In Canaletto's architectural improvisations, he skillfully combined the factual with the imaginary. According to Constable, the church in the background is that of S. Lorenzo, seen from the eastern end as if looking southward along the Rio di Pietà. The campanile at the left resembles that of S. Giustina near S. Lorenzo or that of S. Moise. The fictitious bridge and genre details in the foreground lend a picturesque quality to the scene. There are a number of *pentimenti* in graphite throughout the sheet, the most conspicuous occurring above the campanile, showing how the artist's thoughts evolved. Conceived almost as an exercise in geometric patterns, the drawing is satisfying to the eye in its variety of detail and quality of completeness. Canaletto's deft application of gray washes, reserving the white of the paper for highlights, and his sophisticated pen work serve to animate the surface as well as to imply spatial recession. Finished drawings such as these were intended for sale.

PROVENANCE: J. Hayes; John MacGowan (Lugt 1496); Count Antoine Seilern, London; Koetser, New York; F. A. Stern, New York; Janos Scholz, New York (no mark; see Lugt 2933b).

BIBLIOGRAPHY: Otto Benesch, *Venetian Drawings of the Eighteenth Century in America*, New York, 1947, p. 37, no. 51, repr.; Tietze, 1947, no. 93, pl. 186; "Italian Drawings from the Collection of Janos Scholz," *Metropolitan Museum of Art Bulletin*, May 1965, Part II, p. 342, repr.; W. G. Constable, *Canaletto*, Oxford, 1976, no. 772, repr.; Terisio Pignatti, *Antonio Canal detto Il Canaletto*, Milan, 1976, no. 90; Janos Scholz, *Italian Master Drawings, 1350–1800, from the Janos Scholz Collection*, New York, 1976, no. 142, repr.

EXHIBITIONS: *Drawings from New York Collections*, III, 1971, no. 161, repr. (includes previous exhibitions); Dallas Museum of Fine Arts, Dallas, and Museum of Fine Arts, Houston, *Drawings from the Janos Scholz Collection*, 1977–1978, no. 142,

repr.; Snite Museum of Art, University of Notre Dame, Notre Dame, Ind., *Janos Scholz: Musician and Collector*, 1980, no. 165, repr.

Acc. no. 1973.48
The Janos Scholz Collection. Purchased with the special assistance of the Fellows

Francesco Guardi (Italian)
VENICE 1712 – 1793 VENICE

94 *The Bucintoro off S. Niccolò di Lido*

Pen and brown ink, brown wash, over black chalk on two sheets of paper, pasted together, the larger of which is the reverse of an engraving by Carlo Orsolini inscribed, *Sacrum Convivium*; indistinct black chalk sketch of architecture in opposite direction at upper left corner

Verso: Sketch of street scene in pen and brown ink by Giacomo Guardi, the artist's son; black chalk sketches of gondoliers

14⅝ × 31⅞ inches (371 × 810 mm.)

Watermark: graduated triple crescents above the word MEZANA (cf. Heawood 874–875)

This large compositional sketch was used for the painting of the early 1780's, in the possession of Alessandro Brass, Venice, and records in Guardi's painterly blend of pen and wash one of the most spectacular festivals of eighteenth-century Venice. The *Festa della "Sensa"* (Festival of the Ascension) celebrated annually the marriage of the city of Venice and the Adriatic in commemoration of the conquest of Dalmatia by Doge Pietro Orseolo II about the year 1000. Each year until 1789, the reigning doge made a ceremonial journey on the Bucintoro, a gilded state barge, to the church of S. Niccolò di Lido, located outside the city, where the "wedding service" took place. En route to the church, the doge performed the traditional rite of tossing a consecrated ring into the sea, saying the words *Desponsumus te mare in signum veri perpetuique Domini* ("we marry thee, O Sea, in the sign of the true and eternal Lord").

In the Morgan sheet, the state barge, surrounded by a flotilla of gondolas, is on its return journey to the city where the doge will attend an official banquet followed by masked revelry. The Bucintoro is shown below the church, visible in the center distance, and is greeted by a gunfire salute from the man-of-war on the far right. The island

of S. Elena appears at the extreme left as an unfinished passage sketched in black chalk—a medium frequently used by the artist in the preliminary stages of his drawings.

There are a number of paintings by Guardi devoted to the subject of this aquatic pageant, among which the Bucintoro is shown setting forth on its journey from the Riva degli Schiavoni (Toulouse), then reaching the open sea (Glasgow), arriving at S. Niccolò di Lido (Paris and Philadelphia), and, finally, embarked on its return journey (Copenhagen). Likewise, several drawings that record various details of the procession are preserved at the Museo Correr (Venice), Metropolitan Museum (New York), and Fogg Art Museum (Cambridge, Mass.); the Morgan sheet is among the largest of the surviving drawings. Another version of the subject has been added recently to the collection from the estate of Mrs. Herbert N. Straus (Acc. no. 1978.15).

PROVENANCE: Dubois; David David-Weill, Neuilly; Richard Zinser, New York.

BIBLIOGRAPHY: Gabriel Henriot, *Collection David Weill*, III, Paris, 1928, pp. 221–222, repr.; J. Byam Shaw, *The Drawings of Francesco Guardi*, London, 1951, pp. 28, 50, 75, 79, no. 45, repr.; Felice Stampfle, "The Progress of the Bucentaur by Francesco Guardi," *Gazette des beaux-arts*, XLIII, 1954, pp. 77–82, fig. 1; Terisio Pignatti, *Disegni dei Guardi*, Florence, 1967, under no. LX; Antonio Morassi, *Guardi—tutti i disegni*, Venice, 1975, no. 283, fig. 287.

EXHIBITIONS: Morgan Library, and elsewhere, *Fiftieth Anniversary*, 1957, no. 101, pl. 66; Palazzo Grassi, Venice, *Mostra dei Guardi*, 1965, no. 36, repr.; *Drawings from New York Collections*, III, 1971, no. 195, repr.; Morgan Library, *Major Acquisitions, 1924–1974*, 1974, no. 19, repr.

Acc. no. 1947.2
Purchase

Giovanni Battista Piranesi (Italian)
MOGLIANO VENETO 1720 – 1778 ROME

95 *Gondola*

Pen and brown ink, brown wash, over black chalk

Verso: Ornament with sun and star motifs in black chalk; design for decorative frame in pen and brown ink; similar sketch in red chalk

11⅝ × 26⅞ inches (296 × 683 mm.)

Watermark: bow and arrow (Briquet 738)

This magnificent design for a ceremonial gondola or "bissona" was executed in 1744–1745 during

Piranesi's brief sojourn in Venice following his first residence in Rome. In the words of Hylton Thomas (p. 17), "the motifs incorporated into the design are extraordinarily abundant in number and variety, and each echoes or balances another with the exquisite precision and buoyant harmony of a Mozart quartet." It is an outstanding example of Piranesi's Venetian Rococo period, and is one of several drawings in the collection (designs for title pages, wall panels, and capriccios) that reflect the influence of Giovanni Battista Tiepolo in whose studio Piranesi is believed to have worked at this time. The drawing with its fluid, flickering line also suggests the influence of Francesco Guardi, the view-painter. Andrew Robison has shown that shortly after the artist returned to Rome, he adapted his fanciful design for a gondola to that of a carriage in the foreground of his etching *Veduta della Basilica e Piazza di S. Pietro in Vaticano*.

This important drawing is one of over one hundred and thirty sheets that came to the Morgan Library from the collection of Mrs. J. P. Morgan, constituting by far the largest holding of Piranesi drawings in existence.

PROVENANCE: Mrs. J. P. Morgan, New York; her sons, Junius S. Morgan and Henry S. Morgan, New York.

BIBLIOGRAPHY: Felice Stampfle, "An Unknown Group of Drawings by Giovanni Battista Piranesi," *Art Bulletin*, XXX, 1948, pp. 123–124, 129, no. 10, fig. 3; A. Hyatt Mayor, *Giovanni Battista Piranesi*, New York, 1952, pp. 6, 33, fig. 2 (detail); Hylton Thomas, *The Drawings of Giovanni Battista Piranesi*, New York, 1954, pp. 16–17, no. 16, pls. 16, 17; Morgan Library, *Fifteenth Report to the Fellows, 1967–1968*, 1969, pp. 118–119; Morgan Library, *Review of Acquisitions, 1949–1968*, 1969, p. 160; Andrew Robison, "Piranesi's Ship on Wheels," *Master Drawings*, XI, 1973, pp. 389–392, pl. 47, fig. 1; Jonathan Scott, *Piranesi*, London–New York, 1975, p. 14, fig. 8; John Wilton-Ely, *The Mind and Art of Giovanni Battista Piranesi*, London, 1978, pp. 18, 30, fig. 14.

EXHIBITIONS: Morgan Library, *Piranesi*, 1949, pp. 6–8, 13, no. 10, figs. 6, 7 (detail); Allen Memorial Art Museum, Oberlin College, Oberlin, Ohio, *Exhibition of Master Drawings of the 18th Century in France and Italy*, catalogue in *Oberlin College Bulletin*, VIII, no. 2, 1951, no. 16, repr.; Morgan Library, and elsewhere, *Fiftieth Anniversary*, 1957, no. 102, pl. 67; *Drawings from New York Collections*, III, 1971, no. 219, repr.; Morgan Library, *Major Acquisitions, 1924–1974*, 1974, no. 20, repr.; Hayward Gallery, London, *Piranesi*, catalogue by John Wilton-Ely, 1978, no. 11, repr.; Morgan Library, *Piranesi*, 1978 (revised 1949 exhib. cat.), no. 10, repr.

Acc. no. 1966.11:10

Bequest of Junius S. Morgan and gift of Mr. Henry S. Morgan

96 *Architectural Fantasy*

Pen and brown ink, brown wash
13 × 19 5/16 inches (330 × 491 mm.)
Watermark: none

This imaginary structure composed of a triumphal arch, grand staircase, and colonnades is a recurring theme in the drawings executed by Piranesi in Rome in the 1740's and 1750's—the most fertile period of his architectural fantasies (London, 1978, pp. 25–26). The airy, Rococo patterns of the artist's Venetian drawings (see No. 95) were replaced by a bold, rectilinear style more suited to the rendering of architecture inspired by Roman ruins. The reiterated contours and bold hatching, which animate the austere design and lend it weight and drama, reflect Piranesi's Venetian heritage by way of Canaletto (K. T. Parker, *The Drawings of Antonio Canaletto . . . at Windsor Castle*, Oxford/London, 1948, pls. 4, 5), who often used the same technique in his pen drawings of Venetian vistas. This was first observed by Hylton Thomas in connection with another drawing of a triumphal arch and staircase in the British Museum (*The Drawings of Giovanni Battista Piranesi*, New York, 1954, no. 24, repr.). Piranesi's "superstructures" were often intentionally placed in the foreground to emphasize their colossal scale and forbidding grandeur. One is led to think that an endless succession of colonnades and arches continues beyond the margins of this sheet, their size and scale unfathomable to the imagination.

PROVENANCE: Spencer, London; Janos Scholz, New York (Lugt S. 2933b).

BIBLIOGRAPHY: G. Freedley, *Theatrical Designs*, I, New York, 1940, pl. 9; Charles De Tolnay, *History and Techniques of Old Master Drawings*, New York, 1943, no. 142, repr.; Tietze, 1947, p. 202, no. 101, repr.; Janos Scholz, *Baroque and Romantic Stage Design*, New York, 1949, p. 14, pl. 68; A. Hyatt Mayor, *Giovanni Battista Piranesi*, New York, 1952, p. 38, pl. 24; Janos Scholz, *Italian Master Drawings, 1350–1800, from the Janos Scholz Collection*, New York, 1976, no. 144, repr.; Morgan Library, *Seventeenth Report to the Fellows, 1972–1974*, 1976, p. 176, pl. 17.

EXHIBITIONS: *Drawings from New York Collections*, III, 1971, no. 226, repr. (includes previous exhibitions); Los Angeles, *Old Master Drawings*, 1976, no. 72, repr.; Dallas Museum of Fine Arts, Dallas, and Museum of Fine Arts, Houston, *Drawings from the Janos Scholz Collection*, 1977–1978, no. 144, repr.; Hayward Gallery, London, *Piranesi*, catalogue by John Wilton-Ely, 1978, no. 45; Morgan Library, *Piranesi*, 1978 (re-

vised 1949 exhib. cat.), no. A4, repr.; Snite Museum of Art, University of Notre Dame, Notre Dame, Ind., *Janos Scholz: Musician and Collector*, 1980, no. 166, repr.

Acc. no. 1974.27
The Janos Scholz Collection. Gift of Mr. Scholz

Giovanni Domenico Tiepolo (Italian)
VENICE 1727 – 1804 VENICE

97 *The Dressmaker*

Pen and brown ink, gray-brown, gray, and ocher wash, over black chalk
11 5/16 × 16 7/16 inches (288 × 418 mm.)
Watermark: coat-of-arms with monogram
Signed and dated in pen and brown ink at lower left, *Dom.º Tiepolo / f. 1791*

The Dressmaker and a second genre subject, *A Visit to the Lawyer*, were acquired by the Library at the same time and are both from the sequence of around twenty views of contemporary life, all dated 1791, in which the artist delightfully satirizes the Venetian scene. Domenico, then in his sixties, was no longer in great demand as a painter; he was, moreover, comfortably well off, and drew and painted chiefly for his own pleasure. The amusing Punchinello variations belong to this same period of activity, and it may be, as Byam Shaw has remarked, that these genre scenes —in contrast to the professional side of his art in which he functioned chiefly as his father's able assistant—constitute Domenico's distinctive contribution to Venetian art of the late eighteenth century.

These genre scenes are not related to paintings and were intended by the artist to stand as independent works of art. Although there are certain parallels with the satirical prints and drawings of such contemporary artists as Goya and Rowlandson, Domenico belonged to an older generation and there is nothing particularly pointed about his satire. Here, within a charming Rococo interior, a young girl stands guilelessly studying her reflection in a mirror while the modiste proceeds to outfit her with the latest styles, no doubt in preparation for her introduction to Venetian society. The subject has been traditionally iden-

tified as *A Visit to the Dressmaker's*, but it is more probable, as Felice Stampfle has suggested, that the dressmaker and her assistant, who stands to her right holding an unwieldy bundle of samples of material, have come to fit the girl in her own home, where her chaperon, seated at the left, views the proceedings complacently. The customary grays and browns of Domenico's wash drawings have been delicately enriched by the addition of a light ocher wash. The pendant drawing *A Visit to the Lawyer* (Acc. no. 1967.23), which is not shown here, is of equal interest and high quality.

Among other subjects by the artist, the collection includes seven of Domenico's large biblical scenes and *Punchinello with an Elephant* (Acc. no. IV,151b).

PROVENANCE: Alfred Beurdeley, Paris; sale, Paris, Rahir, 31 May 1920; sale, London, Sotheby's, 6 July 1967, lot 41, repr.

BIBLIOGRAPHY: Henry de Chennevières, *Les Tiepolos*, Paris, 1898, p. 133; Oswald Kutschera-Woborsky, "Die Fresken der Puritàkapelle in Udine und die Kunst Domenico Tiepolos," *Jahrbuch der preussischen Kunstsammlungen*, XLI, 1920, p. 183, fig. 19 (wrongly stated to be in the Louvre); Antonio Morassi, "Domenico Tiepolo," *Emporium*, XCIII, 1941, p. 280, repr. (wrongly stated to be in the École des Beaux-Arts, Paris); J. Byam Shaw, *The Drawings of Domenico Tiepolo*, London, 1962, no. 68, repr.; Morgan Library, *Fifteenth Report to the Fellows, 1967–1968*, 1969, pp. 120f., repr.; Morgan Library, *Review of Acquisitions, 1949–1968*, 1969, p. 173, repr.; Michael Levey, *Painting in Eighteenth-Century Venice*, Ithaca, N.Y., 1980, p. 160, fig. 98.

EXHIBITION: *Drawings from New York Collections*, III, 1971, no. 260, repr.
Acc. no. 1967.22
Purchased as the gift of the Fellows

Jean-Antoine Watteau (French)
VALENCIENNES 1684 –
1721 NOGENT-SUR-MARNE

98 *The Temple of Diana*

Red chalk
10 1/2 × 14 1/4 inches (267 × 362 mm.)
Watermark: fragment of chaplet (close to Heawood 222)

Sometime after leaving Gillot's studio in 1706, Watteau went to work with the ornament de-

signer Claude Audran who was the concierge at the Luxembourg Palace. There, under Audran's influence and with his own innate taste for color and light decoration, Watteau fell under the spell of the newly emerging Rococo style. He produced a number of designs for decorative arabesques, some of which have survived and some of which are known only from the prints made after them in the engraved series *Figures de différents caractères, de paysages et d'études*, which Watteau's friend the noted collector Jean de Jullienne had executed after the untimely death of the frail genius in 1721. The present fanciful arabesque was acquired last year as the generous gift of Mr. and Mrs. Claus von Bulow. The inexhaustible inventiveness of the artist's imagination is here displayed in the proliferation of decorative motives and ideas which came to him so rapidly that he summarily indicated alternates as well. In the central section Diana is seen on a pedestal under a leafy arch with attendant nymphs kneeling before her. The arch is adorned at the top by a stag's head which divides the two halves of the design. To one side, the arch becomes a Rococo arbor supported by herms, while at the other it is transformed into a stone structure culminating in a fantastic shell-like decoration. This side is supported by a column with a *putto* perched on a fountain; a vase motif emerges from a bracket. To the right, elegantly disposed couples, including a nymph and satyr, are lightly sketched. On the other side, two whippets are posed on a line of tracery under which a gracefully suspended net is looped at the center through a circular hunting horn; above, two birds fly. From Watteau's design, the engraver Gabriel Huquier derived two prints, fully developing the draughtsman's alternate suggestions. In the *Temple of Neptune* (Dacier and Vuaflart, no. 224), Huquier supplied the figure of Neptune, absent in Watteau's drawing, and worked up the rusticated arch motif in conjunction with the bracketed vase and the nymphs and satyrs. In the *Temple of Diana* (Dacier and Vuaflart, no. 225), he picked up Watteau's other solution for the arbor or trellis with the herms, and used the attendant nymphs along with the hunting horn and nets, while balancing Watteau's whippets with a running stag of his own invention.

PROVENANCE: Edmond and Jules de Goncourt (Lugt 1089); their sale, Paris, 15–17 February 1897, lot 350 (to Camille Groult for 250 francs); Camille Groult; J. Groult.

BIBLIOGRAPHY: *Figures de différents caractères, de paysages et d'études*, Paris, 1726–1728, no. 225; Roger de Portalis and Henri Béraldi, *Les Graveurs du dix-huitième siècle*, II, 1881, p. 447 (mentions the prints); Léon Deshairs, "Les Arabesques de Watteau," *Archives de l'art français*, VII, 1913, p. 292; Émile Dacier and Albert Vuaflart, *Jean de Jullienne et les graveurs de Watteau au XVIIIᵉ siècle*, Paris, 1929, p. 103, under no. 225; K. T. Parker and J. Mathey, *Antoine Watteau: Catalogue complet de son oeuvre dessiné*, Paris, 1957, p. 29, no. 191, repr.; Yves Bruand and Michèle Hébert, *Bibliothèque Nationale, Département des Estampes. Inventaire du fonds français: Graveurs du XVIIIᵉ siècle*, XI, Paris, 1970, pp. 573f., nos. 1733–1734.

Acc. no. 1980.9

Purchased as the gift of Mr. and Mrs. Claus von Bulow

99 *Seated Young Woman*

Black, red, and white chalk
10×6¾ inches (255×172 mm.)
Watermark: none visible through lining

Watteau's style matured while he lived in the Paris town house of Pierre Crozat where he was able to study Rubens' drawings in the collection of the famous financier and patron of artists. Influenced by the virtuosity of the great Flemish master's technique in *trois crayons*, Watteau himself began to draw in a mixture of three chalks with magical effect. In this casually posed study of a young woman turning attentively to the right, his gift for suggesting the bloom and luminosity of flesh is superbly realized. The rather ample but pretty model may be the same as that used for the nude study of *Flora*, the drawing now in the Louvre (repr. Parker-Mathey, no. 513), which was preparatory for one of the paintings of the Seasons which Watteau was commissioned to paint for Crozat's dining room. It is well known that the artist did not as a rule draw figures with any immediate purpose in mind but kept these studies in a book, using and reusing them in his paintings. Although the *Seated Young Woman* does not appear in any of the surviving paintings of the artist, the drawing was one of one hundred and three etched by the young Boucher for the *Figures de différents caractères* (Dacier and Vuaflart, no. 214). As the late Hyatt Mayor so

aptly observed in *Prints & People* (New York, 1971), "Watteau's red chalk strokes, impeccably accented with black, limbered Boucher's etching needle as it crisply imitated them, and the exercise brilliantly liberated his drawing pencil."

PROVENANCE: Miss James; probably her sale, London, Christie's, 22 June 1891; Thomas Agnew & Sons, London; J. Pierpont Morgan (no mark; see Lugt 1509).

BIBLIOGRAPHY: *Figures de différents caractères, de paysages et d'études*, Paris, 1726–1728, no. 214; Edmond de Goncourt, *Catalogue de l'oeuvre peint, dessiné et gravé d'Antoine Watteau*, Paris, 1875, no. 591; Paul Mantz, *Cent Dessins de Watteau gravés par Boucher*, Paris, 1892, no. 63; Émile Dacier and Albert Vuaflart, *Jean de Jullienne et les graveurs de Watteau au XVIIIe siècle*, Paris, 1929, pp. 29ff.; Regina Shoolman and Charles E. Slatkin, *The Enjoyment of Art in America*, New York, 1942, p. 540, pl. 485; Shoolman and Slatkin, *Six Centuries of French Master Drawings in America*, New York, 1950, p. 46, pl. 27; K. T. Parker and J. Mathey, *Antoine Watteau: Catalogue complet de son oeuvre dessiné*, Paris, 1957, no. 531; Pierre Schneider, *The World of Watteau, 1684–1721*, New York, 1967, p. 89; Malcolm Cormack, *The Drawings of Watteau*, London, 1970, p. 29, pl. 47.

EXHIBITIONS: New York Public Library, *Morgan Drawings*, 1919; Albright Art Gallery, *Master Drawings*, 1935, no. 58; Morgan Library, *New York World's Fair*, 1939, no. 95; Hartford, *Pierpont Morgan Treasures*, 1960, no. 80; Stockholm, *Morgan Library gästar Nationalmuseum*, 1970, no. 53, repr.; Museum of Art, Rhode Island School of Design, Providence, *Rubenisme*, 1975, no. 44, repr.; Wildenstein and Co., New York, *Paris – New York: A Continuing Romance*, 1977, no. 95, fig. 86.

Acc. no. I,278a

100 *Two Studies of the Head and Shoulders of a Little Girl*

Red, black, and white chalk on buff paper; drawn over black chalk sketch of legs

7⅜ × 9⅝ inches (187 × 245 mm.)

Watermark: none visible through lining

From these two beguiling studies of a small girl, Watteau chose the one on the right to play a role in his painting *Pour nous prouver que cette belle*, known familiarly as the *Music Lesson*, in the Wallace Collection, London. She becomes the small listener who leans against her mother's knee and turns her eyes in fascination on the lute. Watteau's finesse in the use of the *trois crayons* technique is virtually unmatched; here, his handling of the three chalks is particularly rich. In the study on the left the white chalk heightening is applied to radiant advantage to suggest the freshness of the child's skin and starched cap. Diagonal strokes of red and black chalk are skillfully used to shade the face of the girl in the other study. Strong accents are used sparingly and, as the late Professor Jakob Rosenberg observed, "a silvery middle tone prevails." The same young model is also represented in a drawing at Orléans (repr. Parker-Mathey, no. 711).

Like the *Seated Young Woman*, the present sheet was once in the notable collection of Watteau drawings belonging to Miss James, most of which passed into the British Museum where they constitute the greater part of the outstanding representation of the artist in that collection.

PROVENANCE: Miss James; probably her sale, London, Christie's, 22 June 1891; sale, London, Christie's, 16 June 1911, lot 76; Thomas Agnew & Sons, London; J. Pierpont Morgan (no mark; see Lugt 1509).

BIBLIOGRAPHY: K. T. Parker, *The Drawings of Antoine Watteau*, London, 1931, p. 31, pl. 41; Regina Shoolman and Charles E. Slatkin, *The Enjoyment of Art in America*, New York, 1942, p. 540, pl. 491; Hélène Adhémar and René Huyghe, *Watteau: Sa Vie—son oeuvre*, Paris, 1950, pp. 216, 222, nos. 126, 162; K. T. Parker and J. Mathey, *Antoine Watteau: Catalogue complet de son oeuvre dessiné*, Paris, 1957, no. 709; James Watrous, *The Craft of Old Master Drawings*, Madison, 1957, pp. 96, 153; Jakob Rosenberg, *Great Draughtsmen from Pisanello to Picasso*, Cambridge, Mass., 1959, p. 96, fig. 179; Pierre Schneider, *The World of Watteau, 1684–1721*, New York, 1967, p. 93; Malcolm Cormack, *The Drawings of Watteau*, London, 1970, p. 35, pl. 82.

EXHIBITIONS: Albright Art Gallery, *Master Drawings*, 1935, no. 59; Lyman Allyn Museum, *Drawings*, 1936, no. 92; Morgan Library, *New York World's Fair*, 1939, no. 96; Morgan Library, and elsewhere; *Fiftieth Anniversary*, 1957, no. 99, pl. 63.

Acc. no. I,278b

Charles-Joseph Natoire (French)
NÎMES 1700 – 1777 CASTEL GANDOLFO

101 *The Cascade at the Villa Aldobrandini, Frascati*

Pen and brown and black ink, brown wash, black and red chalk, heightened with white on light brown paper

12 × 18½ inches (305 × 469 mm.)

Watermark: none visible through lining

Inscribed by the artist at lower left in pen and brown ink, *Belvedere di Fescati*, and signed and dated *C. Natoire 1762* at lower right

Natoire passed a good part of his life in Rome.

As a winner of the *Prix de Rome*, he spent the years from 1723 to 1729 as a student at the French Academy there and late in 1751 he returned as the Academy's Director, an office he held until 1775. Natoire encouraged the study of landscape draughtsmanship among his students by practicing it himself. In June 1752, at the residence of the Duc de Nivernois at Frascati, he drew "quelques points de veue." He remarked in a letter to the Marquis de Marigny that he hoped to add to these works from time to time. The Marquis, brother of the Marquise de Pompadour, was Director of Buildings; and it was Natoire's obligation to make regular reports to him in regard to Academy affairs.

Again at Frascati ten years later he wrote to Marigny on 21 July 1762 that he was sending Pierre-Joseph Mariette four drawings by Pannini, eight by Robert, and four sketched by Durameau. He added that he was also sending Marigny two drawings which he himself had made during his visit to Frascati which were views of the cascade taken from the two opposite sides.

The present sheet which the Library acquired in 1965 and the drawing which entered a New York private collection at the same time are the very pair Natoire referred to. Both drawings are charmingly worked up in his distinctive mixture of pen and wash, colored chalks, and white heightening. Each is dated 1762 and the artist has inscribed the verso of the drawing in the private collection, *pour monsieur le marquis . . .* ; while this view is taken from the head of the cascade, the Library's drawing shows the foot of the cascade on the terrace above the Nymphaeum. To the Morgan sheet Natoire has added the small figure of an artist drawing, perhaps an allusion to one of his students. In 1955 the Library acquired one of the artist's earlier views of Frascati dated 1755 (Acc. no. 1955.3). Possibly these sheets were once part of the album of more than one hundred and six views of Rome by Natoire sold in 1778 after his death.

PROVENANCE: Marquis de Marigny (Abel François Poisson); P. & D. Colnaghi and Co., London.

BIBLIOGRAPHY: Morgan Library, *Fourteenth Report to the Fellows, 1965 & 1966,* 1967, pp. 125ff.; Morgan Library, *Review of Acquisitions, 1949–1968,* 1969, pp. 156f.; Lise Duclaux,

Musée du Louvre. Inventaire général des dessins: École française, XII, Paris, 1975, under no. 55.

EXHIBITIONS: P. & D. Colnaghi and Co., London, *Exhibition of Old Master Drawings,* 1965, no. 18, pl. XIV; Morgan Library, *Major Acquisitions, 1924–1974,* 1974, pp. xxf., no. 26, repr.

Acc. no.1965.18
Purchased as the gift of the Fellows

François Boucher (French)
PARIS 1703 – 1770 PARIS

102 *Four Heads of Cherubim*

Black, red, and white chalk on gray paper
12⅞×9⅞ inches (319×252 mm.)
Watermark: none visible through lining
Inscribed in pen and brown ink at lower left, *f. Boucher* (with paraph)

As the most fashionable exponent of the Rococo style and favorite painter of the Marquise de Pompadour, Boucher was not only in demand as a painter and engraver, but his services as a decorator were also much sought after. He is known to have worked at Versailles, in many of the *hôtels* of Paris, the Opera, and the tapestry manufactories of Beauvais and the Gobelins, as well as the porcelain factories of Vincennes and Sèvres.

The high finish of the four cherub heads has such obvious decorative appeal that it is evident the artist intended the sheet as an independent work to be framed and enjoyed in the *salon* or *boudoir.* Groups of cherubs are present in all of Boucher's devotional paintings, and the artist——who had a son and two daughters of his own whom he undoubtedly sketched—had a real feeling for children which comes across in his paintings and drawings. No fewer than five *livres de groupes d'enfants* are included in his engraved work.

Mrs. Slatkin has drawn attention to the old inscription *f. Boucher* and a paraph which appear at the lower left margin of the Morgan sheet. They apparently occur together on a number of Boucher's finest drawings and are marks of a notary attesting to the authenticity of drawings which formed part of an estate.

PROVENANCE: A. Langton Douglas; J. Pierpont Morgan (no mark; see Lugt 1509); J. P. Morgan (1867–1943).

BIBLIOGRAPHY: The Pierpont Morgan Library, *Review of the Activities and Major Acquisitions of the Library, 1941–1948*, New York, 1949, p. 93; Alexandre Ananoff, *François Boucher*, II, Paris, 1976, p. 40, fig. 988.
EXHIBITIONS: Morgan Library, and elsewhere, *Fiftieth Anniversary*, 1957, no. 100, pl. 62; Hartford, *Pierpont Morgan Treasures*, 1960, no. 82; Stockholm, *Morgan Library gästar Nationalmuseum*, 1970, no. 52; Morgan Library, *Major Acquisitions, 1924–1974*, 1974, p. xiii, no. 27, repr.; National Gallery of Art, Washington, D.C., and Art Institute of Chicago, Chicago, *François Boucher in North American Collections: 100 Drawings*, catalogue by Regina Shoolman Slatkin, 1973–1974, no. 8, repr.; Wildenstein and Co., New York, *Paris – New York: A Continuing Romance*, 1977, no. 85, fig. 87.

Acc. no. III,104b
Purchase

Gabriel de Saint-Aubin (French)

PARIS 1724 – 1780 PARIS

103 *Momus*

Red and black chalk, with a few touches of white
13⅞×9½ inches (353×242 mm.)
Watermark: partially decipherable letters in cartouche and, below, *Auvergne* in cartouche
Inscribed in scroll, probably by the artist, *Recue[il] / de / Déguisem[ents] / du Bal de / Saint Cloud / 1752 / D.s G.¹ de Saint-Aubin*

Gabriel de Saint-Aubin all but abandoned painting at the age of twenty-eight after losing the competition of 1752 for the *Prix de Rome* to Fragonard, but he drew and made prints throughout his life, leaving a sparkling, witty record of every aspect of Parisian life in more than a thousand drawings.

Given its size and technique, the Morgan drawing is unusual in the *oeuvre* of the artist, who is known chiefly for his dazzling interior scenes animated with crowds of people cleverly indicated in a few quick strokes of brush or chalk. The *Momus* is, however, a relatively early work and its quality is entirely consistent with Saint-Aubin's keen sense of movement and style. The drawing is executed chiefly in red and black chalk with all the artist's customary ease and assurance and his own peculiar manner of applying accents.

Momus, the god of banter, is here represented as a ballet dancer. In his raised left hand he grasps the fool's rattle, an attribute which is belied by

the elegance of his costume and the assured grace of his stance. His right hand holds a long inscribed scroll advertising a collection of costume designs for the Ball at St. Cloud in 1752. Although no further drawings or any prints can be associated specifically with this event, Saint-Aubin probably intended his Momus to adorn the title page of a collection of engraved costumes.

PROVENANCE: Gilbert Levy; David David-Weill, Neuilly; Mrs. D. Peck; George de Batz.
BIBLIOGRAPHY: Morgan Library, *Sixth Report to the Fellows*, 1955, pp. 72ff., repr.; Morgan Library, *Review of Acquisitions, 1949–1968*, 1969, p. 168, pl. 47.
EXHIBITIONS: Baltimore Museum of Art, Baltimore, *Divertissements*, 1940 [no cat.]; Wildenstein and Co., New York, *Five Centuries of Ballet*, 1944, no. 98; Morgan Library, and elsewhere, *Fiftieth Anniversary*, 1957, no. 103, pl. 69; Baltimore Museum of Art, Baltimore, *Age of Elegance*, 1959, no. 74; Royal Academy of Arts, London, *France in the Eighteenth Century*, 1968, no. 637, fig. 321; Morgan Library, *Major Acquisitions, 1924–1974*, 1974, p. xxi, no. 28, repr.; Davison Art Center, Wesleyan University, Middletown, and Baltimore Museum of Art, Baltimore, *Prints and Drawings by Gabriel de Saint-Aubin: 1724–1780*, catalogue by Victor Carlson, Ellen D'Oench, and Richard S. Field, 1975, no. 35, repr.; Bell Gallery, Brown University, Providence, *Festivities: Ceremonies and Celebrations in Western Europe, 1500–1790*, 1979, no. 54, repr.

Acc. no. 1954.9
Purchased as the gift of the Fellows

Jean-Baptiste Greuze (French)

TOURNUS 1725 – 1805 PARIS

104 *Portrait of Denis Diderot (1713–1784)*

Black and white chalk, stumped, on warm brown paper
14¼×11⁹⁄₁₆ inches (361×283 mm.)
Watermark: none visible through lining
Inscription pasted on back of frame, *Portrait de Diderot / Dessiné par Greuze pour le Baron d'Holbach / donné par Mr d'Holbach fils à Made de Vandeul / fille de Diderot. / Après la mort de Made de Vandeul, il m'a été donné par Monsr. de Vandeul son fils le 21 Décembre 1824. / E.S.*

Greuze's strong life-size portrait of Diderot shows the subject in profile. This was a fashionable mode of rendering at the time because of the ease with which the profile portrait could then be engraved in quasi-antique medallion style. Such treatment was, of course, most appropriately applied to

sitters who were persons of rank or eminence. Denis Diderot, the famous French *philosophe* and chief editor and author of the renowned French *Encyclopédie*, falls naturally into the latter class. The Morgan drawing has been engraved many times, by Augustin de Saint-Aubin among others.

Diderot has left an account of his own self-image in which he likens himself to certain classical prototypes, and Greuze obviously stressed these supposed qualities in an attempt to portray the sitter on his own terms. It is ironic that in 1765, Diderot had in effect declared Greuze the greatest French artist, but within the space of only four years he reversed this opinion completely, placing Greuze outside the orbit of his critical favor.

The artist is also represented in the collection by several large *têtes d'expression* in red chalk, and recently the Library received *Anacreon in his Old Age Crowned by Love* as the bequest of Therese Kuhn Straus in memory of her husband, Herbert N. Straus (Acc. no. 1977.57).

PROVENANCE: Denis Diderot, Paris (according to Baron Grimm in 1767); Paul-Henri Dietrich, Baron d'Holbach, Paris (1723–1789); his son, M. d'Holbach; Mme de Vandeul, Diderot's daughter; her son, M. de Vandeul; E.S. ("E.S." may be Eugène Salverte according to Arthur M. Wilson); Martial François Marcille (according to Martin), Paris (1790–1856; no mark; see under Lugt S. 605a); his sale, Paris, Defer, 4–7 March 1857 (sold for 135 francs according to Martin, not listed in sale catalogue); Hippolyte Walferdin, Paris; his sale, Paris, Féral, 3 April 1880, lot 76 (sold for 200 francs according to Martin); David David-Weill, Neuilly.

BIBLIOGRAPHY: C. de Valori, "Notice sur Greuze et sur ses ouvrages," *Greuze, ou l'Accordée de Village*, Paris, 1813 (reprinted by A. Montaiglon, ed., in *Revue universelle des arts*, XI, 1860, p. 367, note 1); J. Smith, *Catalogue Raisonné of the Works of the Most Eminent Dutch, Flemish and French Painters*, VIII, London, 1837; *Supplement*, London, 1842, no. 124; T. Thoré, *Le Salon de 1846*, Paris, 1846, p. 5; D. Diderot, *Oeuvres complètes*, XX, ed. M. Tourneux and J. Assézat, Paris, 1875–1877, pp. 116–117; M. Tourneux, "Les Portraits de Diderot," *L'Art*, XII, 1878, pp. 124–125; Baron F. Melchior von Grimm, *Correspondance littéraire, philosophique et critique*, VII, ed. M. Tourneux, Paris, 1879, p. 202; R. Portalis and H. Béraldi, *Les Graveurs du dix-huitième siècle*, Paris, 1880–1882, I, p. 159, II, pp. 64, 266; J. Martin and C. Masson, *Catalogue raisonné de l'oeuvre peint et dessiné de J.-B. Greuze*, Paris, 1908, no. 1108; G. Henriot, *Collection David Weill*, III, Paris, 1928, Pt. I, pp. 209, 211; D. Diderot, *Salons*, ed. J. Seznec and J. Adhémar, Oxford, 1957–1967, IV, p. 164; Morgan Library, *Ninth Report to the Fellows, 1957 & 1958*, 1959, pp. 108f.; Arthur M. Wilson, *Diderot*, New York, 1972, repr. opp. p. 364; Jean Seznec, "Diderot and Neo-Classicism," *The Listener*, 26 October 1972, p. 535, repr.; Pierre Rosen-

berg, "Quatre Nouveaux Fragonard au Louvre," *Revue du Louvre*, III, 1974, pp. 186–187, fig. 7.

EXHIBITIONS: Paris, *La Peinture française depuis la fin du dix-huitième siècle*, 1846 Salon; Wildenstein and Co., New York, *French Eighteenth-Century Pastels, Water-Colors and Drawings from the David-Weill Collection*, 1938, no. 97; Wildenstein, *The French Revolution*, 1943, no. 10; Wildenstein, *French Pastels and Drawings from Clouet to Degas*, 1944, no. 43; Royal Academy of Arts, London, *France in the Eighteenth Century*, 1968, no. 321; University of Michigan Museum of Art, Ann Arbor, *The World of Voltaire*, 1969, no. 47; Wadsworth Atheneum, Hartford, and elsewhere, *Jean-Baptiste Greuze, 1725–1805*, catalogue by Edgar Munhall, 1977, no. 50, repr.
Acc. no. 1958.3
Purchased as the gift of Mr. John M. Crawford

Jean-Honoré Fragonard (French)
GRASSE 1732 – 1806 PARIS

105 *Shepherd Boy and Sheep on a Sunny Hillside*

Brush and brown wash over graphite
13⁹/₁₆×18³/₈ inches (344×466 mm.)
Watermark: none visible through lining
Inscribed on back of mount, in pen and red ink, *N°7*, and *No. 44. / F*

This admirably fresh and detailed landscape stands in direct contrast to Fragonard's sanguine drawings of the elegant villas and gardens which either were executed in Italy or recalled his sojourn there. Fragonard's response to the Northern seventeenth-century landscapists, Ruisdael in particular, who were so popular with French eighteenth-century collectors, is well exemplified in the Morgan sheet. A brilliant draughtsman, Fragonard's drawings are often quick and seemingly effortless in execution; here the artist has used a careful pointillist technique, which he seems to have developed in the 1770's, to render form and especially foliage in tone upon tone of brown wash. While such compositional devices as the silhouetting of the large trees in the foreground and the paralleled diagonals of the hill and the areas of sunlight in the sky are borrowed from Ruisdael, the landscape itself appears to be entirely French. In her recent Fragonard catalogue, Eunice Williams cites and characterizes two related drawings, *L'Abreuvoir sous l'avance d'une roche* and *Le Troupeau sous*

l'orage in the Groult collection (repr. Ananoff, figs. 832, 843), both of which are similar in execution and in the artist's adaptation of the Dutch manner.

PROVENANCE: Sir James Knowles (Lugt 1546); his sale, London, Christie's, 27–29 May 1908, lot 238; Charles Fairfax Murray; J. Pierpont Morgan (no mark; see Lugt 1509).

BIBLIOGRAPHY: Roger de Portalis, *Fragonard: Sa Vie et son oeuvre*, Paris, 1889, possibly p. 309; Fairfax Murray, III, no. 114, repr.; Alexandre Ananoff, *L'Oeuvre dessiné de Jean-Honoré Fragonard (1732–1806)*, III, Paris, 1968, p. 272, no. 1380, fig. 389; Jean Montague Massengale, review of Fragonard exhibition, *Burlington Magazine*, CXXI, no. 913, 1979, p. 271, fig. 104.

EXHIBITIONS: The Montreal Museum of Fine Arts, Montreal, *The Eighteenth Century Art of France and England*, 1950, no. 75; Morgan Library, *Landscape Drawings*, 1953, no. 32, pl. XI; Morgan Library, and elsewhere, *Fiftieth Anniversary*, 1957, no. 105, repr.; National Gallery of Art, Washington, D.C., and elsewhere, *Drawings by Fragonard in North American Collections*, catalogue by Eunice Williams, 1978–1979, no. 49, repr. in color.

Acc. no. III,114

106 *La Récompense* or *Il a gagné le prix*

Black chalk and gray washes; outlines traced for transfer with stylus
Verso: Faint sketch of figure group under a tree in black chalk
16⅞ × 13½ inches (429 × 342 mm.)
Watermark: none

The charming domestic scene depicted here with such spontaneity is traditionally associated with Fragonard's visits to the home of his friend and patron, Pierre Bergeret de Grandcourt. Here, Bergeret's young son, fresh from some schoolroom triumph, is borne into the salon to the welcoming arms of his family.

The Library's drawing is Fragonard's first sketch for *La Récompense* or *Il a gagné le prix*, which the artist then transferred with a dry stylus and very few changes to the sheet of the finished drawing in the Marcille collection. Gray wash is rapidly and knowingly brushed on over the preliminary black chalk sketch in a brilliant display of technique which only a natively gifted draughtsman like Fragonard could command. A pendant composition, *Le Concours*, exists, likewise in a first sketch now in the Städelsches Kunstinstitut at Frankfurt-am-Main, and in a finished drawing which, like the final version of *La Récompense*, is in the Marcille collection.

Felice Stampfle has convincingly dated the Morgan drawing in the early 1780's on the basis of stylistic evidence as well as the facts of M. Bergeret's second marriage in 1777, the approximate age of the child in the drawing who appears to be five or six, and M. Bergeret's death which occurred in 1785.

PROVENANCE: Hippolyte Walferdin; his sale, Paris, 12–16 April 1880, lot 261; Camille Groult; sale, Paris, 19 December 1941, lot 46; Ancel; Mme Mottart; sale, Paris, Charpentier, 8 February 1945, lot 38; Galerie de Bayser, Paris.

BIBLIOGRAPHY: Roger de Portalis, *Fragonard: Sa Vie et son oeuvre*, Paris, 1889, p. 331; Morgan Library, *Seventh Report to the Fellows, 1956*, 1957, pp. 76ff., repr.; Alexandre Ananoff, "Comment dessinait Fragonard," *Jardin des arts*, XXXIII, 1957, p. 522; Morgan Library, *Review of Acquisitions, 1949–1968*, 1969, p. 145, repr.

EXHIBITIONS: Morgan Library, *Major Acquisitions, 1924–1974*, 1974, p. xxi, no. 29, repr.; National Gallery of Art, Washington, D.C. and elsewhere, *Drawings by Fragonard in North American Collections*, catalogue by Eunice Williams, 1978–1979, no. 58, repr.

Acc. no. 1955.5
Purchased as the gift of the Fellows with the special assistance of Walter C. Baker, Mme Renée de Becker, Francis Kettaneh, Mrs. Paul Moore, John S. Newberry, Jr., Mr. and Mrs. Carl Stern, Mrs. Herbert N. Straus, and Forsyth Wickes

Hubert Robert (French)
PARIS 1733 – 1808 PARIS

107 *The South Façade of the Palazzo Poli with the Trevi Fountain under Construction*

Red chalk
12¹¹⁄₁₆ × 17⁹⁄₁₆ inches (323 × 447 mm.)
Watermark: none

The Trevi Fountain, seen here under construction, was completed one hundred and twenty-two years after Pope Urban VIII commissioned Bernini to redesign it in 1640. Not until the time of Clement

XII and after a long series of delays and difficulties involving fourteen popes and a great many architects and sculptors was the project brought to completion; the final design was the work of a talented dilettante, Nicolas Salvi (see H. V. Morton, *The Fountains of Rome*, New York, 1966, pp. 73–87). The Fountain dates back to Roman times and is the terminal of the aqueduct of the Acqua Vergine, which begins in the village of Salone, nine miles east of Rome, and flows part of the way through the original stone channels made by the engineers of Agrippa. Palazzo Poli, seen in the background, was the Roman residence of the Counts of Conti who later became the Dukes of Poli.

The artist's fresh and spontaneous handling of the medium makes this an exceptionally fine example of Robert's draughtsmanship during the latter half of his eleven-year stay in Rome (1754–1765). Its stylistic affinity with his drawings of the Capitoline buildings of the 1760's (Musée des Beaux-Arts, Valence, and the inaugural date of the Trevi Fountain (22 May 1762) together provide an approximate date for the Morgan sheet.

The existence of a counterproof taken from this drawing, in Besançon, was first mentioned in the recent Washington catalogue, as was another larger version of the fountain, unrelated to the Morgan sketch, and last recorded in the sale of 26 November 1919 at the Hôtel Drouot, Paris.

Other drawings in the Library dating from the same period include a *View of the Campidoglio* (1762; Acc. no. III,117) and an important sketchbook (c. 1760–1763; Acc. no. 1958.5) containing a number of architectural studies that were either later incorporated into other drawings or used in connection with etchings for *Les Soirées de Rome* (1764).

PROVENANCE: Mrs. Charles Mitchell; her daughter, Mrs. Allerton Cushman.

BIBLIOGRAPHY: Morgan Library, *Seventeenth Report to the Fellows, 1972–1974*, 1976, pp. 148, 178.

EXHIBITION: National Gallery of Art, Washington, D.C., *Hubert Robert: Drawings and Watercolors*, 1978, catalogue by Victor Carlson, no. 10, repr.

Acc. no. 1973.51
Gift of Mrs. Allerton Cushman in honor of Mr. Janos Scholz

Pierre-Paul Prud'hon (French)
CLUNY 1758 – 1823 PARIS

108 *Female Nude*

Black, white, and pale pink chalk, some stumping, on blue paper
23 3/16 × 12 7/16 inches (589 × 316 mm.)
Watermark: none

While continuing in the French academic tradition, Prud'hon brought a new refinement and high finish to the drawing of the nude, working in black and white chalk and—in the case of the present sheet—a pale pink, almost flesh-colored, chalk. When applied to the rather intense blue paper Prud'hon liked to use, the highly-worked chalk image stands out vividly and the detail of the modelling is very effective in terms of light.

The drawing is a study for the figure of Innocence in *L'Amour séduit l'Innocence, le Plaisir l'entraine, le Repentir suit*. In his monograph on Prud'hon, Jean Guiffrey lists four paintings and two oil sketches of this subject, and at least eleven preparatory drawings including the present study; the painting in the collection of the Duchesse de Bisaccia is reproduced as plate II by Guiffrey. There is also an engraving of the subject by Barthélemy Roger after Prud'hon's drawings.

It is clear in the present drawing that Prud'hon already knew how the figure of Innocence, if not that of Love, was to be posed and placed in the painted version. There Love is personified by an Apollo-like youth with his left arm draped around the shoulder of Innocence; she, eyes demurely downcast, her right arm slipped about Love's waist, stands to the right, her figure partially hidden by the drapery pulled at by a small cupid. In the drawing, Prud'hon has concentrated his attention on the nude figure of Innocence and only Love's left hand on her shoulder is visible, although his form is suggested by the position of her right arm.

Two other fine examples of Prud'hon's draughtsmanship are included in the collection: "*Le Cruel rit des pleurs qu'il fait verser*" (Acc. no. 1956.1), and the preparatory study for the *Portrait of the Empress Joséphine*, the painting of 1805 now at the

Louvre (Acc. no. 1977.58. Bequest of Therese Kuhn Straus in memory of her husband, Herbert N. Straus).

PROVENANCE: Charles Boulanger de Boisfremont (Lugt 353); Mme Power (née Boisfremont); Van Cuyck; George Farrow; sale, London, Sotheby's, 27 March 1969, lot 142, repr.; Camille Groult; Mr. and Mrs. Eugene V. Thaw, New York.
BIBLIOGRAPHY: Edmond de Goncourt, *Catalogue raisonné de l'oeuvre peint, dessiné et gravé de P.-P. Prud'hon*, Paris, 1876, p. 144; Jean Guiffrey, *L'Oeuvre de Pierre Paul Prud'hon*, Paris, 1924, p. 8, no. 14; Morgan Library, *Seventeenth Report to the Fellows, 1972–1974*, 1976, pp. 148, 178, pl. 19.
EXHIBITION: Morgan Library, and elsewhere, *Drawings from the Thaw Collection*, 1975, no. 38, repr.
Acc. no. 1974.71
Gift of Mr. and Mrs. Eugene V. Thaw

Jan van Huysum (Dutch)

AMSTERDAM 1682 – 1749 AMSTERDAM

109 *Flowerpiece*

Black chalk and watercolor
18¹¹⁄₁₆×12¾ inches (475×324 mm.)
Watermark: none
Signed and dated, in pen and brown ink, at lower left, *Jan van Huisem / Fecit 1737*

In his concern to depict the essence of a beautiful floral arrangement, Van Huysum did not always select flowers of the same season for his bouquets. For this drawing, which is one of a pair in the collection, he chose the Crown Imperial (*Fritillaria imperialis*), Apple Blossom (*Pyrus malus*), Tulip (*Tulipa sp.*), Peony (*Paeonia sp.*), Rose (*Rosa*), Larkspur (*Delphinium consolida*), Stock (*Mathola incana*), and Narcissus (*Narcissus sp.*). Among the artist's surviving drawings, none corresponds exactly to his paintings of flowerpieces. According to W. T. Stern (Introduction to White, 1964), Van Huysum sketched these bouquets from his imagination on winter evenings when the light was no longer suitable for painting. The fresh vitality that flowers from the garden bring to the home is conveyed in the happy blend of vigorous chalk lines and freely applied watercolor. The entire sheet shimmers with the energy emanating from these blossoms. A drawing at the Louvre (White, no. 109, repr.) is very close to the Morgan sketch, both in the choice of motives and in the free handling of the medium.

PROVENANCE: Charles Fairfax Murray; J. Pierpont Morgan (no mark; see Lugt 1509).
BIBLIOGRAPHY: Fairfax Murray, I, no. 164, repr.; J. E. Schuler, *Cento Capolavori: L'Arte del disegno de Pisanello a Picasso*, Milan, 1962, pl. 152 (incorrectly noted as in the Louvre, Paris); J. E. Schuler and Rolf Hänsler, *Great Drawings of the Masters*, New York, 1963, p. 152; Christopher White, *The Flower Drawings of Jan van Huysum*, Leigh-on-Sea, 1964, no. 91, pl. 37.
EXHIBITIONS: Morgan Library, and elsewhere, *Fiftieth Anniversary*, 1957, no. 98; The Pierpont Morgan Library, New York, *Flowers in Books and Drawings, ca. 940–1840*, 1980, no. 92, pl. 14.
Acc. no. I,164

William Hogarth (English)

LONDON 1697 – 1764 LONDON

110 *Gin Street*

Red chalk
15½×12 inches (393×306 mm.); right margin of sheet cut around *pentimento*, measuring 2¼×½ inches (58×12 mm.)
Watermark: fleur-de-lis (Heawood 1702)
Inscribed variously as part of design, in graphite, along edge of distiller's roof at left, *KILMAN DISTILLER*, above doorway at right, *S GRIPE PAWN BROKER*; on scroll in lower left corner, *The / Down / fall of / Mᵈᵐ Gin*, and above arch in lower right corner, *Drunk for a penny / Dead Drunk for two pence / Clean straw for nothing*; inscribed in red chalk along margin at lower center, *GIN STREET*

The tragedies of alcoholism which include poverty, squalor, idleness, and death form the subject of this drawing. It is one of a pair in the Morgan collection that are the final studies for a set of prints in reverse published by Hogarth in 1751 under the title *Beer Street* and *Gin Lane*. As Bernard Denvir informs us, according to an advertisement in the *General Advertiser* on 13 February of that year, these prints were intended "to reform some reigning vices peculiar to the Lower Class of People" and were published cheaply in order that they might be more widely distributed. Any additions or alterations made subsequent to these two drawings were presumably executed in the process of engraving. Added to the print of *Gin Street* or *Gin Lane* is the figure of an intoxicated

man running out of a house carrying a child impaled on a stake; the artist also did away with part of the pawnbroker's shop on the right, and depicted the top story of the building next to the coffinmaker's on the left collapsing. *Beer Street*, in contrast to its companion, recommends the consumption of beer instead of gin, and describes a scene of industrious activity and well-being. Interestingly, in the very year these prints were published, Parliament passed the "Gin Act," reducing the number of gin shops in an attempt to curtail the distribution of the liquor.

PROVENANCE: Dr. Lort(?); L. Joly; Charles Fairfax Murray; J. Pierpont Morgan (no mark; see Lugt 1509).

BIBLIOGRAPHY: Fairfax Murray, III, no. 36, repr.; Michael Ayrton and Bernard Denvir, *Hogarth's Drawings*, London, 1948, no. 55, repr.; A. P. Oppé, *Drawings of William Hogarth*, New York, 1948, no. 77, pl. 74; Ronald Paulson, *Hogarth's Graphic Works*, I, New Haven–New London, 1965, p. 209; Joseph Burke and Colin Caldwell, *Hogarth Gravures: Oeuvre complet*, Paris, 1968, p. lviii, no. 222, repr.; Robert R. Wark, *Early British Drawings in the Huntington Collection, 1600–1750*, San Marino, 1969, pp. 29–30, repr.; Ronald Searle, Claude Roy and Bernd Bornemann, *La Caricature: Art et manifeste du XVIᵉ siècle à nos jours*, Geneva, 1974, p. 45, repr.

EXHIBITIONS: Lucy Scribner Library, Skidmore College, Saratoga Springs, N.Y., *Eighteenth Century First Edition English Novels, Manuscripts, and Drawings*, 1949, n.p.; Montreal Museum of Fine Arts, Montreal, *The Eighteenth Century Art of France and England*, 1950, no. 56, repr.

Acc. no. III,36

Thomas Gainsborough (English)

SUDBURY 1727 – 1788 LONDON

111 *Landscape with Horse and Cart, Figures, and Ruin*

Black chalk, watercolor and oil; varnished
8³⁄₄ × 12¹⁄₄ inches (222 × 311 mm.)
Watermark: none visible through lining

Although Gainsborough earned a living principally through portrait commissions, his landscape paintings and drawings, despite the fact that they never sold well to the public, figured prominently in his *oeuvre* throughout his career. His own personal prejudice is aptly revealed in the following lament written to his friend William Jackson: "I am sick of Portraits and wish very much to take my viol-da-gamba and walk off to some sweet village where I can paint landskips and enjoy the fag-end of life in quietness and ease."

The lazy, peaceful qualities of the English countryside were those most appreciated by Gainsborough, who no doubt found in them a soothing remedy for his own high-strung, nervous temperament. Recurrent pastoral themes—scenes of simple country life, peasants reposing in the warmth of summer or the calm of evening—dominate his landscape drawings. The present sheet, executed some time in the 1770's, includes such picturesque details as the horse, rustic cart, and ruins, all motives characteristic of the artist's late drawings of the seventies and eighties. Gainsborough sketched directly from nature, but the drawings he produced were not topographical. A certain air of melancholy pervades the Library's landscape with its bleak, upland setting, isolated figure groups, and reminiscences of the past. The overall mood, due in part to the pastoral subject matter, is accentuated by the dramatic use of light: the sun is low on the horizon and the last vivid rays of daylight stream across the countryside, casting long, broad shadows. While Gainsborough's interest in light was probably derived from close study of the seventeenth-century Dutch Italianate artists, his use of the small group of strongly lit buildings as an accent was undoubtedly borrowed from Claude or Gaspard Dughet. The focal point created by these block-like ruins—whose sole *raison d'être* seems to be their shape and whiteness—is balanced by the thick white highlights on the vase and pedestal, horse cart, and reclining figures. The eye is drawn from foreground to background in a continuous flow along the curved path, and spatial depth is conveyed by means of graded washes, ranging from greens and rusty ochers to pale gray-blues in the distant mountains.

This very painterly landscape drawing was begun in watercolor, finished in oil, and then varnished so as to resemble an oil painting. Gainsborough began experimenting with this technique in the early 1770's and eventually evolved a complicated process which he believed would combine the sensitivity of drawing with the strength and richness of painting. The Library's varnished landscape may have been one in a series of ten draw-

ings imitating oil paintings which the artist exhibited at the Academy in 1772.

PROVENANCE: Charles Fairfax Murray; J. Pierpont Morgan (no mark; see Lugt 1509).

BIBLIOGRAPHY: Fairfax Murray, III, no. 55, repr.; Mary Woodall, *Gainsborough's Landscape Drawings*, London, 1939, p. 141, no. 458; John Hayes, *The Drawings of Thomas Gainsborough*, London, 1971, no. 356.

EXHIBITIONS: Morgan Library, *Landscape Drawings*, 1953, no. 85, repr.; Hartford, *Pierpont Morgan Treasures*, 1960, no. 84.

Acc. no. III,55

112 *Study of a Lady*

Black chalk and stump and white chalk, on buff prepared paper; loss at upper left corner
19½×12¼ inches (495×311 mm.)
Watermark: none visible through lining

An important factor in Gainsborough's genius as a portrait painter is the sympathy with which he treated his feminine subjects, responding instinctively to beauty and charm. The present study of a young woman, whose demure elegance seems to transcend the shimmering frills of her costume, was traditionally accepted as representing Georgiana, Duchess of Devonshire, the celebrated beauty of the day, an understandable misidentification which John Hayes suggests may date back to Gainsborough's own family. (The artist's daughter Margaret gave a "splendid drawing in black and white chalks on dark coloured paper"—probably the Morgan drawing according to Hayes—to Henry Briggs in whose 1831 sale it was catalogued as the Duchess of Devonshire.)

In 1969 Hayes convincingly proposed that the Library's sheet, together with two related drawings in the British Museum, a third in a New York private collection, and a fourth whose whereabouts are unknown, constitute a group of studies from life, executed perhaps in the environs of Richmond where Gainsborough had a house, and preparatory not for the portrait of the Duchess, but for *The Richmond Water-Walk*. Although probably never executed, the painting was to have been a companion picture to *The Mall*, now in the Frick Collection, New York (repr. Hayes, 1969, fig. 51). The *Water-Walk* was commissioned by King George III, as is recorded on the verso of one of the British Museum drawings in an inscription in the hand of John Wilson Croker, who was given the drawing and information about its genesis by Gainsborough's intimate friend William Pearce. Pearce stated specifically that Gainsborough spent one morning in St. James's Park sketching the "high-dressed & fashionable" ladies in preparation for the painting. Sir Henry Bate-Dudley's mention of the work in *The Morning Herald* (20 October 1785) substantiates the details of the commission as well as the type of painting intended: "a companion to [Gainsborough's] beautiful *Watteau-like* picture of the Park-scene, the landscape, Richmond water-walk, or Windsor—the figures all portraits."

The head in the Morgan sheet is clearly individualized, although it is neither a likeness of the Duchess of Devonshire nor of Lady Sheffield whose pose in the painted portrait of 1785–1786 (repr. Hayes, 1969, fig. 44) is identical with that of the Library's figure of a young woman. None of the drawings which Hayes groups together for *The Richmond Water-Walk* can be connected exactly to known portraits. Few preparatory studies for single-figure paintings by Gainsborough exist, a scarcity that is not altogether surprising since the artist—unlike the Flemish master Van Dyck whose full-length portraits he greatly admired—was inclined to attack the canvas directly, and so retaining a sense of immediacy in the appearance of the sitter. It is interesting to note that the figures for *The Mall* were not studied from life, but, according to Gainsborough's friend William Jackson, were drawn "from a doll of his own creation."

Also in contrast to Van Dyck and Rubens, who as a rule did not bother to indicate decorative details of dress and jewelry in the preliminary stages of their portraiture, Gainsborough was primarily interested in the costumes rather than the underlying structure and anatomy of the figures in the *Water-Walk* drawings. His careful transcription of the fashions of the time, notably the large broad-brimmed picture hats very much in vogue and the hair styles with loose curls flowing down on either side of the neck, suggests a date of c. 1785–1790, which is also consistent with Bate-Dudley's announcement in 1785 in *The Morning Herald*.

According to Hayes, the Library's drawing was among those left by the artist to his wife; it then descended through his daughter Margaret either to Henry Briggs or to Richard Lane via Sophia Lane, Gainsborough's niece. It was engraved by Richard Lane under the date of 1 January 1825.

Another Morgan drawing, traditionally attributed to Gainsborough, presumably does represent the Duchess of Devonshire, but is now thought to be the work of Gainsborough Dupont, the eldest surviving son of Gainsborough's sister Sarah (Acc. no. III,1a).

PROVENANCE: Margaret Burr Gainsborough, the artist's wife; Margaret Gainsborough, the artist's daughter; either Henry Briggs (possibly his sale, London, Christie's, 25 February 1831, lot 115); or Sophia Lane, the artist's niece; her son, Richard Lane (according to Hayes); Charles Frederick Huth; his sale, London, Christie's, 19 March 1904, lot 7 (to Vicars for £525); J. Pierpont Morgan (no mark; see Lugt 1509); J. P. Morgan (1867–1943).

BIBLIOGRAPHY: Allan Cunningham, *The Lives of the Most Eminent British Painters*, I, London, 1830 (revised ed. *Annotated and continued to the present time by Mrs. Charles Heaton*, London, 1879, possibly pp. 271, 278); W. Roberts, "Mr. J. Pierpont Morgan's Pictures: The Early English School II," *The Connoisseur*, XVI, 1906, p. 136, repr.; Roberts, *Pictures in the Collection of J. Pierpont Morgan*, London, 1907, under Gainsborough's *Duchess of Devonshire*, repr. in folio ed.; Mortimer Menpes and James Greig, *Gainsborough*, London, 1909, pp. 125, 165; The Pierpont Morgan Library, *Review of the Activities and Major Acquisitions of the Library, 1941–1948*, New York, 1949, p. 94; *Great Drawings of All Time*, IV, 1962, no. 974, repr.; J. E. Schuler, *Cento Capolavori: L'Arte del disegno da Pisanello a Picasso*, Milan, 1962, p. 190, repr. in color; J. E. Schuler and Rolf Hänsler, *Great Drawings of the Masters*, New York, 1963, p. 188, repr. in color; John Hayes, "Gainsborough's 'Richmond Water-Walk'," *Burlington Magazine*, CXI, no. 790, 1969, pp. 28–31, repr.; Hayes, *The Drawings of Thomas Gainsborough*, London, 1971, I, pp. 19, 46, 97, 127–128, no. 61, II, pl. 205.

EXHIBITIONS: Morgan Library, and elsewhere, *Fiftieth Anniversary*, 1957, no. 104, repr.; Tate Gallery, London, and Grand Palais, Paris, *Thomas Gainsborough*, catalogue by John Hayes, 1980–1981, no. 42, repr.

Acc. no. III,63b
Purchase

Benjamin West (Anglo-American)

SPRINGFIELD, PA. 1738 – 1820 LONDON

113 *Gnarled Tree Trunk*

Brush and brown wash, over black chalk, on brown paper; a strip of paper about three inches wide was added by the artist at the bottom; the drawing on this strip is executed in a more reddish shade of brown watercolor than that used in the upper part

25⅝×17¾ inches (650×450 mm.)

Watermark: none

Signed and dated at lower left, in black chalk, *B. West 1784*

In 1970 the Morgan Library purchased, as the generous gift of Mrs. Robert H. Charles, some two hundred sixty drawings by Benjamin West and his son Raphael Lamar West. From this group, the two hundred thirteen drawings by Benjamin constitute the largest single collection of the artist's drawings now known. The Library's holdings span West's career, including the earliest surviving finished drawing (1757) and what may well be his last drawing, a sketch for *Peter's Denial of Christ*, which is inscribed, *the last design by Benj.ⁿ West 1819.*

While West is noted for his formal, Neoclassical compositions and realistic history painting, he reveals a more romantic approach in his sketches of animals and landscapes. The *Gnarled Tree Trunk*, so appealing in its feeling for nature, is an outstanding example of the artist's early mode of Romanticism. From the 1780's on, West was inspired by walks in Windsor Great Park and Little Park; he was especially fascinated by weather-beaten old trees, with a few branches of leaves clinging to the gnarled and twisted stumps, and drew them again and again. This large and highly accomplished drawing was probably derived from earlier sketchbook notations made during his walks, and may be considered an independent work of art. The signature and date (1784) at lower left bear further testimony to the finished, independent nature of the work. Only one other landscape drawing in the Library's collection is signed and dated (Acc. no. 1970.11:115; Kraemer no. 184).

The present sheet is related in subject matter to three other studies of ancient blasted trees at the Morgan Library (Acc. nos. 1967.4; 1970.11:5, Kraemer no. 176; 1970.11:11v, Kraemer no. 155) and two sketches of Herne's Oak at Windsor, the famous tree mentioned in Shakespeare's play *The Merry Wives of Windsor*, one at the Boston Museum, signed and dated *Windsor 1788* (Inv. no. 42.596), the other also at the Morgan Library

(Acc. no. 1970.11:144r; Kraemer no. 177). West was quite fond of Herne's Oak and was distressed when the mighty old tree was cut down by "barbarian hands" in February 1795 as is attested by the inscription in his own hand on one of his drawings at the Folger Shakespeare Library in Washington, D.C. (Inv. no. cs909).

The provenance of *Gnarled Tree Trunk*, along with that of the major part of the collection acquired in 1970, can be traced without interruption back to the artist. The entire group of drawings passed from generation to generation of West descendants until Harry H. Margary, the great-grandson of Maria West (Raphael Lamar West's daughter), sold the collection of drawings by his distinguished ancestor some time in the 1960's.

PROVENANCE: Raphael Lamar West; his daughter, Mrs. Thomas George Margary (née Maria West); her son, Alfred Russel Margary; his son, Thomas A. G. Margary; his son, Harry H. Margary; Thomas Agnew and Sons, Ltd., London; M. Knoedler and Co., New York.

BIBLIOGRAPHY: Morgan Library, *Major Acquisitions, 1924–1974*, 1974, p. xxix, no. 46, repr.

EXHIBITION: The Pierpont Morgan Library, New York, *Drawings by Benjamin West*, catalogue by Ruth S. Kraemer, 1975, no. 174, repr.

Acc. no. 1970.11:2
Purchased as the gift of Mrs. Robert H. Charles

Henry Fuseli (Anglo-Swiss)

ZURICH 1741 – 1825 LONDON

114 *Portrait of Martha Hess*

Black chalk and stump, heightened with white, on light brown paper
20³⁄₈ × 13⁷⁄₈ inches (518 × 356 mm.)
Watermark: illegible fragment

Born and educated in Switzerland, Fuseli travelled to London in 1764 at the age of twenty-three. With the exception of eight important years of study in Rome, the artist remained in England for the rest of his career; he returned to his native Zurich only once, for a six-month visit on his way back to London from Rome.

The *Portrait of Martha Hess* was executed late in 1778 or early in 1779 during this visit to Zurich. Martha and her sister Magdalena Schweizer-Hess were nieces of Fuseli's friend Johan Caspar Lavater; both were apparently the objects of Fuseli's admiration as well as the subjects of numerous drawings, some of which were used in Lavater's *Essays on Physiognomy*. The artist seems to have been especially attracted to the coquettish Magdalena, who was, however, married. The younger Martha, whose portrait shown here is painstakingly rendered in short, deft strokes of black chalk, was definitely the more serious of the two. Unlike her flirtatious sister, Martha was described as "ethereal" and "inclined toward religious fanaticism." That peculiar spiritual quality, emphasized in this drawing by the upturned eyes, is not present in similar portraits of Magdalena (cf. the drawing in Zurich, repr. Tate Gallery, *Henry Fuseli*, 1975, no. 177). More immediately appealing than some of his more extravagant apparitions, the Library's portrait of Martha shows a quiet depth and level of psychological understanding that is unusual in Fuseli's work. Martha's somewhat resigned, melancholic expression seems to anticipate her untimely death from consumption in December 1779, a few months after she posed for Fuseli. Other portraits of her are preserved in the Victoria and Albert Museum, London; the Schlossmuseum, Weimar; and the Kunsthaus, Zurich.

PROVENANCE: A. Paul Oppé, London.

BIBLIOGRAPHY: John Woodward, review of Arts Council exhib., *Burlington Magazine*, XCII, no. 565, 1950, p. 112; Nicolas Powell, *The Drawings of Henry Fuseli*, London, 1951, no. 40, repr.; Morgan Library, *Fifth Report to the Fellows*, 1954, pp. 70–72; Morgan Library, *Review of Acquisitions, 1949–1968*, 1969, p. 146; Raymond Lister, *British Romantic Art*, London, 1973, pp. xiii, 66, repr.; Gert Schiff, *Johann Heinrich Füssli*, Zurich-Munich, 1973, I, no. 584 (incorrectly noted as in collection of Miss Armide Oppé).

EXHIBITIONS: R. E. A. Wilson Gallery, London, *Paintings and Drawings by Henry Fuseli*, 1935, no. 26; Roland, Browse and Delbanco Gallery, London, *Paintings and Drawings by Fuseli*, 1948, no. 18; Arts Council, London, *Fuseli: Catalogue of an Exhibition of Paintings and Drawings*, 1950, no. 50; Graves Art Gallery, Sheffield, *A Selection of Early English Drawings and Watercolours from the Collection of Paul Oppé, Esq.*, 1952, no. 30; Detroit Institute of Arts, Detroit, and Philadelphia Museum of Art, Philadelphia, *Romantic Art in Britain: Paintings and Drawings, 1760–1860*, 1968, no. 67, repr.; Morgan Library, *Major Acquisitions, 1924–1974*, 1974, no. 47, repr.

Acc. no. 1954.1
Purchased as the gift of Mrs. W. Murray Crane

115 Satan Departing from the Court of Chaos

Pen and brown ink; brush and brown, reddish-brown, and black washes; touches of red watercolor; white chalk

15⅜×19¹¹⁄₁₆ inches (387×500 mm.)

Watermark: fleur-de-lis within a shield (cf. Heawood 1827)

Inscribed at left margin, in pen and brown ink, *London 81——82*; in pen and black ink, at lower left, *William Blake*

A work more typical of the artist than the *Portrait of Martha Hess* (see No. 114) is represented here; the subject is taken from Milton's *Paradise Lost*. As a young man Fuseli studied under the influential Swiss critic Johann Jakob Bodmer, through whom he discovered Homer, Dante, the Nibelungenlied, Milton, and Shakespeare. Later as a painter and draughtsman, he turned to these poetic sources for inspiration, searching for unusual subject matter to be reinterpreted in his own bizarre, innovative manner. The specific passage from Milton, which the artist chose to depict in the present sheet (Book II, lines 1010–1014 of *Paradise Lost*), was not commonly illustrated. The scene focuses on the departure of Satan from the court of Chaos following the latter's speech directing him towards the newly created earth: "He ceas'd; and *Satan* stay'd not to reply, / But glad that now his Sea should find a shore, / With fresh alacrity and force renew'd / Springs upward like a Pyramid of fire / Into the wild expanse. . . ." The figure at the right with raised hand represents enthroned Chaos; behind him sits "sable-vested Night," to his right is the bearded, crowned figure with great rounded eyes representing Chance who governs all. Below, almost totally hidden in the darkness, is presumably the figure of "Discord with a thousand various mouths." The Fall of the Rebel Angels is schematically rendered at the far left.

In connection with the Library's drawing, Benjamin Haydon's animated account of a visit to Fuseli's studio takes on added significance: "I followed the maid into a gallery or showroom, enough to frighten anybody at twilight. Galvanized devils—malicious witches brewing their incantations—Satan bridging Chaos, and springing upwards like a pyramid of fire—Lady Macbeth—Paolo and Francesca—Falstaff and Mrs. Quickly —humour, pathos, terror, blood and murder, met me at every look!" It may well be that the *Satan Bridging Chaos* mentioned by Haydon among the strange, fantastic works is identical with the Morgan sheet.

Schiff's dating of the drawing to the 1790's is based on a painting of the subject which Fuseli exhibited in the Milton Gallery. However, the inscription *London 81——82*, as Nancy Pressly correctly noted, is proof of an earlier date, and is certainly more plausible in terms of the style. The two crouching figures of Chaos and Chance may foreshadow several of the figures in William Blake's *Book of Urizen*. According to David Bindman, Blake owned another version of *Satan Departing from the Court of Chaos*, now lost but apparently close to the composition of the Morgan drawing. While Fuseli freely admitted that Blake was "damned good to steal from," it is now equally recognized that Blake himself owed a much larger debt to the influence and encouragement of the older artist.

The Library's group of five Fuseli drawings is due entirely to the generosity of the Crane family. *Satan Departing from the Court of Chaos* and two other drawings, *Psychostasy* (Acc. no. 1974.44) and *Skamandros Tries to Prevent Achilles from Slaying the Trojan* (Acc. no. 1975.44), were the gifts of Miss Louise Crane in memory of her mother, Mrs. W. Murray Crane (and from her collection), whose own generous contribution in 1954 made possible the acquisition of the *Portrait of Martha Hess* and *Meleager* (Acc. no. 1954.2).

PROVENANCE: Mrs. W. Murray Crane; her daughter, Louise Crane.

BIBLIOGRAPHY: Gert Schiff, *Johann Heinrich Füsslis Milton-Galerie*, Zurich-Stuttgart, 1963, pl. 21; Schiff, *Johann Heinrich Füssli*, Zurich-Munich, 1973, I, no. 1020; David Bindman, *Blake as an Artist*, Oxford, 1977, pp. 104, 240–241 under note 22 (incorrectly noted as still in the collection of Mrs. Crane); Morgan Library, *Eighteenth Report to the Fellows, 1975–1977*, 1978, pp. 245, 264.

EXHIBITION: Yale Center for British Art, New Haven, *The Fuseli Circle in Rome*, catalogue by Nancy Pressly, 1979, no. 48, repr.

Acc. no. 1975.43
Gift of Miss Louise Crane in memory of her mother, Mrs. W. Murray Crane

William Blake (English)

LONDON 1757 – 1827 LONDON

116 *"When the Morning Stars Sang Together"*
Job 38:4–7

Pen and brush, black and gray inks and wash, watercolor, over preliminary indications in graphite
11 × 7 1/16 inches (280 × 179 mm.)
Watermark: none visible through lining

This brilliant watercolor belongs to the first set of illustrations to Blake's version of the Book of Job which Pierpont Morgan purchased in its entirety in the famous sale of the Marquess of Crewe in 1903. The artist produced this important series around 1805 for Thomas Butts, a minor civil servant who commissioned many works from Blake between 1799 and 1810. In 1821, the Morgan set was traced and copied by Blake for John Linnell who became the artist's patron and friend in his later years, and who also commissioned the set of Job engravings (1825–1826). In connection with the engravings, Blake produced a series of drawings (now at the Fitzwilliam Museum, Cambridge) in which the original designs were reduced and to which borders were added. Until recently (Bindman, 1977, and Tate Gallery, 1978), the Morgan set had been dated around 1820, much later than it is now supposed. According to Martin Butlin, the signature appearing on some of the sheets was abandoned by 1806 and the style is closer to that of the Bible illustrations Blake produced for Butts between c. 1800 and 1809.

In the subject depicted here, Job and his wife and friends kneel below a layer of clouds over which the Lord presides and re-enacts the Creation of the world. Beneath his outstretched arms are Helios, the sun god, and Selene, the moon goddess; above, in the heavenly realm, the morning stars, or cherubim, rejoice in the name of the Lord. In the engraving, Blake added arms on either side of the figures of the morning stars that are cut off by the edge of the sheet to suggest an infinite number of angels. The artist had used this motif earlier in the marginal design for his illustration to Young's *Night Thoughts* (1795).

Samuel Palmer, one of Blake's young followers, held the design for the morning stars in such high esteem that he thought it should be installed as the great window in Westminster Abbey (Bindman, p. 211). Despite the enthusiasm of Blake's immediate circle of friends, the Job watercolors and engravings—like all his work—were not well received by the artist's contemporaries. Fortunately, they have long since been recognized as one of the supreme achievements of the visionary poet and artist.

PROVENANCE: Thomas Butts; Richard Monckton Milnes, first Lord of Houghton; Robert Offley Ashburton Milnes, fourth Baron and Marquess of Crewe; his sale, London, Sotheby's, 30 March 1903, lot 17 (sold to Sabin and bought by J. Pierpont Morgan through Quaritch for £5600 on 30 June 1903); J. Pierpont Morgan (no mark; see Lugt 1509).

SELECTED BIBLIOGRAPHY: Alexander Gilchrist, *Life of William Blake*, II, London-Cambridge, 1863, p. 213, no. 97(g); Laurence Binyon and Geoffrey Keynes, *Illustrations of the Book of Job by William Blake*, New York, 1935, I, no. 14, II, no. 14, repr.; Geoffrey Keynes, *Blake Studies*, London, 1949, pp. 124–129, pl. 27; Kathleen Raine, *William Blake*, London, 1970, fig. 120; Bo Lindberg, *William Blake's Illustration to the Book of Job*, Abo, 1973, p. 199, 1D, p. 293, 14D; G. E. Bentley, Jr., *Blake Books*, Oxford, 1977, p. 518; David Bindman, *Blake as an Artist*, Oxford, 1977, pp. 208–214; William Vaughan, *William Blake*, London, 1977, no. 31, repr.

EXHIBITIONS: Philadelphia Museum of Art, Philadelphia, *William Blake*, 1939, no. 138, repr., p. 87; Morgan Library, *Fiftieth Anniversary*, 1957, no. 106, pl. 71; Tate Gallery, London, *William Blake*, 1978, catalogue by Martin Butlin, no. 195, repr.

117 *Mirth*

Pen and brush, black and gray inks, watercolor
6 3/8 × 4 13/16 inches (162 × 122 mm.)
Watermark: M & J LAY 1816
Signed in lower right corner, in pen and black ink, *Inv WBlake*.

In 1949, the Morgan Library acquired Blake's twelve designs for Milton's poems *L'Allegro* and *Il Penseroso*. These drawings, dated c. 1816–1820, share the same early provenance as the Library's watercolors for the Book of Job, beginning with the artist's patron Thomas Butts. It was not until the sale in 1903 of the collection of the Earl of

Crewe that the two series went their separate ways: the *Book of Job* was bought by J. Pierpont Morgan and the Milton series went to Marsden J. Perry, also an American. Blake's Milton illustrations for Butts included *Paradise Lost* and *Comus* (both at the Museum of Fine Arts, Boston; the latter only in part), *On the Morning of Christ's Nativity* (Huntington Library, San Marino), and *Paradise Regained* (Fitzwilliam Museum, Cambridge).

This charming drawing is the first of six illustrations for *L'Allegro* and depicts Mirth and her attendants, who are personifications of *Jest & youthful jollity / Quips & Cranks & Wanton Wiles / Nods & Becks & wreathed smiles / Sport that wrinkled Care derides / And Laughter holding both his Sides.* The watercolor comes with a transcription of the appropriate verse and a commentary in the artist's own hand, as do the other eleven drawings. The artist made two engravings of the Morgan composition (first state, c. 1816–1820 and second state, c. 1820–1825), suggesting that he intended to engrave the entire series as he did the illustrations of the Book of Job.

After nearly fifty years of separation, the beautiful Milton series was reunited with the Job watercolors in this collection. Their acquisition would not have been possible without the assistance of the then newly formed Association of Fellows and the signal generosity of the late Mrs. Landon K. Thorne (who also gave and bequeathed her important Blake collection to the Library) and Mr. Paul Mellon.

PROVENANCE: Thomas Butts; sale, London, Foster & Son's, 29 June 1853, lot 99 (to Milnes for £7.7s); Richard Monckton Milnes, first Lord of Houghton; his son, the Earl of Crewe; his sale, London, Sotheby's, 20 March 1903, lot 16 (to A. Jackson for £1,960); Marsden J. Perry; W. A. White; Alfred T. White, Brooklyn, New York; Mr. and Mrs. Adrian Van Sinderen, New York (daughter of A. T. White).

SELECTED BIBLIOGRAPHY: Adrian Van Sinderen, *Blake the Mystic Genius*, Syracuse, 1949, p. 58, repr.; Morgan Library, *First Report to the Fellows*, 1950, pp. 56–60; Pamela Dunbar, *William Blake's Illustrations to the Poetry of Milton*, Oxford, 1980, pp. 115ff.

EXHIBITIONS: Morgan Library, *Major Acquisitions, 1924–1974*, 1974, no. 48, repr.; Tate Gallery, London, *William Blake*, catalogue by Martin Butlin, 1978, no. 239, repr.

Acc. no. 1949.4:1
Purchased with the support of the Fellows with the special assistance of Mrs. Landon K. Thorne and Mr. Paul Mellon

Francisco Goya y Lucientes (Spanish)
FUENDETODOS 1746 – 1828 BORDEAUX

118 *"Pesadilla" (Nightmare)*

Point of brush, gray and black washes
$10^3/_8 \times 6^3/_4$ inches (264 × 171 mm.); the sheet, which is irregular, measures $7^1/_8$ inches (181 mm.) across the top edge
Watermark: *J HO*[NIG & ZOONEN]
Inscribed by the artist at bottom in black chalk, *Pesadilla*; numbered by him at top in brown ink, *20*; numbered by another hand in black ink above Goya's number, *41*

Drawing as a preliminary activity in preparation for a painting was of little interest to Goya. Like the master he emulated—Velázquez—Goya drew directly on canvas. It is therefore no surprise that three-fifths of the thousand or so drawings that survive from the hand of this artist are independent works of art executed for his own pleasure and that of his friends. Four hundred seventy-six of these drawings are known to have been contained in eight albums which were dismembered in the 1840's. Due to financial difficulties, Goya's son Xavier reassembled a selection of these into three albums in order to sell them, first mounting the drawings on pink paper and renumbering them.

The Morgan sheet belongs to the Black Border Album, so-called for the single or double ruled lines with which Goya "framed" each figure or group. It is also one which Xavier mounted on pink paper and included among those to be sold. The "Black Border" drawings are the largest in scale of all those in the albums and date to the years 1803–1812, roughly contemporary with the celebrated etchings *Disasters of War*. Goya created the image of "nightmare" with brush and india ink—a medium the artist perfected and used exclusively until 1824 when he emigrated to Bordeaux. The woman astride the flying bull is terror-stricken, her eyes bulging and mouth open in a never-ending scream of horror. The exact meaning and source of this image remains uncertain. According to Gassier, Goya must have been inspired "by certain toreros who rode one bull while fighting another." The flying bull appears in Goya's later drawings, but with a comic overtone. There is another drawing carrying the same

title and number as the Morgan sheet, preserved at the Metropolitan Museum of Art since 1919, but it belongs to a different series.

PROVENANCE: Paul Lebas, Paris; his sale, Paris, Hôtel Drouot, 3 April 1877, one of lots 12, 78, or 79 (to E. Féral for 14 francs); E. Calando, Paris (Lugt 837); his sale, Paris, Hôtel Drouot, 11–12 December 1899, lot 73 (175 francs); Mr. and Mrs. Richard J. Bernhard, New York.

BIBLIOGRAPHY: Morgan Library, *Ninth Report to the Fellows, 1958 & 1959*, 1959, pp. 112–114, repr.; Morgan Library, *Review of Acquisitions, 1949–1968*, 1969, p. 148, pl. 40; Pierre Gassier, "Une Source inédite de dessins de Goya en France au XIX^e siècle," *Gazette des beaux-arts*, LXXX, July–August 1972, p. 112, no. 12; Pierre Gassier, *Francisco Goya Drawings: The Complete Albums*, New York–Washington, D.C., 1973, pp. 213–214, no. E.20; A. Hyatt Mayor, *Goya: 67 Drawings*, Greenwich, 1974, no. 29, repr.

EXHIBITION: Morgan Library, *Major Acquisitions, 1924–1974*, 1974, p. xx, no. 32, repr.

Acc. no. 1959.13
Gift of Mr. and Mrs. Richard J. Bernhard

119 *"Dejalo todo a la probidencia" (Leave it all to providence)*

Brush and black wash
$10\frac{1}{2} \times 7\frac{1}{4}$ inches (268 × 185 mm.)
Watermark: none
Inscribed by the artist in pencil at lower center, *Dejalo todo a la probidencia*; numbered by the artist in pen and brown wash at upper center, *40*

Like the preceding sheet, this drawing belongs to the Black Border Album of 1803–1812. Here, the broadly brushed figure of a woman of the people, mute and melancholy in the acceptance of her fate, is set forth with supreme authority, the pale, half-shadowed face luminous among the deep blacks of the heavy shawl. In her resignation, she stands in striking contrast to her pendant in the album, a workman railing against his bitter lot. The same woman appears in a sheet earlier in the sequence of the album (no. 33) where she is actually called *La Resignación* (Museum of Fine Arts, Boston).

PROVENANCE: Paul Lebas, Paris; sale, Paris, Hôtel Drouot, 3 April 1877, lot 104 (as "Elle laisse tout à la Providence"); De Beurnonville, Paris; his sale, Paris, Hôtel Drouot, 16–19 February 1885, part of lot 50; Clément, Paris; Alfred Beurdeley, Paris (Lugt 421); his sale, Paris, Galerie Georges Petit, 2–4 June 1920, lot 169; Hector Brame, Paris; Edith Wetmore, New York; Karl Kup, New York; Helmut Ripperger, New York;

T. Edward Hanley, Bradford, Penn.; Mr. and Mrs. Eugene V. Thaw, New York.

BIBLIOGRAPHY: Paul Lafond, *Goya*, Paris, n.d., p. 157, no. 88; Harry Wehle, *Fifty Drawings by Francisco Goya*, New York, 1938, p. 14; Eleanor A. Sayre, "An Old Man Writing: A Study of Goya's Albums," *Bulletin, Museum of Fine Arts*, Boston, 1958, p. 136; Pierre Gassier and Juliet Wilson, *Goya: His Life and Work*, London, 1971, no. 1406; Pierre Gassier, "Une Source inédite de dessins de Goya en France au XIX^e siècle," *Gazette des beaux-arts*, LXXX, July–August 1972, p. 116; Pierre Gassier, *Francisco Goya Drawings: The Complete Albums*, New York–Washington, D.C., 1973, pp. 193, 217, E.40, repr.

EXHIBITIONS: Art Institute of Chicago, Chicago, *The Art of Goya*, 1941, no. 64, repr.; Albright Art Gallery, Buffalo, *The T. Edward Hanley Collection*, 1960, no. 139; Wildenstein and Co., New York, *Paintings and Drawings from the Hanley Collection*, 1961, no. 67, repr.; Gallery of Modern Art, New York, and Philadelphia Museum of Art, Philadelphia, *Selections from the Collection of Dr. and Mrs. T. Edward Hanley*, 1967, p. 68; Columbus Gallery of Fine Arts, Columbus, *Works from the Hanley Collection*, 1968, no. 142, repr.; Morgan Library, and elsewhere, *Drawings from the Thaw Collection*, 1975, no. 66, repr.

Mr. and Mrs. Eugene V. Thaw
Promised gift to The Pierpont Morgan Library

Jean-Auguste-Dominique Ingres (French)
MONTAUBAN 1780 – 1867 PARIS

120 *Portrait of Guillaume Guillon Lethière (1760–1832)*

Pencil on wove paper
$11 \times 8\frac{3}{4}$ inches (280 × 221 mm.)
Watermark: none
Inscribed at lower right, *M. de Ingres / a Mad^{lle} Lescot*, and signed (and erased, but still legible) beneath dedication, *Ingres rome 1815*

Ingres' great talent for portraiture manifested itself early and he drew likenesses of many of his friends and associates while he was at the French Academy in Rome. He portrayed his friend and mentor, Guillaume Guillon Lethière, first in the profile portrait of 1811 now in the Fogg Art Museum (repr. *Ingres Centennial Exhibition*, 1967, no. 19)—virtually repeated in the drawing at present in the Bonnat Collection at Bayonne—and again in 1815 in this superb frontal portrait made for Lethière's friend Hortense Lescot. The drawing came to the Library as part of a group of beautiful

drawings in the bequest of Therese Kuhn Straus in memory of her husband, Herbert N. Straus. Here, the artist's pencil captures not only the physiognomical likeness of the man who directed the French Academy during Ingres' term there as a pensioner, but something of his character as well. The sitter is revealed as the genial and intelligent, if somewhat vain, man of whom Alexandre Dumas wrote: "Monsieur Lethière était à la fois un beau talent, un bon coeur et un charmant esprit." Ingres' portrait of Lethière has immense dash and sweep, and every nuance of detail is crisply delineated in a range of tonal effects resulting from the alternation of soft and hard pencils. The tautly stretched paper tablet which the artist used served not only as a convenient support in the actual execution of the portrait, but also provided a fine resilient surface on which Ingres could draw with absolute control.

PROVENANCE: Mlle Hortense Lescot, later Mme Louis-Pierre Haudebourt; Adrien Fauchier-Magnan; private collection, Paris; sale, Paris, Hôtel Drouot, Salle 7, 13 November 1922, lot 12, repr.; Mr. and Mrs. Herbert N. Straus, New York.

BIBLIOGRAPHY: Henry Jouin, *Musée de portraits d'artistes*, Paris, 1888, p. 119; Georges Lecomte, "David et ses élèves,", *Les Arts*, XII, October 1913, p. 18, repr.; Morton D. Zabel "Ingres in America," *The Arts*, XVI, 1930, p. 379, repr.; Aline B. Louchheim, "The Great Tradition of French Drawing from Ingres to Picasso in American Collections," *Art News Annual*, XLIII, no. 16, 1944, p. 129, p. 130, repr.; Agnes Mongan, *Ingres: 24 Drawings*, New York, 1947, no. 9, repr.; Hans Naef, "Ingres und die Familie Guillon Lethière," *du*, December 1963, pp. 65–78, fig. 1; Norman Schlenoff, "Ingres Centennial at the Fogg Museum," *Burlington Magazine*, CIX, 1967, p. 379; Mongan, *Ingres as a Great Portrait Draughtsman*, Colloque Ingres 1967, Montauban, 1969, p. 141; Ebria Feinblatt, "An Ingres Portrait for Los Angeles," *The Connoisseur*, CLXX, April 1969, p. 262, fig. 4; Naef, "Ingres und die Villa Medici," *du*, September 1972, p. 660, repr.; Naef, *Die Bildniszeichnungen von. J.-A.-D. Ingres*, Bern, 1977–1978, I, pp. 408ff., IV, no. 135, repr.; Morgan Library, *Eighteenth Report to the Fellows, 1975–1977*, 1978, pp. 244, 269f., repr.

EXHIBITIONS: Palais des Beaux-Arts de la Ville de Paris, Paris, *David et ses élèves*, 1913, no. 332; Chambre syndicale de la curiosité et des Beaux-Arts, Paris, *Ingres*, 1921, no. 64; Albright Art Gallery, *Master Drawings*, 1935, no. 95, repr.; Springfield Museum of Fine Arts, Springfield, Mass., and M. Knoedler and Co., New York, *David and Ingres*, 1939–1940, no. 47; Fogg Art Museum, Harvard University, Cambridge, *Ingres Centennial Exhibition*, catalogue by Agnes Mongan and Hans Naef, 1967, no. 30, repr.

Acc. no. 1977.56
Bequest of Therese Kuhn Straus in memory of her husband, Herbert N. Straus

121 *Portrait of Charles-Désiré Norry (1796–1818)*

Pencil on wove paper
7¹³⁄₁₆ × 5¹³⁄₁₆ inches (198 × 148 mm.)
Watermark: none
Signed, inscribed, and dated by the artist at lower left, *Ingres à Mr Norry / Pere. / rome / 1817*

Ingres' skill as a portrait draughtsman is again demonstrated in this deft characterization of Charles-Désiré Norry, which was presented to the Library in 1977 as the handsome gift of Mr. and Mrs. Claus von Bulow. There will never be a great deal known about the young man since he died in 1818 at the untimely age of twenty-two, a year after he sat for his portrait. He was studying architecture in Rome with the intention, no doubt, of following in the profession of his father, Charles Norry (1757–1832), the practicing architect. When the latter came to Rome to visit the younger Norry in 1817, both father and son sat to Ingres for portraits. The portrait of the father, who survived his son by fourteen years, is now in the collection of Mr. William S. Paley, New York (repr. Naef, *Die Bildniszeichnungen von J.-A.-D. Ingres*, Bern, 1977–1978, IV, no. 215).

PROVENANCE: Charles Norry; Henri Rouart; Alexis Rouart; Louis-Henry Rouart; John S. Newberry, Jr.; E. V. Thaw and Co., New York.

BIBLIOGRAPHY: Henry Lapauze, *Ingres: Sa Vie et son oeuvre*, Paris, 1911, p. 184, p. 165, repr.; Waldemar George, "Portraits par Ingres et ses élèves," *La Renaissance de l'art français*, XVII, October-November 1934, p. 197, repr.; "Detroit Sees France from David to Courbet," *Art Digest*, February 1950, p. 13, repr.; Hans Naef, *Die Bildniszeichnungen von J.-A.-D. Ingres*, Bern, 1977–1978, II, p. 232, IV, no. 216, repr.; Morgan Library, *Eighteenth Report to the Fellows, 1975–1977*, 1978, pp. 244, 269.

EXHIBITIONS: Galerie Balzac, Paris, *De David à Manet*, 1924, no. 179, repr.; Galerie Jacques Seligmann, Paris, *Portraits par Ingres et ses élèves*, 1934, no. 22; Detroit Institute of Arts, Detroit, *French Painting from David to Courbet*, 1950, no. 23; Detroit Institute of Arts, Detroit, *Recent Additions to the Collection of John S. Newberry*, 1951, no. 14, repr. as frontispiece; Carnegie Institute, Pittsburgh, *French Painting, 1100–1900*, 1951, no. 156, repr.; Fogg Art Museum, Harvard University, Cambridge, Mass., *Thirty-Three French Drawings from the Collection of John S. Newberry*, 1960, no. 20, repr.; Galerie Paul Rosenberg, New York, *Ingres in American Collections*, 1961, no. 24, repr.

Acc. no. 1977.37
Purchased as the gift of Mr. and Mrs. Claus von Bulow

Caspar David Friedrich (German)

GREIFSWALD 1774 – 1840 DRESDEN

122 Moonlit Landscape

Watercolor
9¹⁄₈×14¹⁄₈ inches (232×359 mm.)
Watermark: none visible through lining

Since both the paintings and the drawings of Germany's greatest Romantic artist are preserved for the most part in his native country, it is rare to find drawings, let alone drawings of this caliber, in an American collection. It is significant that when the American exhibition *German Master Drawings of the Nineteenth Century* was assembled in 1972, Friedrich was represented by works borrowed from abroad. This drawing, which recently emerged from the possession of the descendants of the artist's sister, has been catalogued both as an early work around 1803 and a work of around 1830–1835. It would seem to have more in common with the spirit of the later works than those of the earlier years.

Friedrich, replying to a criticism of his painting *The Cross in the Mountain*, wrote that "every truthful work of art must express a definite feeling, must move the spirit of the spectator to joy or sadness, to melancholy or to lightheartedness . . ." (Tate Gallery, London, *Caspar David Friedrich*, 1972, p. 16). The mood expressively evoked in the present drawing is definitely that of sadness or melancholy, symbolized very specifically in the statue that seems to represent the *Mater Dolorosa*, the moonlight glinting on the hilt of the sword plunged into her bosom. The moonlight also touches lightly on the broken tree trunk and the fence, which have been interpreted as symbolic of the death of Christ even as the birch tree and the moon may, in terms of Friedrich's religiosity, signify the Resurrection.

PROVENANCE: Catherine Dorothea Sponholz (1766–1808), the artist's sister; Caroline Sponholz, the artist's niece; her descendant, F. Pflugradt, Zingst; Galerie Meissner, Zurich.

BIBLIOGRAPHY: G. Pogge, "Neues über Caspar David Friedrich," in *Stralsunder Tageblatt*, 1 November 1920; Werner Sumowski, *Caspar David Friedrich-Studien*, Wiesbaden, 1970, p. 159, no. 351, fig. 445; Helmut Börsch-Supan and Karl

Wilhelm Jähnig, *Caspar David Friedrich*, Munich, 1974, no. 440, repr.

EXHIBITION: Morgan Library, and elsewhere, *Drawings from the Thaw Collection*, 1975, no. 107, repr.

Mr. and Mrs. Eugene V. Thaw
Promised gift to The Pierpont Morgan Library

Joseph Mallord William Turner (English)

LONDON 1775 – 1851 CHELSEA

123 View of Dunster Castle from the Northeast

Watercolor over faint indications in graphite
9¹⁄₄×14¹⁄₂ inches (235×367 mm.)
Watermark: none visible through lining

This beautiful watercolor is an especially fine example of Turner's work in the 1790's when he was occupied with views of castles, country houses, and cathedrals on his travels through England and Scotland. The drawings of this decade exhibit a profound change in style, as the young artist in the company of Thomas Girtin made the transition from topographer to colorist. The Morgan sheet, and a companion view of the same subject, were engraved by S. Rawle on 1 May 1800, the former entitled *Dunster Castle, Somersetshire, North-East View*; the plate was dedicated to Mr. J. Fownes Luttrell, M.P., the owner of the castle whose family had resided there since 1376. In this elaborately finished watercolor, the rich tonalities of Turner's washes applied in layers to convey depth and atmosphere have retained their effectiveness. The grand vista is skillfully animated by the play of light and shadow, and the dark foreground in the lower left corner serves to dramatize the view of the castle seen in the distance, reflecting the fleeting light of the sun as the clouds part in the sky.

PROVENANCE: Colonel Hibbert; his sale, Christie's, London, 4 December 1886, lot 48 (as "Dunster Castle from the Park"); bought by Agnew, sold to Rawlinson in 1887); W. G. Rawlinson; sale, Sotheby's, London, 21 November 1945, lot 53 (bought by Agnew; sold to Lady Bilsland); private collection, England.

BIBLIOGRAPHY: Sir Walter Armstrong, *Turner*, London,

1902, p. 250; W. G. Rawlinson, *The Engraved Work of J. M. W. Turner*, I, London, 1908, pp. lxxxviii, 21, no. 48; Andrew Wilton, *The Life and Work of J. M. W. Turner*, 1979, pp. 312–313, nos. 119 and 120 (titles and provenance of the two drawings confused).

EXHIBITION: Thomas Agnew and Sons, London, *Annual Watercolour Exhibition*, 1946, no. 83.

Acc. no. 1980.32
Purchased on the bequest of Lois Duffie Baker

John Constable (English)
EAST BERGHOLT, 1776 – 1837 LONDON

124 *View of Cathanger near Petworth*

Graphite, on two sheets of paper pasted together
8 1/16 × 13 5/8 inches (205 × 347 mm.)
Watermark: none visible through lining
Inscribed by the artist, in upper left corner, in graphite,
Petworth Sepr. 12 / 1834 Cat Hanger

Constable first set eyes on the Petworth estate in Sussex in July 1834. After considerable prodding from his portrait-painter friend Thomas Phillips, Constable accepted an invitation from Lord Egremont to return to Petworth House for an extended visit in September of the same year. The artist was provided with a carriage every day to tour the neighboring countryside and the two-thousand-acre park surrounding the mansion that had been landscaped by Capability Brown. Of almost equal inspiration to Constable would have been the family collection of paintings that included the work of Titian, Van Dyck, Claude, Reynolds, Gainsborough, as well as Turner who enjoyed the patronage of the third Earl of Egremont and had a studio there.

The view from the south side of Petworth House encompasses the farm on the estate known as the "Cat Hanger," which is situated on the far side of the Rother, a tributary of the Arun. The drawing is especially effective when seen at a distance due to the power of suggestion in the dots and dashes of Constable's soft pencil applied with the exactness of an expert draughtsman. It was the artist's custom to use a fixative on drawings executed in soft pencil; the occasional "bare" spot at the lower

and middle left as well as the faded year in the inscribed date at the top are areas where the fixative did not take. The artist probably executed this drawing on the spot in his sketchbook, with the drawing extending onto the left-hand page. Later he cut out both sheets and pasted them together before applying the fixative.

PROVENANCE: Edward Seago; Baskett and Day, London; Mr. and Mrs. Eugene V. Thaw, New York.

EXHIBITION: The Tate Gallery, London, *Constable*, catalogue by Leslie Parris, Jan Fleming-Williams, and Conal Shields, 1976, no. 315, repr., and under no. 316.

Mr. and Mrs. Eugene V. Thaw
Promised gift to The Pierpont Morgan Library

Samuel Palmer (English)
NEWINGTON 1805 – 1881 REDHILL

125 *Pear Tree in a Walled Garden*

Watercolor and tempera over preliminary drawing in brush and gray wash, on gray paper; traces of graphite
8 3/4 × 11 1/8 inches (222 × 283 mm.)
Watermark: none

In the mid-1820's the young Palmer for reasons of health left London with his father and old nurse and moved to Shoreham. He spent about seven years in the delightful, sequestered Kentish village, and he christened the lovely valley in which it was set "the Valley of Vision." The paintings and drawings of this time, the inspired visionary landscapes, are regarded as his most significant achievement. For the better part of his stay in Shoreham, Palmer shared a residence called Waterhouse, a Georgian house from which he had access to the old garden that extended down to the river. When this drawing was exhibited at the Victoria and Albert Museum in 1925, it was still in the possession of A. H. Palmer, the artist's son, and he suggested at the time that it was a study made in the Waterhouse garden, or, if not, in the garden of a Mr. Groonbridge that apparently was the most remarkable in the region. It might be mentioned that the photograph of Waterhouse as it appears today, which was recently published by James Sellars (*Samuel Palmer*, London, 1974,

pl. 33), shows at the right the corner of an auxiliary building that seems to be constructed of the same stone as the wall in the drawing, but such stone was probably native to the region and might also have been used in the walls of Mr. Groonbridge's garden.

The present drawing is often paired with *In a Shoreham Garden* (Victoria and Albert Museum, London; repr. Grigson, *Visionary Years*, pl. 34), a drawing oriented vertically but of the same size and likewise representing a fruit tree in luxuriant bloom, this time an apple tree. In a letter of 17 May 1829, addressed to John Linnell, Palmer speaks of his "delight at the glory of the season," adding, "Tho' living in the country, I really did not think there were those splendours in visible creation which I have lately seen" (A. H. Palmer, *The Life and Letters of Samuel Palmer*, London, 1892, p. 178). Palmer may have counted these trees among the "splendours" of his first spring at Waterhouse and rejoiced to have in his garden this espaliered pear tree that put forth its "clotted blossoms" with such prodigality in its surviving half. (One notes that the artist carefully rendered the clamp holding one of the branches against the wall.) The phrase "clotted blossoms," apparently first used by the artist's son to describe the rich bloom of the innumerable orchards of Shoreham (*Life and Letters*, p. 40) and adopted by all writers on Samuel Palmer ever since, would have pleased the father, who appreciated poetic language and sought for vivid imagery in his letters.

The explosive vitality of the blossom-laden, almost blossom-burdened, tree and the exaggerated scale of the green leaves in the foreground that seem to lead a life of their own invest this corner of an English garden with a quality that borders on the surreal—to which Palmer might have responded, "Excess is the essential vivifying spirit, vital spark, embalming spice . . . of the finest art" (David Cecil, *Visionary and Dreamer . . . Samuel Palmer and Edward Burne-Jones*, The A. W. Mellon Lectures in the Fine Arts, 1966, Princeton, 1969, p. 50). As a footnote to the history of this drawing, it should be recorded that it crossed the Atlantic at the close of the Second World War in token of the Oxford owner's appreciation of hospitality offered in Cambridge, Massachusetts, during that war. The drawing was presented to the Library by Mr. and Mrs. Thaw as this book went to press.

PROVENANCE: A. H. Palmer, Tilford, Surrey, and Vancouver, B.C.; sale, London, Christie's, 4 March 1929, lot 45; Victor Rienacker; Mrs. K. T. Parker, Oxford; Mrs. Paul J. Sachs, Cambridge, Mass.; Mr. and Mrs. Victor O. Jones (née Elizabeth Sachs); R. M. Light and Co., Boston; Mr. and Mrs. Eugene V. Thaw, New York.

BIBLIOGRAPHY: Geoffrey Grigson, "Samuel Palmer at Shoreham," *Signature*, November 1937, pp. 11, 14, repr.; Grigson, *Samuel Palmer: The Visionary Years*, London, 1947, pp. 90ff., 174, no. 77, pl. 33; Grigson, *Samuel Palmer's Valley of Vision*, London, 1960, p. 32 under no. 45.

EXHIBITIONS: Victoria and Albert Museum, London, *Drawings, Etchings and Woodcuts by Samuel Palmer and Other Disciples of William Blake*, 1926, no. 56 (as "Study of a Wall Fruit Tree in Blossom"); Stedelijk Museum, Amsterdam, *Two Centuries of English Painting*, 1936, no. 223; Bibliothèque Nationale, Paris, *Aquarelles de Turner, Oeuvres de Blake*, 1937, no. 114; Musée du Louvre, Paris, *La Peinture anglaise*, 1938, no. 216; Durlacher Brothers, New York, *The Work of Samuel Palmer*, 1949, no. 11; Arts Council, London, *Samuel Palmer and his Circle: The Shoreham Period*, 1957, no. 29; Detroit Institute of Arts, Detroit, and Philadelphia Museum of Art, Philadelphia, *Romantic Art in Britain*, 1968, no. 181, repr.; Morgan Library, and elsewhere, *Drawings from the Thaw Collection*, 1975, no. 112, repr.; Judy Egerton, *English Watercolour Painting*, London, 1979, no. 42, repr.

Acc. no. 1980.37
Gift of Mr. and Mrs. Eugene V. Thaw

PLATES

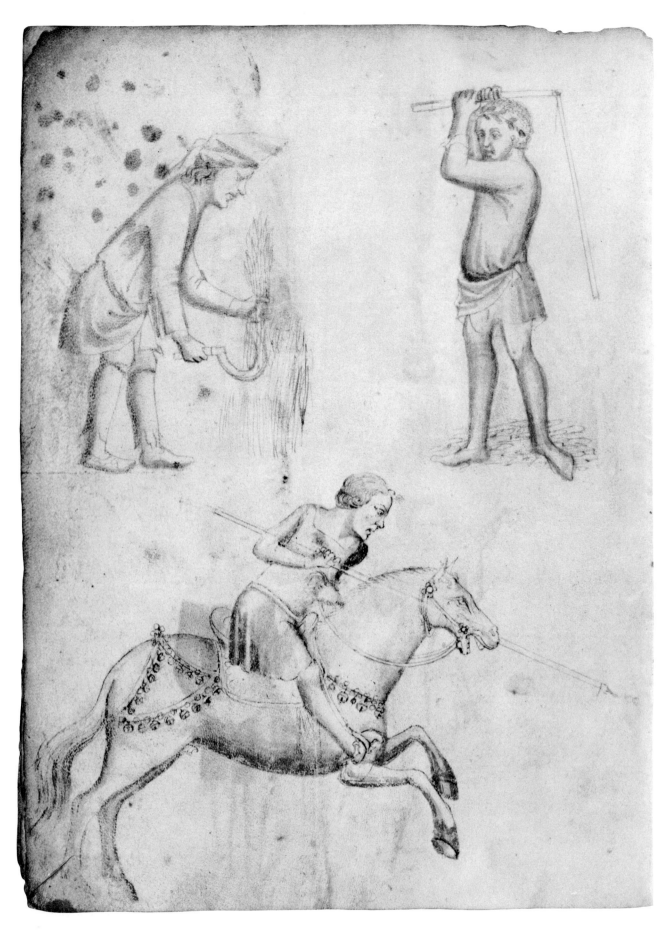

1a. LOMBARD SCHOOL *Occupations of the Month: June, July, August*

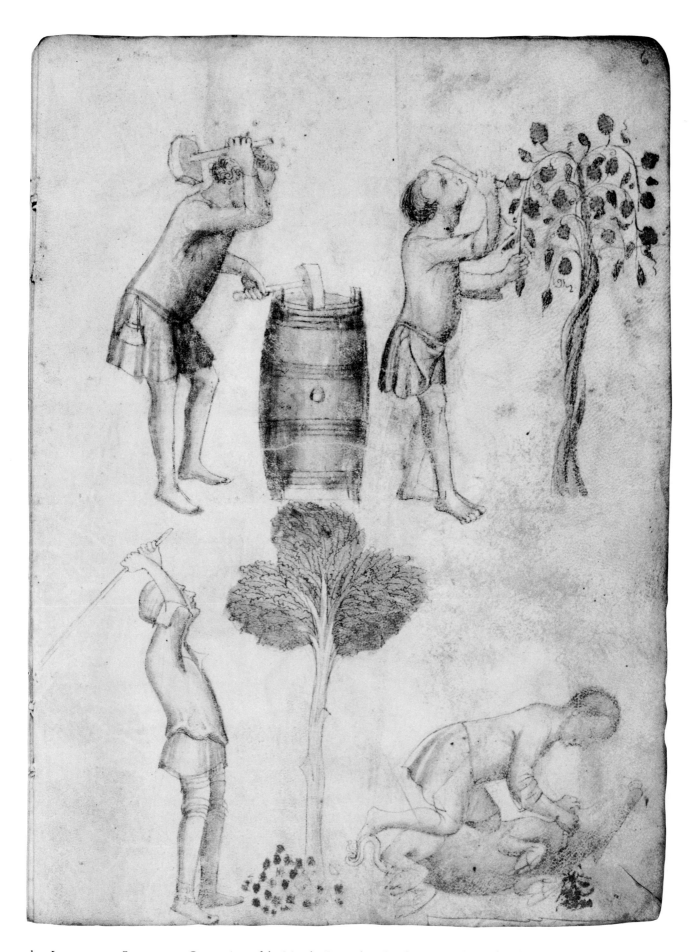

1b. LOMBARD SCHOOL *Occupations of the Month: September, October, November, December*

2. FLORENTINE SCHOOL *The Martyrdom of S. Miniato*

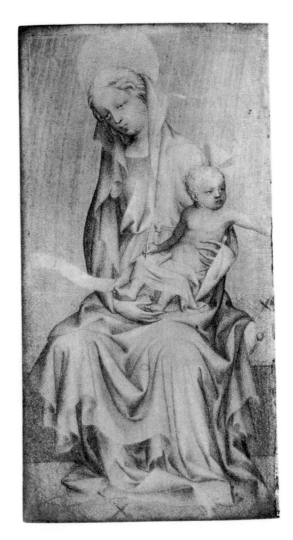

3. FRENCH SCHOOL, C. 1400 *Virgin and Child*

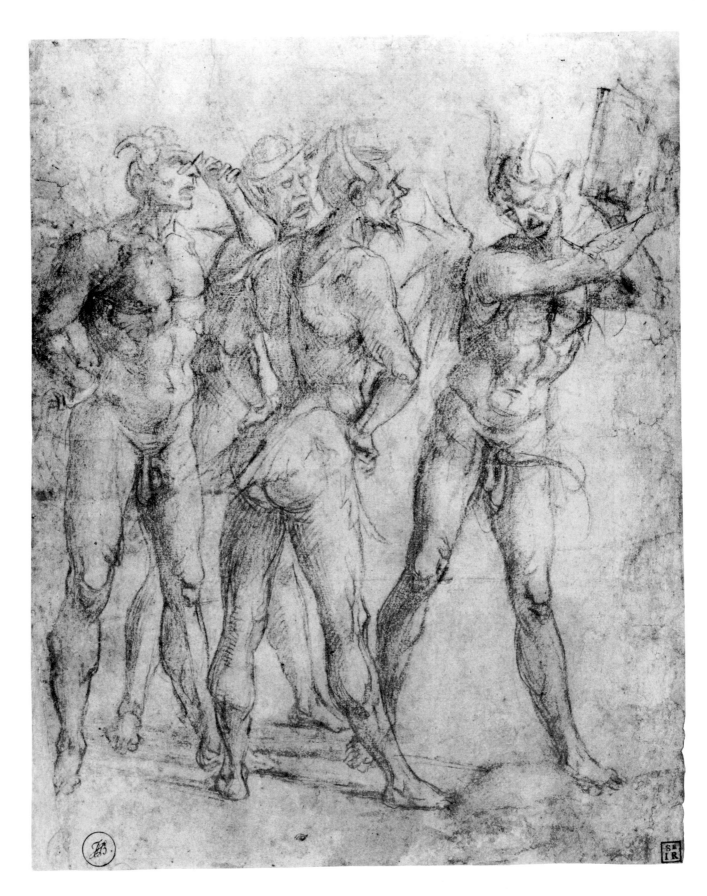

4. LUCA SIGNORELLI *Four Demons*

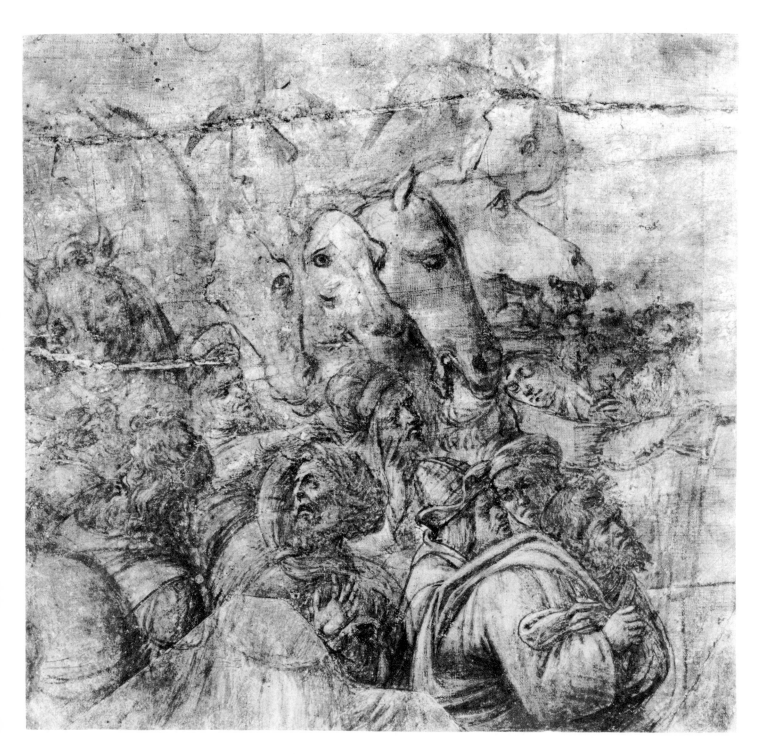

5. SANDRO BOTTICELLI *Fragment of an Adoration of the Magi*

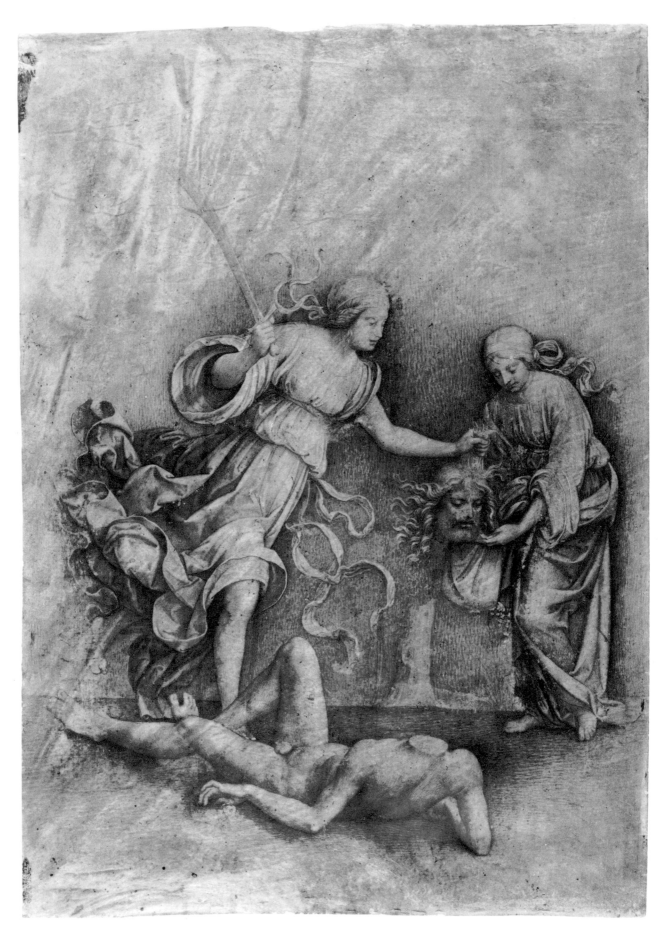

6. FRANCESCO FRANCIA *Judith and Holofernes*

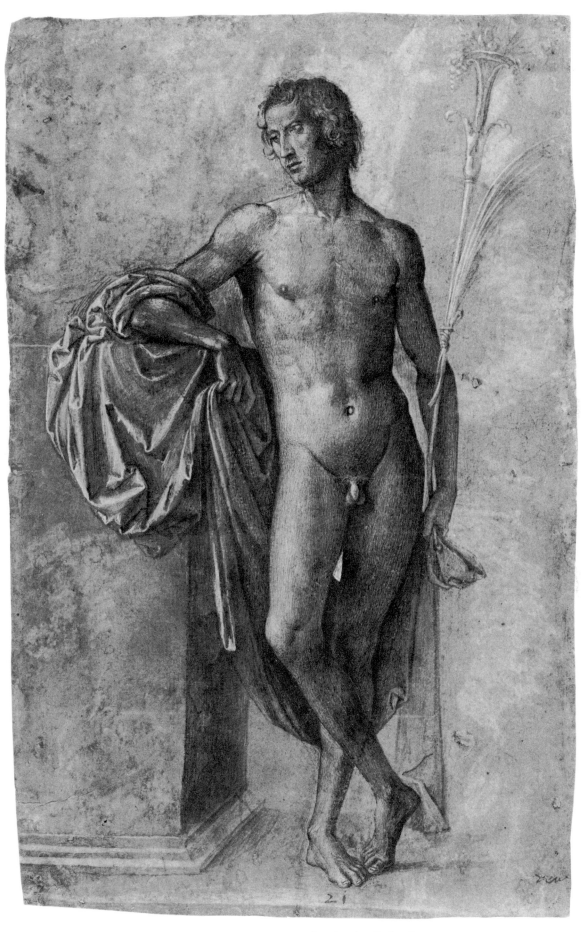

7. BARTOLOMEO MONTAGNA *Nude Man Standing beside a Pedestal*

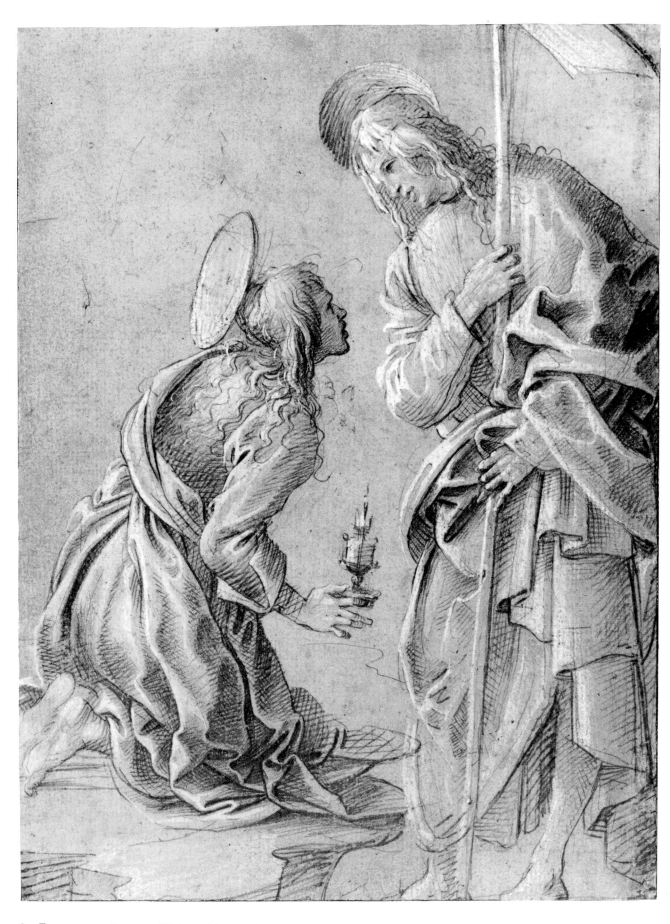

8. FILIPPINO LIPPI *Christ and the Magdalene*

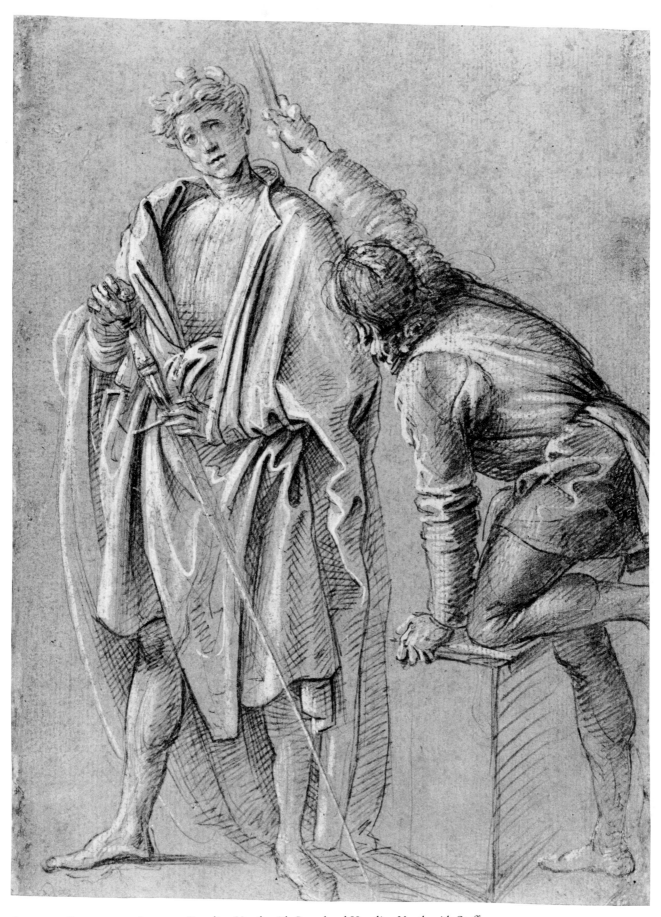

8 verso. FILIPPINO LIPPI *Standing Youth with Sword and Kneeling Youth with Staff*

9. FRANCO-FLEMISH SCHOOL(?) *Drapery Study*

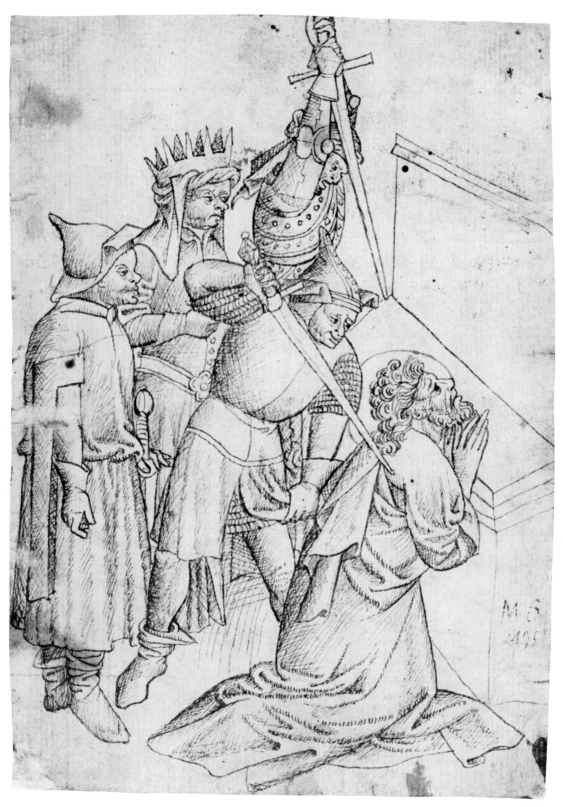

9 verso. FRANCO-FLEMISH SCHOOL(?) *Murder of a Saint Kneeling before an Altar*

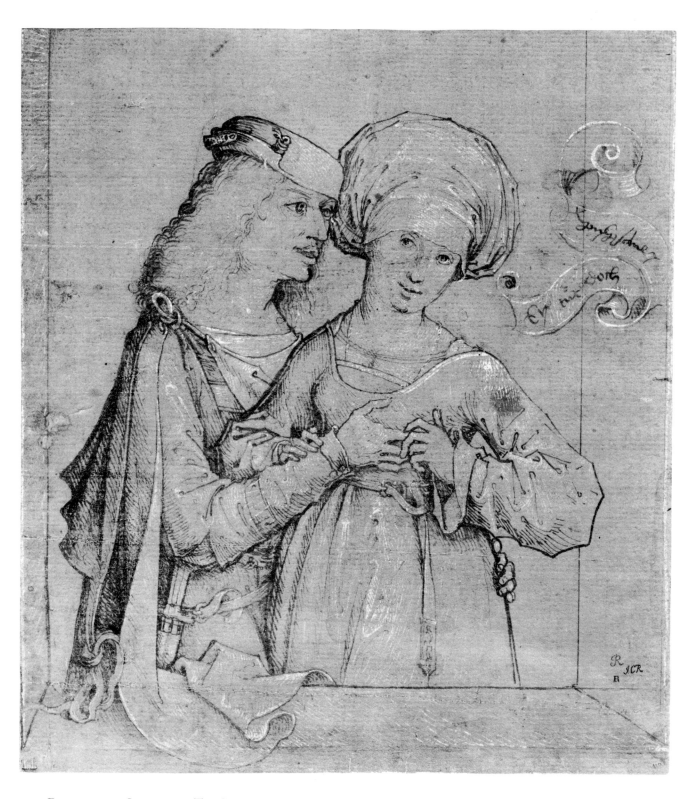

10. BERNHARD STRIGEL *Two Lovers*

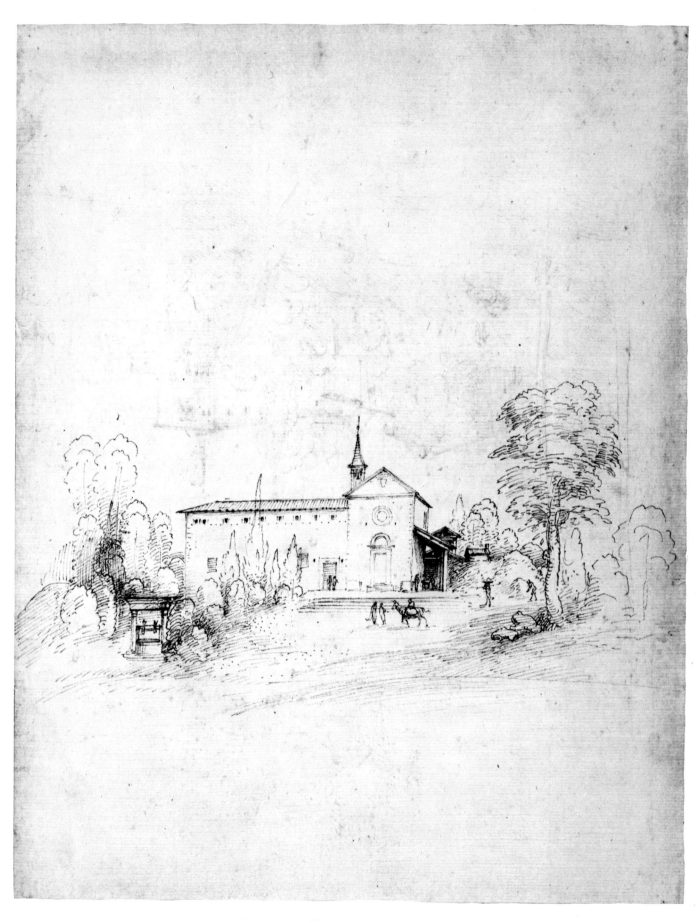

11. FRA BARTOLOMEO *Monastery Church and Well*

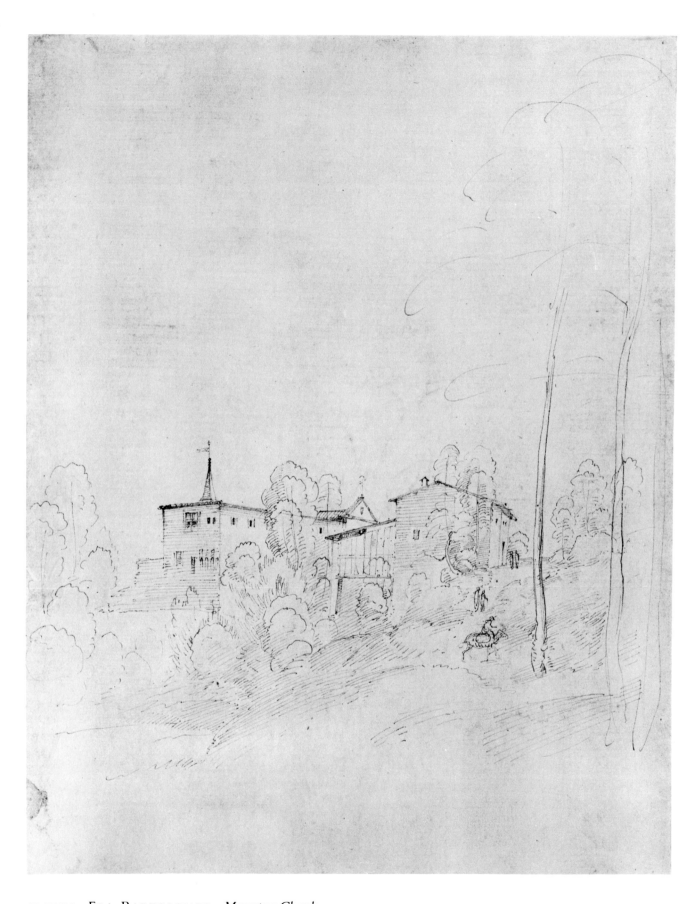

11 verso. FRA BARTOLOMEO *Monastery Church*

12a. MICHELANGELO *Studies of David Slaying Goliath*

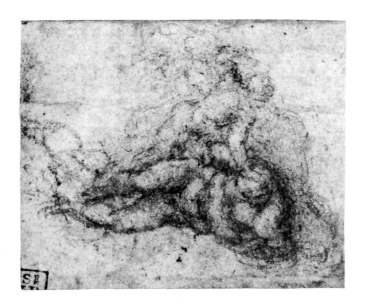

12b. MICHELANGELO *Studies of David Slaying Goliath*

13. RAPHAEL *The Meeting of Frederick III and Eleanor of Portugal*

14. PORDENONE *The Conversion of St. Paul*

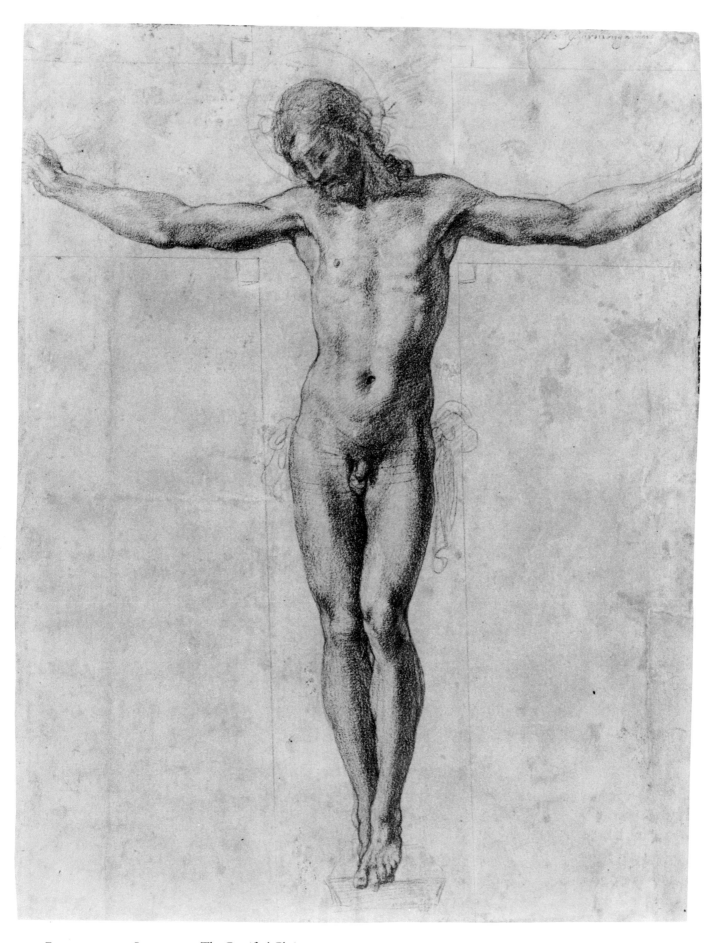

15. FLORENTINE SCHOOL *The Crucified Christ*

16. ANDREA DEL SARTO *Youth Carrying a Sack on his Head*

16 verso. ANDREA DEL SARTO *Youth Carrying a Sack on his Head*

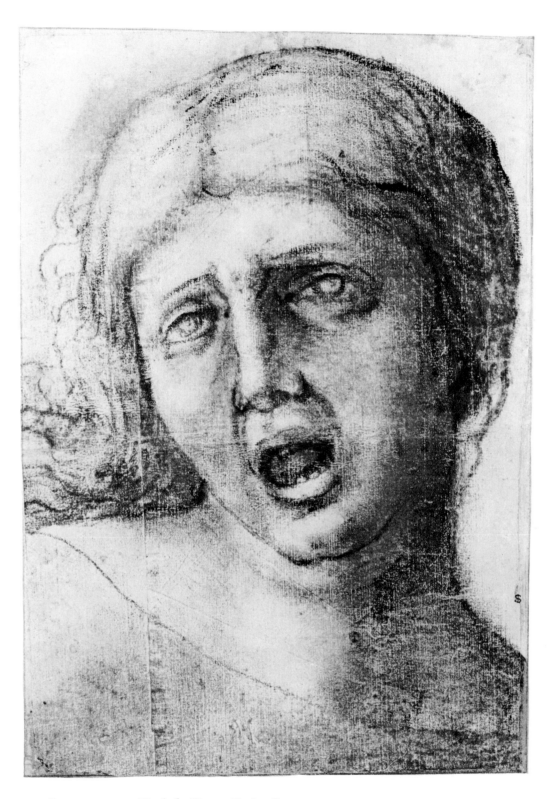

17. CORREGGIO *Head of a Woman Crying Out*

18. JACOPO PONTORMO *Standing Nude and Two Seated Nudes*

18 verso. JACOPO PONTORMO *Striding Nude with Upraised Arms*

19. PERINO DEL VAGA *The Miracle of the Loaves and Fishes*

20. PARMIGIANINO *Three Putti*

Parmegiano.

N 14

20 verso. PARMIGIANINO *Diana and Acteon*

21. PARMIGIANINO *Apollo and Marsyas*

22. PARMIGIANINO *The Infant Christ Asleep on the Lap of the Virgin*

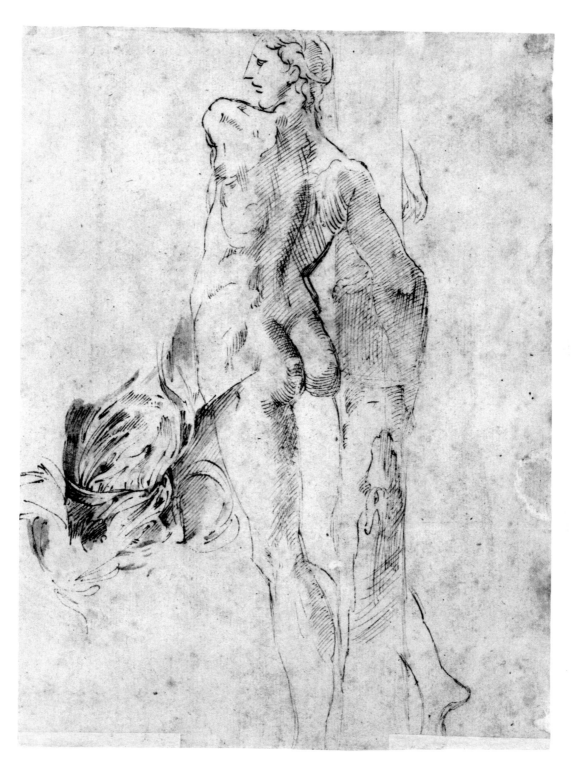

22 verso. PARMIGIANINO *Antique Statue of Dionysus*

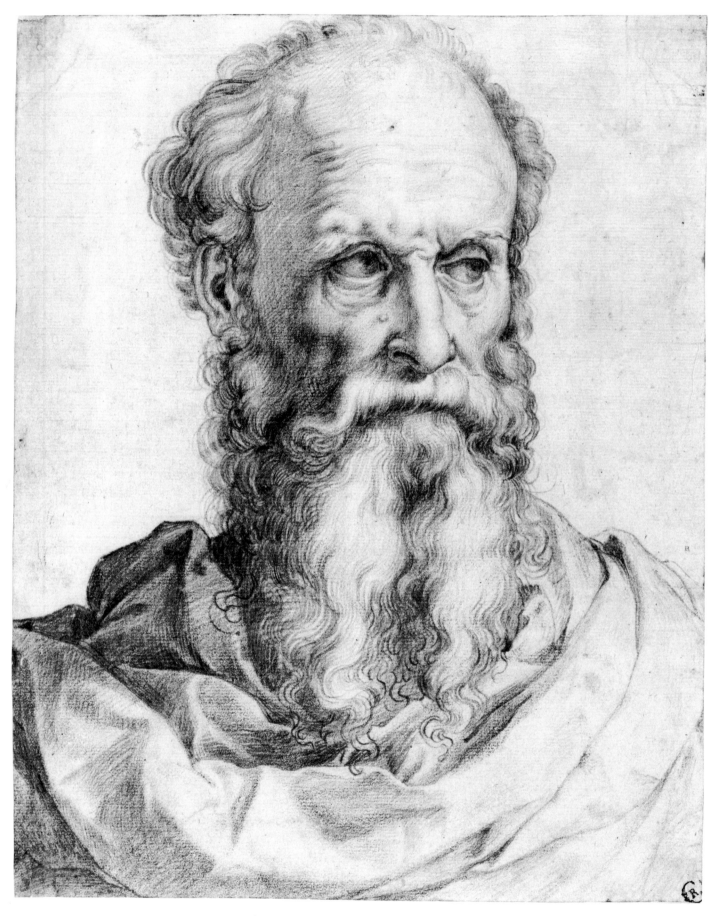

23. FRANCESCO SALVIATI *Head of a Bearded Man*

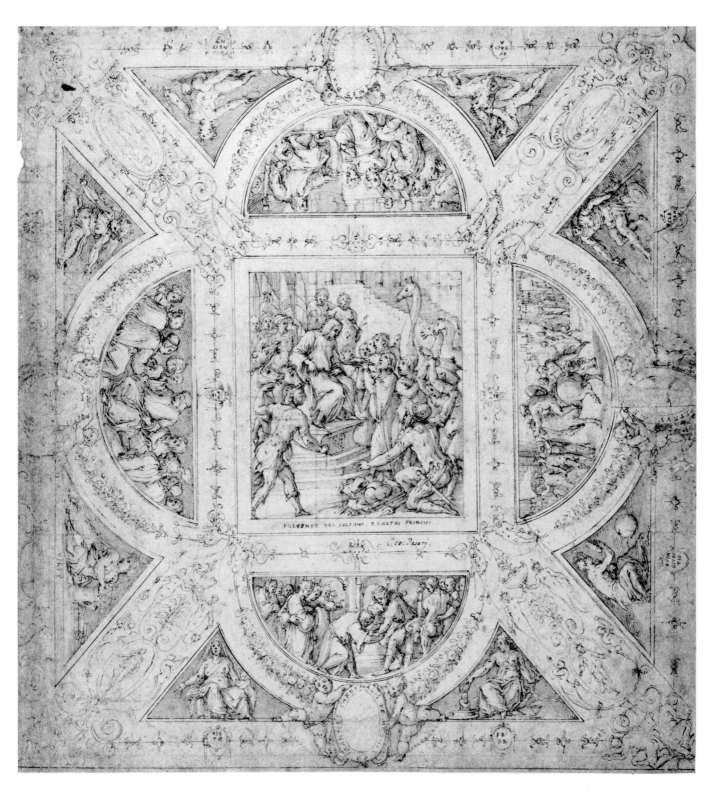

24. GIORGIO VASARI *Design for a Ceiling*

25. JACOPO TINTORETTO *Head of the "Emperor Vitellius"*

26. PAOLO VERONESE *Studies for the Finding of Moses*

27. FEDERICO ZUCCARO *The Emperor Frederick Barbarossa Kneeling before Pope Alexander III*

28. Antoine Caron *The Water Festival at Bayonne*

29. Maître de Flore *Procris and Cephalus*

30. HIERONYMOUS BOSCH, attributed to *Group of Ten Spectators*

31. Pieter Bruegel the Elder *Mountain Landscape*

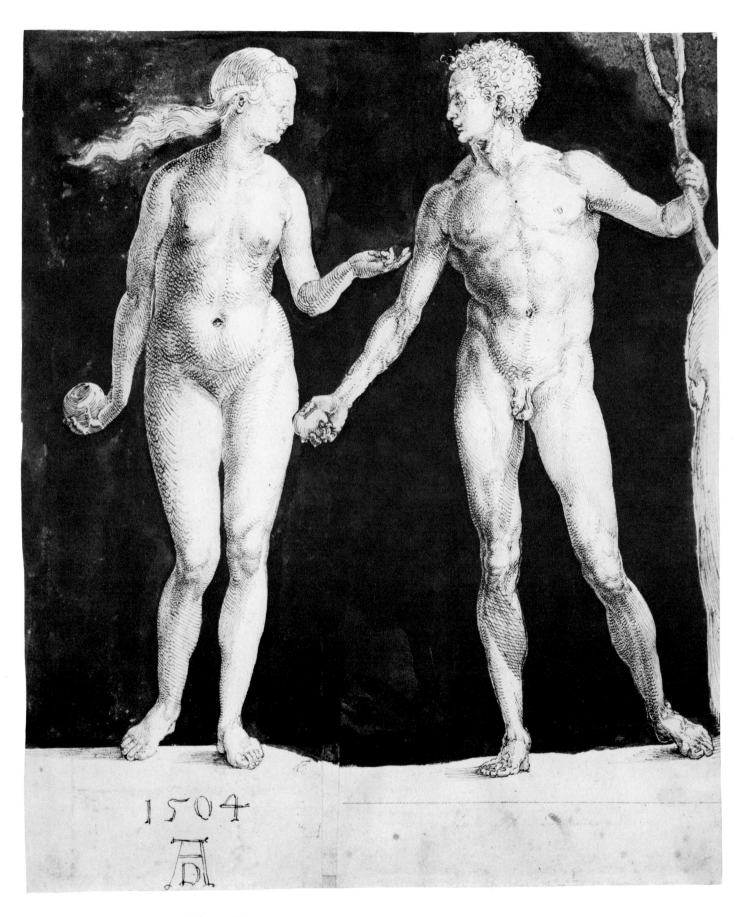

1504

32. ALBRECHT DÜRER *Adam and Eve*

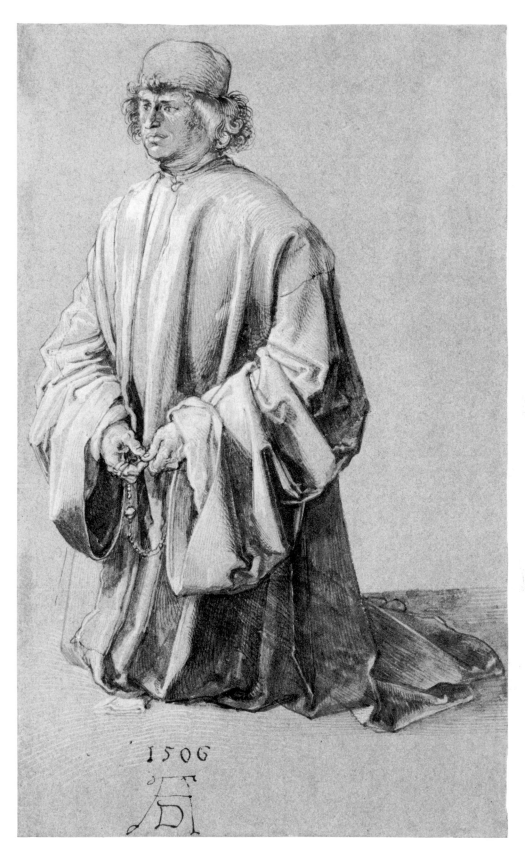

33. ALBRECHT DÜRER *Kneeling Donor*

34. ALBRECHT DÜRER *Design for the Pommel Plate of a Saddle*

35. ALBRECHT DÜRER *Design for a Mural Decoration*

36. JÖRG BREU THE YOUNGER *Horseman Attacking a Fallen Warrior*

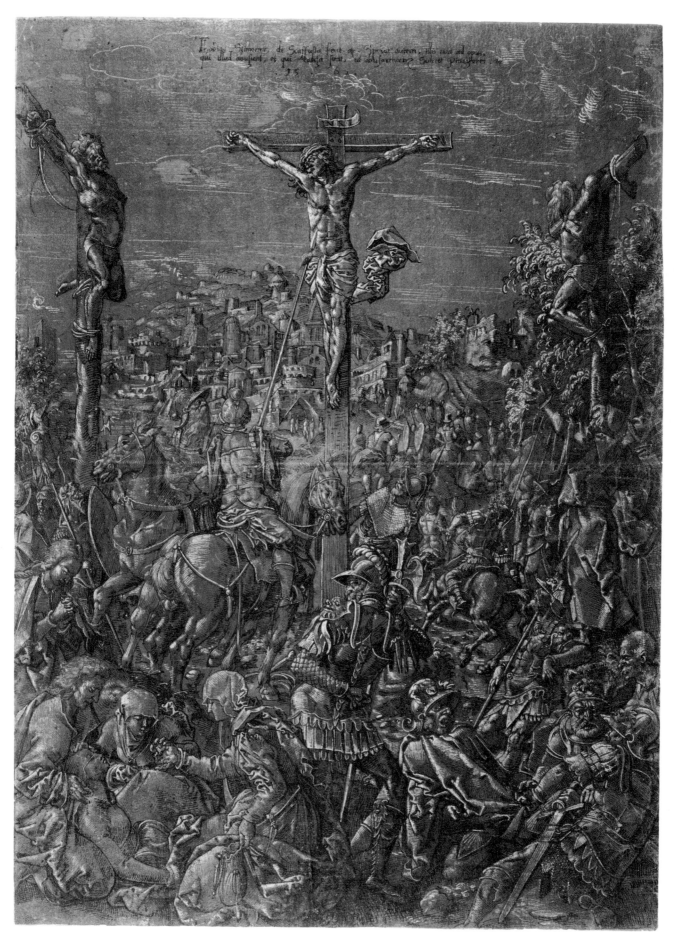

37. TOBIAS STIMMER *The Crucifixion*

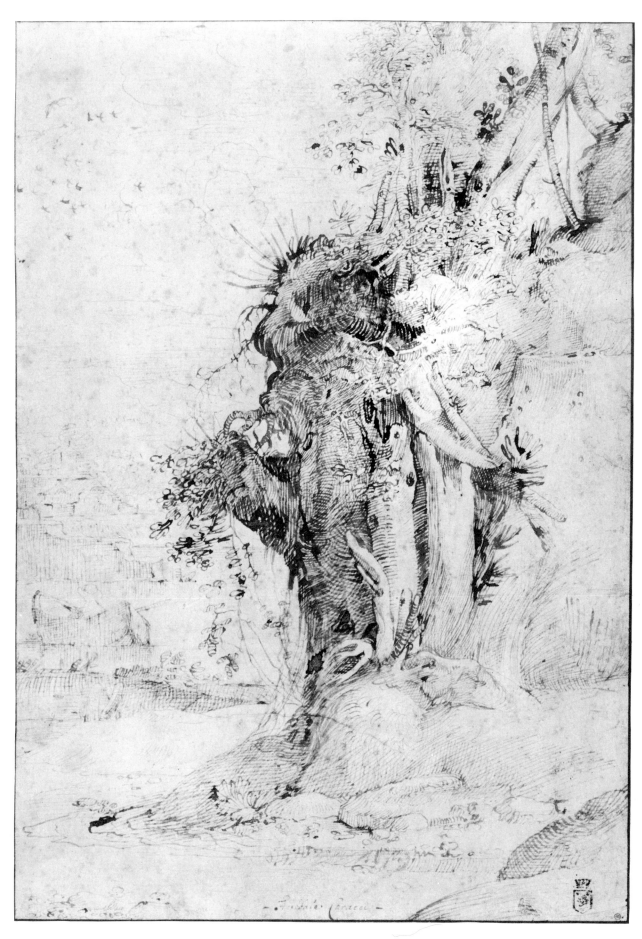

38. ANNIBALE CARRACCI *Eroded River Bank with Trees and Roots*

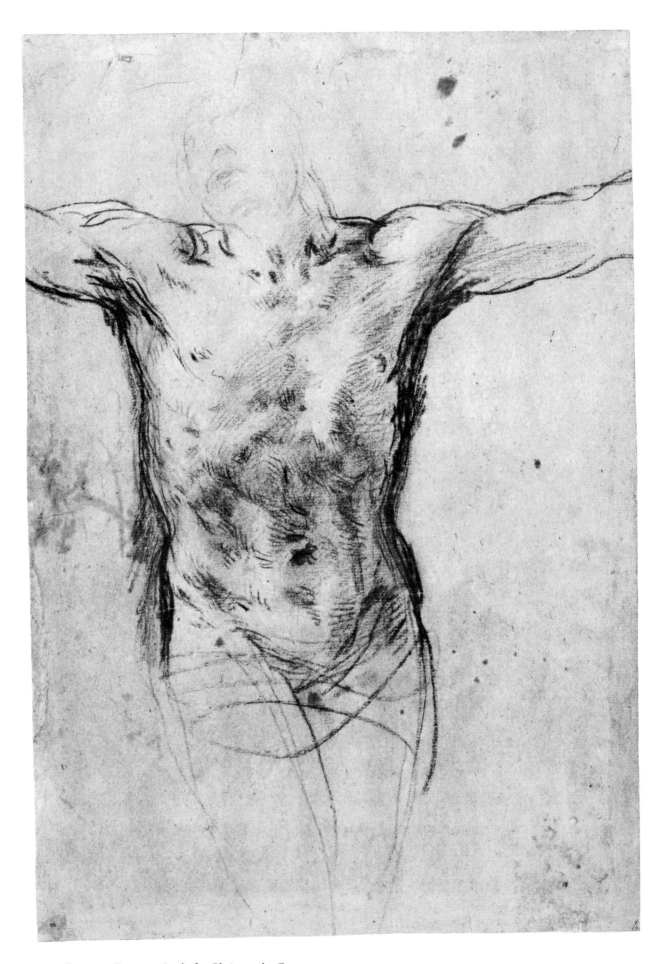

39. GUIDO RENI *Study for Christ on the Cross*

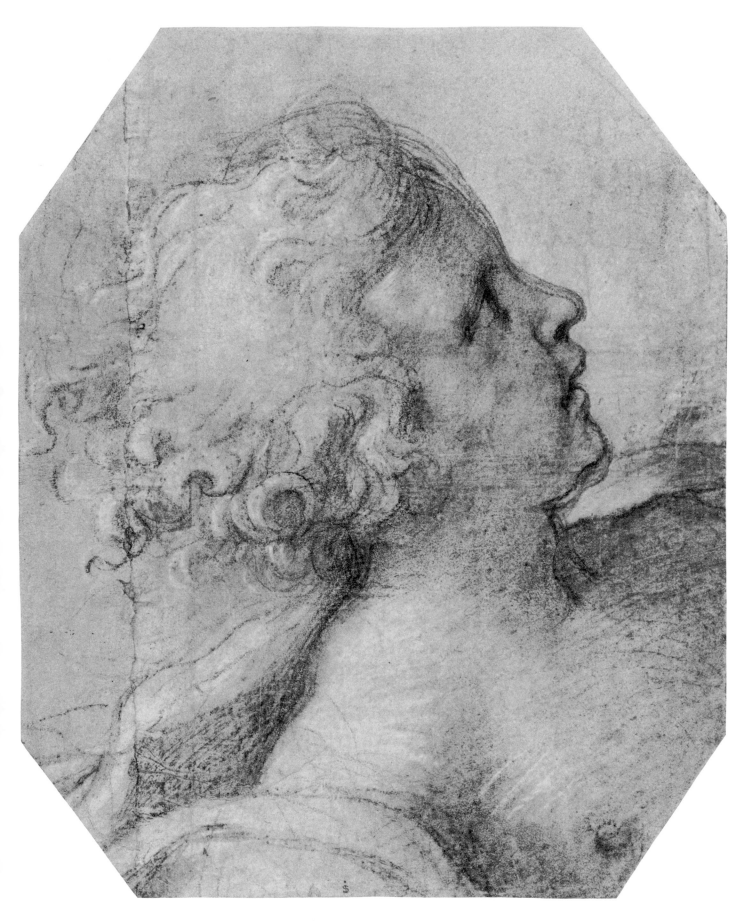

40. DOMENICHINO *Head of an Angel*

41. BERNARDO STROZZI *Head of Christ*

41 verso. BERNARDO STROZZI *Bust of Catherine of Alexandria; Sculptured Head; and Nude Figure Group*

42. GUERCINO *The Virgin Giving the Scapular to St. Albert*

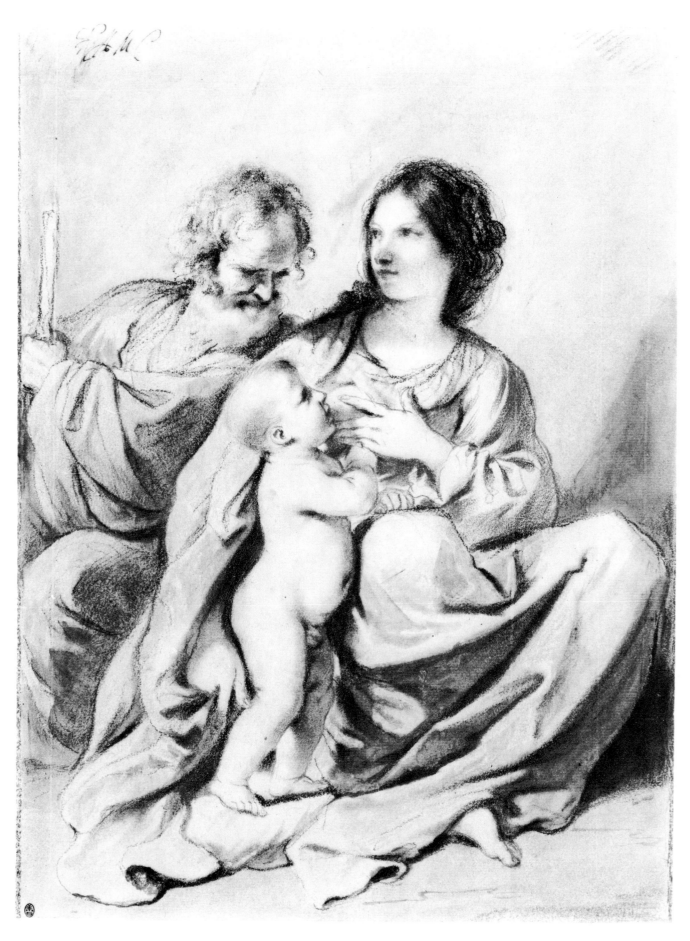

43. GUERCINO *The Holy Family*

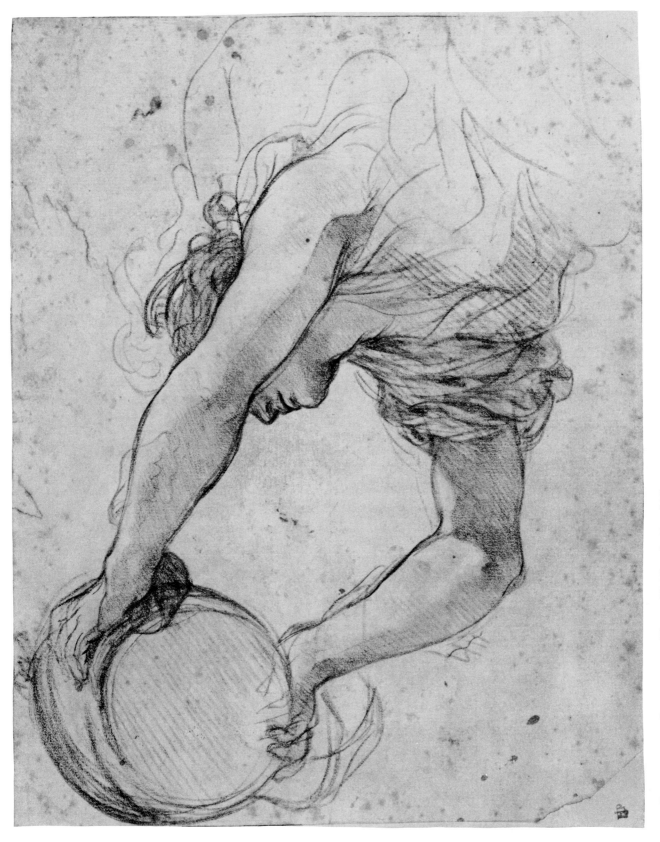

44. PIETRO DA CORTONA *Woman Holding the Papal Tiara*

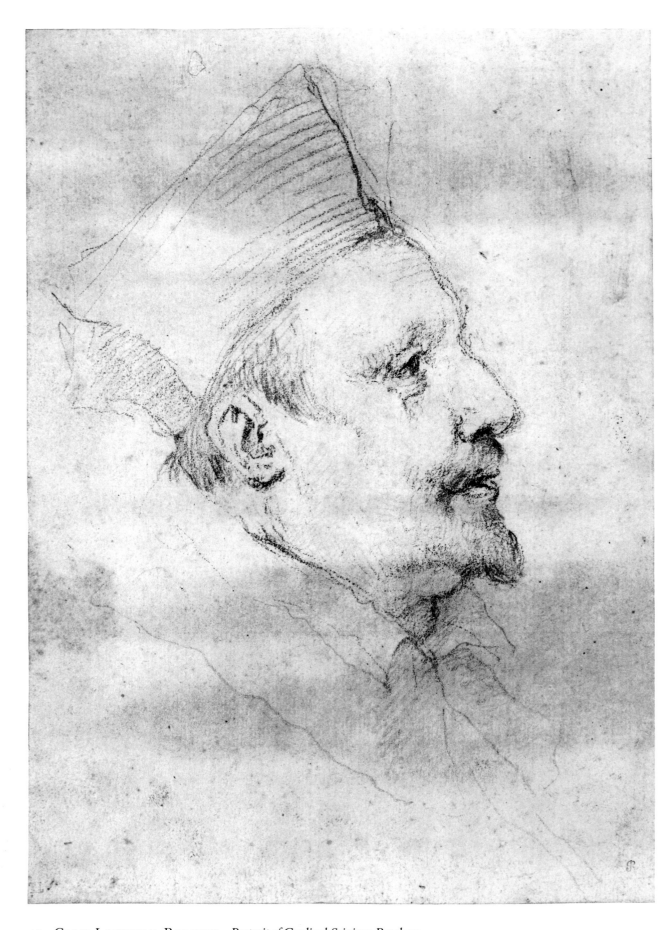

45. GIAN LORENZO BERNINI *Portrait of Cardinal Scipione Borghese*

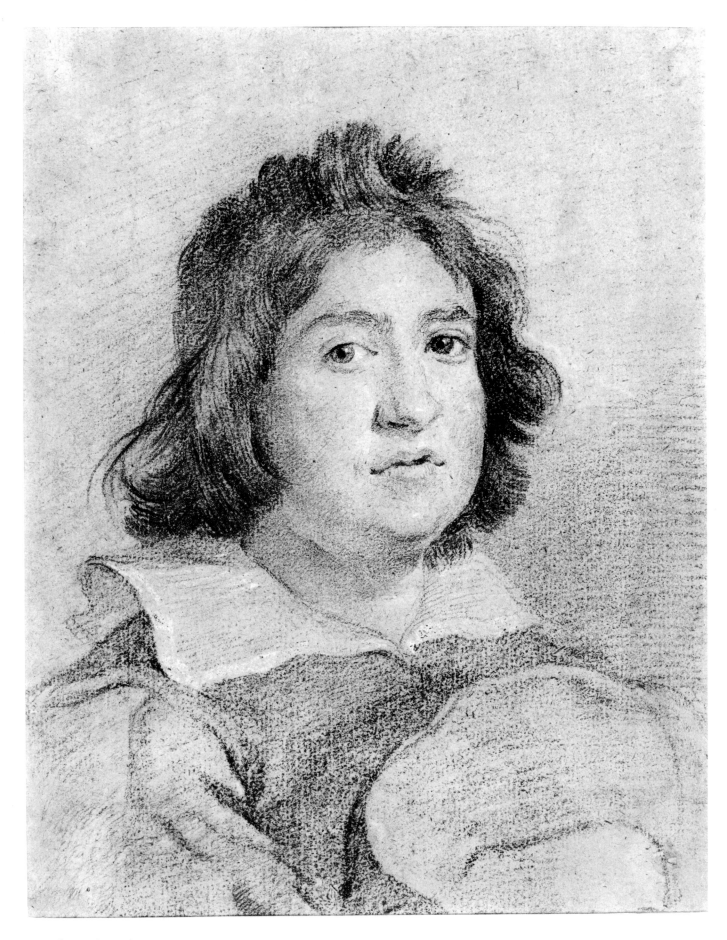

46. GIAN LORENZO BERNINI *Portrait of Sisinio Poli*

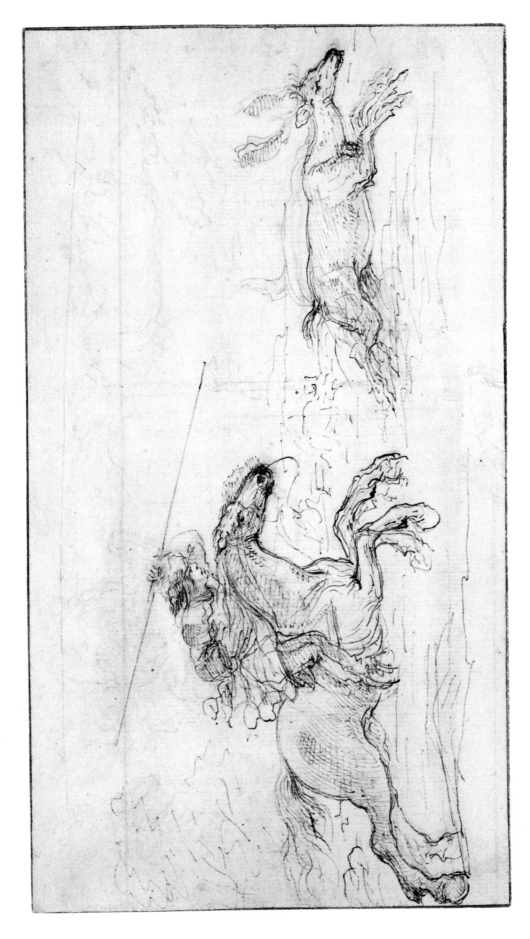

47. STEFANO DELLA BELLA *Stag Hunt*

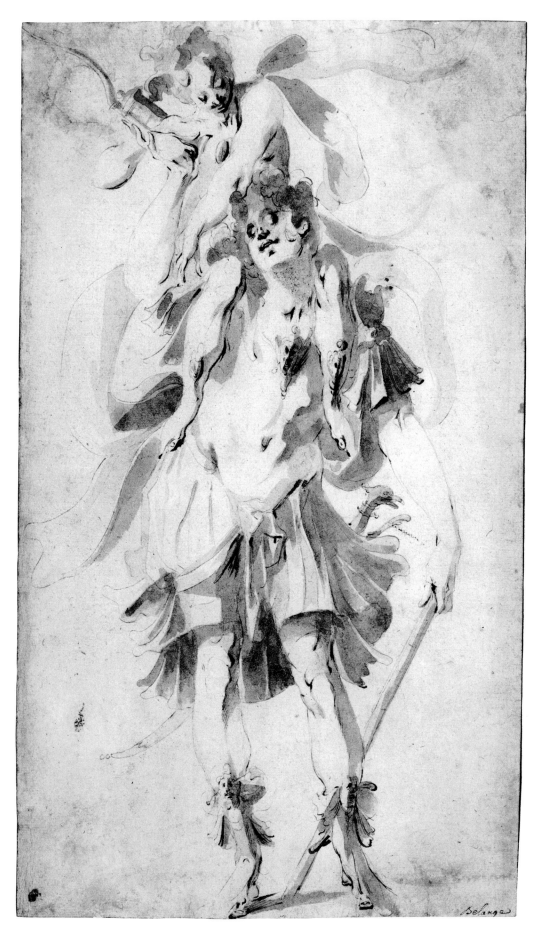

48. JACQUES BELLANGE *The Hunter Orion Carrying Diana on his Shoulders*

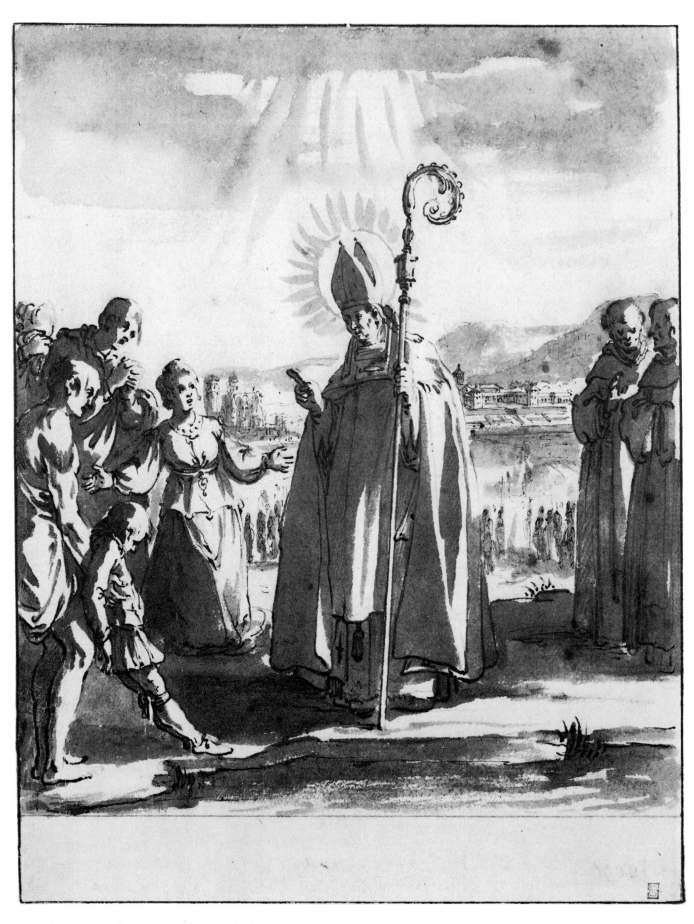

49. JACQUES CALLOT *The Miracle of St. Mansuetus*

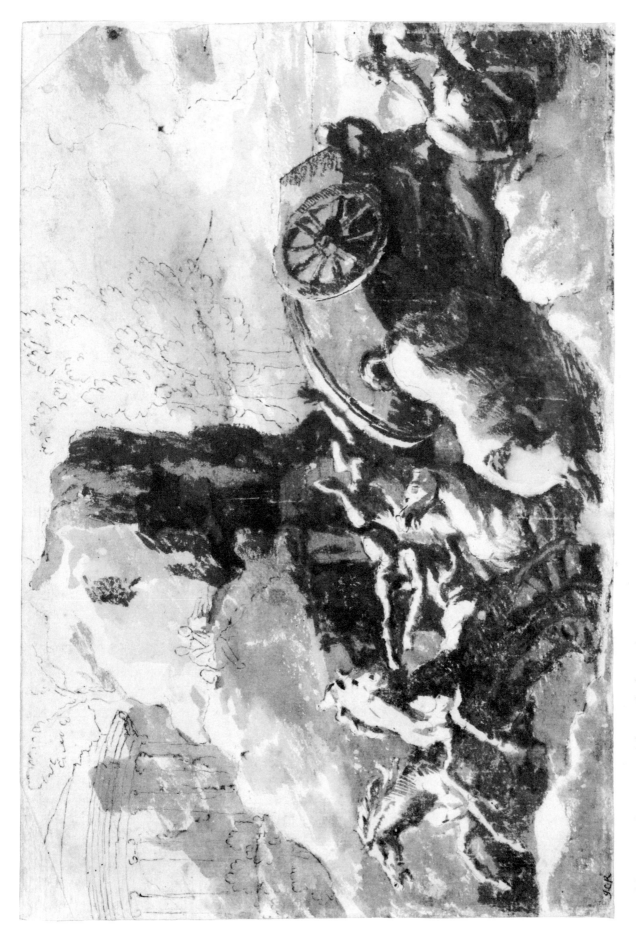

50. Nicolas Poussin *The Death of Hippolytus*

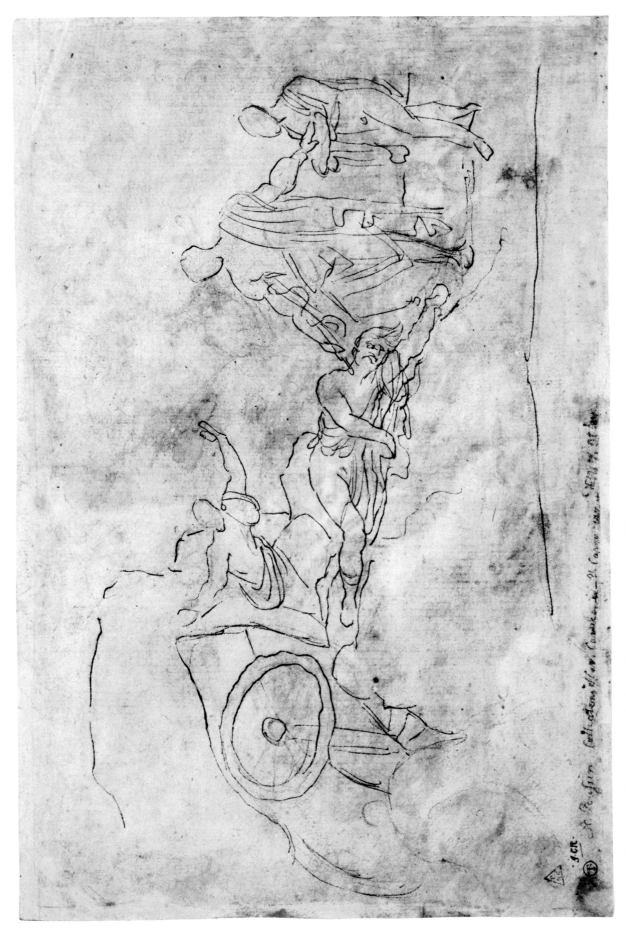

50 verso. NICOLAS POUSSIN *Asclepius Restoring Hippolytus to Life*

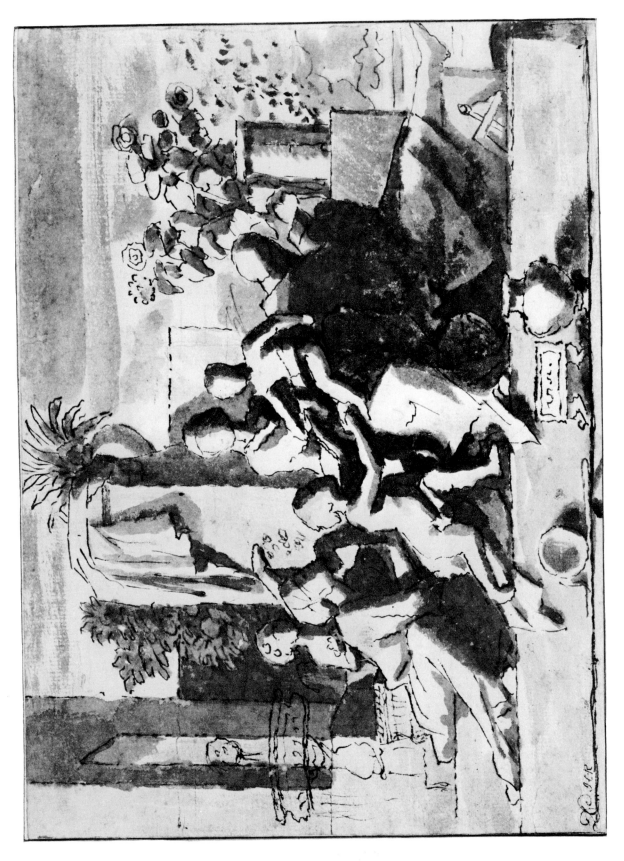

51. NICOLAS POUSSIN *The Holy Family*

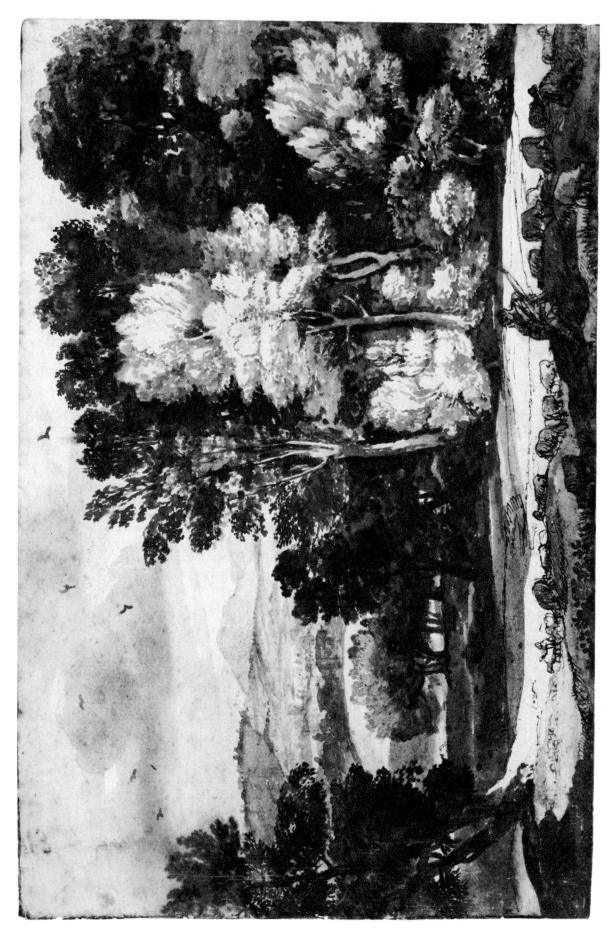

52. CLAUDE LORRAIN *Landscape with Shepherd and Flock*

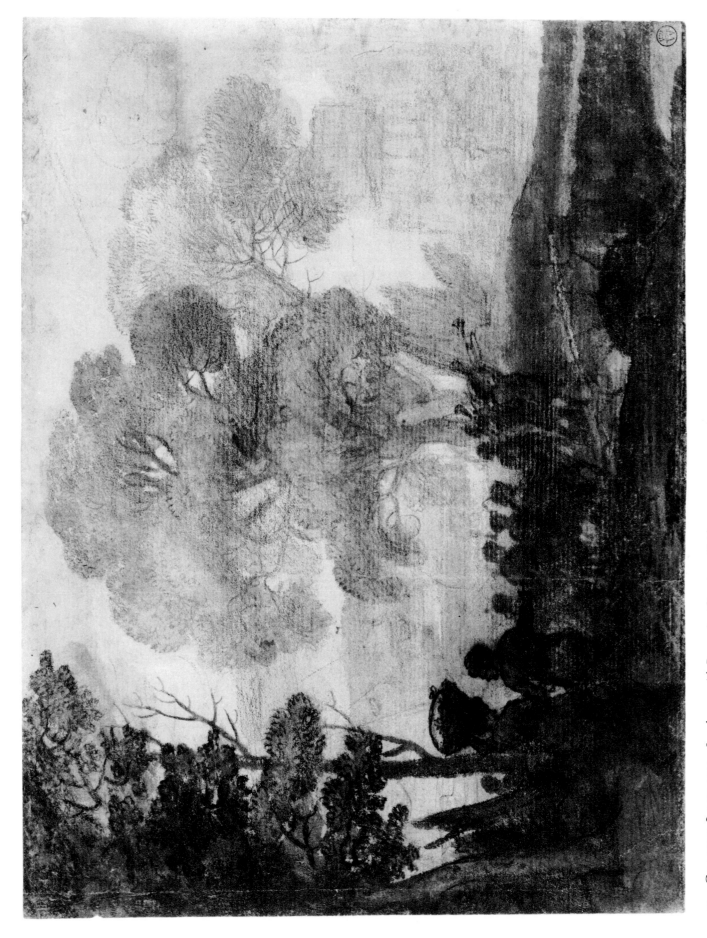

53. CLAUDE LORRAIN *Landscape with Procession Crossing a Bridge*

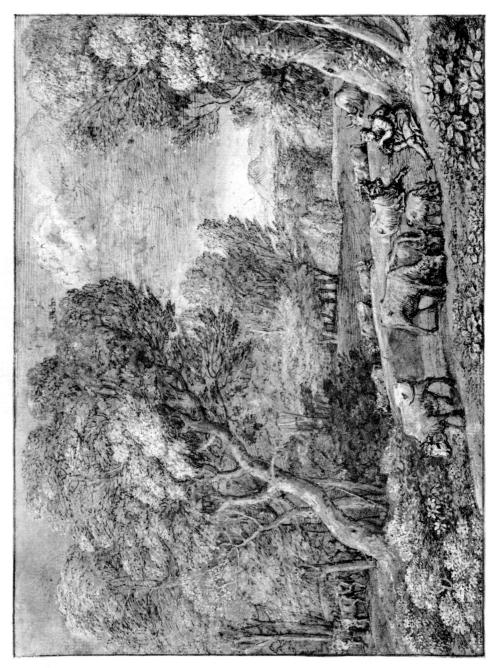

54. CLAUDE LORRAIN *Apollo Watching the Herds of Admetus*

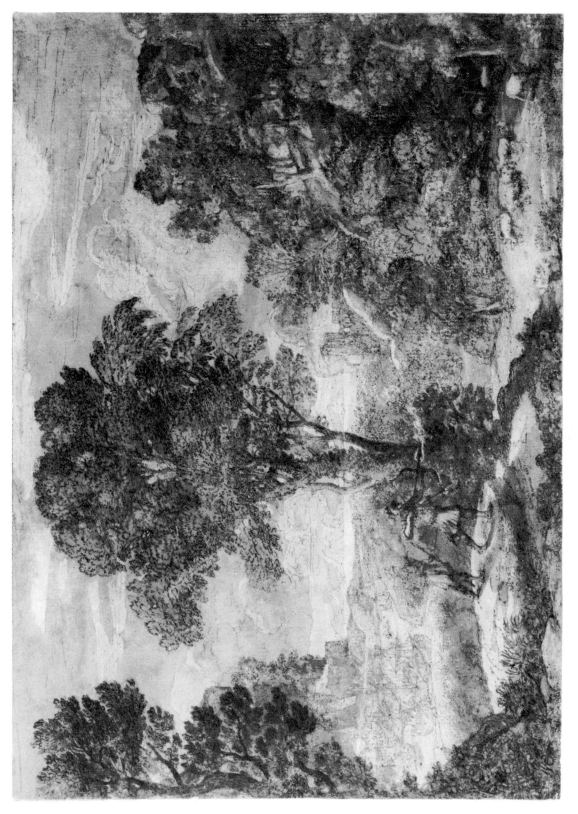

55. CLAUDE LORRAIN *Landscape with Aeneas and Achates Hunting the Stag*

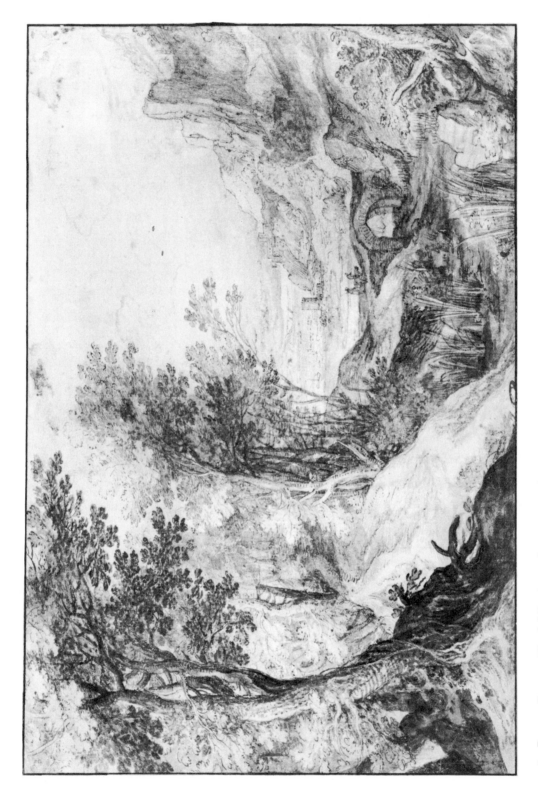

56. PAUL BRIL *Wooded Ravine with Distant Harbor View*

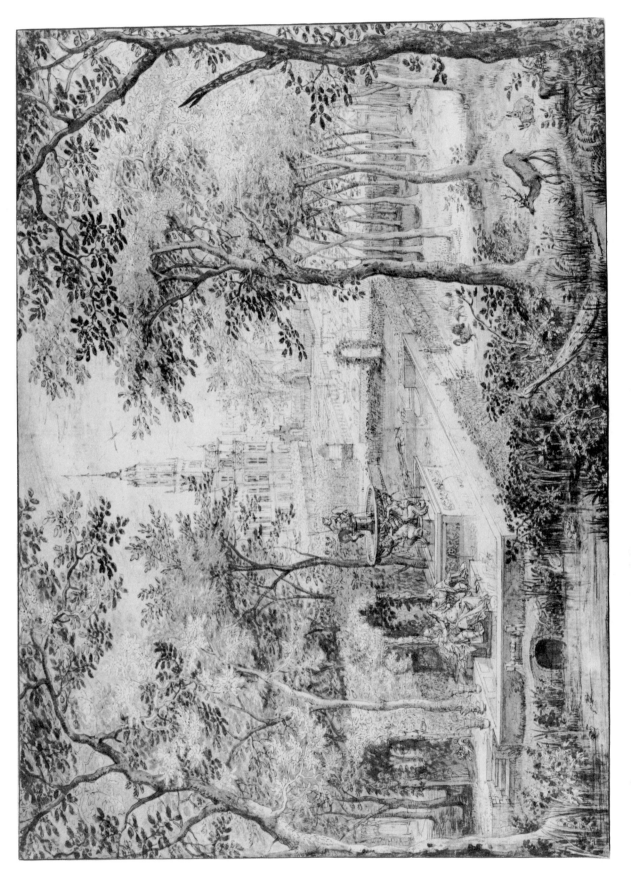

57. DAVID VINCKBOONS *Landscape with Susanna and the Elders*

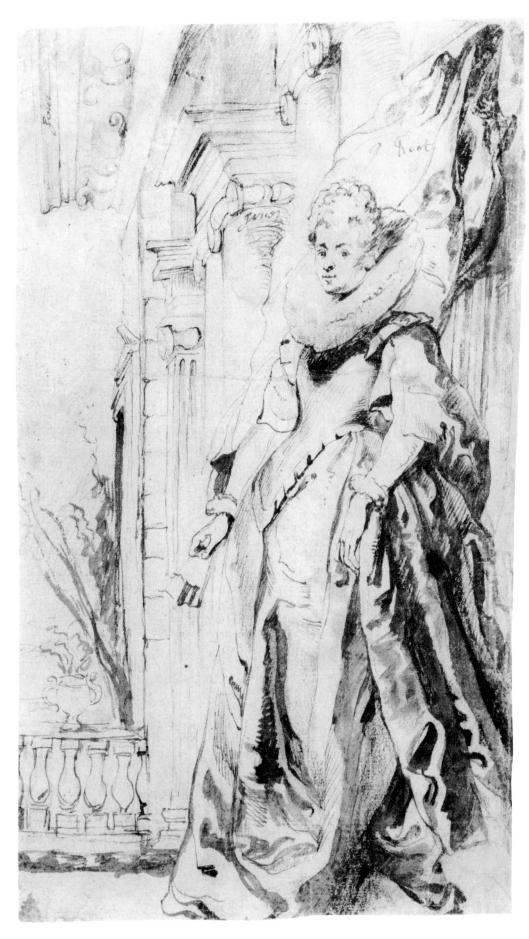

58. PETER PAUL RUBENS *Portrait of Marchesa Brigida Spinola Doria*

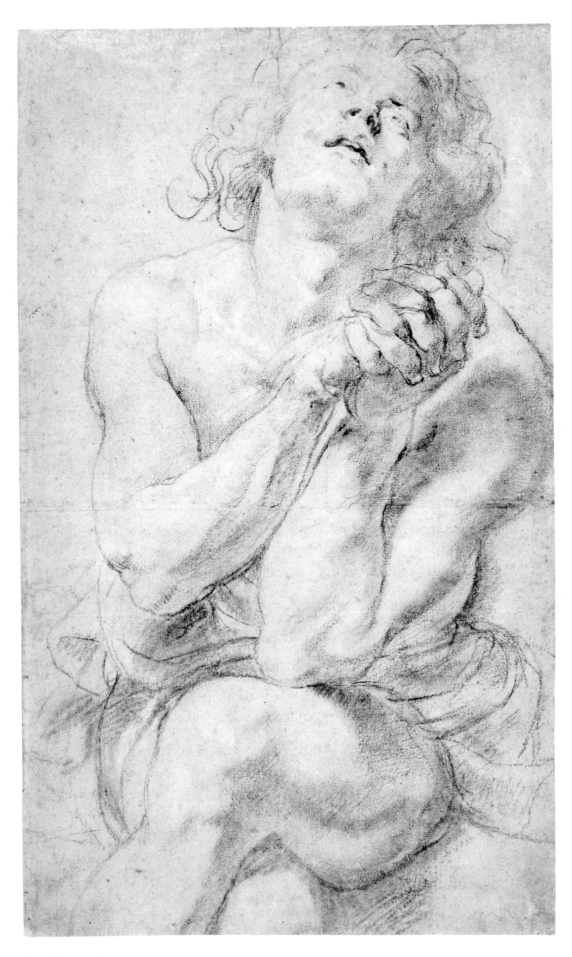

59. PETER PAUL RUBENS *Seated Nude Youth*

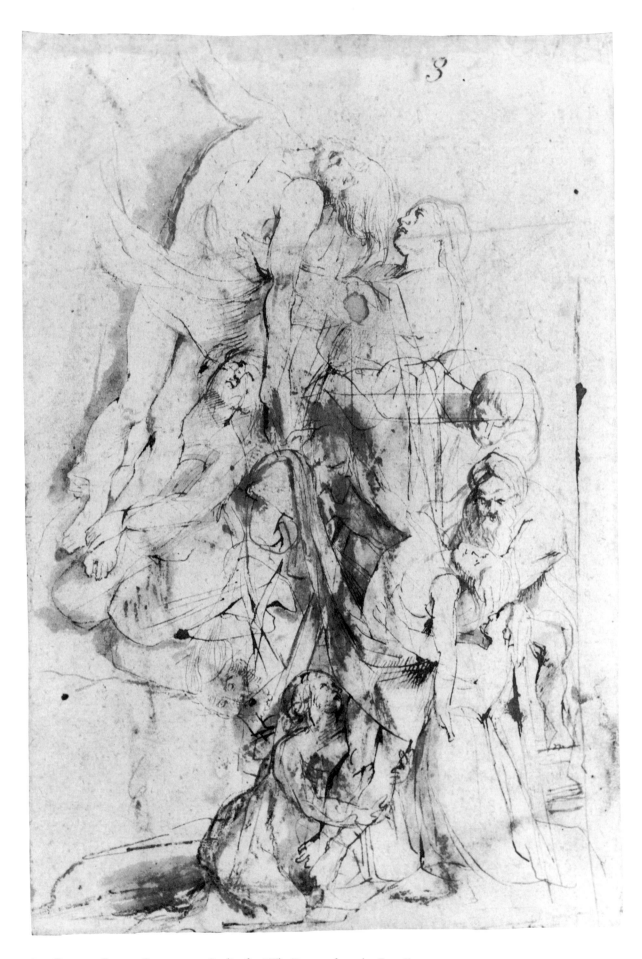

60. PETER PAUL RUBENS *Studies for "The Descent from the Cross"*

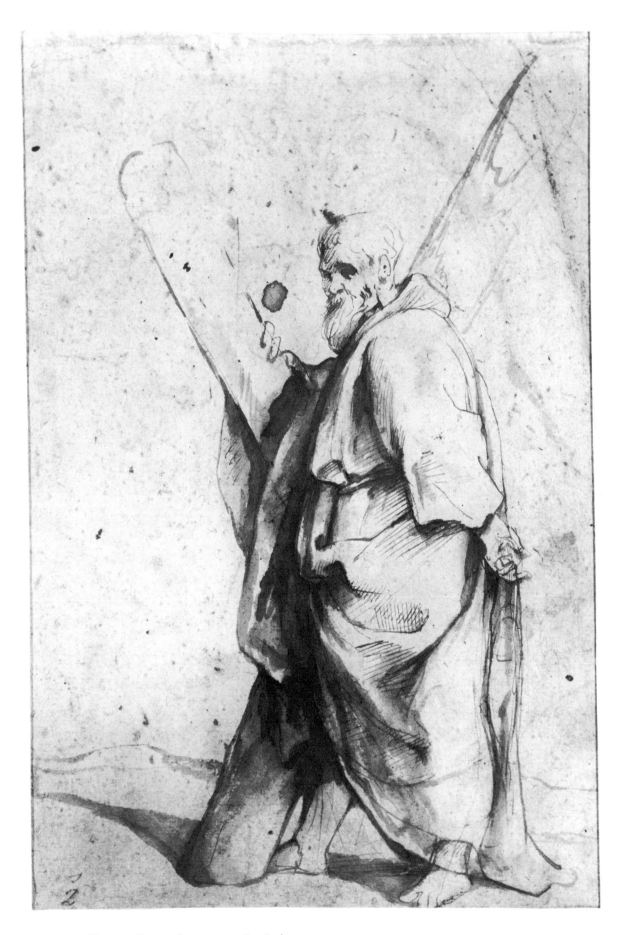

60 verso. PETER PAUL RUBENS *St. Andrew*

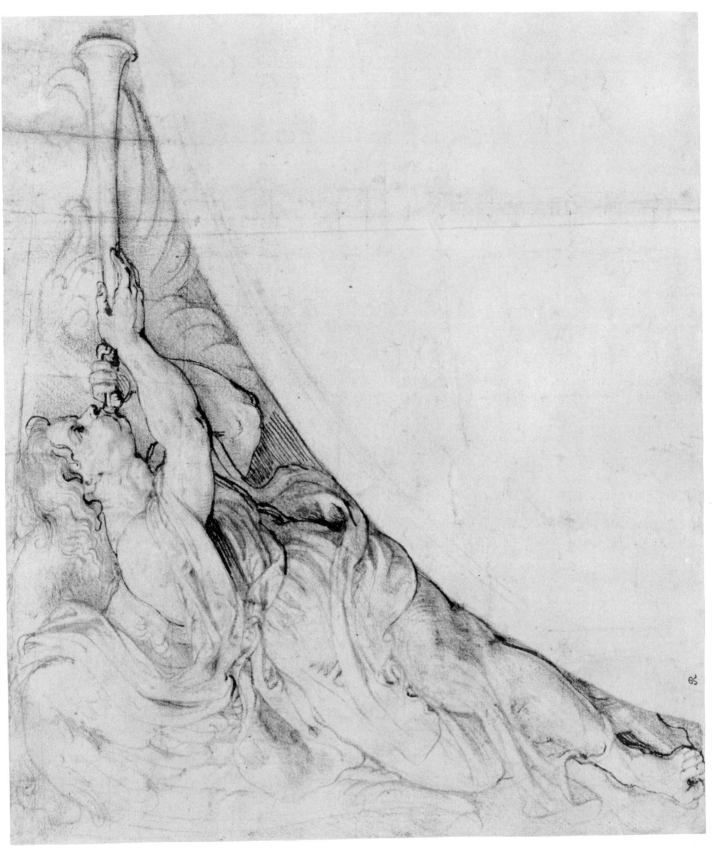

61. Peter Paul Rubens *Angel Blowing a Trumpet*

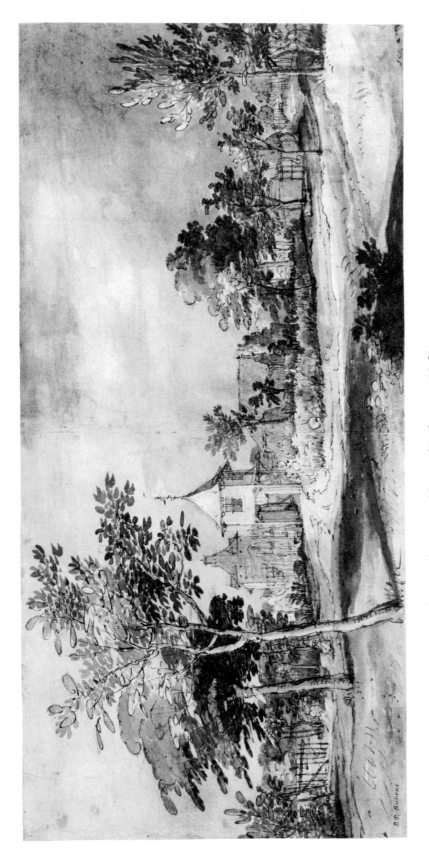

62. FLEMISH SCHOOL, c. 1610 *Landscape with Farm Buildings: "[Het] Keysers Hof"*

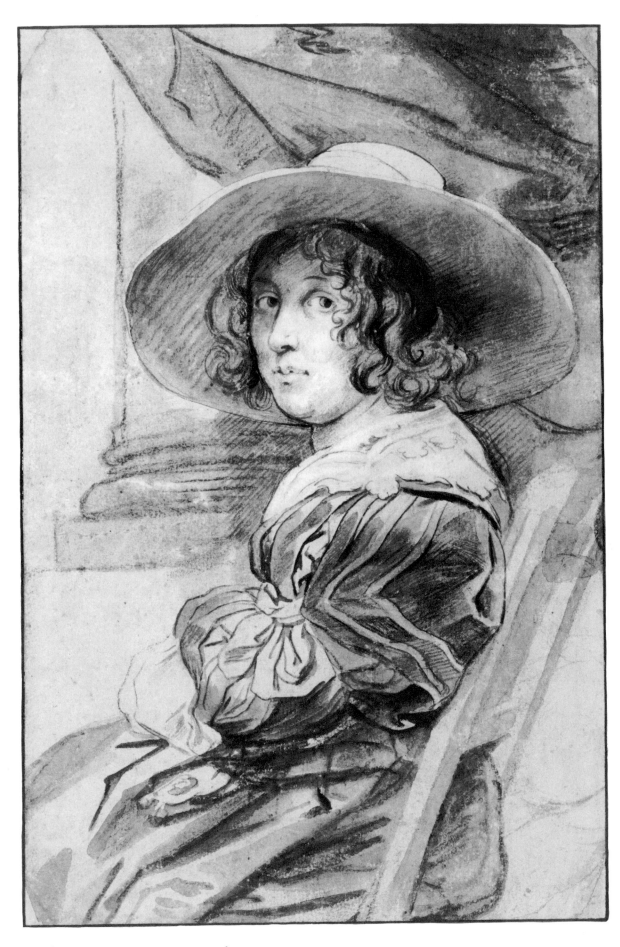

63. JACOB JORDAENS *Portrait of a Young Woman*

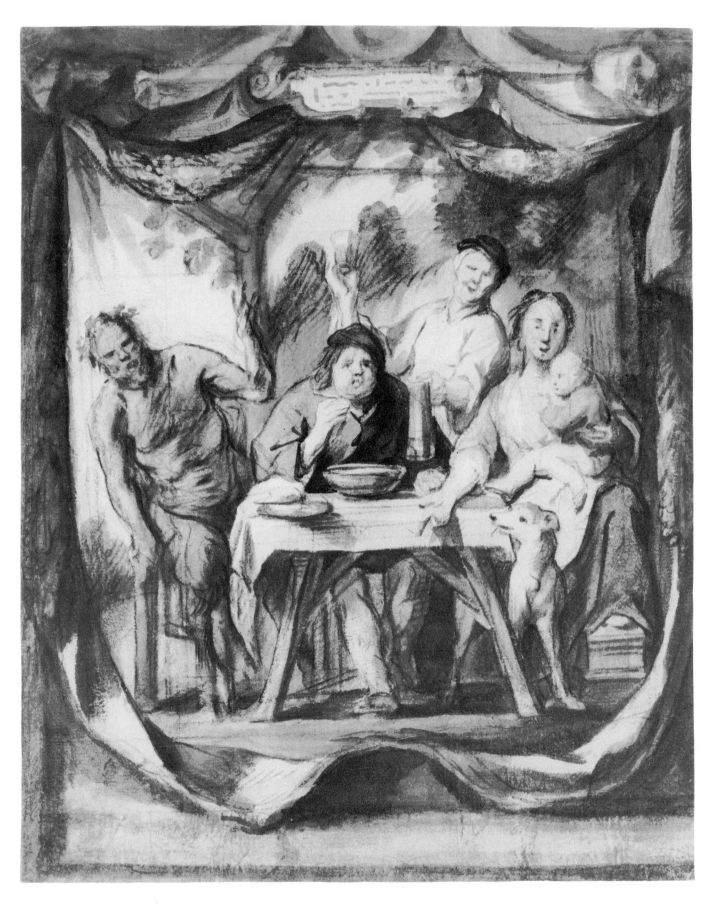

64. JACOB JORDAENS *The Satyr and the Peasant*

65. ANTHONY VAN DYCK *Diana and Endymion*

66. ANTHONY VAN DYCK *View of Rye from the Northeast*

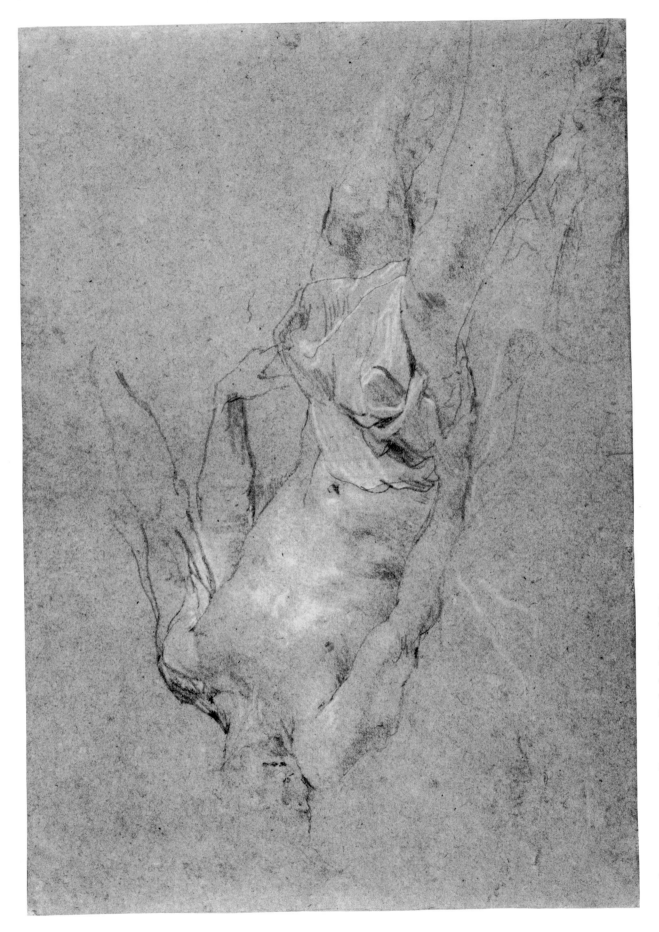

67. ANTHONY VAN DYCK *Study for the Dead Christ*

68. ADAM FRANS VAN DER MEULEN *View of Valenciennes*

69. HENDRICK GOLTZIUS *The Judgment of Midas*

70. HENDRICK GOLTZIUS *Young Man Holding a Skull and a Tulip*

71. ABRAHAM BLOEMAERT *St. Roch*

72. JACQUES DE GHEYN II *Mountain Landscape*

73 · JACQUES DE GHEYN II *Design for a Garden Grotto*

74. REMBRANDT VAN RIJN *Woman Carrying a Child Downstairs*

75. REMBRANDT VAN RIJN *Two Mummers on Horseback*

76. Rembrandt van Rijn *Three Studies for a "Descent from the Cross"*

77. REMBRANDT VAN RIJN *Canal and Bridge beside a Tall Tree*

78. REMBRANDT VAN RIJN *Seated Female Nude*

79. JAN LIEVENS THE ELDER *Portrait of a Man*

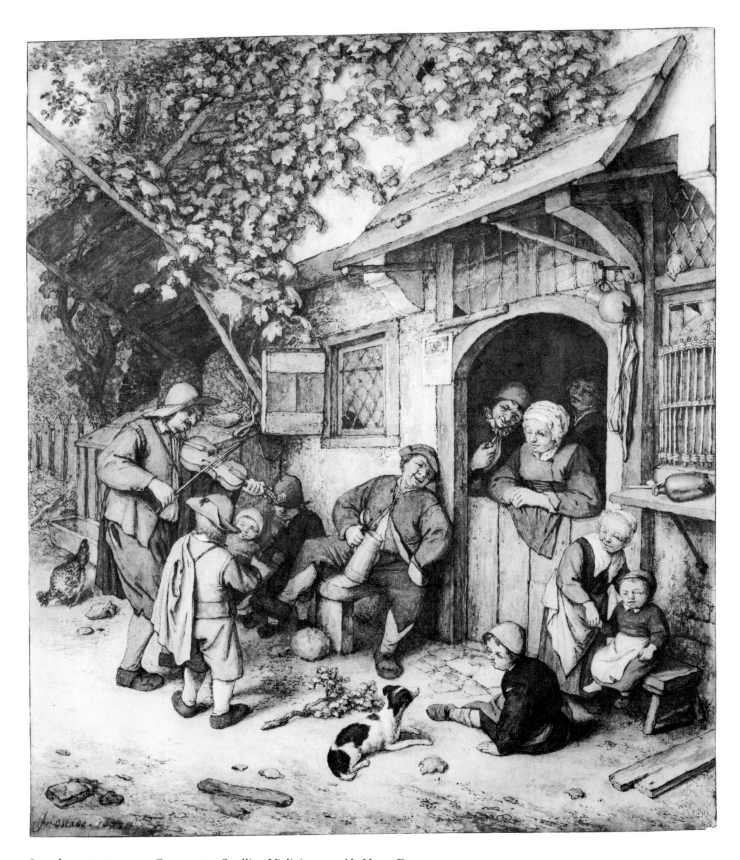

80. ADRAIEN VAN OSTADE *Strolling Violinist at an Ale House Door*

81. PHILIPS KONINCK (?)　*View of the Buitenhof at The Hague*

82. Aelbert Cuyp *Landscape with a Watermill*

83. Lambert Doomer *The Spring at Cleves*

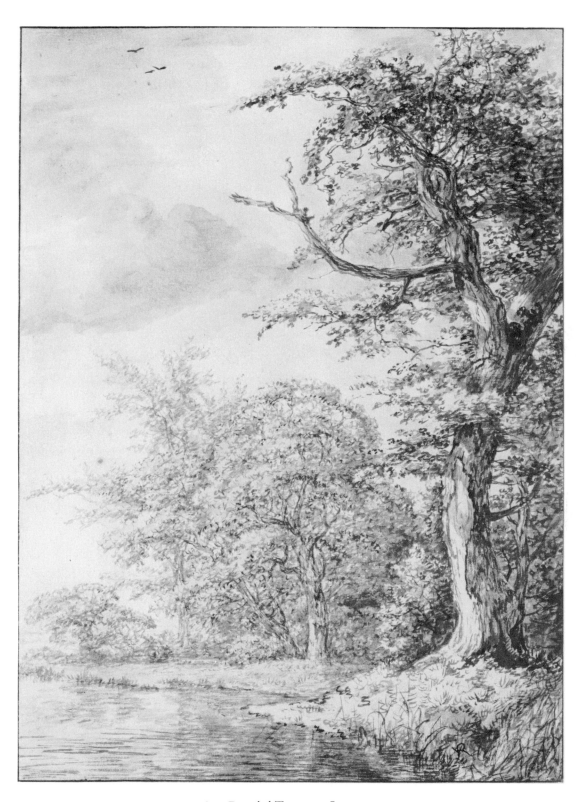

84. Jacob van Ruisdael *Sun-Dappled Trees on a Stream*

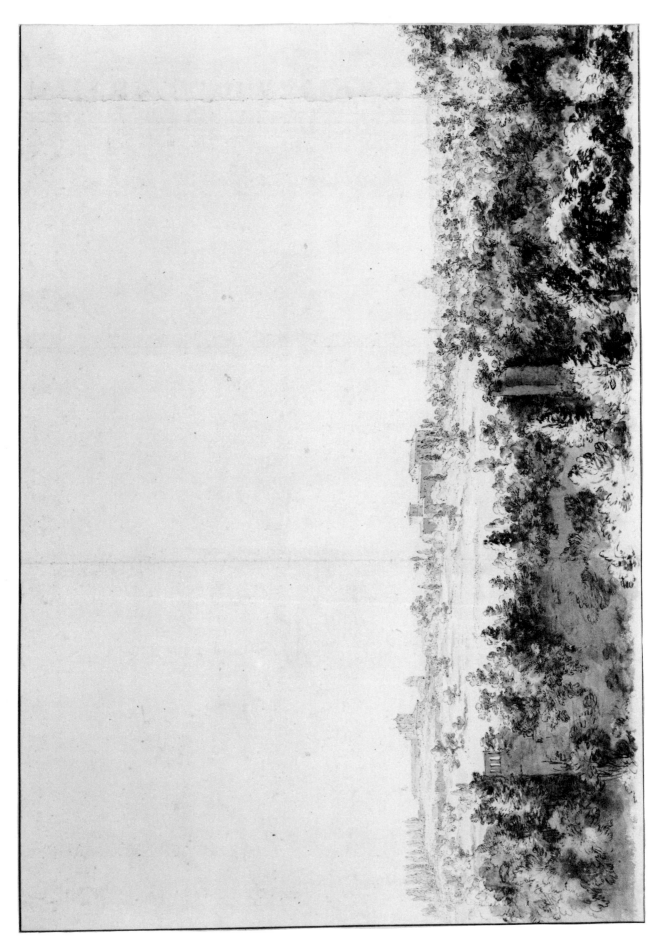

85. JAN DE BISSCHOP *View of Rome* (I)

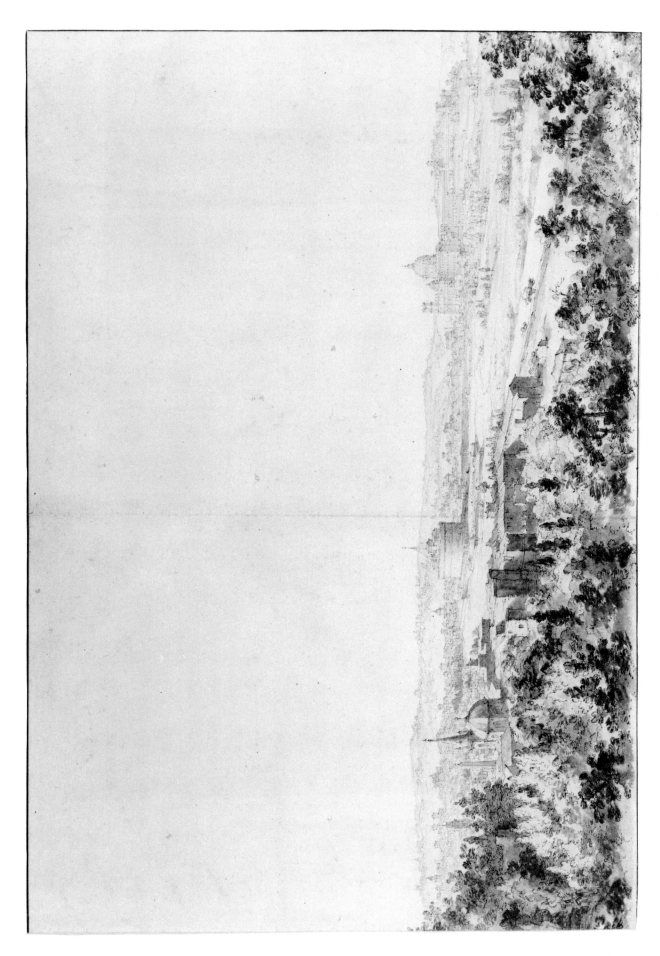

85. JAN DE BISSCHOP *View of Rome* (2)

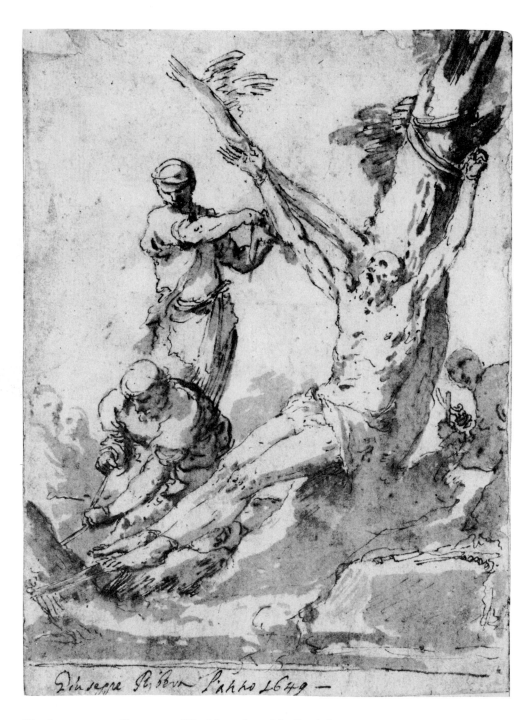

86. JUSEPE DE RIBERA *The Martyrdom of St. Bartholomew*

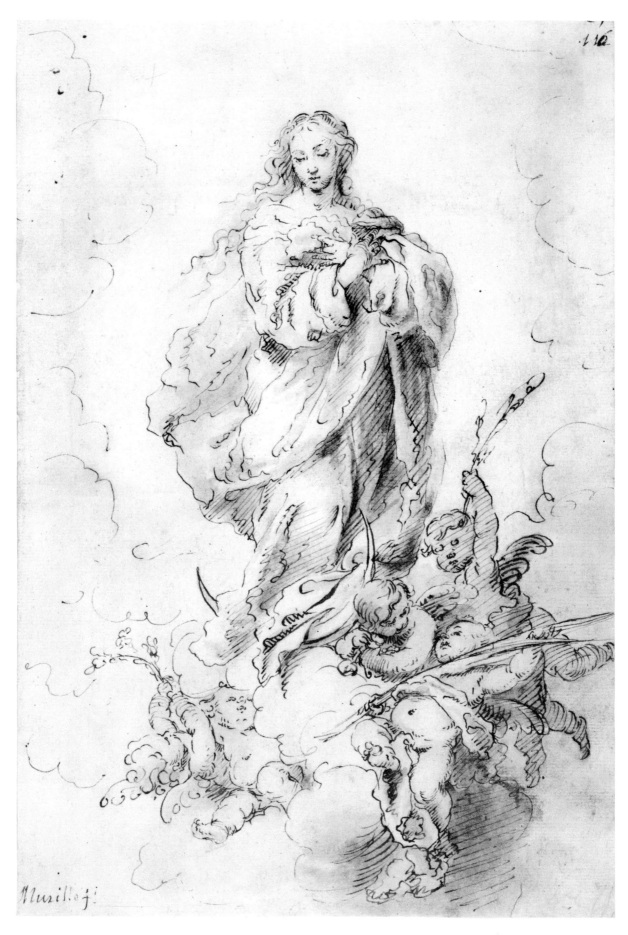

87. BARTOLOMÉ ESTEBAN MURILLO *Immaculate Conception*

88. FRANCISCO HERRERA THE YOUNGER *The Vision of St. John on Patmos*

88 verso. FRANCISCO HERRERA THE YOUNGER *Seated Male Nude; Designs for Ornament; Ground Plans*

89. GIOVANNI BATTISTA PIAZZETTA *Young Woman Holding a Jingle Ring*

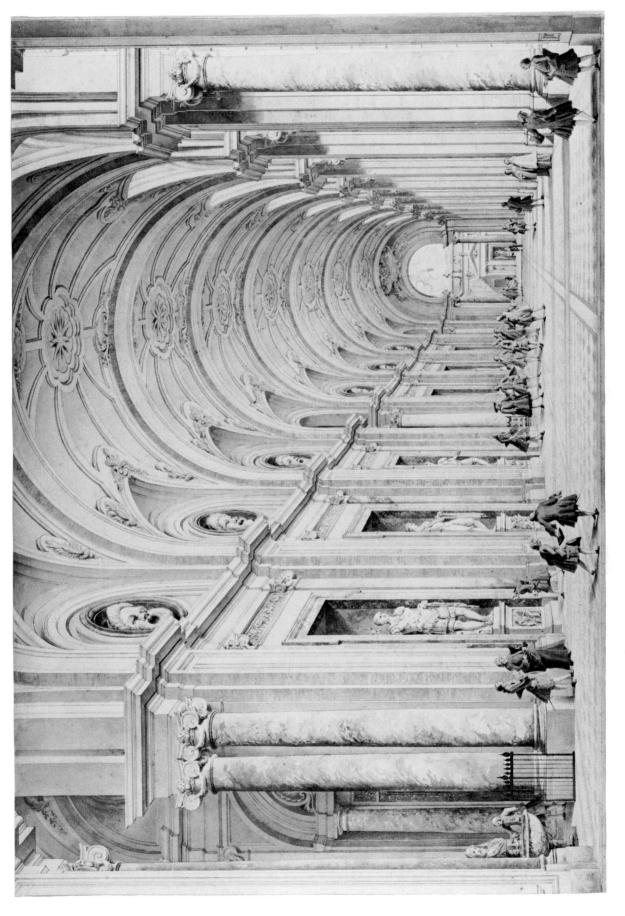

90. Giovanni Paolo Pannini *Interior of the Villa Albani, Rome*

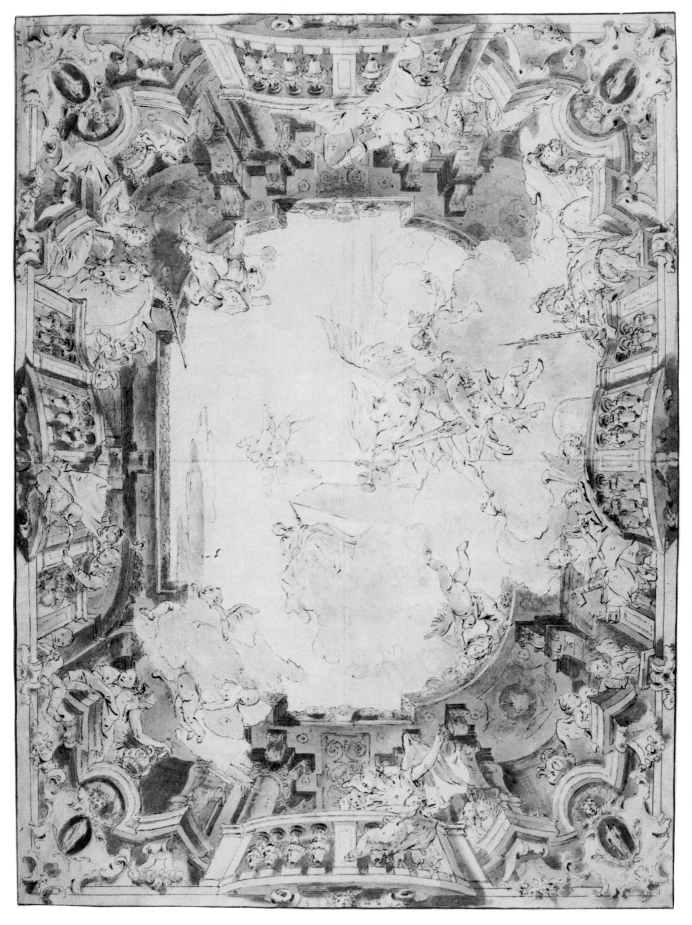

91. GIOVANNI BATTISTA TIEPOLO *Design for a Ceiling*

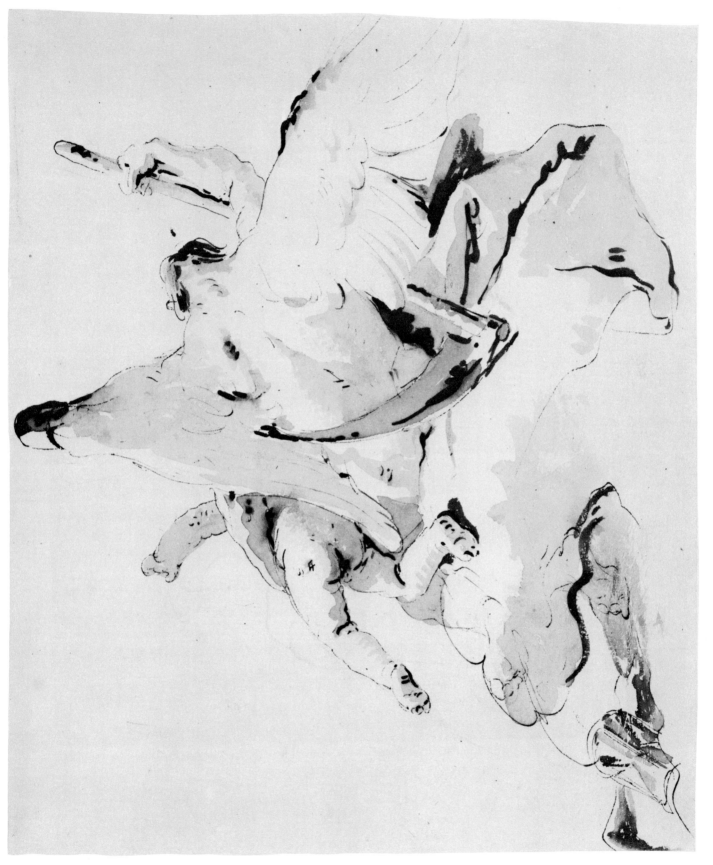

92. GIOVANNI BATTISTA TIEPOLO *Time and Cupid*

93. CANALETTO *Architectural Capriccio*

94. Francesco Guardi *The Bucintoro off S. Niccolò di Lido*

94 verso. GIACOMO GUARDI *Architectural Studies and Figures*

95. Giovanni Battista Piranesi *Gondola*

95 verso. GIOVANNI BATTISTA PIRANESI *Ornament with Sun and Star Motifs; Decorative Frames*

96. GIOVANNI BATTISTA PIRANESI *Architectural Fantasy*

97. GIOVANNI DOMENICO TIEPOLO *The Dressmaker*

98. Jean-Antoine Watteau *The Temple of Diana*

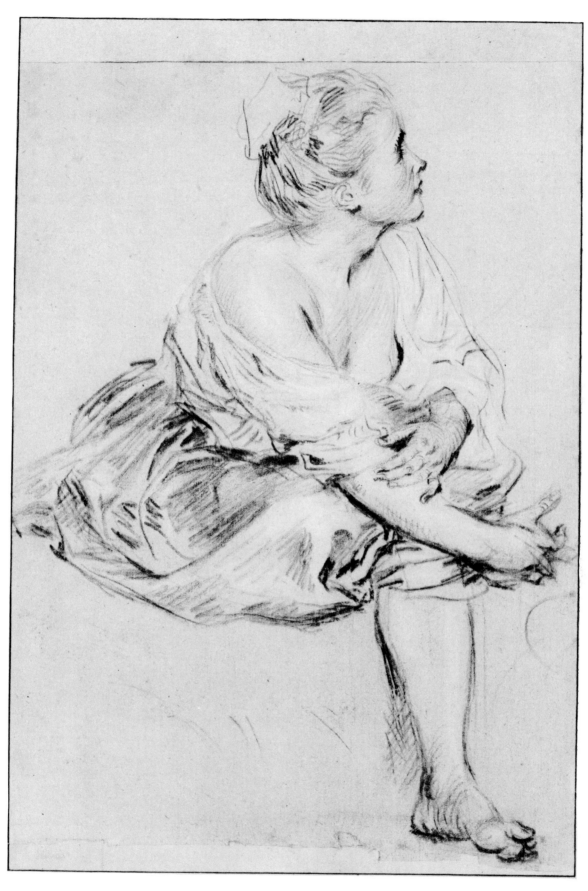

99. JEAN-ANTOINE WATTEAU *Seated Young Woman*

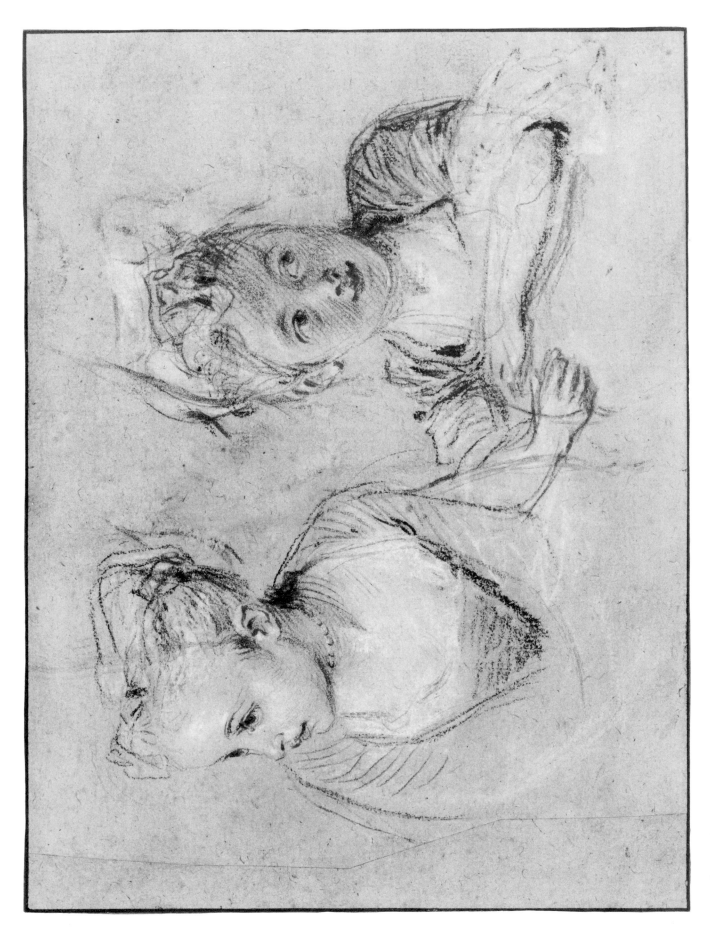

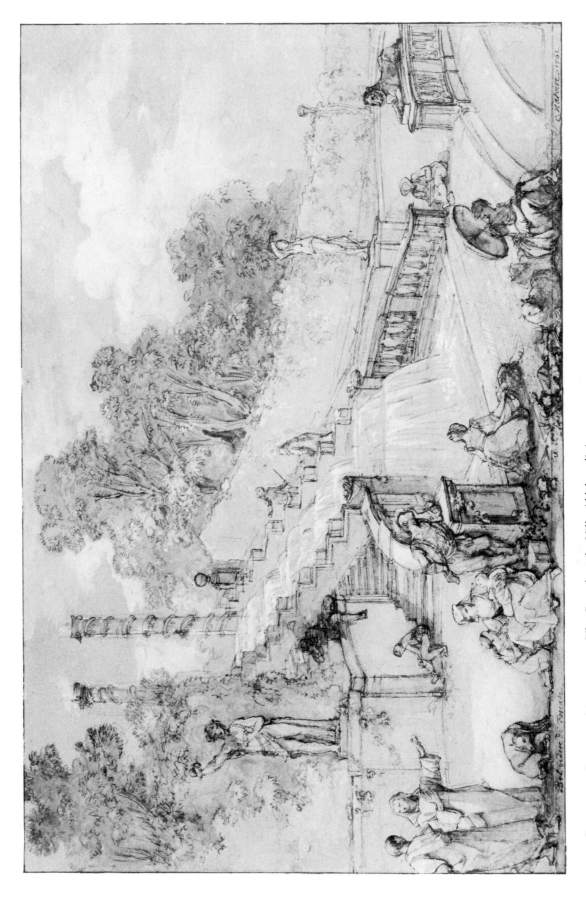

101. CHARLES-JOSEPH NATOIRE *The Cascade at the Villa Aldobrandini*

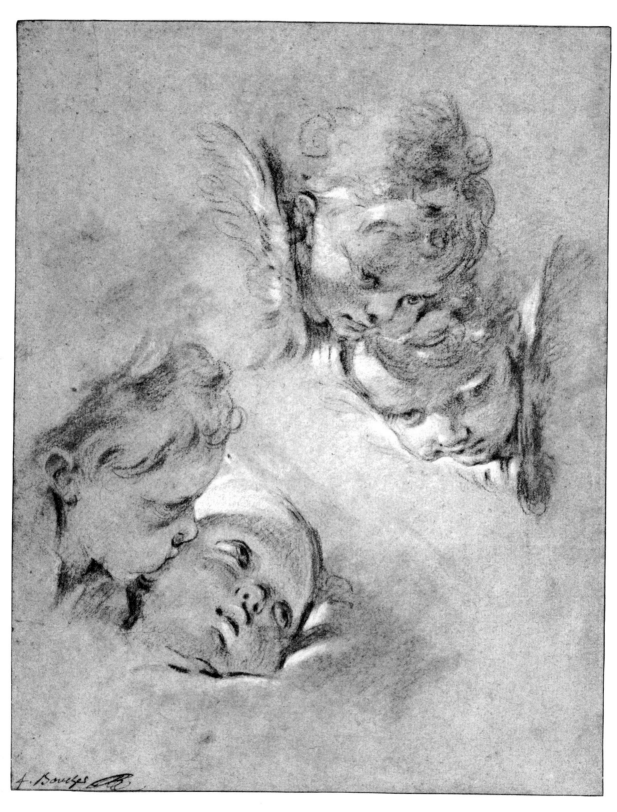

102. FRANÇOIS BOUCHER *Four Heads of Cherubim*

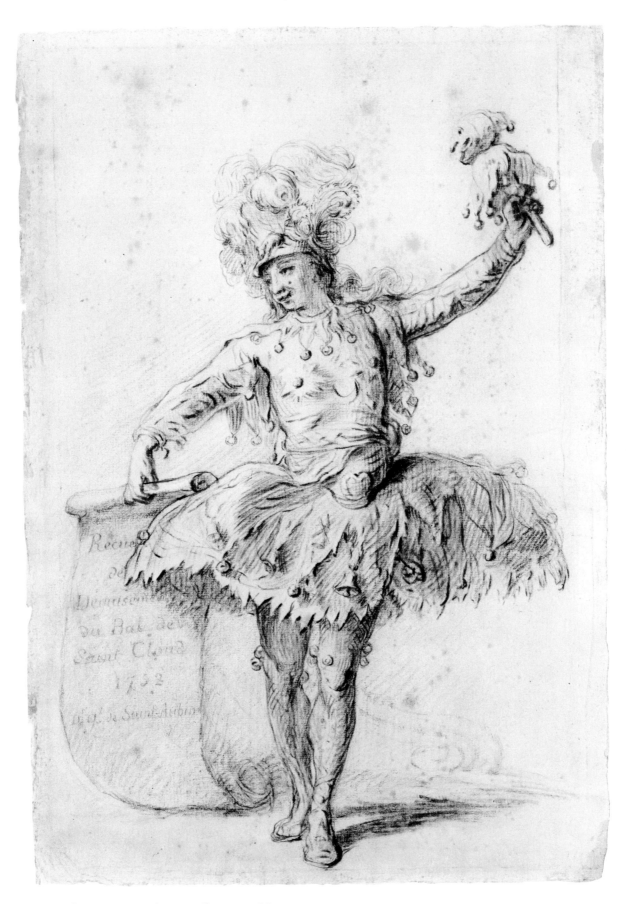

103. GABRIEL DE SAINT-AUBIN *Momus*

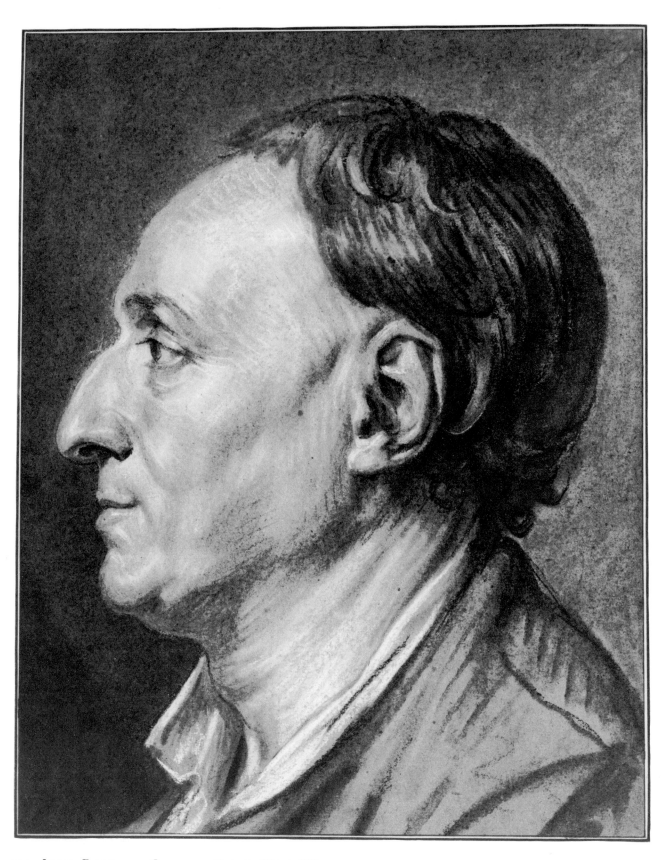

104. JEAN-BAPTISTE GREUZE *Portrait of Denis Diderot*

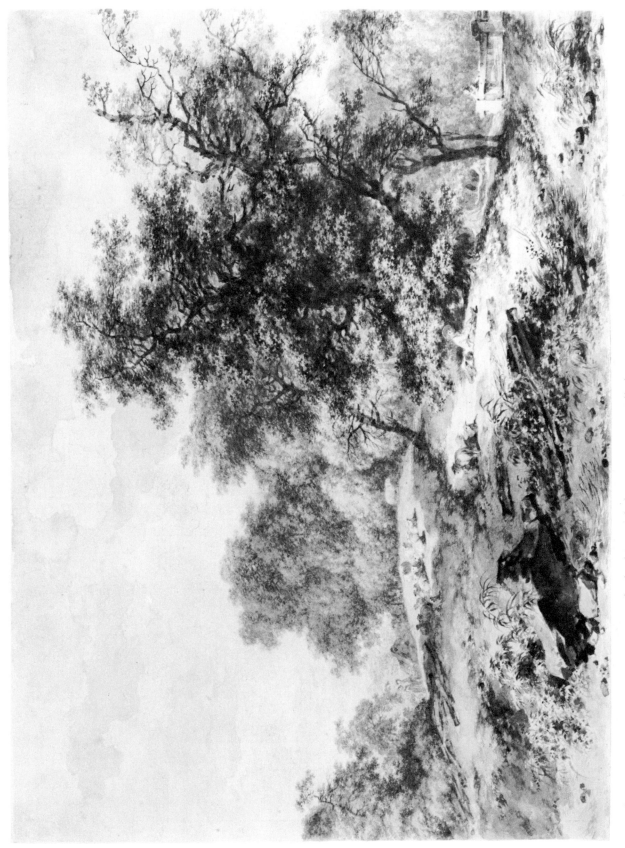

105. JEAN-HONORÉ FRAGONARD *Shepherd Boy and Sheep on a Sunny Hillside*

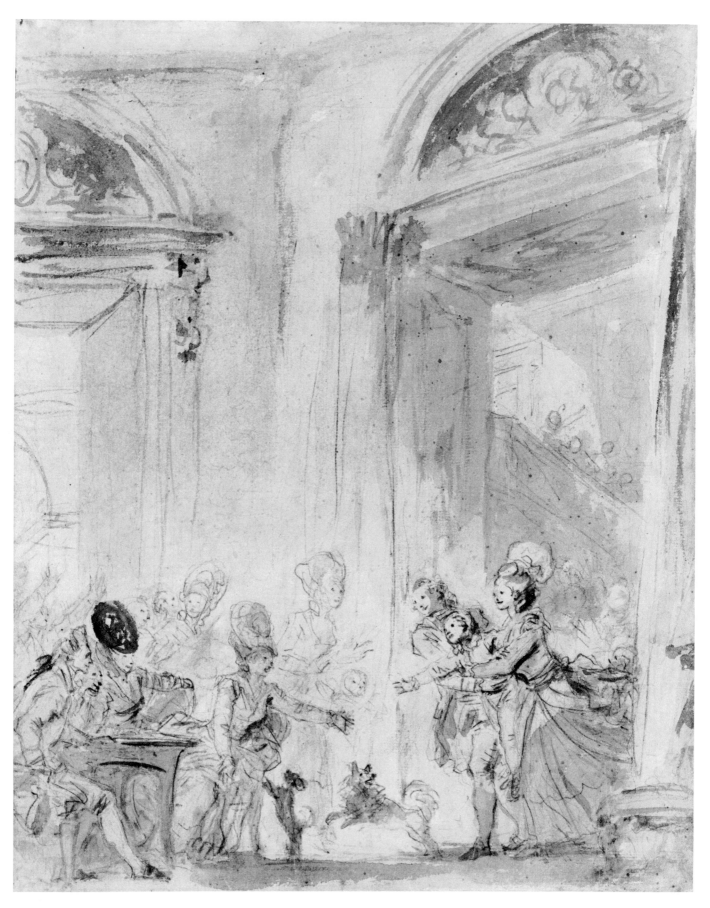

106. JEAN-HONORÉ FRAGONARD *"La Récompense"*

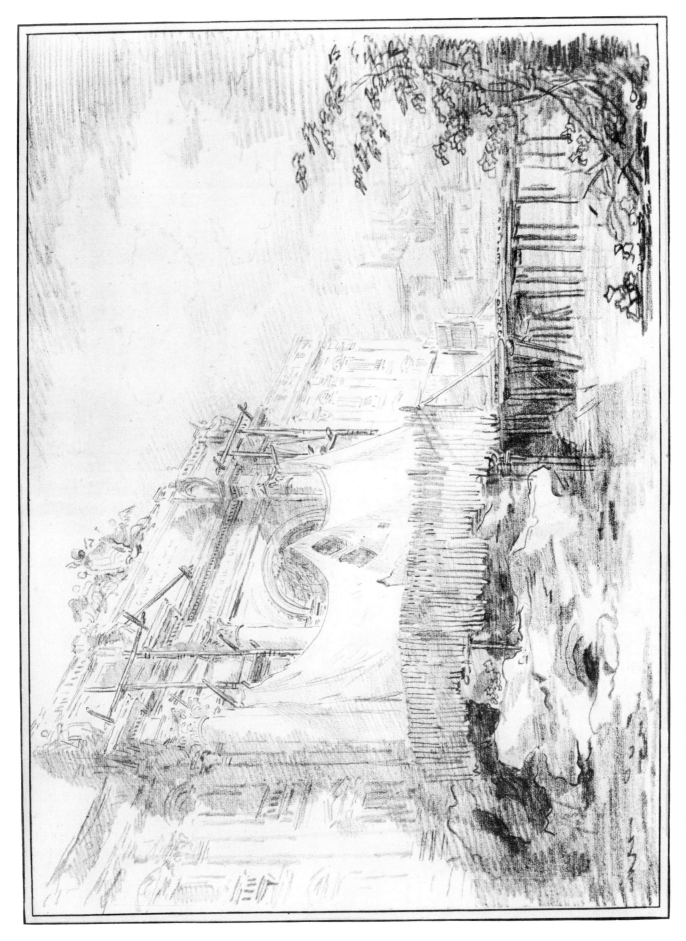

107. HUBERT ROBERT *The Trevi Fountain under Construction*

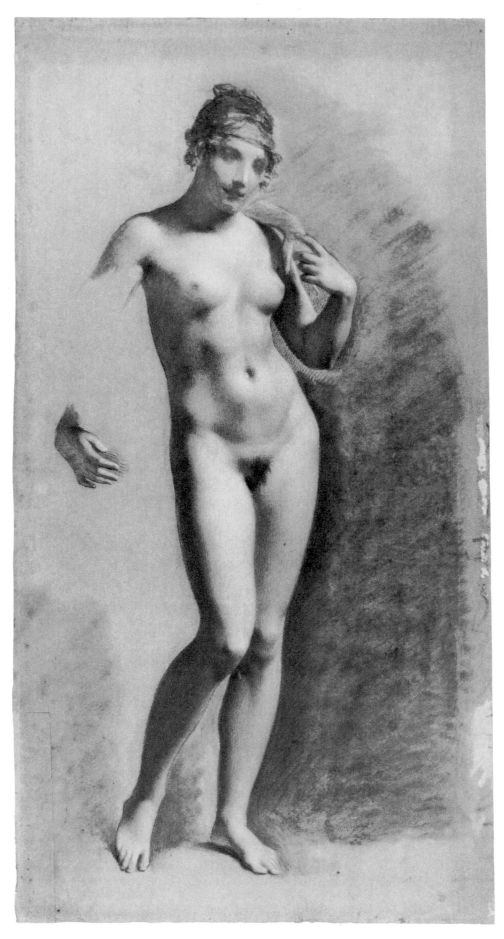

108. PIERRE-PAUL PRUD'HON *Female Nude*

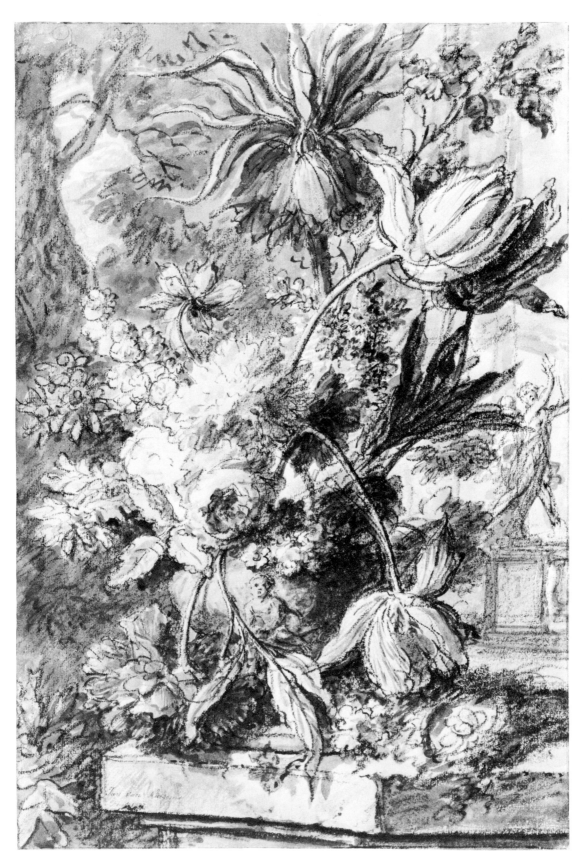

109. Jan van Huysum *Flowerpiece*

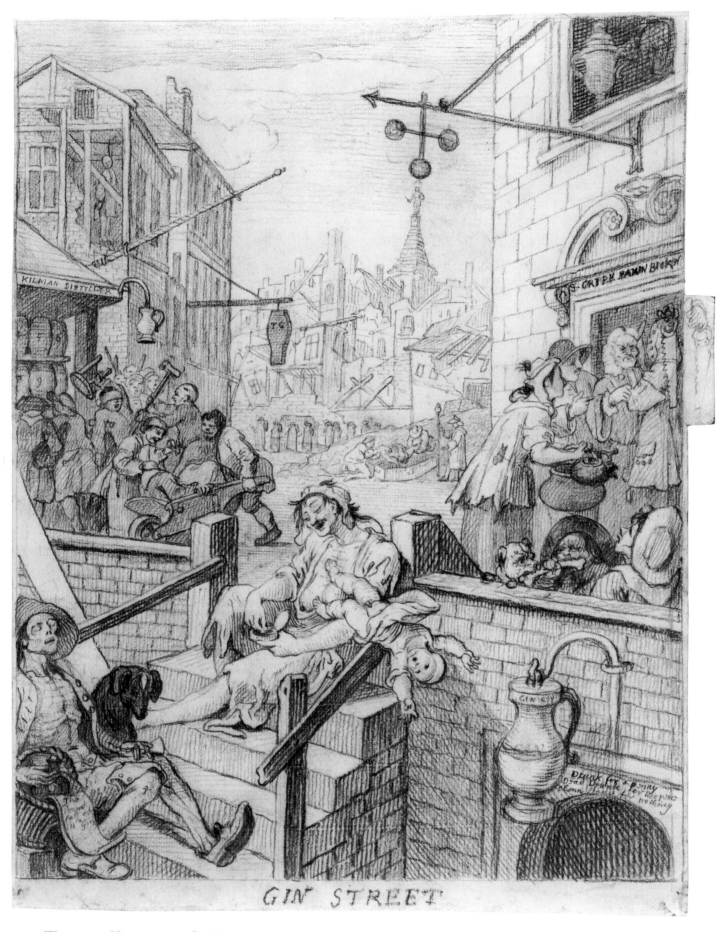

GIN STREET

110. WILLIAM HOGARTH *Gin Street*

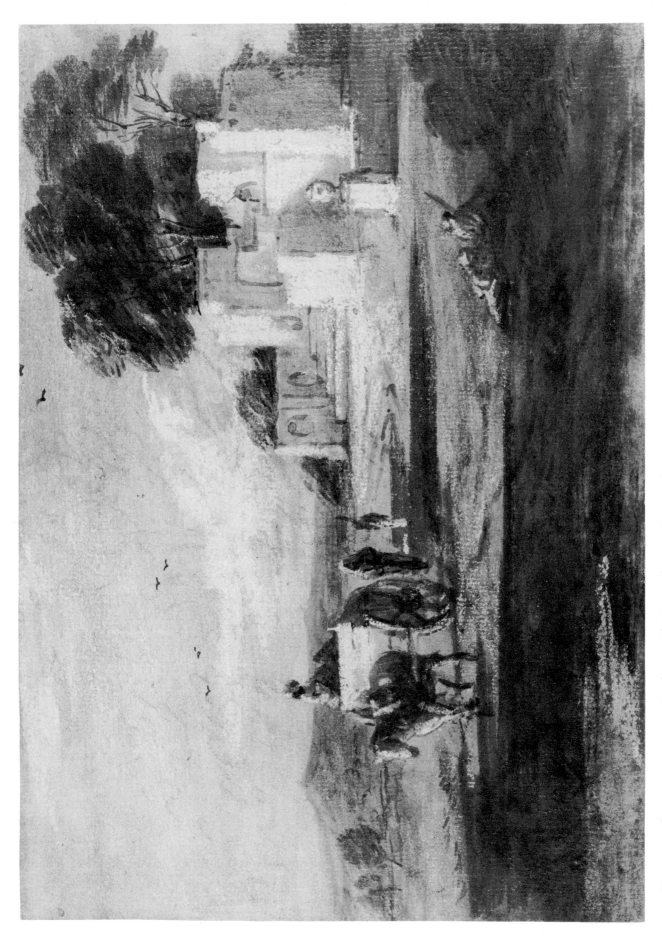

III. THOMAS GAINSBOROUGH *Landscape with Horse and Cart, Figures, and Ruin*

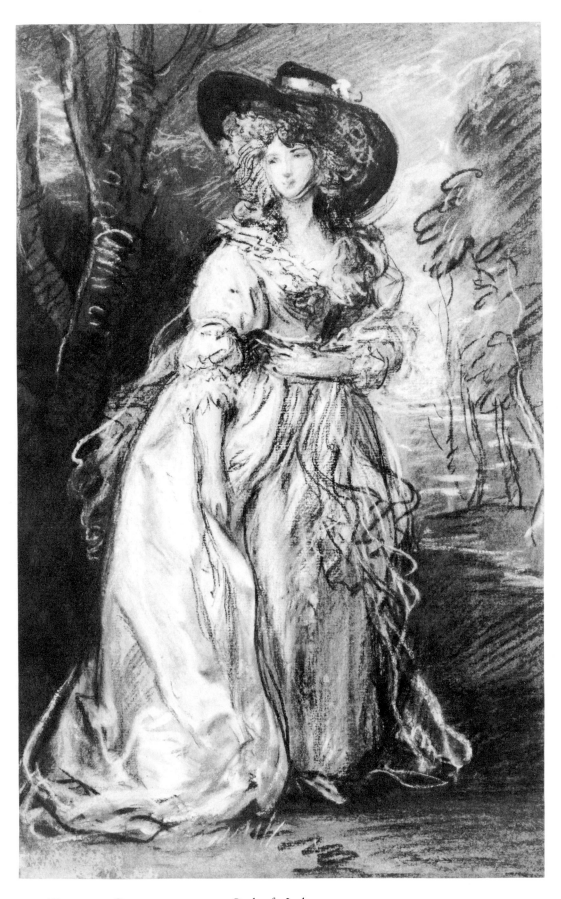

112. THOMAS GAINSBOROUGH *Study of a Lady*

113. BENJAMIN WEST *Gnarled Tree Trunk*

114. HENRY FUSELI *Portrait of Martha Hess*

115. HENRY FUSELI *Satan Departing from the Court of Chaos*

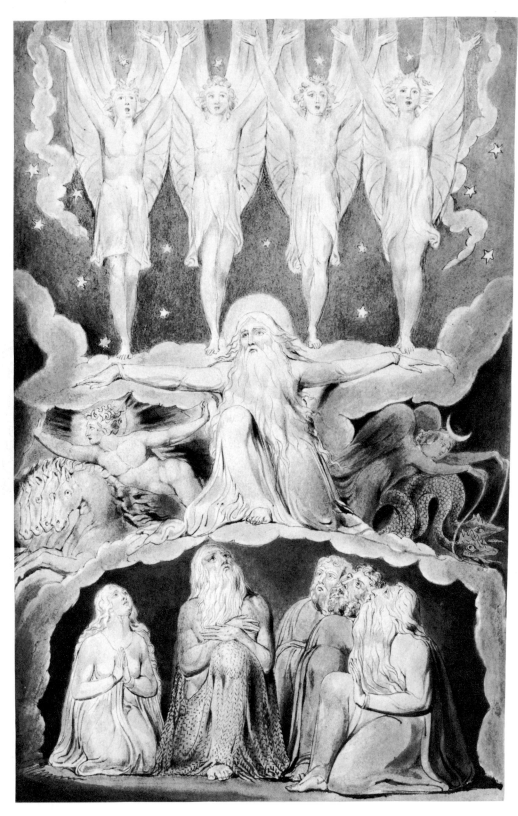

116. WILLIAM BLAKE *"When the Morning Stars Sang Together"*

117. WILLIAM BLAKE *Mirth*

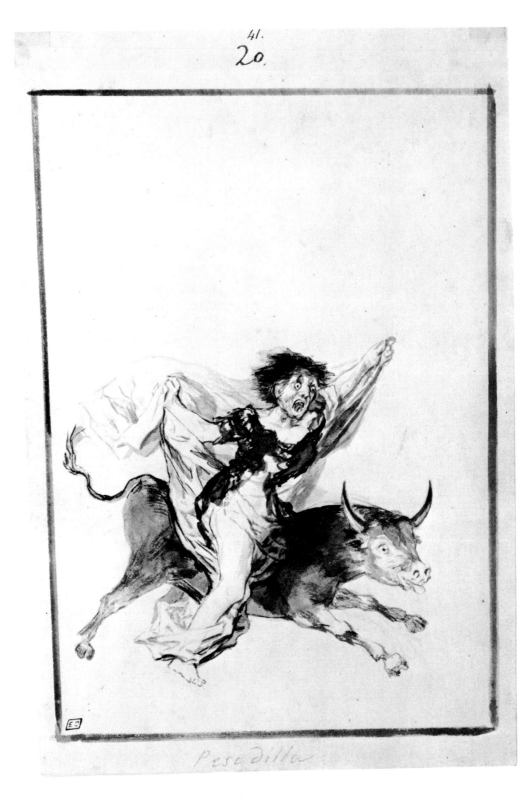

118. FRANCISCO GOYA *"Pesadilla"*

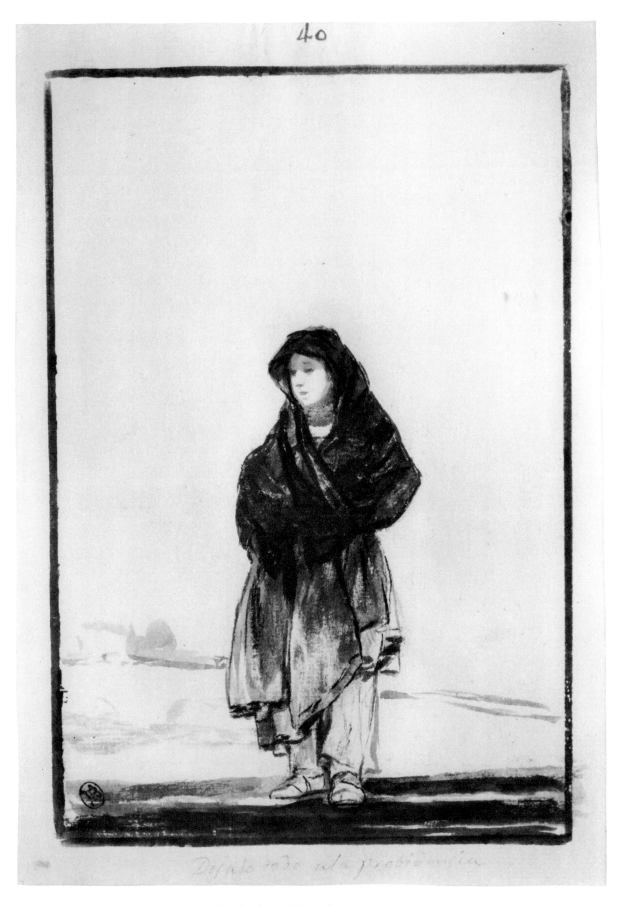

119. FRANCISCO GOYA *"Dejalo todo a la probidencia"*

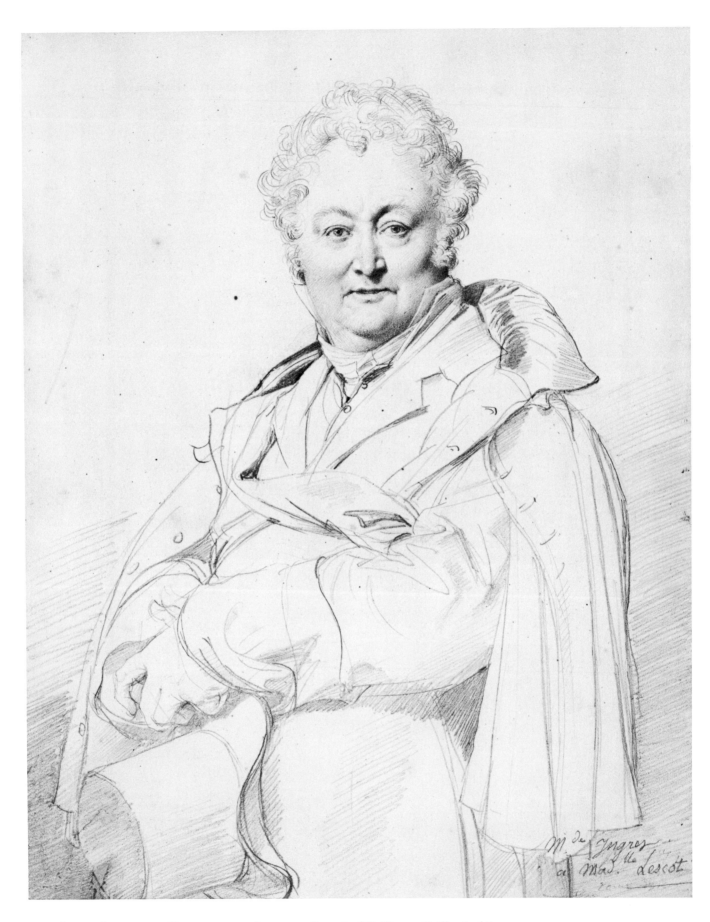

120. JEAN-AUGUSTE-DOMINIQUE INGRES *Portrait of Guillaume Guillon Lethière*

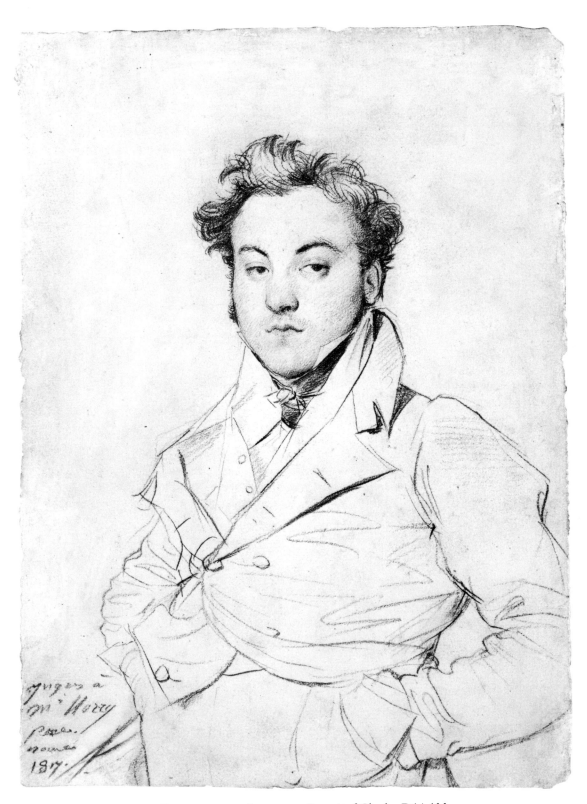

121. Jean-Auguste-Dominique Ingres *Portrait of Charles-Désiré Norry*

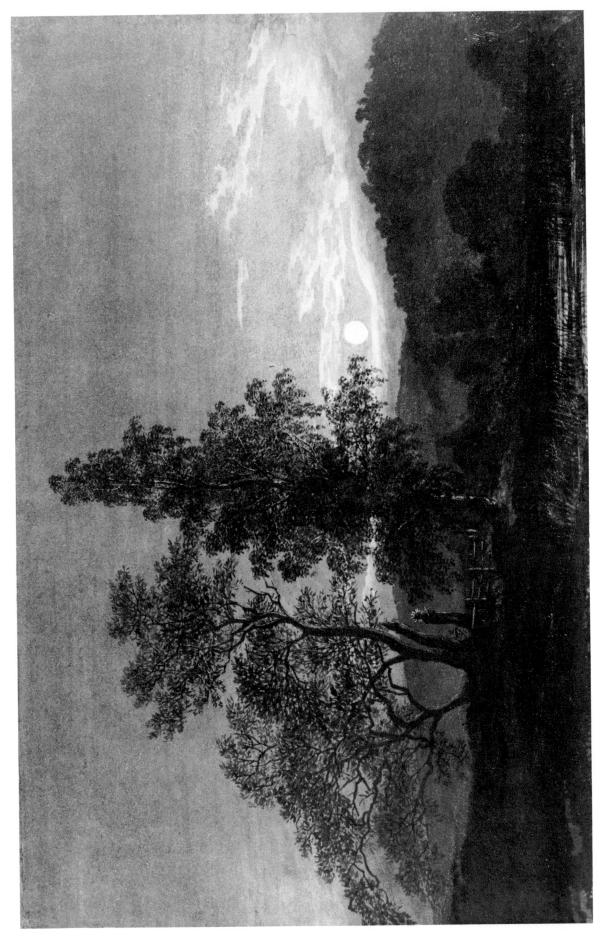

122. CASPAR DAVID FRIEDRICH *Moonlit Landscape*

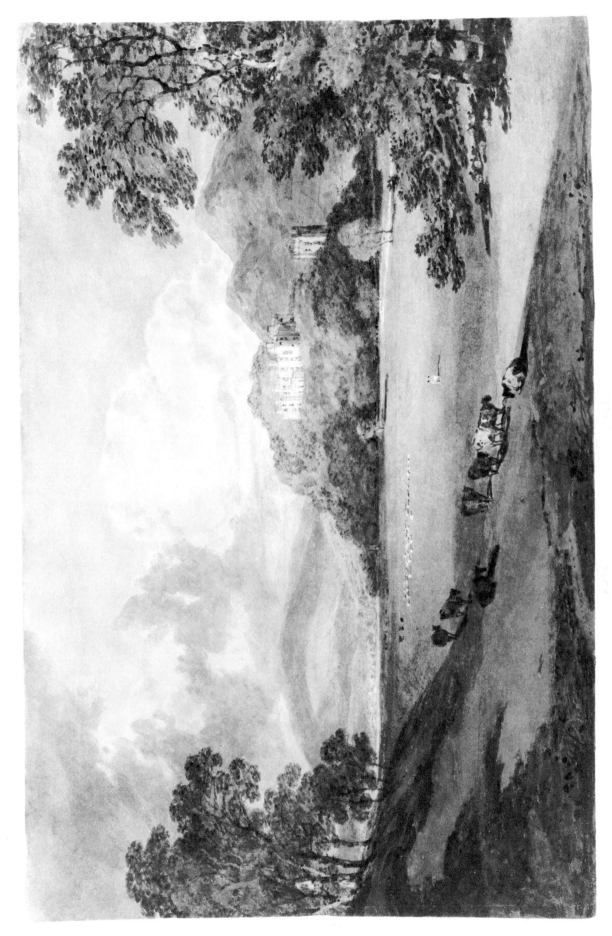

123. Joseph Mallord William Turner *View of Dunster Castle from the Northeast*

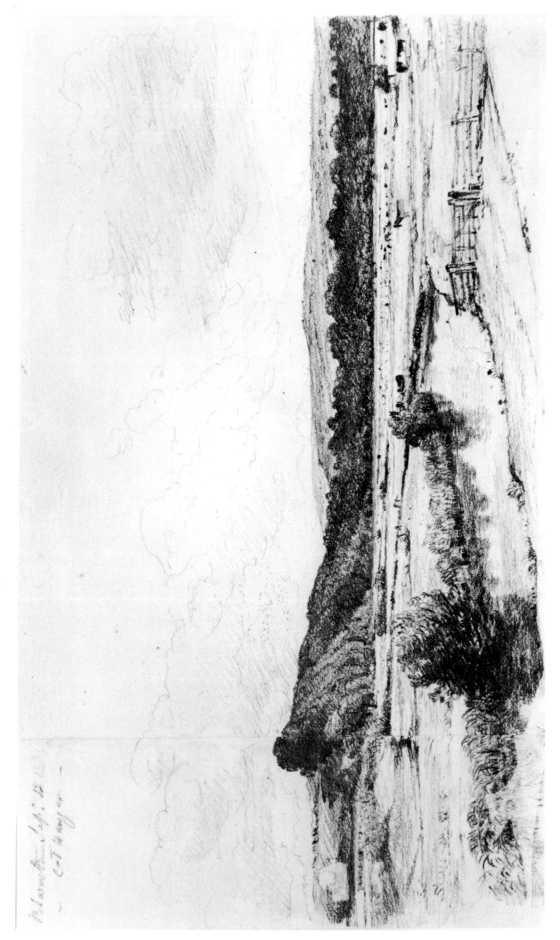

124. JOHN CONSTABLE *View of Cathanger near Petworth*

125. SAMUEL PALMER *Pear Tree in a Walled Garden*

INDEX OF ARTISTS